The Art of
THOMAS
GAINSBOROUGH

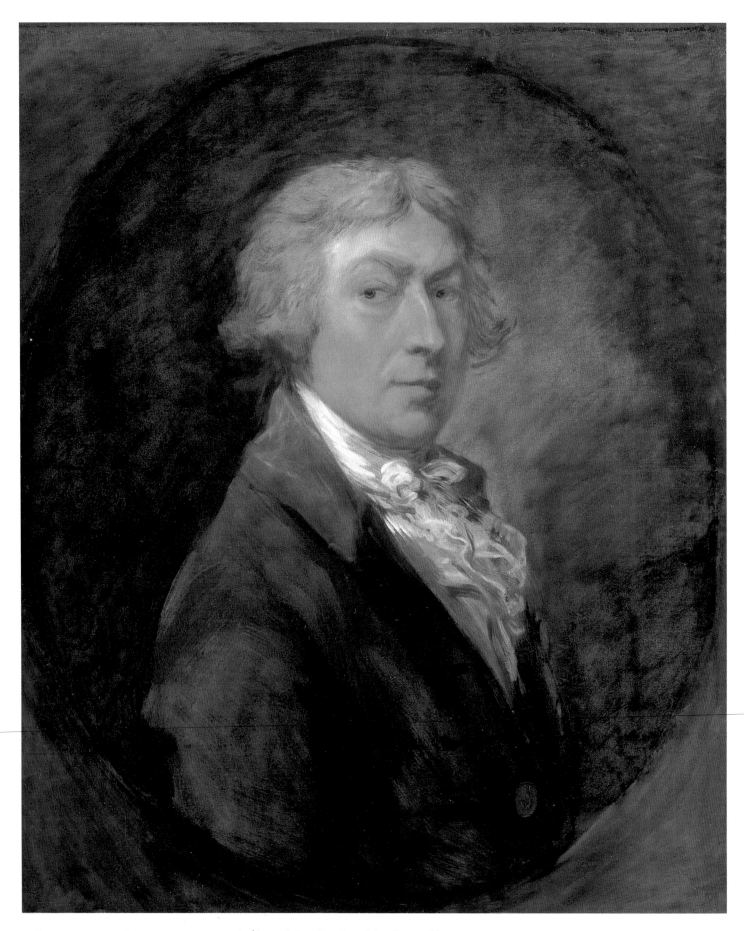

Self-portrait, *c.*1787, oil on canvas, 749 × 610 (29½ × 24). London, Royal Academy of Arts.

The Art of
THOMAS GAINSBOROUGH

'a little business for the Eye'

MICHAEL ROSENTHAL

Published for

THE PAUL MELLON CENTRE
FOR STUDIES IN BRITISH ART

by

YALE UNIVERSITY PRESS
NEW HAVEN & LONDON

Designed by Gillian Malpass

Printed in Italy

Library of Congress Cataloging-in-Publication Data

Rosenthal, Michael.
 The art of Thomas Gainsborough: "a little business for the eye" / Michael Rosenthal.
 p. cm.
 Includes bibliographical references and index.
 ISBN 0-300-08137-5 (cloth: alk. paper)
 1. Gainsborough, Thomas, 1727-1788 – Criticism and interpretation.
 I. Gainsborough, Thomas,
1727-1788. II. Title.
ND497.G2R76 1999
759.2-dc21 99-20882
 CIP

A catalogue record for this book is available from The British Library

Illustrations are of works by Gainsborough, unless otherwise indicated.
Measurements are in millimetres, with imperial equivalents in parentheses.

Contents

Acknowledgements

THIS BOOK HAS BEEN SO LONG IN THE WRITING, that I must begin by thanking Yale University Press, and in particular Gillian Malpass, for bearing with me so patiently, and for reuniting me with Caroline Williamson, who copy-edited the text. Hilary Rosenthal has been even more tolerant. During the course of the years I have become indebted to so many people, that to list them all would be impossible. I must, however, thank John Barrell, Ann Bermingham, David Brenneman, Gordon Bull, Anthea Callen, Deb Clark, Malcolm Cormack, Ian Donaldson, Gordon Bull, Natasha Eaton, Deborah Graham, Andrew Hemingway, Simon Jary, Charlotte Klonk, Paul Langford, Simon McVeigh, Joy Pepe, Martin Postle, Alex Potts, Geoff Quilley, Richard Read, Kate Retford, Kim Sloan, David Solkin and Andrew Wilton who have all offered valuable assistance of various kinds. I am grateful to the staffs of the Bodleian Library, and the Print Room at the British Museum, and must particularly acknowledge Lavinia Wellicome, curator at Woburn, who allowed me to inspect Gainsborough's portraits and landscapes under ideal conditions, and who has gone out of her way to help me. I am grateful to Alice Rosenthal, for the loan of her computer, and to Alan Godson, without whose supports the book would not have been written. Marcia Pointon kindly sent me a manuscript copy of her recent book, *Strategies for Showing*, and John Brewer was similarly generous with a chapter from *The Pleasures of the Imagination*. Over the years I have enjoyed both the humour and friendship of, as well as hugely enjoyable conversations (traces of which surface throughout this book) with Louise Campbell and Paul Hills. John Hayes has answered every query and, characteristically, sent me a manuscript of his new edition of Gainsborough's *Correspondence*, while Susan Sloman has, as generously, done likewise with her important articles on Gainsborough and has offered all help imaginable. I do not know if those who choose to study particular individuals do it out of some instinctive empathy with them, but Gainsborough was a kind and generous character, and so, it appears, are most of those who specialise on him. Sam Smiles, Shearer West, Brian Allen and Hugh Belsey all read through a draft of the book and offered invaluable criticism and encouragement. It was Brian Allen in addition who inspired me finally to get the book written, while Hugh Belsey has, over the years, been a fount of information and has always been ready to supply photographs and find time for conversation. His great achievement as curator of Gainsborough's House, building up its collections and persuading owners to lend works, deserves to be generally acknowledged. It is cause for sadness that Michael Kitson did not live to see the completion of this book, for he took a keen interest in it, and, like very many others, I owe an extraordinary amount to his teaching. I should like, too, to remember Ernst Rosenthal, Dennis Godson, Mick Hill and Callum Macdonald.

I have been lucky enough to work at the University of Warwick, where scholarship receives every encouragement, and where, over many years I have had the great good fortune to encounter generations of final-year students, who have tolerated my frequent forays from my office to the slide room, and who have taught me rather more about eighteenth-century British art than I have taught them. I am indebted to all of them, not least because they have repeatedly confirmed both the necessary integration of research and teaching, and the pleasure of scholarship for its own sake at a period in British history when barbarians who believe otherwise have steadily become entrenched within and without the academic establishment. One intention of this book is to display the art of Gainsborough – albeit in

facing page Detail of pl. 180.

reproduction – to as many people as possible. Some of those who supply illustrations now charge prices so extravagantly high as to militate against this. As some of the worst culprits are public institutions, these might perhaps cogitate both on their social responsibilities and on the possibility that price may not be the only measure of value.

I began working on the book during a Visiting Fellowship at the Humanities Research Centre, the Australian National University, when I was able to use the superb resources of the Australian National Library. A Visiting Fellowship at the Yale Center for British Art allowed me time to carry out concentrated research in their excellent collections. A grant from the British Academy allowed me to travel widely in the United States to look at paintings by Gainsborough (and others) in collections there. Parts of Chapter Seven were published in the *Art Bulletin*, and of Chapter Eight, in *Eighteenth-century Life*, while other passages within the book appeared in *Apollo*.

Introduction

THIS BOOK OFFERS A STUDY of the art and career of Thomas Gainsborough, as both developed during a period when the British art world underwent an extraordinary transformation. When Gainsborough became an art student in 1740, very little contemporary painting was on public display. The first exhibition at the Society of Artists took place in 1760, and in 1768 the foundation of the Royal Academy transformed artistic practice. From then on, art criticism in the press developed at speed, aesthetic debates raged, and artistic rivalries could be intense.

Meanwhile the national economy, once predominantly agrarian and mercantile, was increasingly influenced by other factors. Colonial territories supplied cheap raw materials for processing, and manufactures, industry and technology were developing at high speed. Agricultural improvement was geographically specific but significant. The service sectors – legal, commercial, financial – which all these developments required, themselves expanded in turn. What was recognised as a new type of society, a commercial one, had been giving cause for concern well before John Brown's memorable expression of his worries in 1757; while its increasing diversity was rendering it incomprehensible to some.[1] The phenomenal success of John Wesley and Methodism surely owed something to this new social fluidity.

The art market was in the process of establishing itself as one composed of specific and competing interests, among which it could seem chimerical to seek some unambiguously correct 'taste', although this did not stop people trying. During the 1740s, the St Martin's Lane painters – Hogarth, Hayman, Highmore, Gainsborough – handled paint similarly enough in relation to certain kinds of subject to indicate that they and their customers shared a common culture. By the 1780s painters' styles aimed to impress their originality, their difference, marking them out within a competitive market. The paintings of Reynolds, West, De Loutherbourg, Stubbs and Gainsborough are markedly different from one another in appearance and, often, subject. As Paul Langford has written, 'The polite and commercial people of the 1730s was still polite and commercial in the 1780s: it did not, in any fundamental sense, inhabit the same society.'[2]

As the illustrations in this book reveal, Thomas Gainsborough's art was itself no static thing, and I propose to show that the more it is looked at, the more questions are raised. Thomas Gainsborough was a subtle, learned, deeply intelligent artist – despite his own occasional attempts to portray himself as a kind of *idiot savant*, a personification of chaos who arrived at things by chance and instinct. On a visit to Lord Shelburne's, Gainsborough met and was profoundly impressed by the lawyer John Dunning. He described the encounter to his friend, the Exeter musician William Jackson:

> He is an amazing *compact* man in every respect; and as we get a sight of everything by comparison only think of the difference betwixt Mr. Dunning almost motionless, with a Mind brandishing, like lightening, from corner to corner of the Earth, whilst a Long cross made fellow only flings his arms about like thrashing flails without half an Idea of what he would be at . . .[3]

Jackson himself compounded this representation of Gainsborough:

> Sir Joshua's character was most solid – Gainsborough's most lively – Sir J. wished always to reach the foundation of opinions. The swallow in her airy course, never skimmed a

1 *John Henderson*, c.1777, oil on canvas, 743 × 616 (29¼ × 24¼). London, National Portrait Gallery.

surface so light as Gainsborough touched all subjects – that bird could not fear drawing more, than he dreaded deep inquisitions.[4]

By contrast, the painter Sir Francis Bourgeois told Joseph Farington that, 'With all his apparent carelessness Gainsborough knew mankind well and adapted himself to their humour, when He thought it worthwhile', for, as the artist once wrote to Sir William Chambers, sometimes it was strategic to 'affect a little madness'.[5]

We should be cautious also about taking Gainsborough's fabled illiteracy at face value. 'So far from writing, [he] scarcely ever read a book', wrote William Jackson. However, Gainsborough evidently knew the writings of Thomas Gray and John Brown on the Lake District, and took 'the idea of a Country Churchyard from Mr Gray'. Critics connected his paintings to the writings of Shenstone and Sterne.[6] Gainsborough cannot have been immune to the literary and intellectual culture of his time. He went to the theatre. He heard sermons. He chatted to sitters, and conversed with Dr Johnson, the actors James Quin and David Garrick, the Duke of Bedford, and, later in his life, George III. His friend the actor John Henderson (pl. 1) was fixated enough on Lawrence Sterne to get nicknamed 'Shandy', and famed for reading Sterne aloud, as in Gainsborough's portrait of him, when he 'happily disseminated', and 'forcibly exhibited' the author's characters. Gainsborough, who 'was so like Sterne in his Letters, that, if it were not for an originality that could be copied from no one, it might be supposed that he had formed his style upon a close imitation of that author', was tuned enough into the latter's humour to name his dog 'Tristram'.[7] This is not to suggest that Gainsborough was bookish and literary in, say, the same way as Reynolds; but neither was he cut off from the intellectual and ideological issues engaged his contemporaries. As Timothy Clifford put it, Gainsborough

> so much acted the part of the Romantic genius unfettered by academic precepts and the use of learned pictorial quotations that biographers have readily accepted his own assessment of himself and so have been in danger of misunderstanding certain aspects of his real achievement.[8]

This book assumes that Gainsborough's art is complicated, and historically remote. There is a host of issues to be looked at: from stylistic developments, to the various histories and alternative representations of Gainsborough's portrait sitters, from art and the cult of sensibility, to the ways in which paintings were viewed within the elaborate schemes of internal decoration into which they were integrated. The first part of this book gives an account of Gainsborough's career from the point of view of the moves he made – from London to Sudbury, to Ipswich, to Bath, and then back to London – and what the professional motives for these might have been. The discussion will focus on the geography and the managing of a career, both to supply an overview over the paths Gainsborough took, and to highlight some of the problems met by many artists at that time. This is followed by a discussion of his training and the formation of his aesthetic, as an introduction to the subsequent chapters, which focus on portraiture, landscape, art and the cult of sensibility, and the varying perceptions of what the fine arts were and how they functioned socially towards the end of Gainsborough's life. The aim is to communicate, through a study of the art of Thomas Gainsborough, something of what it meant to be a painter in Georgian England.

1 *Studentship and Suffolk*

3 *Self-portrait as a Boy*, c.1738–40, oil on panel, 229 × 197 (9 × 7¾). Private collection.

THOMAS GAINSBOROUGH DEMONSTRATED SUCH STRIKING ARTISTIC PRECOCITY that in 1740, when he was thirteen, his father sent him from Sudbury in Suffolk to London, to train as an artist. If, as seems plausible, the self-portrait of a youth discovered by Adrienne Corri is of Gainsborough (pl. 3), then that decision would have been well founded.

William Hogarth had restarted the Academy at St Martin's Lane in 1735, and this was a principal base for the metropolitan artistic community. Henry Bate wrote of Gainsborough, from whom he would have heard it, that 'Mr Gravelot the engraver was also his patron, and got him introduced at the Old Academy of Arts, in St Martin's Lane.'[1] The émigré French artist Hubert Gravelot taught Gainsborough, and legend has it that he designed the decorative surrounds for the series of heads Gravelot was inventing and Houbraken would engrave for Birch's *Lives of Illustrious Persons in Great Britain*. A comparison of drawings shows that Gainsborough was quick to pick up Gravelot's graphic system of suggestive rather than bounding chalk line, with the drapery disposed in generally highlit volumes (pls 4, 5). Gainsborough is also supposed to have studied at Gravelot's house under the engraver Charles Grignion. He learned painting from Francis Hayman, who thought enough of him by 1746 or 1747 to get him to do the landscape in the portrait *Elizabeth and Charles Bedford* (private collection) 'whilst he is in Town', which, incidentally, lets us know that Gainsborough was working as an independent painter; and that he was peripatetic, most probably between London and Sudbury, for he had to have come to town from somewhere. By 1749–50 Hayman was putting a 'Gainsborough' landscape into a portrait of the architect George Dance, and they maintained friendly relations at least into the 1750s and, doubtless, beyond.[2]

Gainsborough was an art student during a time which, 'by a stroke of great fortune, happened to be among the most exciting and productive in the whole history of the arts in this country; and he made the most of his opportunities'.[3] Outside the Academy, the St Martin's Lane painters formed the core clientele of Slaughter's Coffee House, a centre for the *avant garde* in London. Mostly young, these artists insisted on taking material nature and modern life for their subject, rather than inventing any ideal: a position which, as we shall see, was antagonistic to that held by other contemporaries, particularly the group associated with Lord Burlington, but which they were able to articulate artistically in various places.[4]

One site at which they displayed their work was at Jonathan Tyers's pleasure gardens at Vauxhall. The centrepiece of the gardens was Louis François Roubiliac's statue of Handel (pl. 6), which manifested the ironies of this modernist aesthetic: the composer being sufficiently of this world to have both slippers off; while his inspiration was so great that his music was composed on Orpheus's lyre, with a putto setting down the notes. The joke was akin to the one Hogarth made about Diana, the goddess of chastity, in *Strolling Actresses dressing in a Barn* (pl. 282).

The plan to decorate the supper boxes at Vauxhall Gardens with large paintings was said to have originated with Hogarth. In 1741–42 it was put into effect under the direction of Francis Hayman.[5] Visitors to the Gardens would have been liable to sensory overload. There was music. There were copious amounts of food and drink. Tyers laid on spectacular lighting and landscape effects, the latter culminating in the mid-1750s with the creation of the Cascade, placed in 'a most beautiful landscape in perspective of a fine hilly country with a miller's house and a water mill, all illumined by concealed lights', with moving strips of tin

2 Detail of pl. 25.

4 (*above left*) *Study of a Young Girl walking*, late
1740s, black chalk and stump, white chalk and
pencil on brown paper, 383 × 238 (15 × 9¼).
Ownership unknown, reproduced Hayes 1970
plate 15, cat. 815.

5 (*above right*) Hubert François Gravelot, *A
Young Lady seated on a Chair, turned to the Left*,
c.1744, 325 × 255 (12¾ × 10), black chalk
heightened with white on buff paper. Sudbury,
Gainsborough's House.

6 (*facing page top left*) Louis François Roubil-
iac, *Handel*, 1735, marble. London, Victoria and
Albert Museum.

7 (*facing page top right*) George Bickham, *The
Invitation to Mira*, from *The Musical Entertainer*,
1737–38. Sudbury, Gainsborough's House.

mimicking the sound and look of flowing water. He had learned the popularity of such
strategems in 1738, with the unveiling of *Handel*, sited in a niche in the grove, which inspired
verses portraying the statue either as the composer or as Orpheus resurrected. The mix of
the mundane and the marvellous was all the more striking because the Roubiliac work-
shop had been so deft in creating its illusion. *Handel* embodied a magic unreality (captured
in one of George Bickham's song sheets from *The Musical Entertainer* (pl. 7)) which was
exactly suited to the ambience Tyers was striving to create.[6] The paintings at the backs of
the supper boxes added the stimulation of the pictorial to the delights of the gustatory.

The decoration of the supper boxes was carried out in so short a time that a large
artistic team must have been employed.[7] Hayman used the St Martin's Lane painters, and
because, like George Lambert, he earned money at scene painting in the theatre, he could
have recruited other such artists. It is hard to imagine that the young Gainsborough was
not involved, and a good case has been made for his having painted at least one figure of
Children building Houses with Cards (done after a design of Gravelot's) (pl. 8).[8] With a work
like *The Play of See-Saw* (pl. 9) the imagery is tantalising. As is apparent in Gainsborough's
and Hayman's small portraits of the late 1740s and early 1750s, the latter had taught his
pupil an economical and effective technique (introduced into English artistic practice by
Sir Godfrey Kneller) for representing women's drapery: the blue-grey canvas ground serves

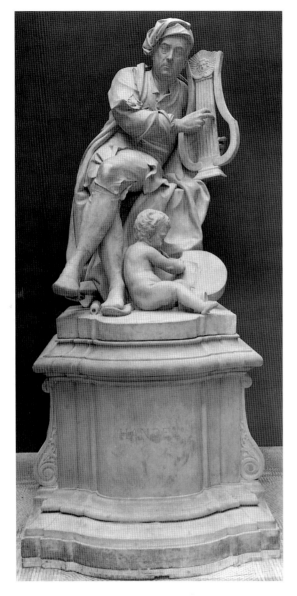

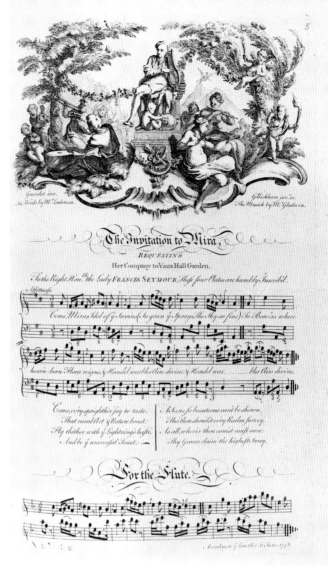

8 Francis Hayman, *Children building Houses with Cards*, *c.*1743, oil on canvas. Viscount Gort, Hamsterley Hall. Gainsborough is thought to have been responsible for the seated male figure at the centre of the composition.

9 Francis Hayman, *The Play of See-Saw*, *c.*1741–42, oil on canvas, 1,390 × 2,415 (54³/₄ × 95). London, Tate Gallery.

10 *The Charterhouse*, 1748, oil on canvas, diameter 559 (22). London, Thomas Coram Foundation for Children.

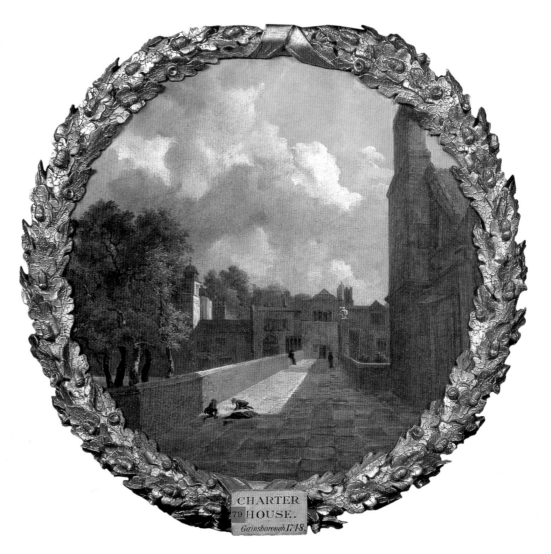

as a middle tint, with the drapery itself painted in the local colour, overlaid with highlights of white.[9] We see it here. The faces do not however have the large noses and thryoid eyes typical of Hayman's work, but red lips, rosy cheeks and a vivacity anticipating the pertness of some of Gainsborough's later painted figures.

While one can only guess at the degree of Gainsborough's involvement at Vauxhall, we are certain about his contribution to the decoration of the Foundling Hospital.[10] Hogarth had presented the Hospital with his extraordinary portrait of its moving spirit, *Captain Coram* (pl. 133), and by December 1746, the artists, alert to the potential advantages of public exhibition of their works, were proposing to donate appropriate pictures. Gainsborough painted perhaps three roundels in 1748, but only *The Charterhouse* (pl. 10) survives.

Edward Haytley, Samuel Wale and Richard Wilson also painted roundels featuring the different hospitals of London for the Foundling Hospital. Haytley and Wale dealt with topography, detailing architecture, enlivening their scenes with suitable staffage, Haytley underlining the modest pretensions of his contributions by using the same sky in each of his paintings. Wilson and Gainsborough, however, avoided the crisp delineation of buildings and their details. Wilson placed St George's Hospital (pl. 11) in the left distance, blocked in those windows not obscured by shadow, and created a landscape painting in which the fall of a sunlight which determines the representation of surfaces as tone, and hue imposes pictorial coherence. We learn little about the architectural detail of this hospital, or about the kinds

of people who visited it. Gainsborough went a step further. In *The Charterhouse* chiaroscuro hardly assists the viewer to perceive the distinctive features of a building which is in any case pictured from a viewpoint designed to display it as an exemplar of perspective rather than an object in the cityscape. What limited light a cloudy sky lets through falls with shocking brilliance. The figures we can make out appear to be two small boys playing marbles.

By the time Gainsborough painted *The Charterhouse*, he was settled back in Sudbury, but evidently still known in London as a talented landscapist. He could not, though, make a living at landscape. One contemporary recalled him as 'only a landscape painter, and merely as such must have starved – he did not sell six pictures a year'. His biographer, Philip Thicknesse, wrote of his not having 'formed any high Ideas of his own powers, but rather considered himself as one among a crowd of young Artists, who might be able in a country town (by throwing his hand to every kind of painting) [to] pick up a decent livelihood'.[11] A few years later, Joshua Kirby, a mutual friend of Hogarth and Gainsborough, described him as a 'very great Genius' in landscape, but in 1758, when Gainsborough was preparing his move to Bath, Hogarth warned a young man off studying art: 'As we know several Eminent Landscape Painters &c who get but a very small income'.[12] Gainsborough's failure, in spite of his talent, to earn a living is interesting in light of his having married Margaret Burr, an illegitimate daughter of the Duke of Beaufort, in 1746, for she came with an annuity of £200, an enormous sum which should have secured their financial independence.[13]

However, Susan Sloman has shown that as early as 1751, 'the annuity was being used as security for loans' of significant amounts of money – £300 in 1755.[14] This would suggest that he was living above his means, a phenomenon which might underlie Henry Angelo's comment on Margaret Gainsborough that her 'parsimony was beyond the endurance of any man possessing the least spirit of liberality, and Gainsborough was liberal to excess'.[15]

Gainsborough was picking up what work he could in Sudbury, from portraits such as *Mr and Mrs Andrews* (pl. 25) to (atypical) views such as that of St Mary's Church, Hadleigh (pl. 113), commissioned by the rector, the Reverend Dr Thomas Tanner. He was painting numerous landscapes but selling few, if any. Sudbury was too small to support a painter – 'Exeter is no more a place for a Jackson than Sudbury in Suffolk is for a G.', he later wrote to his friend, the musician William Jackson, whose talents he felt too conspicuous for confinement at Exeter (where he was Master of Choristers at the Cathedral).[16] The birth of Gainsborough's second daughter, in summer 1751, may have brought home to him the need to make money, and prompted the move to Ipswich in 1752.

Ipswich was a thriving port, trading with the Continent and along the coast. In addition, the town served as a market for local farmers. Its population was then between 10,000 and 11,000 people. Not many miles away was Colchester, also prosperous. Between them, Gainsborough's market was potentially extensive, particularly when one takes into account the squirarchy scattered around that part of East Anglia, and the fact that he was already on excellent terms with Joshua Kirby, house painter and printseller, and Hogarth's agent at Ipswich, who could have introduced him to people.[17] However, things did not go that well, apparently. In 1753 he wrote to his landlady, 'I call'd yesterday upon a Friend in hopes of borrowing money to pay you, but was disappointed . . . I'm sorry it happens so but you know I cant make money any more than yourself'; in 1756 he, was asking a Mr Harris to 'stay till midsum for the money'; and in 1758 he told William Mayhew,' a Colchester attorney, that 'business comes in and being chiefly in the Face way I'm afraid to put people off when they are in the mind to sit', demonstrating the chronic anxieties then attendant upon making a living from art (although portraiture would supply a far more secure income than landscape).[18]

Gainsborough, then, was pragmatic enough to know that only face painting would earn him a living, and by keeping to the provinces, he was displaying common sense, allied to business acumen. In the 1750s, Jean André Rouquet commented on the enormous numbers of portrait painters trying to get a living in London, so it was logical to try elsewhere. And only after 1774 would Thomas Gainsborough again be a full-time resident of London. Despite the intense competition, his reputation was by then secure enough to allow him to charge prices second only to those of Reynolds, and he was getting the most exalted patronage.[19]

Gainsborough's strategies may be compared with those of Joseph Wright, popularly known as a painter of extraordinary light effects, as well as of landscapes and subject pictures, but who had begun as a portraitist, and who produced portraits throughout his career. Like Gainsborough, he was prepared to move around if circumstances demanded it. After finishing a second stint of pupillage under Thomas Hudson, he returned to his home town, Derby, from where he would make occasional forays elsewhere into the provinces. He was in Liverpool from the end of 1768 to the summer of 1771, and tried Bath from November 1775 to June 1777. George Stubbs appears to have taught himself to paint in Liverpool between 1741–45, before moving to York, where he spent eight years painting portraits. In the mid-1750s he visited Italy, and between 1756 and 1758 he was based at Horkstow, Lincolnshire, where he dissected and drew horses in preparation for his book *The Anatomy of the Horse* (1766). From 1758 he was trying to establish himself in London, but only after 1760, when his excellence in painting horses had attracted the grand aristocratic patrons who, in an ideal world, would have been promoting great schemes of history painting, did he get any financial stability. And Stubbs would consistently paint portraits, and subjects

besides the equine.[20] Even Joshua Reynolds began by following something like this pattern. After he had completed his training in 1744 he worked in Devonport and London until 1749, when he set sail for Italy. Devonport was close to his home town of Plympton in Devonshire and supplied sitters in the form of naval officers. And, although he was uniquely able to call his own tune, and charge astronomical prices, particularly after the 1770s, he still aimed to consolidate his considerable reputation with subject and historical pictures.[21] Others, notably the brothers George and John Smith of Chichester, had national reputations, but safeguarded their livings by keeping to the provinces.

Artists had to work in a market.[22] Thomas Gainsborough's time at St Martin's Lane, and his contact with the entrepreneurial Hogarth, would have brought home to him that the system of patronage based around courts and aristocratic largesse, such as Alexander Pope had held was maintained by the third Earl of Burlington, was gone, if it had ever really existed. There was little to be had from the state, less from the church. Yet the liberal arts, including painting, were considered central to the expression of the civilised virtues and exemplary public morality of a great nation, such as Britain considered itself to be. Until the advent of public exhibitions – despite the habit of paying private visits to view artists' work – painters had to be inventive in finding places in which to display their pictures.[23] The embellishment of the Foundling Hospital was one attempt at a solution; and the various attempts from 1748 onwards at founding an Academy were another. These proceeded, more or less acrimoniously, through the 1750s, until Hayman organised the exhibition in the Rooms of the Society of Arts in 1760.[24] Exhibitions solved some but not all of the problems of artistic survival in the social confusion of an evolving commercial society. Portrait painting seemed the best option. 'Painters find no encouragement amongst the English for any other work,' wrote Johnson in 1759, whilst in 1761 Daniel Webb observed that the 'extraordinary passion which the English have for portraits, must ever prevent the rise of history painting among us.'[25]

Some developed their own strategies. Richard Wilson, Joshua Reynolds and various other British artists and architects tracked aristocratic Grand Tourists to Italy, in particular to Rome, from the 1750s. For Wilson the trip was of signal importance, not least because during it he decided to profess landscape rather than portrait painting. He studied the styles of earlier painters such as Claude and Dughet, acquired a comprehensive and profound knowledge of the Roman Campagna, and 'was able to associate with the English aristocrats who visited Rome on a much more intimate and equal footing than would have been possible in Britain'. Wilson subsequently invented a grand manner landscape, appropriate to the presentation of Italian or British scenes, to classical or more modern subjects, in generalised and abstracted terms befitting the culture of a patriciate steeped in classical literature and alert to the underlying moral purpose of art. This tactic worked. Wilson attracted patrons while in Rome and was relatively successful until the end of the 1760s.[26] Maybe hitching his wagon to one particular social group limited his patronage and narrowed his commercial options.

Reynolds was more astute. While in Italy between 1750 and 1752, he gained as complete a knowledge as possible of the forms and techniques of Renaissance and modern Italian art and consequently became supremely well equipped to create portraits in a grand style, corresponding to Wilson's achievement in landscape painting. Reynolds enjoyed the great advantage as a portraitist of not needing to ally himself with any one group of patrons, and his career flourished. Once he had become founding President of the Royal Academy and was delivering his *Discourses*, he was able, however subtly, to promote the kinds of works in which he specialised.

Competition for markets shaped tactics. Allan Ramsay returned to London from Italy and began practising in August 1738, having taken care to make a good impression on suitable British visitors while abroad. His selling point was a new manner of portrait. He had learned a system of vermilion underpainting which gave a 'lifelike' illusion to flesh, and his paint,

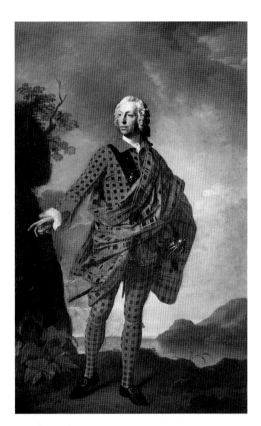

12 Allan Ramsay, *Norman, twenty-second Chief of MacLeod*, c.1747, oil on canvas 2,235 × 1,371 (88 × 54). Collection of MacLeod of MacLeod, Dungevan Castle, Skye.

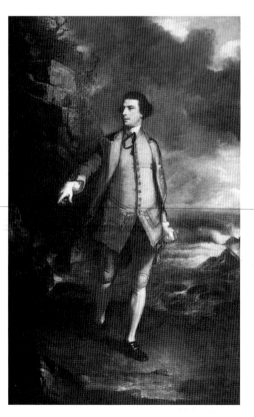

surface was far smoother than that to which people were used: 'rather lick't than pencilled', observed George Vertue. To contemporaries it would have appeared startlingly different from the norm. And, with the help of influential patrons such as Dr Mead, Ramsay was phenomenally successful: in 1740 he wrote that 'I . . . now play the first fiddle my Self.'[27] It was Ramsay who around 1747 adapted the pose of the Apollo Belvedere (mediated through a contemporary sculptural reworking by Legros) to his portrait *Norman, twenty-second Chief of McCleod* (pl. 12). Its novelty can be judged by comparing it with a more conventional portrait of a gentleman, Hudson's *Theodore Jacobson*, or Gainsborough's *Augustus John, third Earl of Bristol* (pl. 15). The painter could now invite the connoisseur to recognise artistic quotation and paraphrase, and consequently associate particular qualities of cultural achievement and general refinement with the sitter. Soon after returning from Italy, Reynolds, who was probably alerted to Ramsay's invention by the drapery painter Joseph Van Haecken, responded with *Commodore Keppel* (pl. 13), which he kept on show in his house to advertise his powers.[28] It was no accident that in 1754 Ramsay set off on a second trip to Italy, with the express intention of working: making memoranda from the masters, drawing at the French Academy in Rome.[29]

In 1759 Edward Fisher made a mezzotint print after *Commodore Keppel*. Innovation was one way of attracting attention, publishing of keeping it, and Fisher went on to engrave twenty-eight of Reynolds's paintings, including a print after the famous *Laurence Sterne* (pl. 14), produced to capitalise on Sterne's amazing popularity.[30] In some instances the print itself was meant to attract attention through its artistic inventiveness, in others the interest lay in the person represented. Collecting prints after the heads of the noteworthy was common during this period; as we saw, Gainsborough early in his career designed the decorative surrounds for *The Heads of Illustrious Persons of Great Britain*. The prints after Reynolds both lent themselves to this use and directed attention to the unique abilities of Reynolds himself.[31] Mezzotint communicated the painterly qualities of chiaroscuro, texture and sfumato, and provided a reproduction less abstracted than would be the case with line engravings, which translated the painting into its own discrete pictorial language.

Prints supplied invaluable publicity. In 1760 the Smiths of Chichester claimed status and respectability by including their own work in a collection of prints after various masters, including Rembrandt, published by themselves. The following year, Wollett's engraving after Richard Wilson's *The Destruction of Niobe's Children* reputedly fetched Boydell, the publisher, around £2,000 – and was precisely calculated to appeal beyond the contracted horizons of the typical tradesman. Consequently, if such a person bought a copy of the print he could congratulate himself on appropriating the high ground of patrician culture. As for Wilson, he profited from the sale of the painting to a royal patron, the Duke of Cumberland, and the chance to produce replicas, so all parties involved did very well.[32] There is an analogy here with Joseph Wright's having those subject pictures unique to him systematically reproduced in fine mezzotint, starting with William Pether's rendering of *A Philosopher giving a Lecture on the Orrery* (pl. 16), which John Boydell published in May 1768. Wright published the prints around six months after the paintings had been exhibited, and entered into an engagement with his engravers which maximised their profits above 'any fee that Boydell might offer'.[33] They also helped consolidate a considerable reputatation, for from his first exhibiting *The Orrery* in 1766, Wright had been getting dream reviews.[34]

Gainsborough stands out as atypical. He was apparently unsystematic about having his works reproduced, and prints after his portraits emerged at fairly uneven intervals. The four that James McArdell made after Gainsborough portraits in the 1750s and early 1760s (pl. 17) hardly compare with the 'nearly forty' plates that he worked on for Reynolds before his death in 1765.[35] The same was true of Gainsborough's landscapes. In 1759, after the move to Bath, when he was intent on establishing his reputation, Gainsborough inscribed a careful landscape drawing (pl. 18), 'Gainsborough fec: 1759', with the evident intention of publishing it to advertise his talents in the landscape way. It never happened, though he was at the

15 (*right*) *Augustus John, third Earl of Bristol,*
1768, oil on canvas, 2,324 × 1,524 (91½ × 60).
Ickworth, National Trust.

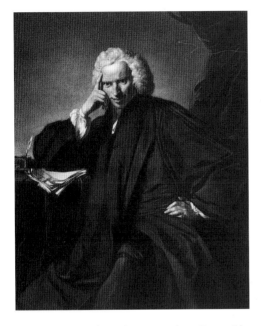

14 Edward Fisher after Sir Joshua Reynolds,
Laurence Sterne, 1761, mezzotint. London, British
Museum.

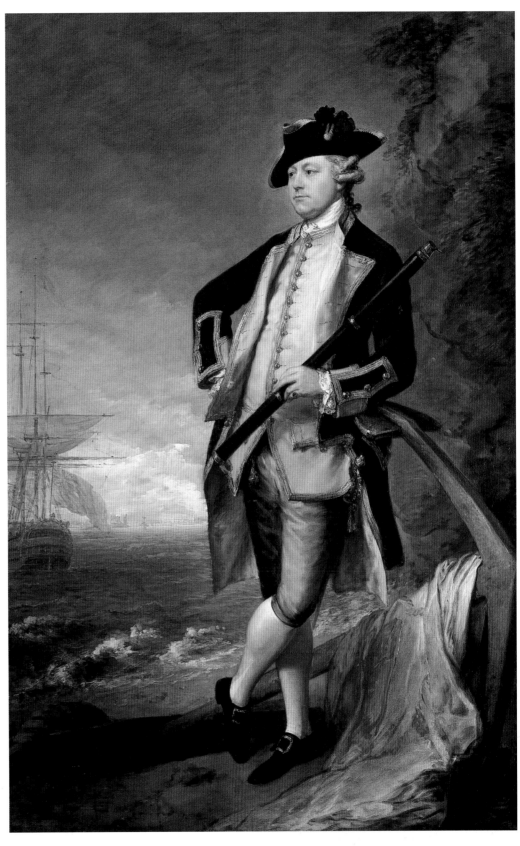

13 (*facing page bottom*) Sir Joshua Reynolds,
Commodore Augustus Keppel, 1753, oil on canvas,
2,388 × 1,470 (92 × 57). London, National
Maritime Museum.

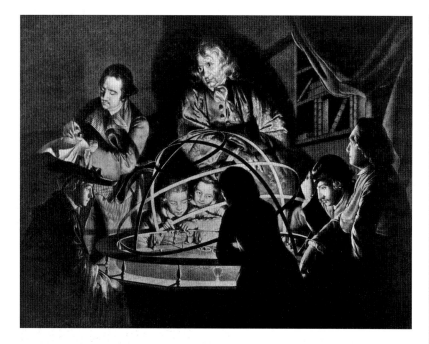

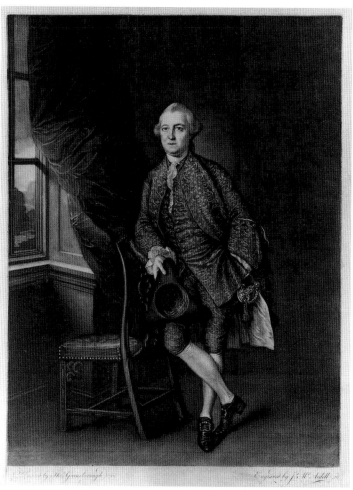

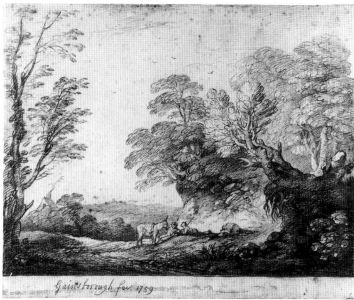

17 (*above*) James McArdell after Gainsborough, *Sir Edward Turner, Bart.*, 1762, mezzotint. Sudbury, Gainsborough's House.

18 (*left*) *Landscape*, 1759, pencil, 281 × 387 ($11^{11}/_{16}$ × $15^{1}/_{4}$). London, Courtauld Gallery.

16 (*top*) William Pether after Joseph Wright, *A Philosopher giving a Lecture on the Orrery*, publ. John Boydell, 20 May 1768, mezzotint. Derby Museums and Art Gallery (936-20-24).

time despatching early and unsold Suffolk landscapes to the London silversmith and picture-dealer Panton Betew, who had engravings made after them between 1760 and 1782 (pl. 19). Anyone who became familiar with Gainsborough's landscapes at that time through engravings would have been seeing work unlike that which he was actually painting.

He was also relatively cavalier with respect to the printmaking process. Boydell had published engravings after his drawings in 1744. In *Dr Brooke Taylor's Perspective made Easy*, Joshua Kirby included a landscape composition inscribed 'T. Gainsborough fecit aqua forte', and 'J. Wood perfecit' (pl. 20) – pointing to the former's impatience with the complexities of etching. The same team finished off a wooded landscape with gypsies (pl. 21) in 1759, and between times Philip Thicknesse had the London engraver William Austin engrave the view of Landguard Fort that he had commissioned Gainsborough to paint (pl. 22). Then there were those canvasses left with Panton Betew. Until the 1770s, when he began experimenting with aquatint and soft-ground etching, that was it.[36]

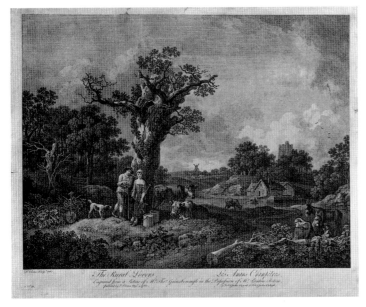

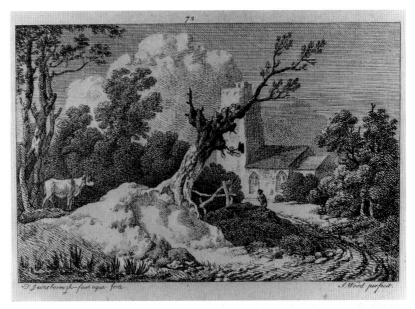

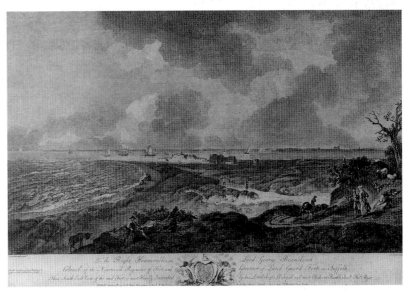

22 (*above*)　T. Major after Thomas Gainsborough, *Landguard Fort*, 1754, engraving.

21 (*left*)　*The Gipsies*, 1759, engraving, inscr. 'Painted and etch'd by T. Gainsborough' and 'Engrav'd and Finished by J. Wood'.

19 (*top left*)　F. Vivares after Thomas Gainsborough, *The Rural Lovers*, publ. 1760, engraving. Sudbury, Gainsborough's House.

20 (*top right*)　*Wooded Landscape with Church, Cow and Figure*, 1753–54, etching, inscr. 'T. Gainsborough fecit aqua forte' and 'J. Wood perfecit', publ. in J. Kirby, *Dr. Brooke Taylor's Perspective made Easy*, Ipswich, 1754, fig. 72.

Gainsborough had, as we shall see, a sharp business brain. So he may have thought of his art in various ways: the landscapes as private works, intended for friends, or for sympathetic buyers to find out, and portraits as the means of making a living. The paucity of prints of his work *may* have helped reinforce the exclusivity of the paintings themselves. The rapid rise of his picture prices after reaching Bath points to this conclusion. In comparison with Reynolds, Gainsborough was not much of an inventor when it came to compositional formulae. He painted heads, figures in landscapes and figures in interiors, reworking a fairly limited repertoire of portrait formats: a strategy that fits with an outlook that saw portraiture, for the most part, as a means of getting money.

15

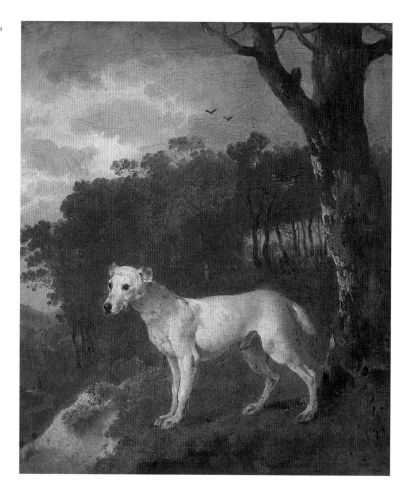

23 *Bumper*, 1745, oil on canvas, 349 × 298 (13¾ × 11¾). Private collection.

He did not do particularly well in Ipswich, despite attracting some distinguished sitters. Philip Thicknesse, recalling his introduction to Gainsborough, recalled that he 'received me in his painting room, in which stood several portraits truly drawn, perfectly like, but stiffly painted and worse coloured; among which was the late Admiral Vernon'.[37] It may be that people were unwilling to spend money on portraits redeemed only by likeness when a little more money would pay for something from an artist of reputation. And Thomas Gainsborough was identified more as a landscape painter, one, moreover, who could turn his hand to anything. His catering to the mid-eighteenth-century craze for Dutch landscapes is indicated by such entries as 'a Dutch landscape, prepared by Mr Gainsborough' or 'Wynants, a landscape, the figures by Mr Gainsborough' in a 1762 sale catalogue.[38] Even forgery failed. And once in Sudbury, Gainsborough showed himself willing to paint anything, from a portrait of a famous dog, *Bumper* (pl. 23), or people in landscape, to topographical views such as that of the series of ponds which the Ipswich brewer John Cobbold sank in Holywells Park to feed his brewery (pl. 24) or *St Mary's Church, Hadleigh* (pl. 113), probably painted in collaboration with Joshua Kirby. Gainsborough gave up this kind of work as soon as he was able.

John Hayes has pointed out that we need only glance at a Wootton hunting scene to gauge how extraordinary *Bumper* was (Gainsborough painted the dog's owner, Mrs Hill, a few years later).[39] An inscription on the back of the picture records that this was 'A most Remarkable Sagacious Cur', putting him in the company of other dogs – like Ringwood with his laudatory inscription in Venus's Vale at Rousham – which the English found extraordinary enough to honour. A comparison with Stubbs, who would later paint foxhounds with as much care, reveals an unexpected anthropomorphism, for, just as in portraits of humans, Bumper is alert to something outside the pictured space, and is thus granted his

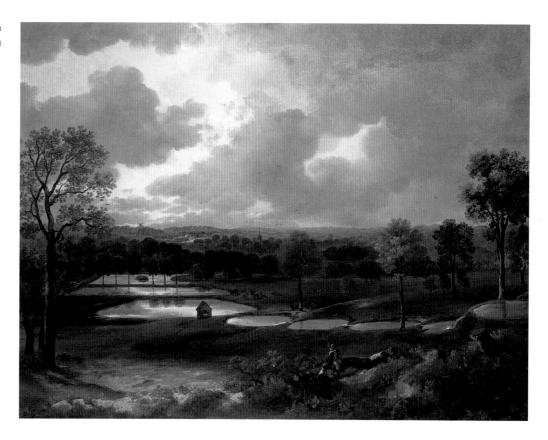

24 *Holywells Park, Ipswich*, 1748–50, oil on canvas, 508 × 660 (20 × 26). Ipswich Borough Council Museums and Galleries.

own consciousness. In anticipating one of the quintessential themes of the cult of sensibility, the artist reveals that an empathy with the animal world seems to have been natural with him.[40] *Bumper*'s landscape – dark, with regimented trees – relates to the studies and compositions of landscape motifs that Gainsborough was doing at that time. Given the numbers of such paintings and drawings which ended up in the hands of Joshua Kirby, they appear to have answered no general demand.[41]

His fortunes fluctuated. Small studies of figures in landscapes were liked, perhaps because these were perceived to be the height of fashion. Gainsborough's portrayal of himself with his family in this manner suggests that he found this mode entirely sympathetic. The near contemporary *Mr and Mrs Andrews* (pl. 25) is a fascinating example of such a work. The view is from the farm Auberies at Bulmer, across the Stour Valley, to Sudbury and Cornard. Gainsborough has itemised the pasture, oak plantations in which cattle browse, enclosures with sheep, and the remains of a cornfield that was clearly drill-sown, for the stubble is in lines which, as much as the loaded heads of wheat, show Andrews to be in the van of farming practice. The painting of the young couple attempts to demonstrate that one can farm and still be polite.

That bench, worked intricately, and with a shell carving to Mrs Andrews's left, is terrifically elegant. Andrews is dressed for shooting and, if the *Female Spectator* is to be believed, accidentally unfashionable, for in 1744, four years previously, the Kevenhuller Cock hat which he sports had been 'so much the fashion a little time ago'.[42] On the other hand, Ann Bermingham quotes the *British Magazine* in 1746 calling it the 'rage' in London, to warn us of the traps of fashion.[43] Mrs Andrews, in contrast, is almost painfully elegant and demure. The oak tree, recalling the emblematic oak from the first scene of *Marriage-à-la-Mode*, points to the aim of this union's being to found a dynasty. Andrews is wealthy enough – he could afford a portrait, and his gun license indicates his being a freeholder of £100 a year – and the agricultural profusion defines him as a good landholder in the terms laid out a few years previously by Alexander Pope:

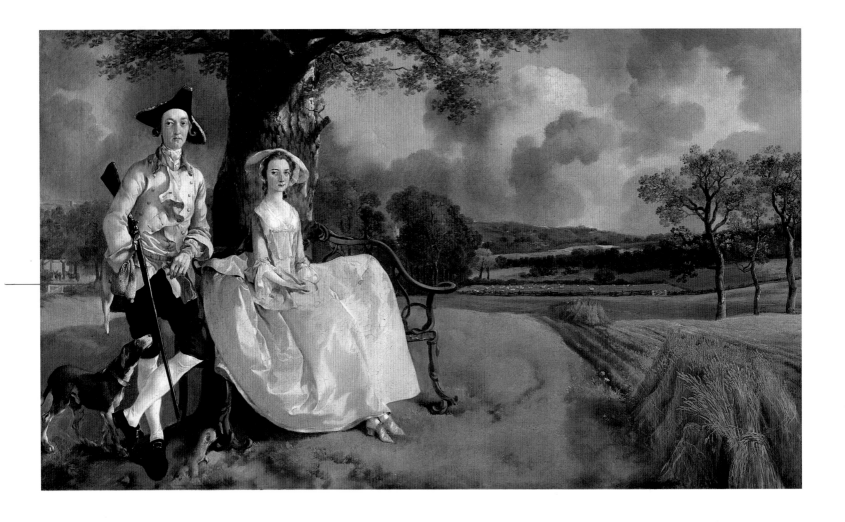

25 *Mr and Mrs Andrews*, c.1748, oil on canvas, 698 × 1,194 (27½ × 27). London, National Gallery.

His Father's Acres who enjoys in peace,
Or makes his neighbours glad, if he encrease;
Whose chearful Tenants bless their yearly toil,
Yet to their Lord owe more than to the soil;
Whose ample Lawns are not asham'd to feed
The milky heifer and deserving steed;
Whose rising Forests, not for pride or show,
But future Buildings, future Navies grow:[44]

The catch of course is that Andrews was new to the land, for he 'actually succeeded to the . . . estate in 1750'.[45] Gainsborough assists in creating a fiction that his sitter is long established in living the moral country life.

The patron surely dictated the appearance of this painting, which is unusual in Gainsborough's *oeuvre*, in one extremely telling respect. Like many other eighteenth-century pictures, by artists ranging from Arthur Devis to Richard Wilson, this is about the ownership of land, that central contemporary issue that practically kept the legal industry going. Yet, Gainsborough, exceptionally, very seldom bothered with the notion of property-ownership in any direct way. Around 1764 he apparently took pains to evade a commission from Lord Hardwicke to paint a view of his house (but see p. 124 below); and when, in the late 1760s, he painted a view for Samuel Newton, the owner of King's Bromley in Staffordshire, rather than represent the mansion, he painted what was seen looking out from the property, so that the significance of the country house to the painting was not apparent.[46] And as few of his landscapes are concerned with the celebration of property, Gainsborough's portraits

in landscapes equally seldom exalt the ownership of real estate, although this will often have been a pre-requisite to their sitters' having a portrait done at all. Rather they pose against it, walk through it or contemplate within it. Late portraits such as *The Morning Walk* (pl. 241) are in a direct line of descent from those East Anglian gentry pictured by the young Gainsborough in their local countryside, although not in sufficient numbers to earn him a satisfactory living in Sudbury. This prompted his move to Ipswich, where, as we have seen, he was already getting commissions from such prominent citizens as John Cobbold. He installed his family in a comfortable house in the town centre some time after June 1752.[47]

He may have been encouraged to do this by Joshua Kirby, who, having moved to London in 1755, subsequently gave Gainsborough an excellent metropolitan connection (in 1759 Kirby's son was under pupillage to Gainsborough).[48] This was a close and permanent relationship. Kirby engineered Gainsborough's introduction to George III, and, shortly before his death, Gainsborough stated that he wished to be interred near Kirby's grave in Kew churchyard.[49] It was evidently an attraction of opposites, described thus by Henry Angelo:

> Everyone acquainted with Gainsborough knew that he was a rattle. It was therefore highly amusing to witness the contrast of character in him and his friend, the mild and modest Kirby . . .
>
> I remember Gainsborough once saying, in speaking of the landscape effects of his old crony Kirby, whom he really loved, and, capricious as he was, whom he never slighted, that if on their sketching excursions an unusually picturesque building or a fantastically formed tree occurred, Kirby immediately sat down to delineate it . . . 'His lines are all straight,' said Gainsborough, 'and his ideas are all crooked, by Jove! How the devil the old frump ever consented to Hogarth's travestie frontispiece to his Treatise on Perspective, I could never devise; had I proposed such a thing, he would have pronounced me mad.'[50]

Kirby and Gainsborough would go sketching together along the Orwell – Constable would learn of these excursions over forty years later – and *The Suffolk Traveller*, which Kirby's brother, John, published in 1764, may have registered Gainsborough's impact when it devoted one of its very few descriptions of landscapes to the scenes on the banks of that river.[51]

While based in Ipswich, Gainsbrough was generally regarded with affection. George William Fulcher records the son of the Reverend Robert Hingeston, the master of Ipswich Grammar School, as recalling that 'he was a great favorite of my father; indeed his affable and agreeable manners endeared him to all with whom his profession brought him in contact . . . I have seen the aged features of the peasantry light up with a grateful recollection of his many acts of kindness and benevolence.'[52] Gainsborough might have been mercurial – one of the landscapes Kirby owned was a wooded scene with gypsies, which had been cut with a knife by Gainsborough when the client said he did not like it – but there is abundant evidence that he was well liked. And this is highly germane to the way he handled his career. Rather than engage in the up-market self-advertisement of a Reynolds, Thomas Gainsborough (at least, once he was installed at Ipswich) appears to have attracted business in part through the agency of Kirby, but more deliberately by using friendships and contacts (as we learn in detail from John Bensusan-Butt).[53] This was a promising system, with the potential (in the event unrealised) to expand his circle of patrons. But the fact that Gainsborough could have social connections as well as business dealings with his clients was to remain important. For instance in 1755 he must have made an impression on the Duke of Bedford (who had commissioned a pair of landscapes), a man both a scion of the patriciate and a prominent politician, for in the 1760s the Duke ordered portraits of himself and his immediate family, an opportunity Gainsborough relished: 'I cannot resist the honour of doing something for the Duke of Bedford productive of future advantages.' And he was on good enough personal terms to be off-hand with the Duke's agent in 1765, and to address a mildly facetious letter to the Duke himself three years later.[54]

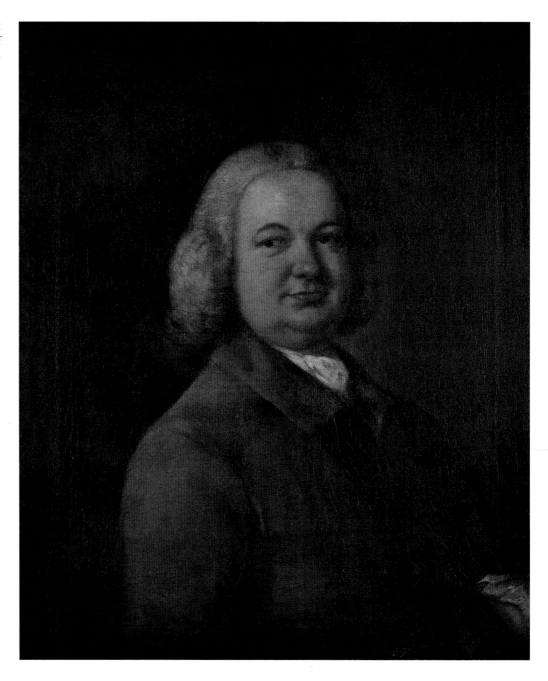

To discover who in Ipswich knew whom and how well, and whether or not this affected commissions Gainsborough received, is not possible. His clients were active in local politics both in Ipswich and in Colchester. There is also the case of the Ipswich music club, to which the artist belonged,[55] as did the organist and composer Joseph Gibbs, whom he portrayed. It is clear enough from the Reverend Robert Hingeston's remarks that Gainsborough had intimate acquaintance in Ipswich, in this instance close enough to give Hingeston's father, James Hingeston, the painting of Gainsborough's own daughters chasing a butterfly. It seems that he was getting patronage not from the highest social levels – the people with real money (from real estate) – but from the middle classes. He did portraits of clergymen, lawyers, substantial farmers, small landholders. And commissions were not plentiful. They came on average to around seven or eight *per annum* which, at his prices, would not bring in enough to let the Gainsboroughs pay the rent and eat as well (assuming that Mrs Gainsborough's annuity did not enter the picture).[56]

In his portraits, Thomas Gainsborough began to move away from figures in landscapes, perhaps because they were comparatively fussy to do, to produce heads or three-quarter lengths. Around 1757 his handling of paint became rougher and sketchier. He was quite informative on this when he wrote to William Mayhew (pl. 26) in March 1758:

> You please me much by saying that no other fault is found in your picture than the roughness of the surface, for that part being of use in giving force to the effect at a proper distance, and what a judge of painting knows an original from a copy by; in short being the touch of the pencil, which is harder to preserve than smoothness. I am much better pleas'd that they should spy out things of that kind, than to see an eye half an inch out of its place, or a nose out of drawing when viewed at a proper distance. I don't think it would be more ridiculous for a person to put his nose close to the canvas and say the colours smell offensive, than to say how rough the paint lies; for one is just as material as the other with regard to hurting the effect and drawing of a picture. Sir Godfrey Kneller used to tell them that his pictures were not made to smell of: and what made his pictures more valuable than others with the connoisseurs was his pencil or touch.[57]

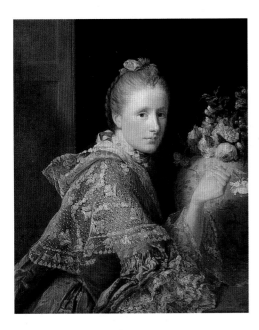

27　Allan Ramsay, *Margaret Lindsay, the Painter's Second Wife*, c.1758–60, oil on canvas, 762 × 609 (30 × 24). Edinburgh, National Gallery of Scotland.

Until the mid- to late 1750s, despite what Thicknesse had to say, Gainsborough had maintained the manner of Hogarth or Hayman in the heads of his sitters and represented form through modelling: paint defined planes, colours. Now, as he made clear to Mayhew, his manner had developed into one in which, close to, the work of the brush was almost offensive. This development has been attributed to the influence of the French pastellists La Tour and Perroneau, the idea being that Gainsborough's hatching manner equated to the myriad strokes of which a pastel portrait is made up. It is extremely likely that he was alerted to this technique by Allan Ramsay. Ramsay returned from the Continent in 1757, where he had been impressed by contemporary French portrait painting (finding La Tour 'vastly natural') and began to paint extraordinarily French-looking portraits, in terms both of technique and of the presentation of the sitter (pl. 27). Francis Cotes, too, was striving to make his pastel portraits equate with the appearances of oil painting, shifting portraiture in the direction of delicacy and refinement. Ramsay's female portraiture in particular has been noted for its intimate directness, which was so striking that Reynolds was quick to imitate it.[58] There was real novelty in a technique of suggesting features rather than describing them, and giving the illusion of the representation of a particular individual, rather than someone whose personality was presented stereotypically by traditional portrait formulae. Gainsborough was surely getting this knowledge in London. Kirby was based there, and was in close contact with Hogarth, who was himself on good terms with Ramsay, and we recall that Nathaniel Dance had met Gainsborough in London before 1755.[59] It is entirely plausible that, on trips to London, Gainsborough took a good look at what was going on. In Ipswich he was inhabiting a congenial environment; but if he was going to be a success as an artist, it would have to be elsewhere.

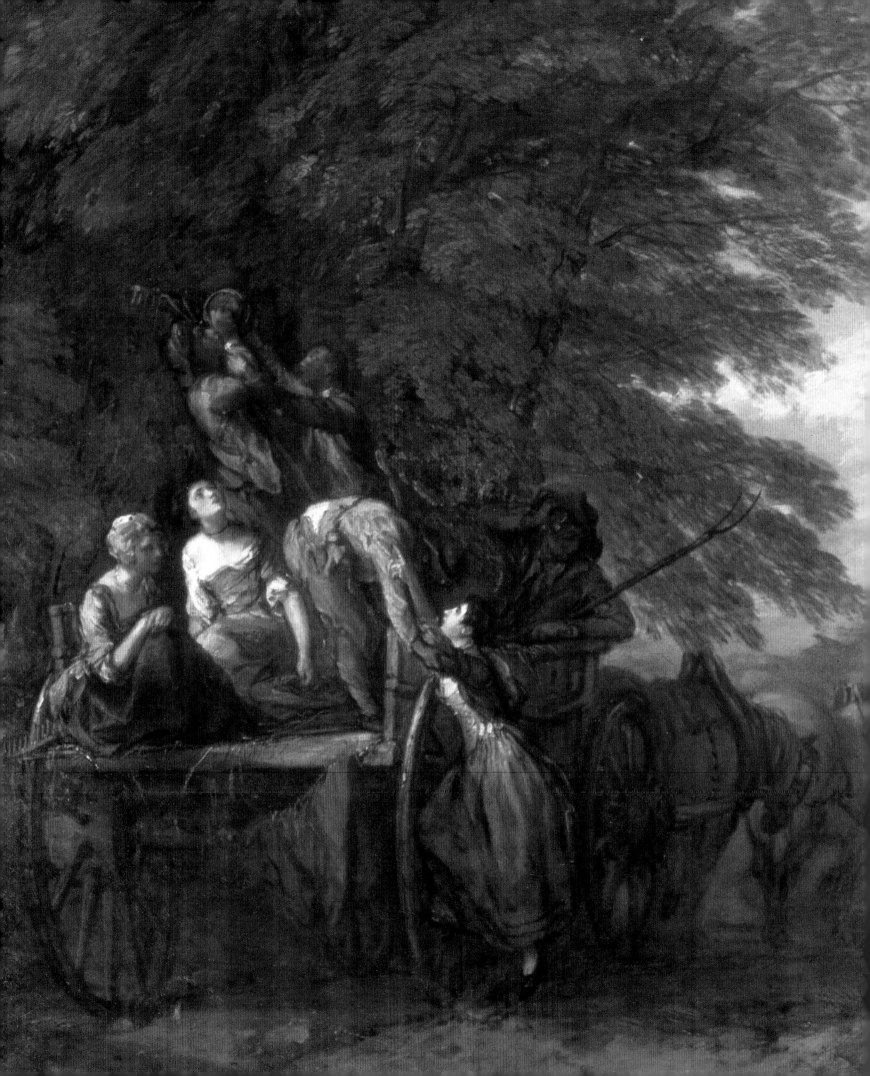

2 Bath

DESPITE HIS ENJOYING A MODICUM OF success – in 1755 he received sums of fifteen and twenty-one guineas from the Duke of Bedford for a pair of landscapes, and he was also getting portrait commissions (pls 33, 34) – in the autumn of 1758 Gainsborough made an extremely successful exploratory trip to Bath, and the following year was to set up in the city.[1] He was an immediate hit, very quickly raising his prices from five to eight guineas for a head.[2]

Bath was an ideal environment for a portrait painter. It was attracting numerous wealthy visitors each year; and although many were regulars, there was enough variation in this pool of prospective clients to keep several artists in work. Both Gainsborough and William Hoare painted portraits, and cordial relations between them suggest that neither was impinging on the other's practice. They served their clientele with different kinds of portrait, Hoare specialising in pastel.[3]

Philip Thicknesse claimed that it was on his advice, and that of unnamed others, that Thomas Gainsborough decided to move to Bath.[4] This would make sense. Thicknesse, who wintered there, was alert to the pickings a portraitist might get in the city, and, when Gainsborough did go, he knew both the best time to be there and how to make an instant reputation. At the time Bath was undergoing unprecedented expansion. In 1743, a population of 10,000 inhabited 1,339 houses. By 1775 – the year after Gainsborough had left for London – almost one thousand more houses were up, and the population had risen by 7,000. Between 1766 (when he took a house in the Circus) and 1775, 564 houses were built, and the population increased by a further 4,000. In 1757 there were twenty-three weekly coaches to London; in 1771, forty-six.[5] 'I believe Sir it would astonish you', wrote Gainsborough to Mr Richard Stevens M.P. in 1767, 'to see how the new buildings are extending in all points from the old center of Bath, The Pump Rooms – We almost reach Lansdown and Cleverton – down, north and south, but not quite to Bristol and London for East and West.'[6]

Enough of Georgian Bath survives to exhibit the ordered civic architectural environment of streets, squares, crescents, circuses, theatres, assembly rooms, pump rooms, chapels and parades which were being thrown up in a fever of speculative greed (pl. 29). Renaissance theorists, pre-eminently Alberti, had written of the idea of the city in terms of abstracted political ideas: it should aspire to supply an appropriate built environment for the political, military, religious, mercantile and commercial interests by and for whom it was constructed. An architectural decorum, explicit in propriety of design – the arrangement of public and private spaces and the interrelationships of different classes of buildings – would articulate the social and civic codes of the different ranks and kinds of people who together formed the body of society. Bath was England's first and most noteworthy planned city, the new buildings rising to the north and west of the mediaeval maze of alleys and courts where the classes of people who catered to the various needs of the polite still lived. Like any resort, it aimed to make leisure pay; so while the elegantly rational architecture advertised its *bona fides* through a neoclassical style, which asserted its propriety by associating itself with Roman virtue and Roman ideals, it supplied the theatre for a species of social display that was resolutely modern.[7]

The best-known contemporary account of Bath – one presented to its numerous readers by the *Town and Country Magazine* as 'a description of the late improvements in Bath' – is

28 Detail of pl. 214.

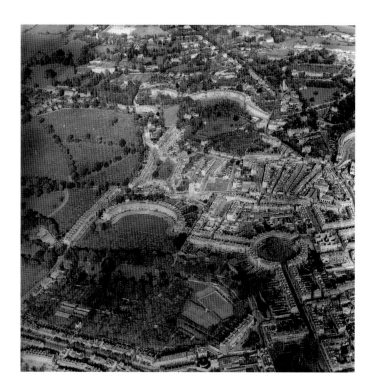

that which Smollett has the irascible Matthew Bramble pen in *Humphry Clinker* (1771). The Circus is 'a pretty bauble, contrived for shew', and 'inconvenient from its situation', while the other developments are a chaos 'contrived without judgement, executed without solidity, and stuck together with so little regard to plan and propriety, that the different lines of the new rows and buildings interfere with, and intersect one another in every different angle of conjunction'. He attributed 'these absurdities' to

> The general tide of luxury, which hath overspread the nation, and swept all, even the very dregs of the people. Every upstart of fortune, harnessed in the trappings of the mode, presents himself at Bath, as in the very focus of observation. – Clerks and factors from the East Indies, loaded with the spoil of plundered provinces; planters, negro-drivers, and hucksters, from our American plantations, enriched they know not how; agents, commissaries, and contractors, who have fattened, in two successive wars, on the blood of the nation; usurers, brokers, and jobbers of every kind; men of low birth, and no breeding, have suddenly found themselves translated into a state of affluence, unknown to former ages; and no wonder that their brains should be intoxicated with pride, vanity, and presumption. Knowing no other criterion of greatness, but the ostentation of wealth, they discharge their affluence without taste or conduct, through every channel of the most absurd extravagance; and all of them hurry to Bath, because here, without any further qualification, they can mingle with the princes and the nobles of the land

Bramble's niece, Lydia Melford, was, on the other hand, entranced:

> Bath is to me a new world – All is gayety, good-humour, and diversion. The eye is continually entertained with the splendour of dress and equipage; and the ear with the sound of coaches, chairs, and other carriages.[8]

This was a world in which Gainsborough had by then been living for a dozen years, and where 'entry was available to anyone who wore the right clothes and could afford the subscription of two and a half guineas which gave access to assembly rooms and balls; for as far as Bath was concerned, you were a gentleman or a lady if you dressed and behaved like one'.[9]

Pretence, disguise and play-acting, implicit in the architecture, were universal among the visitors. Display was sovereign.[10] And it was remarked accordingly. The Reverend John Penrose noted that 'Ladies without Teeth, without Eyes, with a foot and a half in the grave, ape youth, and dress themselves forth with the fantastick Pride of eighteen or twenty', and, of the parade on the Parade, wrote to his daughter that she 'would be greatly diverted, if you were to see, how the Gentlemen walk up and down with Spectacles on (themselves a mere Spectacle) . . . Those who don't wear Glasses on their Noses, carry them in their Hands, and constantly apply them to their Eyes: for it's quite the fashion to be near-sighted.' Modishness was having a field day.

> The Bath Ladies are not very lovely. The very Fashions, which the Ladies must follow, or they had as good be out of the World, will not even suffer them to be wholesome. Such Ladies as have their own Hair, not artificial, and have it dressed by the Barber, do not comb their Heads for three months together. Whether they kill the Lice with Quicksilver, or Mr. Coode's hammer, or by what other contrivance, is a secret; but they endeavour to conceal the Stink of their filthy Heads with Perfumes, Essences, etc. This is worse than Painting an inch thick: but Painting too is very necessary to a fine Lady.[11]

Smollett represented the atmosphere at an Assembly as comprising

> *A compound of villainous smells*, in which the most violent stinks, and the most powerful perfumes contended for the mastery. Imagine to yourself a high exalted essence of mingled odours, arising from putrid gums, imposthumated lungs, sour flatulencies, rank armpits, sweating feet, running sores and issues, plasters, ointments, and embrocations, hungary-water, spirit of lavender, assafoetida drops, musk, hartshorn, and sal volatile, besides a thousand frousty streams which I could not analyze.

When Matthew Bramble succumbs to this and passes out, his nephew, Jery Melford, gives thanks for the 'coarseness' of his own organs.[12]

Humphry Clinker recreates the fantastic theatre of the city at the same time as revealing that it could supply polite amusement even for so fastidious a person as Matthew Bramble. In an early instance of faction, Bramble is agreeably pleased to renew his acquaintance with the famous actor James Quin. Through Jery Melford we discover both Quin's amazing capacity for wine — 'he was carried home with six good bottles of claret under his belt' — and gift for 'extravagantly entertaining conversation'.[13] Thomas Gainsborough also drank with Quin and enjoyed his company, and did at least two portraits of him — a fine head, 'almost certainly . . . cut from a larger canvas' (pl. 30) — and the portrait (a 'wonderful effort' according to Gainsborough's friend, Henry Bate) exhibited at the Society of Artists in 1763 (pl. 32).[14] A humorous empathy is communicated in his presenting Quin in a pose similar to that in Hogarth's portrait of another master of disguise, the wily Jacobite rebel *Simon, Lord Lovat* (pl. 31), Quin, in his turn, bequeathed Gainsborough a very generous £50 after his death in 1766.[15]

In November 1773 Philip Thicknesse (who was still in close and regular contact with Gainsborough) summed up the charms of Bath. 'I can go to the Coffee House and spend two hours from seven to nine, I can look around and see seven or eight men all of general knowledge and many skilful in some particular, and suit my present mood with the conversation I feel most inclined to partake of.'[16] Bath, the resort of polite society during the winter months — by 1780 the season, which began in September, stretched to May — was an ideal base for a portrait painter.[17] R. S. Neale writes that

> In the Autumn of 1765, as many as 148 persons of quality were numbered among the visitors. The list included three princes, four dukes, four duchesses, one marquis, two marchionesses, twenty-four earls, twenty-two countesses, forty viscounts, forty-three viscountesses, twelve barons, twelve baronesses, one ambassador, one archbishop and five bishops.[18]

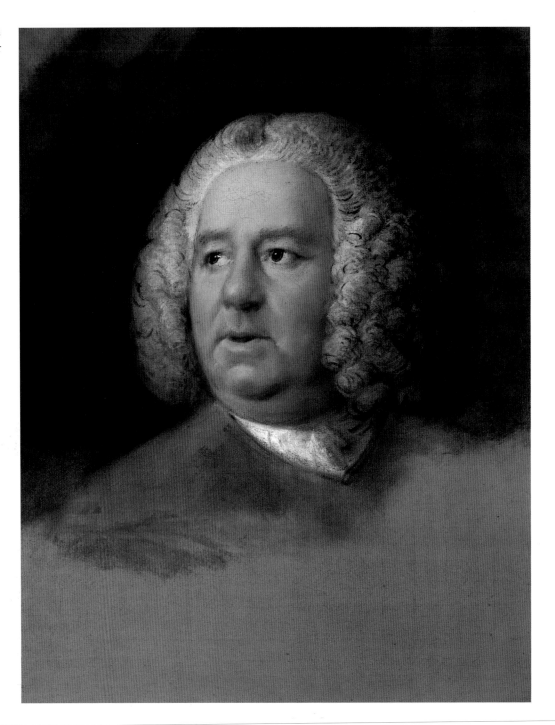

30 *James Quin*, 1763, oil on canvas, 648 × 508 (25½ × 20). The Royal Collection. © Her Majesty Queen Elizabeth II.

Over the winter of 1764–65, Gainsborough had been painting the Duke of Bedford and his family (pls 33, 34). Amongst the full-lengths he exhibited at the Society of Artists in 1767 were the state portrait of *John, fourth Duke of Argyll* (pl. 35) along with the more private *George, Lord Vernon* (pl. 36), the sitter lost in thought, in a landscape.[19] Elevated patronage signified good business; and this had been the intention from the first.

As we have seen, trade in Ipswich had not been brisk. When Thomas Gainsborough thanked the attorney William Mayhew for his 'kind invitation of procuring me a few heads to paint when I come over', he meant it. He let the same correspondent know in March 1758 that 'business comes in and being chiefly in the Face way, I'm afraid to put people off when they are in the mind to sit', revealing both that he was having to take whatever work

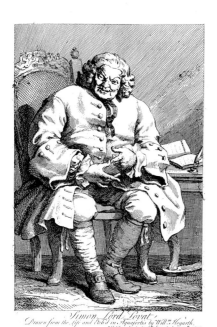

31 William Hogarth, *Simon, Lord Lovat*, 1746, etching, 13³/₁₆ × 8⁷/₈ [14⁵/₁₆ × 9⁵/₁₆] (335 × 225 [363 × 236]). London, British Museum.

32 *James Quin*, 1763, oil on canvas, 2,337 × 1,524 (92 × 60). Dublin, National Gallery of Ireland.

33 *Gertrude, Duchess of Bedford*, 1764, oil on canvas, 762 × 625 (30 × 25). By kind permission of the Marquess of Tavistock and the Trustees of the Bedford Estate.

he could get, and that he knew that, to live, he would have to paint portraits.[20] East Anglia would never produce the numbers of clients that he could anticipate in Bath.

Gainsborough prepared his move with some care. His new, 'hatched' manner, which, at a proper distance, created the illusion of an animated likeness in the spectator's eye, was designed to attract attention, and to set his portraits apart from those of others (including the rather more finished pastels of William Hoare). As we have seen, in October 1758 he took a trip with the intention of testing the water, timing his arrival to coincide with the start of the Bath season.[21] A letter written by the poet laureate, William Whitehead, to Viscount Nuneham on 6 December that he made a gratifying impact:

> We have a Painter here who takes the most exact likenesses I ever yet saw. His painting is coarse and slight, but has ease and spirit. Lord Villiers set to him before he left Bath,

34 *John, fourth Duke of Bedford*, 1764, oil on canvas, 762 × 625 (30 × 25). By kind permission of the Marquess of Tavistock and the Trustees of the Bedford Estate.

& I hope we shall be able to bring his Picture to town with us, it is he himself & preferable in my opinion to the finest unlike picture in the Universe, tho' it might serve for a sign. He sate only twice. The Painter's name is Gainsborough.[22]

Gainsborough's tactics were working. His manner was getting noticed, with qualified admiration. Granting it 'ease and spirit' was to allow it gentlemanly good breeding, 'the Art of pleasing, or contributing as much as possible to the Ease and Happiness of those with whom you converse', as Fielding had put it.[23] The face was held to express character – 'what chiefly pleases in the Countenance, are the Indications of *Moral Dispositions*' – what John Locke had earlier called 'the language whereby . . . internal Civility of Mind is expressed' and good manners, the physical embodiment of a politeness that comprised among other things, ease and spirit, which, as Hogarth indicates in Plate 2 of *The Analysis of Beauty*, were of signal social moment (pls 37, 38).[24] 'Why should the attitude of a Lady, or Gentleman, when

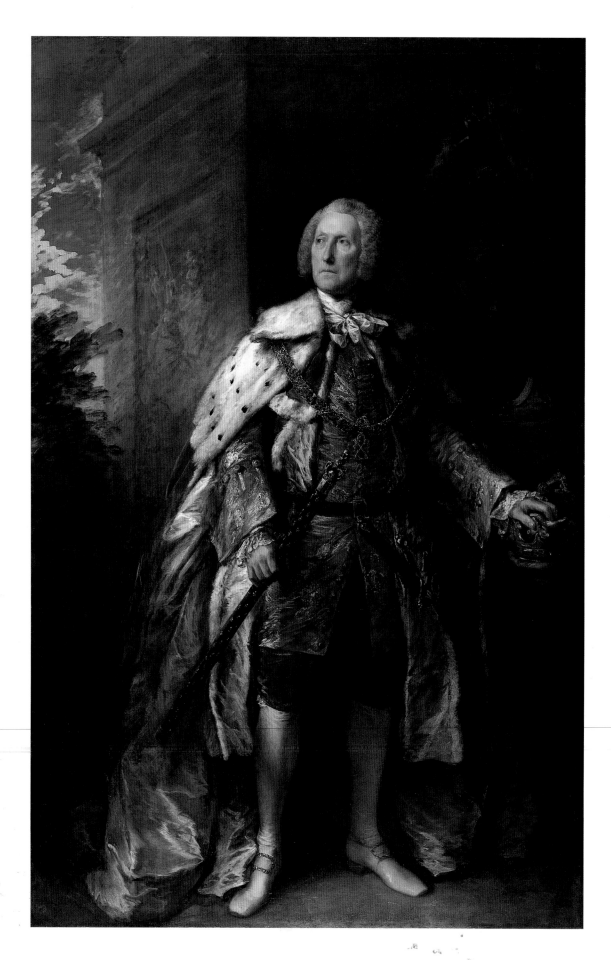

35 *John, fourth Duke of Argyll*, 1767,
oil on canvas, 2,311 × 1,537 (91 ×
60¹/₂). Edinburgh, National Portrait
Gallery of Scotland.

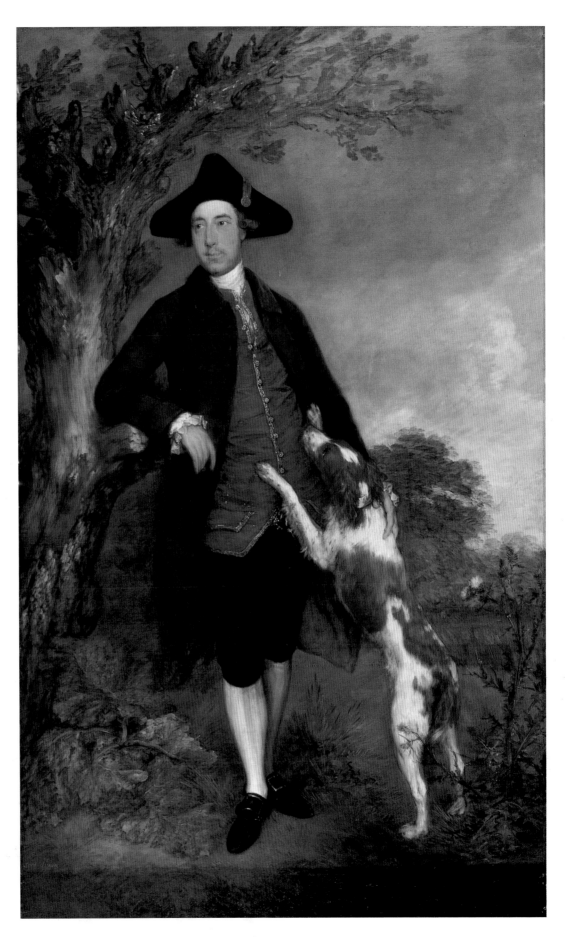

36 *George, Lord Vernon*, 1767, oil on canvas, 2,463 × 1,504 (97 × 59). Southampton City Art Gallery.

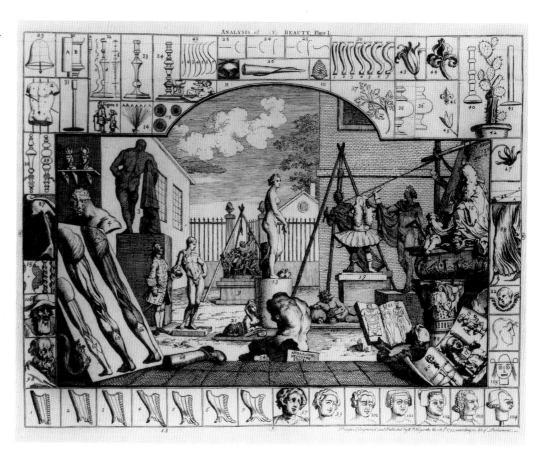

37 William Hogarth, *The Sculptor's Yard*, 1753, etching and engraving, from *The Analysis of Beauty*.

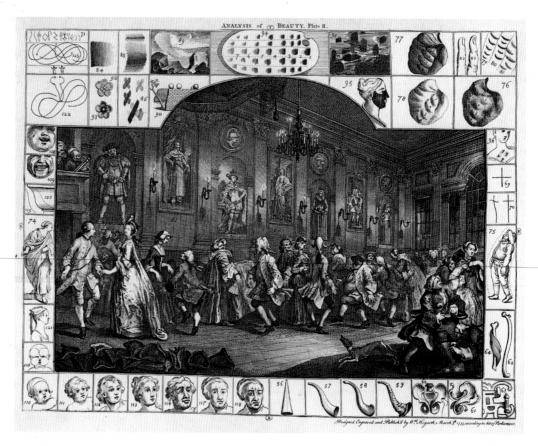

38 William Hogarth, *The Country Dance*, 1753, etching and engraving, from *The Analysis of Beauty*.

39 *Unknown Man*, c.1758, oil on canvas, 625 ×
750 (24$^1/_2$ × 29$^1/_2$). Oxford, Ashmolean Museum.

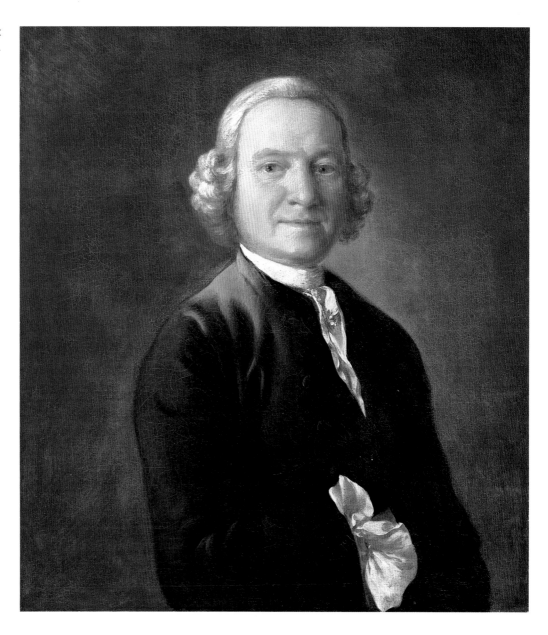

drawing, be less graceful than when playing a harpsichord', asked E. Fitzgerald, author of
The Artist's Repository, in 1788, to press home the importance of not only being polite, but
showing it.[25] Moreover, Gainsborough was being commended for taking a likeness so strik-
ing as to be 'he himself'.[26] And, although the issue was, as we shall see, contentious,
Gainsborough was keen to capitalise on his gift for attaining this perfection. It is notable in
this respect that when he paints the same people, even after some years, as in the case of
Mrs Horton who became the Duchess of Cumberland (pls 155, 156), they stay recognis-
able. It was a risky strategy, however. When Gainsborough was perceived to have missed the
likeness, as with a portrait of George Lucy of Charlecote, problems ensued.[27]

In 1772 the *Town and Country Magazine* published an account of Gainsborough, on his
1758 first trip to Bath. Written by someone who knew him well, very probably Philip
Thicknesse, it laid out his then aims and intentions (which, in the context of 1772 we shall
see to have been a counterblast to what Reynolds was saying about portraiture and likeness
in his *Discourses*).[28] Supposedly drawn from the diary of a valetudinarian 'genius hunter',
who had been so struck by the sight of a Gainsborough landscape that he had felt impelled

to meet its painter, the text is notable for recording highly informative conversations between him and a 'Gentleman' intimate with the artist. Just as Whitehead thought a portrait 'he himself', the Gentleman states that Gainsborough's 'pictures may not be said so properly to be *like* the originals as to *be* the people themselves'. This may well be echoing what the artist himself wished people to perceive in his portraits – Ozias Humphry, an intimate in the early 1760s, wrote of Dr Charleton's portrait (pl. 44) that it 'absolutely seemed upon first entering the Room, like a living Person', and in 1770 Thicknesse (comparing Reynolds unfavourably to Gainsborough) said that from such a work one might 'form the same judgement of the person as from the Life'.[29] Gainsborough gained a reputation for this gift from the start. Reviewing the Society of Artists' exhibition in 1762, the *St James's Chronicle* commended *Mr Poyntz* (pl. 40) for its 'pleasing likeness', and his skill was taken so much as given at the time of his death that both his obituarists and Sir Joshua Reynolds, in his fourteenth *Discourse*, were at pains to analyze the means by which the illusion was achieved. It was a main selling point, although the gift had to be exercised with tact. It is recorded of the Swiss artist Liotard, in England between 1753 and 1755, that his likenesses were 'too strong to please those who sat to him, thus he had great employment the first year and very little the second'.[30]

According to the account in the *Town and Country Magazine*, the 'genius hunter', having made the painter's acquaintance, then discovers him to be not at home. The Gentleman explains: 'G. says he, by this time knows the value of his time too well to throw it away one any one . . . if you choose to see him, sit to him, and then he does not lose by your company.' This fits with what we know. Thicknesse censured Lord Bateman's failure to offer Gainsborough patronage during a visit he made in 1774, for 'every five days was a loss to him of at least an hundred pounds', while, in a letter of 1767 to William Jackson, Gainsborough exclaimed:

> now damn Gentlemen, there is not such a set of Enemies to a real artist in the world as they are, if not kept at a proper distance. *They* think (and so may you for a while) that they reward your merit by their Company & notice; but I, who blow away all the chaff & by G – in their eyes too if they dont stand clear, know that they have but one part worth looking at, and that is their Purse; their Hearts are seldom near enough the right place to get a sight of it – If any gentleman comes to my House, my man asks them if they want me (provided they dont seem satisfied with seeing the Pictures) & then he askes *what* they would please to want with me; if they say a Picture, Sir please to walk this way and my Master will speak with you; but if they only want me to bow and compliment – Sir my Master is walk'd out – and so my dear there I nick them.[31]

Gainsborough, like Reynolds, did not consider himself to hold any subservient position to his clients, and the letter reminds us that the relationship was not so straightforward as between suppliers and customers within a market. This is clear enough from Gainsborough's wishing that 'the People with their damn'd Faces could but let me alone a little', or grumbling that 'I'm sick of Portraits', together with recollections such as Henry Angelo's:

> If a portrait happened to be on the easel, as Quin said, he was in the humour for a growl at the dispensation of all sublunary things. If, on the contrary, he was engaged in a landscape composition, then he was all gaiety – his imagination in the skies.[32]

And the extent to which Gainsborough's treatment of his sitters varies demands that we be alert to the complexities of his practice. He had a nose for business. He hardly sold landscapes, yet wrote to the young Ozias Humphry that 'I should be grateful to send you any of my landskips to copy, did it not affect the sale of new Pictures, to have any copies taken of them', while, of course, he gave away landscape drawings and paintings to his closest friends.[33]

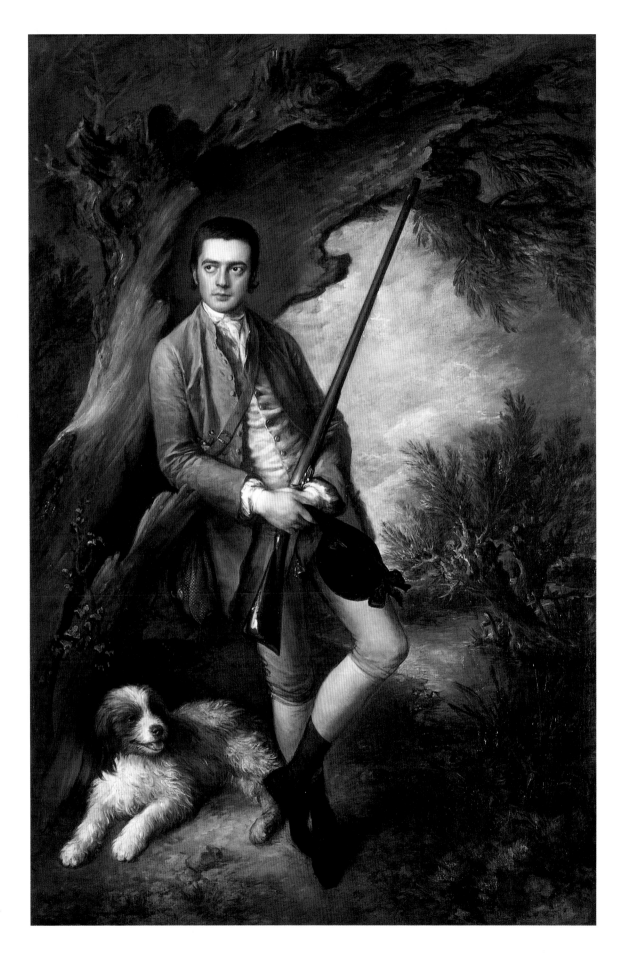

40 *William Poyntz*, 1762, oil on
canvas, 2,349 × 1,524 (92$\frac{1}{2}$ × 60).
Althorp.

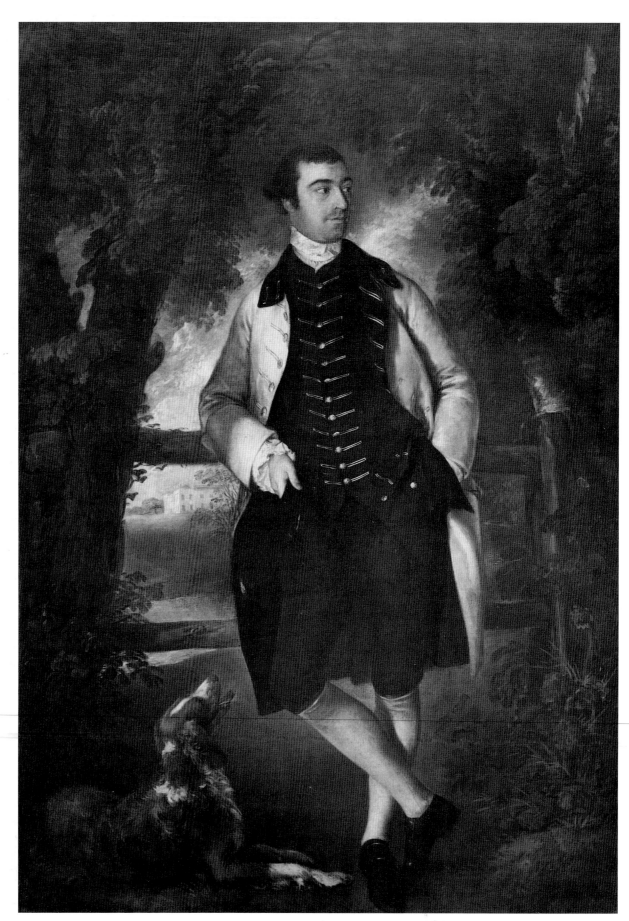

41 *William Wollaston*,
c.1758, oil on canvas, 2,159 ×
1,473 (85 × 58). Private
collection.

42 (*facing page*) *William
Wollaston*, 1758–59, oil on
canvas, 1,207 × 978 (47¹/₂ ×
38¹/₂). Ipswich Borough
Council Museums and
Galleries.

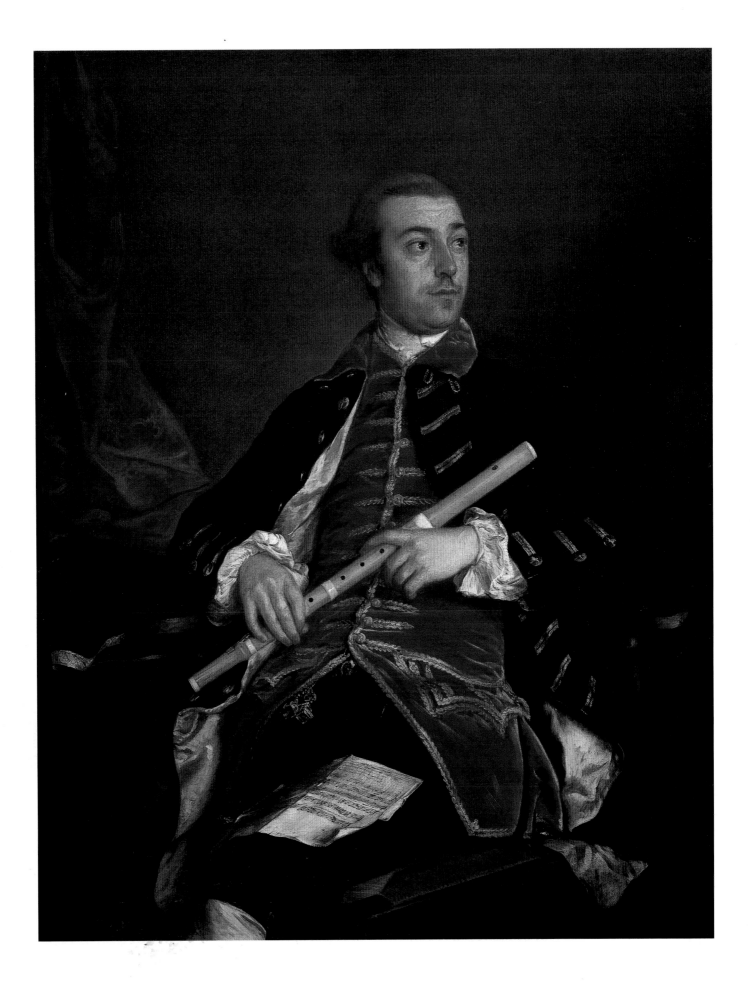

Gainsborough's reconnaissance trip to Bath showed what rich pickings he might have, and he settled for good at the beginning of the 1759 season.[34] By then he had learned other things besides. There was an element of censure in Whitehead's comments that his painting was 'coarse and slight', such as 'might serve for a sign'; and, if, as seems logical, the fine portraits of William Wollaston of Finborough in Suffolk (pls 41, 42) were painted in 1759, before the final move to Bath, then Gainsborough was consciously adding refinement to a striking likeness. In the one, Wollaston, so lost in thought as not to notice his dog, leans on a stile at his seat, Fingest. The portrait initiated a formula which Gainsborough would re-use.[35] As it is a full length, Wollaston was evidently aiming to give the artist what help he could, a motive which might explain the second picture, for, if both were on display in his painting room, their reconisably portraying the same person attested to Gainsborough's gift for catching a likeness. This one is about creative domestic relaxation, Wollaston pausing in the middle of playing some music. The head is turned away, and the hatching and short brushstrokes, thin paint layers giving a transparency to their texture, suggest the imperceptible contours and shifts in hue of the flesh of the face. The eyebrows are at different levels, and the features shown from at least two viewpoints, so that it is in the eye of the spectator that what is optically unstable gets fixed as a likeness. Giovanni Bellini had shown what could be done with different viewpoints in his *Doge Loredan* (National Gallery, London) but here the brushwork further unfixes perceptual stability, so that looking at the portrait in part matches the experience of looking at a person, with constant small movements: of heads, of the viewer's eyes.[36] Wollaston is represented as leaning back in his chair for a moment, with the sheet music with its runs of semi-quavers laid across his thigh, and the brilliance of the colouring — scarlet waistcoat, deep blue coat and gold braid — perhaps matching the spirit and harmony of his playing.[37] This is the work of an artist who was making significant technical advances over a short period, and, once Gainsborough was back in Bath, these efforts paid off.

As we have seen, by February 1760 he had raised his price for a head — in this instance a portrait of George Lucy of Charlecote — from five to eight guineas. Thicknesse tells us that 'business came in so fast' (in Bath he painted around twenty portraits per annum, compared with seven in Ipswich) that he was soon charging twenty guineas for a head, forty for a half-length, and sixty for a full-length.[38] Gainsborough was becoming wealthy. On moving to Bath, he leased an extremely expensive house, rental value £150 per annum, from the Duke of Kingston. Thicknesse characteristically claims to have persuaded Gainsborough to embark on this tenancy, and to have calmed Margaret Gainsborough, agitated by the thought of spending so much money.[39] The house in Abbey Street, at the centre of the trading area of the city, was ideally suited to catch the attention of visitors going to take the waters, or to the abbey itself. Gainsborough painted in a north-facing room on the first floor, showing representative works to such visitors as the fictitious 'gentlemen' about whom the artist had waxed satirical, in the 'best parlour'. Various portraits of gentlemen, seated or standing by a window through which can be inspected an entirely invented landscape, feature this painting room (pls 43, 153).

Gainsborough let rooms to visitors from quite early on, while his sister, Mary Gibbon, took the ground-floor milliner's shop. After his move to Lansdowne in autumn 1765, he kept only the painting and display rooms, and on taking up residence at 17 Circus in 1766 he relinquished these too, although retaining the lease.[40]

After the move to Lansdowne, Gainsborough wrote to his friend, the attorney James Unwin, that

> I have taken a House about three quarters of a mile in the Lansdown Road; 'tis sweetly situated and I have every convenience I could wish for; I pay 30 pounds per year, and so let off all my House in the smoake except my Painting Room and best parlour to show Pictures in. Am I right to ease myself of as much Painting work as the Lodgings will bring in. I think the scheeme a good one.[41]

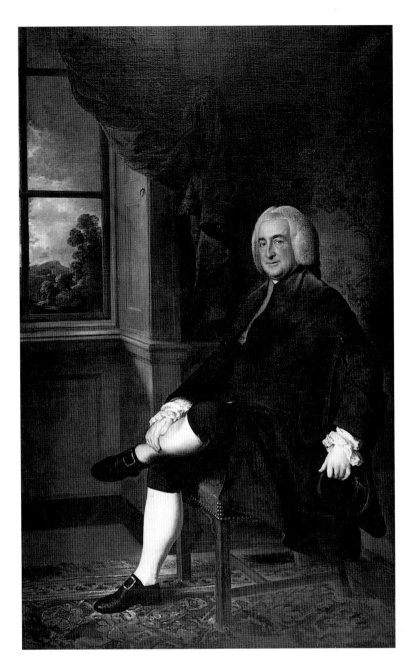

That is, income from rentals was cushioning his earnings from portraiture and allowing him to paint less.

Though apparently half-hearted, Gainsborough's approach to the business of portraiture was commonsensical. While there were practical reasons behind his choice of 17 Circus – his first-floor painting room was lit from the north and the show-room from the south – by relocating there Gainsborough also displayed his social status. Neighbours included Lord Clive, William Pitt the elder, and his old patron the fourth Duke of Bedford.[42] Visiting artists' show rooms was a fashionable recreation, and both the Reverend John Penrose and Mrs Dorothy Richardson wrote about their visits to Gainsborough's house. From the latter (visiting on 7 May 1770) we learn that he displayed work in various stages of completion, and that in other rooms were landscapes, copies after old masters and a Rubens – to indicate that his modern art looked back to a particular seventeenth-century tradition.[43] Gainsborough took some care over the display of his work and apologised to Garrick in

1772 for keeping the actor's portrait in 'hopes of getting one copy *like*, to hang in my own Parlour, not as a show Picture, but for my own enjoyment, to look when I please at a Great Man', teasing the actor, a popular celebrity, who would have known as well as Gainsborough that the display of his portrait would have been an attraction to visitors.[44]

Jean André Rouquet gives an account of the habit of visiting painters' rooms:

> Every portrait painter in England has a room to shew his pictures, separate from that in which he works. People who have nothing to do, make it one of their morning amusements, to go and see these collections. They are introduced by a footman without disturbing the master, who does not stir out of his closet unless he is particularly wanted. If he appears, he generally pretends to be about some person's picture, either to have an excuse for returning sooner to his work, or to seem to have a good deal of business, which is sometimes a good way of getting it. The footman knows by heart all the names, real or imaginary, of the persons, whose portraits, finished or unfinished, decorate the picture room: after they have stared a good deal, they applaud loudly, or condemn softly, and giving some money to the footman, they go about their business.[45]

This is precisely as Gainsborough described the ritual to William Jackson. He was not, however, indifferent to his paintings' reception. He wrote of his portrait to the Dr Dodd who was later hanged for forging the signature of the fifth Earl of Chesterfield, that

> The ladies say it is very handsome as it is; for I peep & listen through the keyhole of the door of the painting room on purpose to see how you touch them out of the pulpit as well as in it. Lord! Says one, what a lively eye that gentleman has![46]

The keyhole would have been in the double doors which separated the painting room from the show room. Nevertheless, some visitors to artists' studios seemed to register very little:

> Papa *wd* walk out this morn: which was very wrong, as *no one* can hardly against the wind. I went out . . . to see Hoare's and Gainsbro's Pictures, & I lost my Hat petticoat breath & every thing . . . I saw nothing very capital at the two Painters, excepting a portrait of the Dss of Kingston in her weeds . . .[47]

Bath was able to support varieties of artists, from Gainsborough at the top end to miniaturists and others, and their supplying particular and distinct markets appears to have dampened down any damaging rivalry. In 1773, William Hoare sent Gainsborough a copy of Reynolds's fifth *Discourse*, quite possibly to tease him (as we shall see). Gainsborough ended his own letter of acknowledgement with

> As Mr. G. hates of all things the least tendency to the sour Critic, hopes to talk over the affair some Evening over a Glass, as there is no other Friendly or sensible way of settling these matters except upon *Canvas*.[48]

This points to their enjoying a convivial relationship. The same year, Hoare organised a commission for one of Gainsborough's landscapes from Henry Hoare of Stourhead.[49]

Gainsborough became quickly established within the upper echelons of Bath society. He was friendly with the eminent doctors Charleton, Schomberg and Moysey (pls 44, 45), though he fell out with the latter, who suggested that the psychiatric illness from which Gainsborough's daughter Margaret suffered in 1771 was symptomatic of heriditary syphilis.[50] Ralph Allen, whose stone had built Bath and whose fortunes were partly consequent upon the success of the resort, had a small landscape of *c.*1759–62, and the artist would 'always' speak of his 'patronage and favour' later in life.[51] In general he kept the company of 'musicians, actors, painters, and miniaturists'.[52] The singer Thomas Linley (pl. 46) (with whom William Jackson had connections) 'dominated the Bath musical scene, which was said to be on a par with that offered in London', and it was he who invited the viola da gamba virtuoso, and subsequent intimate of Gainsborough's, Carl Friedrich Abel (pls 47, 85), to play

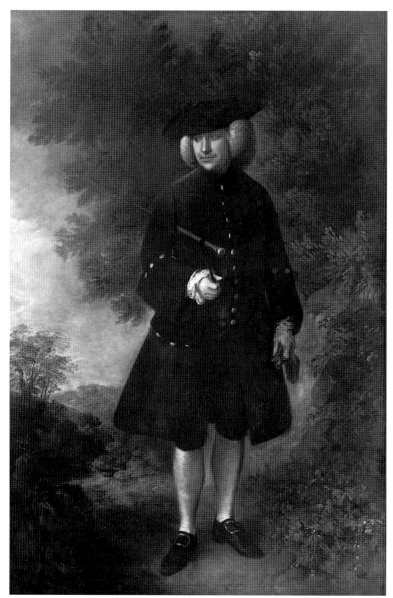

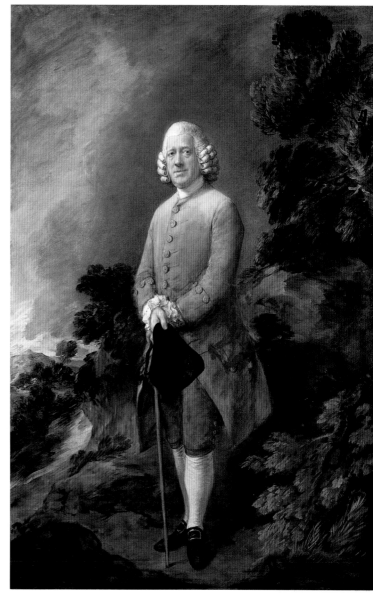

44 (*above left*) *Dr Rice Charleton, c.*1764, oil on canvas, 2,290 × 1,525 (90 × 60). Bath, Holburne Museum.

45 (*above right*) *Dr Ralph Schomberg, c.*1770, oil on canvas, 2,330 × 1,536 (91¾ × 60½). London, National Gallery.

in the city.[53] We have noticed Gainsborough's amiable relations with William Hoare, and he was so loyal to the now forgotten Bath landscape painter Edmund Garvey as to engineer his elevation to R.A. over Joseph Wright in 1783.[54] Garrick came to Bath from time to time, and met Gainsborough at Quin's funeral in 1766: as the latter was addressing him as 'my dear Friend' by 1768, they evidently found each other congenial company from early on.[55]

At Bath, Gainsborough carried on doing the sorts of things he had been doing at Ipswich, but at a higher level. Rather than associating with Gibbs and the Musical Club, he could now fraternise with Linley and Abel.[56] He also had access to some major collections of paintings, forming connections with 'Corsham, Longford Castle, Shobdon and Stourhead, all of whose owners sat to him or bought his work'.[57] By 1764 he was apparently on good terms with the Earl of Pembroke, for he wrote to James Unwin, 'I was very agreeably favour'd with yours at my return from Wilton where I have been about a week, partly for my amusement, and partly to make a drawing from a fine horse of Ld. Pembroke's, on which I am going to set General Honeywood, as large as life.'[58] At Wilton part of the amusement would have consisted of enjoying the fine collections of paintings by Van

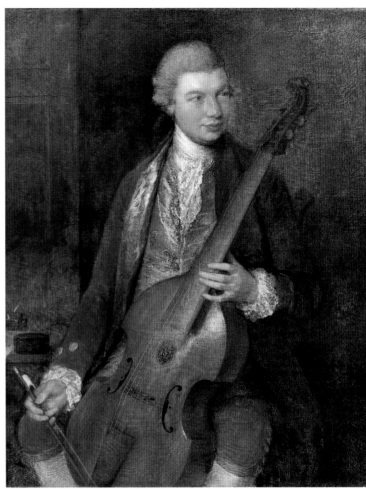

Dyck, to which his own work responded both in format and handling, attaining an extraordinary virtuosity in the painting of costume. Stourhead offered both the famous gardens, and landscapes by Gaspard or Claude – which is to remind us again that we must sometimes take what Gainsborough himself wrote, or what others wrote about him, with a pinch of salt. William Jackson maintained that 'Claude was no favourite with Gainsborough. He thought his pencilling tame and insipid.' Not then to notice Gainsborough making compositional and colouristic references to Claude in some of his landscapes, for instance the fine painting of *c.*1763 (pl. 49), supposed to have been one of a pair given to Francis Hayman, will be not to see them completely.[59] He relished the opportunity to study seventeenth-century masters. After he had painted the Duke and Duchess of Montagu in 1768 (pl. 135) he wrote to Garrick:

> I could wish you to call *upon any pretence* any day after next Wednesday at the Duke of Montagu, because you'd see the Duke and Duchess in my *last* manner; but not as if you thought anything of mine worth that trouble, only to see his Grace's Landskip of Rubens, and the 4 Vandykes whole length in his Grace's dressing room.[60]

He was pleased with his own efforts, and inferred that their proper context was in the company of an aristocratic collection of old masters.

This is important in terms of Gainsborough's professional procedures on reaching Bath. He put himself through a programme of intensive copying, by which, as I have suggested, he learned a great deal about the handling of paint and the management of drapery from

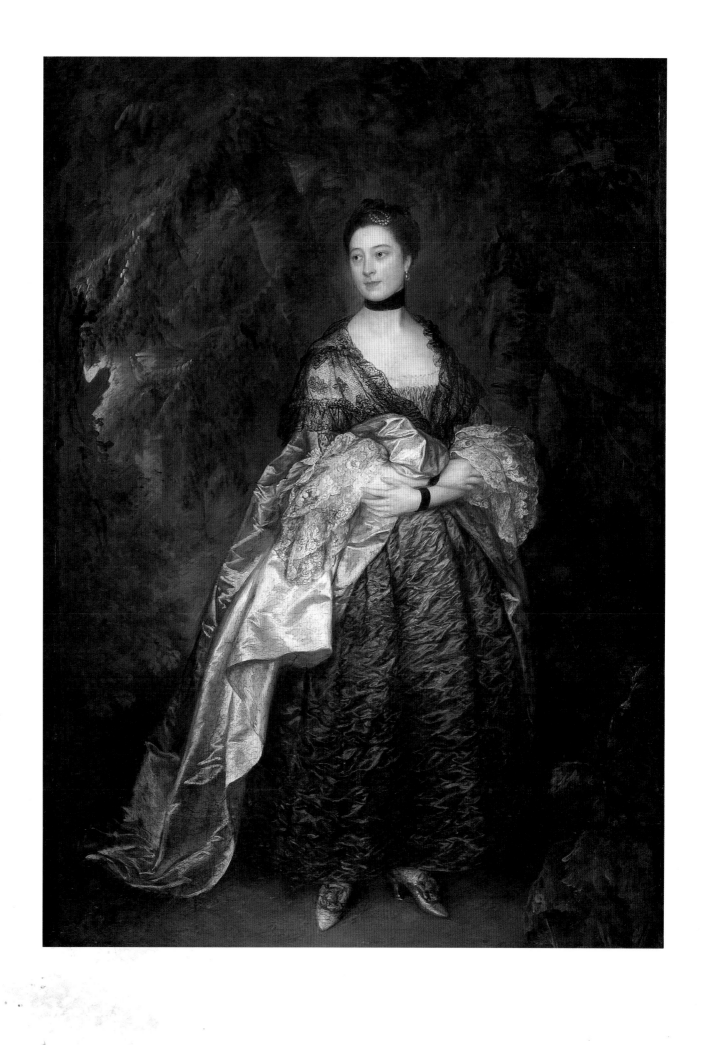

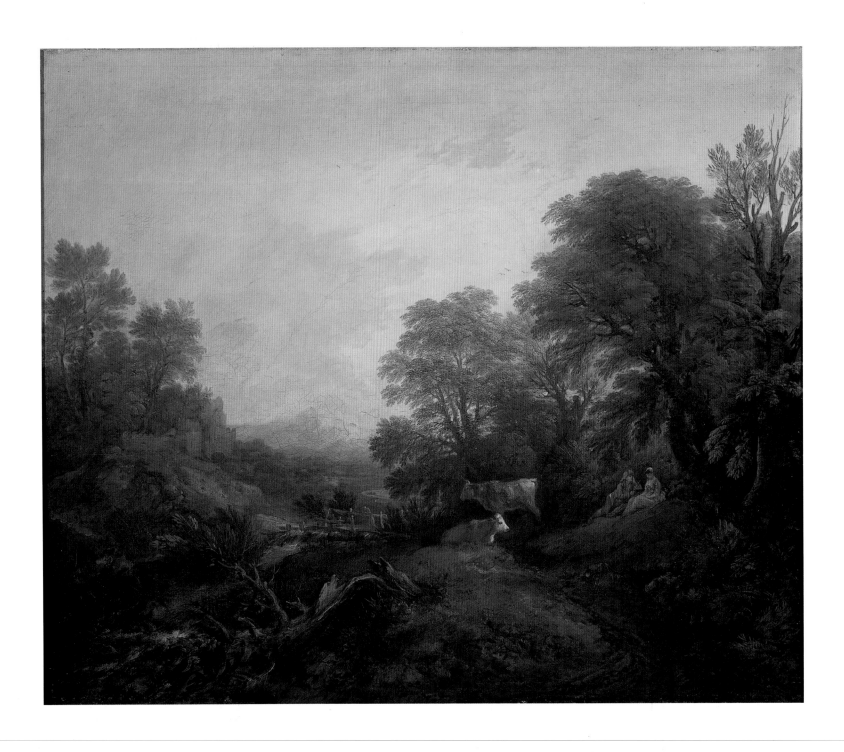

49 *Wooded Landscape with Rustic Lovers*, *c*.1762–63, oil on canvas, 610 × 737 (24 × 29). Philadelphia Museum of Art: Given by Mr. and Mrs. Wharton Sinkler.

Van Dyck. The effects are detectable by 1760, with *Ann Ford* (pl. 161), and clearly visible around 1764 in portraits of *Lady Alston* (pl. 48) and *Mary, Countess Howe* (pl. 287). The latter two are conspicuously brilliant in handling, and both, importantly, are full lengths, allowing Gainsborough to display his capacities on a large canvas. The brushwork does recall Van Dyck. The pose of *Mary, Countess Howe* may also do so; there is an echo of *Elizabeth Howard, Countess of Peterborough*.[61] But each sitter is dressed in the latest fashion, and Countess Howe's 'tight-bodied' gown and high-heeled shoes play a real part in dictating her pose.[62] In such portraits as these Gainsborough demonstrates a learning which is 'muted . . . residing in a pose, a motif, a detail of the dress, a feature of the setting . . . pictorial incidents, easily recognised by the eighteenth-century spectator . . . designed to evoke a web of associations'. In addition, by these tactics Gainsborough 'not only elevated the status of his art but also his

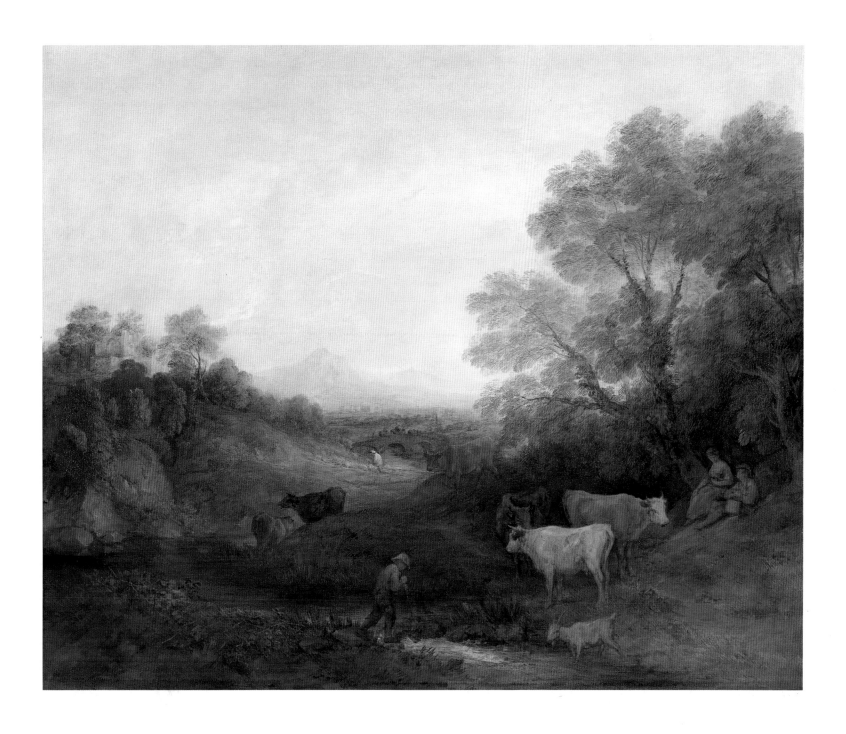

50　*Landscape with Cattle*, c.1773, oil on canvas, 1,200 × 1,450 ($47^{1}/_{4}$ × $57^{1}/_{4}$). New Haven, Yale Center for British Art, Paul Mellon Collection.

own position, for he revealed that he was not simply an artisan or craftsman, but a cultivated gentleman in possession of scholarship and ingenuity'.[63]

In this he was consciously establishing a particular professional position, as a supplier of a luxury item of a unique character, for nobody else could paint with his facility or *brio*, or was so esteemed for catching a likeness. Consequently, he was more or less able to paint on his own terms. To begin with, he worked through connections, as he had done to an extent in Suffolk. Sir William St Quintin (whom Gainsborough would, around 1763, refer to as his 'good friend') had commissioned his own three-quarter length in 1760.[64] This indicated that the artist was getting trade from the upper reaches of Bath society, and he confirmed his status with the full-length *Robert Craggs, Earl Nugent* (pl. 43), again in 1760. The sitter, M.P. for Bristol, had been prominent in public life and was friendly with people such as Oliver

Goldsmith. The portrait, one of those set in Gainsborough's painting-room, has the sitter in relaxed pose, one arm draped over the back of the chair, the other resting on the ankle of a leg thrown over the knee.[65] He seems to turn to look at the spectator, or, perhaps, to address the painter, and the curtain is not now the stock allusion to seventeenth-century tradition, but an actual one. The pose looks to be an invention of Gainsborough, unusual enough to attract notice, which was probably the intention. At this period, both Allan Ramsay and Joshua Reynolds were going beyond standard portrait formats, and the comparative novelty of their productions must have been striking. Gainsborough used the *Nugent* to alert the London public to his own talents, showing it at the second exhibition of the Society of Artists in 1761, and reminding us that provincial painters were obliged to stay alert to the metropolitan scene, particularly when working in Bath whose many visitors had a London base, and which can be thought of as virtually a metropolitan outpost.

Inventiveness in portraiture was a useful tactic for getting noticed. Thus it was that Mrs Mary Delany wrote to her friend Mrs D'Ewes in 1760 that

> This morning went with Lady Westmoreland to see Mr. Gainsborough's pictures (the man that painted Mr. Wise and Mr. Lucy), and they may well be called what Mr. Webb *unjustly* says of Rubens, 'they are *splendid impositions*'. There I saw Miss Ford's picture, a whole length with her guitar, a most extraordinary figure, handsome and bold; but I should be very sorry to have any one I loved set forth in such a manner.[66]

Aside from revealing that educated women were *au fait* with the latest ideas of writers such as Daniel Webb, and that Mrs Delany was able to identify Gainsborough by mentioning people he had painted previously, this passage testifies to the originality of his full-length portrait of Ann Ford (pl. 161) who was known both for her beauty and for her musical gifts, and who had been prominent in Bath when Gainsborough had been there in 1758. The portrait, despite its brilliance, was not exhibited, in part because it was artistically contentious, and in part because of the sitter's recent history.[67] In general, Gainsborough was properly fastidious in selecting which of his canvases to submit to public scrutiny, and extremely careful to make maximum impact at exhibition.

As noted by Sir Ellis Waterhouse, Gainsborough strategically sent a series of full-length portraits ('and a very few landscapes') to the exhibitions at the Society of Artists and, after 1769, at the Royal Academy. *Robert Craggs, Earl Nugent* and *William Poyntz* (pls 43, 40) we have noticed. The latter was a vehicle for the display of Gainsborough's wit and invention. Poyntz rests for a moment from his sport, to look out beyond the spectator. As Gainsborough confessed himself 'deeply read in petticoats', and liked lewd puns (as when he ended a letter to the prim William Jackson, 'if you was a Lady I would say what I have often said in a corner by way of making the most of the last Inch. Yours up to the hilt') the position of the gun will be no accidental pointer to Poyntz's youthful vigour.[68] Poyntz should normally have cradled his gun in the crook of his arm, barrel pointing safely away, as Reynolds painted Philip Gell doing (avoiding in the process any phallic symbolism).[69] In later portraits of gentlemen out shooting, George Stubbs would likewise show gun barrels pointing correctly to the ground.[70] In this case the artist, like any portraitist of sense, produced with an image that flattered as more or less corresponding with the probable self-image of the sitter; very likely making a visual pun about Poyntz's 'stock' and its potential (always a consideration with the male patriciate). The risqué aspect would have done it no harm on the exhibition wall. Poyntz's portrayal is not simply that of young man as libido. His relaxed natural manner expresses a sympathy with his surroundings, qualities stressed by the empathetic pose of his spaniel. Shooting is less an example of conventional rustic behaviour than an excuse to contemplate in the woods a philosophical pleasure advocated by the poet James Thomson, among others.

At the exhibitions of the Society of Artists, Thomas Gainsborough was bent on making his mark. He drew attention to himself in his unique handling of paint, and through the

ways in which sitters were shown. In 1763 Gainsborough followed *Poyntz* with the sensational portrait of James Quin (pl. 32). Garrick said it was 'much and deservedly admired', and had 'merit to warm the most stoical painter'; Ozias Humphry that 'few Pictures have ever been more popular.'[71] It also threw down the gauntlet to Sir Joshua Reynolds, who had already attained legendary 'eminence'.[72] The previous year Reynolds had earned both great applause and the astronomical sum of 300 guineas for his portrait of the theatrical superstar David Garrick, torn between the figures of Comedy and Tragedy, in the manner of a Choice of Hercules (pl. 51). The *St James's Chronicle* proclaimed that the 'Portraits of this Artist have served to prove, that he is equal to a much greater task', and found the *Garrick* 'Admirable! Finely imagined and finely executed', with Comedy in particular 'extremely enchanting'.[73] Reynolds laid out his ambitions by referring both to Italian painting – Comedy is meant to be in the way of Correggio, Tragedy, Guido Reni – and the theories of Lord Shaftesbury, for the latter had been warm in his advocacy of the Choice of Hercules as a fit subject for painters.[74]

Gainsborough eschewed allegory. Quin was firmly of the here and now. His pose blended two from Hogarth: the restless tension of *Captain Coram* (pl. 133), the expository gestures of *Simon, Lord Lovat* (pl. 31). Behind Quin a fairly large bust of Shakespeare alludes to the superiority of a modernity based on native tradition. In the same way, Hogarth has his own self-portrait resting on volumes of Shakespeare, Swift and Milton; and, in 1762, Zoffany portrayed Garrick and his wife beside their Shakespeare Temple, in which Roubiliac's statue of the bard is discernible, at Hampton.[75] *Quin*, a painting 'of uncommon force and vigor . . . truth and animation', was an open challenge to Reynolds.[76] *Garrick between Tragedy and Comedy* measured 58 by 72 inches, Gainsborough's canvas, 92 by 60, dimensions which are hardly irrelevant when the centrality of full-length canvases to strategic exhibiting is taken into account.

Jousting with Reynolds apart, Gainsborough was systematically courting notice in the London exhibition. *General Honeywood* (pl. 54) in 1765 was an essay in equestrian portraiture. In 1766 Garrick was represented with his arm around a bust of Shakespeare (pl. 52), in an attempt at a more elevated art, uneasily alluding to Scheemakers's celebrated statue of Shakespeare in Westminster Abbey (pl. 53), itself popularised as a Derby porcelain figure.[77] And, as we have seen, in 1767 Gainsborough followed these up with portraits of the Duke of Argyll and Lord Vernon. Although demand for portraits prevented Gainsborough from painting many landscapes, these, too, reveal developments in technique, improvising from the examples of Ruisdael, Rubens and others in scenes which recreated the hilly and woody scenery surrounding Bath, shifting his art on to a level at which any connoisseur would have to understand this modern painting in terms of a fine art tradition.

This style was developed further in the *Landscape with Milkmaid and Drover* (pl. 55) which was sold to Gainsborough's old friend Sir William St Quintin, for £43 11s 6d. The painting attracted notice. A reviewer thought there was 'much to be commended, the figures are in a fine taste, the cart-horses and foreground are extremely fine and well painted, but the trees are too blue and hard'.[78] Between then and 1767 Gainsborough's landscape style was transformed (pertinently he was writing to Garrick of his 'latest style' in 1768) and *The Harvest Wagon* of 1767 (pl. 214), which is far lighter in tone and more brilliantly suggestive in touch, appears to constitute a deliberate move from a handling evolved from the study of Ruisdael, to one where the technique has assimilated lessons from Rubens, Watteau, and, to an extent, Claude.[79] This in its turn removed Gainsborough's landscapes from the direct imitation of what was understood as nature at its least elevated to something rather more courtly and refined.

To examine his exhibited works is to follow Gainsborough's shrewd attempt at establishing rather more than a local reputation. He was elected to the Society of Artists in March 1765, and when the Royal Academy was founded in 1768 was initially the only provincial artist invited to join (Hoare was subsequently added to the list, while Wright was not even

51 Sir Joshua Reynolds, *Garrick between Tragedy and Comedy*, 1762, oil on canvas, 1,480 × 1,830 (58¼ × 72). London, Somerset Maugham Theatre Collection.

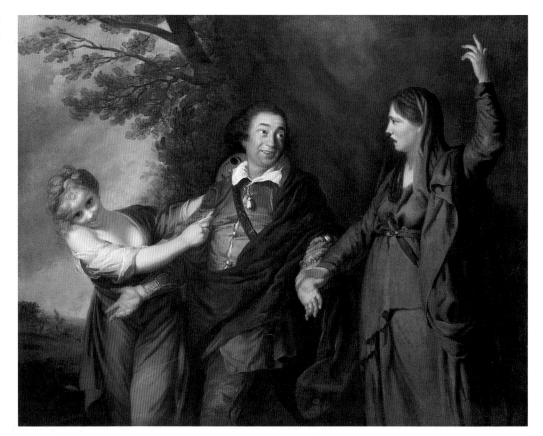

52 (*below left*) Valentine Green after Thomas Gainsborough, *David Garrick*, 1769, mezzotint. Sudbury, Gainsborough's House.

53 (*below right*) H. Scheemakers, *Monument to William Shakespeare*, marble. London, Westminster Abbey.

54 *General Honeywood*, 1764, oil on canvas, 2,857 × 2,934 (112½ × 115½). Sarasota, Florida, John and Mable Ringling Museum.

considered).[80] For this to have happened he must have been tuned in to and keenly aware of metropolitan developments. In part this would have been a consequence of regular visits to London (it was on one such trip in July 1763 that he contracted a near-fatal venereal infection). Indeed, there is evidence that Gainsborough had access to somewhere to paint while in the city. To a Captain Townshend he wrote in 1762 of making 'the alterations' his sitter 'shall think necessary in your picture', although 'the time of my coming to Town remains yet uncertain'. When in 1771 he was meeting major problems with a portrait of Lady Dartmouth, which had signally failed to please, he wrote to the Earl of 'attempting another to please your Lordship when I can be in London for that purpose or Lady Dartmouth comes to Bath'.[81] To go to London made sense: he could check on the display of his works at exhibition and reacquaint himself with old friends. The trip would have done little damage to his business, for the exhibition opened in May, at the end of the Bath season.

Another incentive to keep an eye on things was created by the way that, now the artists were organised enough among themselves to form the Society of Artists and mount an exhibition, their rivalries became more explicit and their activities of more general interest. The pamphlet *A Call to the Connoisseurs*, published by 'T.B.' in 1761, was seemingly written in that Hogarthian idiom of blaming picture dealers, 'Who bear the same Antipathy to a real Artist that a Eunuch does to a Man', for calumnifying modern art. Hence Hogarth 'is the most perfect Master of all the Characters and Passions', Reynolds's powers 'are perfect in the highest degree', Wilson is 'without Question the greatest Landscape

Landscape with a Milkmaid and Drover, 1766, oil on canvas, 1,148 × 939 (45 × 37). Private collection.

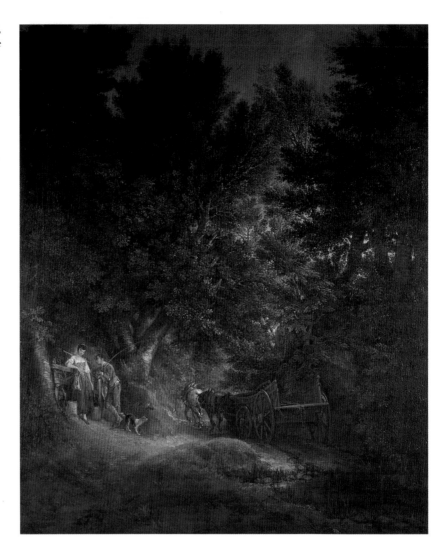

Painter I have ever seen', and Lambert is 'always equal and sometimes superior to GASPAR POUSSIN'. Gainsborough gets no mention.[82] The *St James's Chronicle* reprinted excerpts from *A Call to the Connoisseurs*, with its extravagant praise of Hogarth being answered by the *London Chronicle's* reprinting Reynolds's *Idler* essays 'as a single "Letter on Painting"'. In these Reynolds had disparaged Hogarth, and the reprinting may have been intended to affect reactions to the Society of Artists' exhibition.[83]

In the 1760s there was little of the factionalism and partiality which became so noticeable later, although as early as 1766 the *Public Advertiser* called Reynolds's exhibited pictures 'very bad Designs, very ill finished', thought some of Gainsborough's work 'miserable', and found that Wright had 'the fewest Faults and greatest Beauties', while, in the *Gazetteer*, T.B. was as categorical in minimising Wright's achievements.[84] The eventual establishment of the Royal Academy in 1768 was in itself controversial. It generated some vitriolic press – the letters 'Fresnoy' contributed to the *Middlesex Journal*, in which Reynolds stood accused of 'base apostacy [sic]' and whose 'proceedings . . . from first to last, against the Society of Artists of Great Britain, have been uniformly iniquitous' are notable in this instance – and created a poisonous schism between those who remained in the Society of Artists, and those who were perceived secretly and treacherously to have plotted to form the new Academy. Indeed, these events made up the content of a publication of 1771, *The Conduct of the Royal Academicians, While Members of the Incorporated Society of Artists of Great Britain, viz. From the Year 1760, to their Expulsion in the Year 1769.*[85]

Thomas Gainsborough was indirectly involved in all this, though Fresnoy did not list him amongst the guilty men. His great friend Joshua Kirby was elected President of the Society of Artists in 1768, in the midst of this upheaval. On 25 November Reynolds wrote to Kirby to refuse the offer of a Directorship in the Society, at which time he was corresponding with Gainsborough, soliciting his membership of the soon-to-be established Royal Academy.[86] On 5 December Gainsborough himself wrote to Kirby: 'I thank you for the honour done me in appointing me one of your Directors, but for a particular reason I beg leave to resign, and am gentelmen, your most obliged and obedient and humble Servant.'[87] This must have taken some writing, for he and Kirby were ancient and intimate friends, and from all the evidence of his letters, Gainsborough was extremely loyal. Such behaviour was the measure of the significance he perceived the Royal Academy to have. What he may not have calculated was the unexpected ways in which it would affect his artistic practice.

3 The Royal Academy

THE FOUNDATION OF THE ROYAL ACADEMY had a seismic impact on the British art world. The aims and pretensions of its founders were apparently straightforwardly laid out by the founding President, Sir Joshua Reynolds, in the first of the discourses he would deliver (and publish) from 1769 until 1790. 'GENTLEMEN', he began, 'An Academy, in which the Polite Arts may be regularly cultivated is at last opened among us by Royal Munificence. This must appear an event in the highest degree interesting, not only to the Artists, but to the whole nation.' And, he went on, 'WE are happy in having a PRINCE, who has conceived the design of such an Institution, according to its true dignity; and who promotes the Arts, as the head of a great, a learned, a polite, and a commercial nation; and I can now congratulate you, Gentlemen, on the accomplishment of your long and ardent wishes.'[1] It sounds unexceptionable. Yet, in one view, the establishment of the Royal Academy had been accomplished by the treacherous machinations of such men as William Chambers (exploiting his advantage of previously having been architectural tutor to the King) and Benjamin West. Here however it was presented as a great patriotic project: the establishment of an institution under royal patronage through which the fine arts would develop to a condition appropriate to the status Britain assumed in the world.

Thomas Gainsborough was acutely sensible of the wisdom of being a founder member, and of the significance of the institution itself: hence the appalling snub to his friend Joshua Kirby, and the detached irony of a letter, written on May Day 1772, explaining to the Honourable Edward Stratford why portraits of himself and his wife had failed to materialise at the promised time.

> When you mention *Exhibition Pictures*, you touch upon a string, which once broke, all is at an End with me; but I do assure you, nay I swear by Saint Luke's Pencil, I have not dress'd nor sent a finished half length out of my doors since yours have been in hand so that I beg you to have patience to hear me, and I beg Mrs. Stratford to keep you in good nature for a moment, I do solemnly promise you to finish your Pictures in my best manner before any other from this time. I was obliged to cobble up something for the Exhibition or else (so far from being knighted) I should have been expel'd the Society, and have been look'd upon as a deserter, unworthy my *Diploma* sign'd with the King's own hand, which I believe you have seen most beautifully framed & hung up in my Painting-Room, *behind the Door*.[2]

As we shall see, Reynolds's knighthood irked Gainsborough (as well as others, Fresnoy accusing him of using nefarious means to get 'up to the heaven of knighthood').[3] It is worth noting that while Gainsborough's diploma hangs where it cannot be seen, it is, none the less, 'most beautifully framed'. To belong to the Academy was from the start a necessary evil, with its rooms forming the most significant exhibition space in Britain. Gainsborough put Stratford off because he had commissioned mere half-lengths, not the full lengths which, since Stratford was at the time prepared to lay out the astronomical sum of £40,000 on a housing development in the City of London, he could have well afforded to do.[4] Some years later (in March 1784) Gainsborough apologised similarly to the Earl of Essex about the delay in completing a portrait of the Earl presenting a cup to a Thomas Clutterbuck:

> Mr. Gainsborough presents his humble service to Lord Essex; and acquaints his Lordship that the Exhibition opening very early this year, and the season having been so bad

for finishing his Pictures, he finds it will be impossible to begin the picture for Mr. Clutterbuck, without danger of spoiling it, before May; when if Lord Essex should be in Town, he will not undertake any work before he begins it, and will wait upon his Lordship or send to appoint a sitting.[5]

Success at the exhibitions of the Society of Artists had always been important. Now, with the Academy assuming to itself an exalted public status, the pressure increased, particularly for an artist who, like Gainsborough, was not prominent in the metropolitan eye.

His awareness of the presence of Sir Joshua Reynolds as a professional rival became focussed in the years around 1770. For some time it had been clear that Reynolds was, designedly, establishing himself as a phenomenon in contemporary British art, intent on making his name with an innovative species of 'historical' portrait (with precedents none the less in seventeenth-century art) in which the sitter was either aggrandised through reference to some extremely respectable artistic prototype, or complimented by being represented in an abstracted and idealised fashion.[6] Desmond Shawe-Taylor quotes Reynolds's fifth *Discourse*, delivered in December 1772: 'When a portrait is painted in the Historical Style, as it is neither an exact minute representation of an individual, nor so completely ideal, every circumstance ought to correspond to this mixture. The simplicity of the antique air and attitude, however much to be admired, is ridiculous when joined to a figure in a modern dress.'[7] Shawe-Taylor notes the full-length of *Elizabeth Gunning, Duchess of Hamilton and Argyll* (1759) (pl. 57) as the first of Reynolds's portraits 'to meet these requirements'. He goes on to remark on the enticing imagery of this conception, and the extent to which it would become so modish as signally to affect what other artists painted. Gainsborough, ever the modernist, was, with canvases such as *Mary, Countess Howe* (pl. 287) (*c.*1763–64) or *Lady Alston* (pl. 48) (mid-1760s), almost alone in resisting the fashion.[8] And even he had to make concessions. *Lady Ligonier* (pl. 171) may not be so classically draped as some of Reynolds's women; she is, none the less, clad in an 'imagined costume'.[9] To complicate the issue further, Reynolds was prepared to paint contemporary women – an excellent example would be *Susanna Gale* (pl. 58) – with all the brilliance his drapery painter could supply to modern modes.

To use specialists to do the subordinate parts was both to pay them their due respect and implicitly to put the technical virtuosity of Gainsborough, who, following Hogarth, painted his drapery himself, into its proper place. From reading over the earlier *Discourses* we see that from the beginning Reynolds understood one of the responsibilities of his position as the promotion of what he understood to be a proper and civic mode of art. Besides holding showpiece annual exhibitions, the Royal Academy had superseded the St Martin's Lane Academy as the most important art school in the country. Professional artists taught students drawing from casts and living models. Lectures were given not only on subjects directly pertinent to the fine arts, but on others such as history. This followed to an extent the regime which prevailed in the French Academy, and from that institution too Reynolds took over the practice of *Conférences*, lectures on the fine arts to be given by the principal painters. He regularised the system, usually delivering his own lecture on the occasion of the annual prize-giving, each December: annually until 1772, biennially thereafter.

From the first, Reynolds exhorted the student to 'apply his strength to that part of the art where the real difficulties lie; to that part which distinguishes it as a liberal art'; and to the centrality of the liberal arts to 'a great, a learned, a polite, and a commercial nation' he would, from time to time, return.[10] In part he was rehearsing a controversy which had been carrying on since the Renaissance, combatting the notion that the fine arts were inferior because of their calling into play manual or mechanical skills, rather than demanding, in the way of literature, a capacity for abstracting thought. But Reynolds may also have been promoting a more mundane position. In Britain, artists, with the exception of Benjamin West and Reynolds himself, were not particularly highly valued, if the prices their works could

57 (*above left*) Sir Joshua Reynolds, *Elizabeth Gunning, Duchess of Hamilton and Argyll*, 1759, oil on canvas, 2,385 × 1,475 (93¹/₄ × 58). Port Sunlight, Lady Lever Art Gallery.

58 (*above right*) Sir Joshua Reynolds, *Miss Susanna Gale*, 1763–64, oil on canvas, 2,100 × 1,188 (83 × 46³/₄). Melbourne, National Gallery of Victoria, Felton Bequest.

fetch are taken as a guide. The cost of the jewels and fabrics represented in a full-length portrait could exceed what some painters might expect to make from it − a 'single dress might cost £50 in materials alone'.[11] Therefore it was essential to establish a significant British school of painting. There was, Reynolds maintained,

> a greater number of excellent Artists than were ever known before at one period in this nation; there is a general desire in our Nobility to be distinguished as lovers and judges of the Arts; there is a greater superfluity of wealth among the people to reward the professors; and, above all, we are patronised by a Monarch, who, knowing the value of science and elegance, thinks every Art worthy his notice, that tends to soften and humanize the mind.

And, he went on, 'One advantage, I will venture to affirm, we shall have our Academy, which no other nation can boast. We shall have nothing to unlearn.'[12]

Academic organisation had become an imperative, because there was now 'a greater number of excellent Artists' than ever before in Britain. However, these had their own styles and varieties of subject matter, thus making it hard to conceive of a British school. By the late 1760s, for example, Benjamin West was painting histories in his own version of an *avant-garde* European style; Joseph Wright was astounding spectators with works such as *An Experiment upon a Bird in an Air Pump* (pl. 242); Richard Wilson had shown the scope for adapting Italianate landscape to native scenery; George Stubbs's horse pictures, genre and animal subjects were unprecedented; and Gainsborough was creating portraits of great elegance and unexampled technique, alongside domestic landscapes which, complementing Wilson's, adapted seventeenth-century northern European models to native scenery. Then, as we have been seeing, there were the innovations and inventions of Reynolds himself. The variety and quality of contemporary art matches the boasts T.B. had made in 1761. Two years later, an anonymous writer would commend the Society of Artists for rescuing 'the rising generation of Artists' from 'obscurity' and giving them 'the happiest opportunity of exhibiting their favourite talents to the best advantage', introducing them to patrons and getting them reputations founded not 'on the partial voice of private friendship, but on the merit of public approbation'.[13]

Yet that striking individuality amongst the artists, developing from their having to define and cater for particular markets, could also denote a society lacking form and cohesion, one lacking a collective identity such as would allow the formation of a national school. A writer of the time noted how

> In England the several ranks of men slide into each other almost imperceptibly, and a spirit of equality runs through every part of their constitution. Hence arises a strong emulation in all the several stations and conditions to vie with each other; and the perpetual restless ambition in each of the inferior ranks to raise themselves to the level of those immediately above them. In such a state as this fashion must have uncontrolled sway. And a fashionable luxury must spread like a contagion.[14]

Against this had to be set the very obvious fact that, while British society might have been displaying an unprecedented fluidity, it was nevertheless clearly hierarchical. At the top was the monarch, and from him through the Lords temporal and spiritual one descended through the ranks to, eventually, the poor. Until the advent of the Pitt administration, the peerage adapted and to a small degree expanded to accommodate those with wealth enough to require the trappings of power, but the main development, as described in the quotation above, was in 'middle-class' occupations.

If, despite appearances to the contrary, society was cohesive, then an argument for an aesthetic that cut through the temporary or the fashionable to what was essential to all art had great attractions, particularly in a Royal Academy of Art with the national role which Reynolds claimed was its obligation.[15] In the earlier *Discourses* he appeared to be making something like this case, as he attempted to communicate the necessity for such an art to the rising generation. From the start he aimed to set the contemporary within an art historical context. Students must learn from the example of earlier painting, but this must be of 'established reputation'. Such painting would generally be Italian – and he pointed to various works by Lodovico Carracci in the Palazzo Zampieri as ideal models, as though his auditors knew as much about Italian paintings as he did, or had ready access to Bologna, although if they had known them at all it would have been through monochrome prints.[16]

In the third *Discourse*, delivered in December 1770, Reynolds began to flesh out his ideas. He differentiated various kinds of art, putting that which seeks only to imitate particular nature against that which communicates the appearance of 'an ideal beauty, superior to what is to be found in individual nature'.[17] By intelligent contemplation, the artist will eventu-

ally become 'possessed of the idea of that central form . . . from which every deviation is deformity', a process that can be accelerated by studying antique sculpture. That form will itself have to vary (thus to avoid monotony) because of the different and various characters of the figures that the artist will come to represent.[18] Once this is done, the artist must 'become acquainted with the genuine habits of nature, as distinguished from those of fashion . . . endeavour to separate simple, chaste nature, from those adventitious, those affected and forced airs or actions, with which she is loaded by modern education'.[19] Eventually he warns against presuming that the only end of art is the creation of an illusion: 'it is not the eye, it is the mind, which the painter of genius desires to address'.[20] Thus Reynolds lays down the criteria for, an art which will retain a universal impact because unsullied by particular concerns to fulfill what he may have seen as his brief by virtue of his public position.

Reynolds was developing ideas already laid out in the final two *Idlers*, which, as we have seen, were reprinted in the *London Chronicle* in 1761. As I have proposed, it may be no coincidence that these had first appeared within months of the first exhibition of the Society of Artists, and reappeared in time for the second one. This tactical timing went well beyond self-promotion. Reynolds was maintaining that a generalising, Italianate art, was superior to the particular naturalism associated with William Hogarth. Targetting Hogarth and his theories, at a time when the latter's star was on the wane, signals that, to an extent, professional self-interest also underpinned Reynolds's pronouncements (Hogarth, who had not shown at the first exhibition, sent work, including the sensational *The Lady's Last Stake* (pl. 162), to the second).[21] Ann Bermingham has properly warned that, if we 'take Reynolds at his word . . . we do so at our peril', and some might have wondered if, when he warned artists off the idea that the end of art was to deceive the eye, he meant specifically to contradict Roger de Piles's assertion that the '*end*' of painting 'is, *to deceive the eye*'.[22] Reynolds could find every justification for advocating an art which would stand the test of time, but because he was arguing through counter-examples his stance can seem less than disinterested.

Towards the end of the *Discourse*, attention is turned to 'the various departments of painting', duly listing representative genres and their practitioners – 'the Battle-pieces of Bourgogne, the French Gallantries of Watteau . . . the Landscapes of Claude Lorraine, and the Sea-Views of Vandevelde'. Reynolds maintained that these artists 'have in general, the same right, in different degrees, to the name of a painter, which a satirist, an epigrammatist, a sonneteer, a writer of pastorals, or descriptive poetry, has to that of a poet'. He allowed merit to these various departments, even 'though none enter into competition with this universal presiding idea of the art'. And, he went on,

> The painters who have applied themselves more particularly to low and vulgar characters, and who express with precision the various shades of passion, as they are exhibited in vulgar minds (such as we see in the works of Hogarth) deserve great praise; but as their genius has been confined on low and vulgar subjects, the praise which we give must be as limited as its object.[23]

It is revealing to unravel the various threads of this argument.

Only the grand style, according to Reynolds, could divest itself of the trivia of contemporaneity and therefore hope to communicate unambiguously across generations and nations. Reynolds himself recognised that this evaded the awkward fact that pictorial content was unavoidably historically specific. So, at the beginning of the fourth *Discourse*, delivered in December 1771, he addressed this problem:

> the subject is generally supplied by the Poet or Historian. With respect to the choice, no subject can be proper that is not generally interesting. It ought to be either some eminent instance of heroick action, or heroick suffering. There must be something either in the action, or in the object, in which men are universally concerned, and which powerfully strikes upon the publick sympathy.[24]

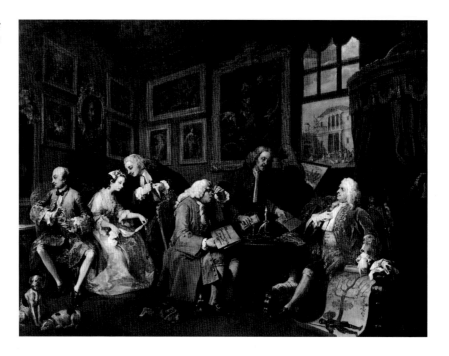

He assumed an exclusive position. By 'publick' Reynolds would have understood a civic body of disinterested gentlemen, in practice the patriciate, and thus he firmly associated the highest sort of art with the highest sort of person, although he allowed access, too, to those, who by their own efforts, had acquired the culture and capacity to comprehend it.[25] These, after all, could be expected to be familiar with poetry and history. Beneath the great style he ranked those various other departments in an hierarchical system matching that which organised society. No genre was without merit; but that merit had to be qualified according to its ranking and limitations, an unexceptionable thesis in view of academic convention. None the less, the social aspect demands notice. Hogarth paints 'low and vulgar characters', so the praise his art can be given must be 'as limited as its object'. Implicit here was the fact that Hogarth had himself been a 'low and vulgar' character, and it was as such that he was represented by those with whom he came into conflict both in the 1750s and 1760s.[26] Reynolds's language was loaded, then, and, arguably, misleading. Hogarth painted history pictures, and much else besides 'low and vulgar characters': aristocrats in *Marriage à la Mode* (pl. 59); members of the more opulent classes in *The Lady's Last Stake* (pl. 162).

Gainsborough made his affiliation to the Hogarthian clear in the momentous *James Quin* (pl. 32), and Reynolds's pronouncements must have had the potential to make a rival portraitist uncomfortable.[27] For a start, he was not promoting the kind of painting at which Gainsborough excelled. In the fourth *Discourse*, Sir Joshua appears to have been putting certain kinds of contemporary art very firmly in their place. Take a paragraph such as this:

> The great end of the art is to strike the imagination. The Painter is therefore to make no ostentation of the means by which this is done; the spectator is only to feel the result in his bosom. An inferior artist is unwilling that any part of his industry should be lost upon the spectator. He takes as much pains to discover, as the greater artist does to conceal, the marks of his subordinate assiduity. In works of the lower kind, everything appears studied, and encumbered; it is all boastful art, and open affectation.[28]

In 1758 Gainsborough had written to William Mayhew about the importance of the 'roughness of the surface . . . the touch of the pencil'. In the Royal Academy exhibition of 1771 his exhibits had included full-length portraits of Lord and Lady Ligonier (pls 170, 171). Each is colouristically rich and varied. With *Lady Ligonier* in particular, paint is handled with

supreme, abstracted virtuosity, so that what Reynolds would call 'odd scratches and marks' optically form themselves into vibrating illusions of flesh, drapery and foliage (pl. 56).[29] This display of technique – or something like it – is belittled by Reynolds as 'subordinate assiduity . . . boastful art, and open affectation'. Reynolds may not have been directing his aim at Gainsborough, but the latter could be forgiven for being made to feel uneasy by his counselling painters to avoid 'all trifling or artful play of little lights', and not to 'debase his conceptions with minute attention to the discriminations of Drapery, It is the inferior stile that marks the variety of stuffs.'[30]

Towards the end of this *Discourse*, Reynolds said:

> It may be asserted that the great style is always more or less contaminated by any meaner mixture. But it happens in a few instances that the lower may be improved by borrowing from the grand. Thus if a portrait painter is desirous to raise and improve his subject, he has no other means than by approaching it to a general idea. He leaves out all the minute breaks and peculiarities in the face, and changes the dress from a temporary fashion to one more permanent, which has annexed to it no ideas of meanness from its being familiar to us. But if an exact resemblance of an individual be considered as the sole object to be aimed at, the portrait painter will be apt to lose more than he gains by the acquired dignity taken from general nature. It is very difficult to ennoble the character of a countenance but at the expense of the likeness, which is what is most generally required by such as sit to the painter.[31]

This is tantamount to declaring that the first object of the portrait painter is not to take a recognisable likeness but to present a surrogate image of the sitter; and Reynolds may be following another of Piles's precepts: that the central concern of portraiture is effective characterisation (although how this is to be divorced from likeness is a problem not addressed).

This position may be exemplified by the viewing habits of Thomas Pennant, who was, arguably, typical of his time. Recording a visit to Coombe Abbey in 1780, these remarks on a portrait of James Stuart, Duke of Richmond, were characteristic:

> In black, with long flowing flaxen hair, and a dog by him. This illustrious nobleman forms one of the most aimiable characters in the reign of *Charles I*. His attachment and his affection to his royal relation was unequalled: he is even said to have offered his own life to save that of his beloved master.[32]

The image has served principally to stimulate a train of previously assimilated associations. If this view is taken to its logical conclusion, any portrait of a Stuart aristocrat might serve, because nobody could now know what the Duke of Richmond had looked like anyway. All that matters is that the sitter in his portrait can be identified. On the other hand, when Sir Oliver Surface is appalled that his nephew, Charles is prepared to 'sell' his 'forefathers' in *The School for Scandal*, his thus referring to the family portraits indicates the power that could reside in them as surrogates for deceased ancestors.[33]

60 William Dickinson after Henry Bunbury, *A Family Piece*, 1781, stipple, printed in sepia. London, British Museum.

The Duke of Richmond was an aristocrat with an historically defined identity. By the late eighteenth century, British portraitists were serving a more socially amorphous clientele – Henry Bunbury's celebrated caricature *A Family Piece* (pl. 60) is evidence enough of that – and people sat to different artists, so that portraits could be compared. Both Reynolds and Gainsborough painted Caroline Russell (pls 62, 63), who became the fourth Duchess of Marlborough.

Reynolds produced a generalising three-quarter length, painted in such a way as to reduce any sensual appreciation of handling or paint textures. True to his theory, the surface is virtually matt, so as to divorce the idea embodied in the image from the materiality of its realisation. The paint does enough to signify a person who would hardly appear to be the same woman shown in Gainsborough's portrait. Working in the same idiom as Allan Ramsay's *Mrs Bruce of Arnot* (pl. 67), Gainsborough paints Caroline Russell in part profile but turning

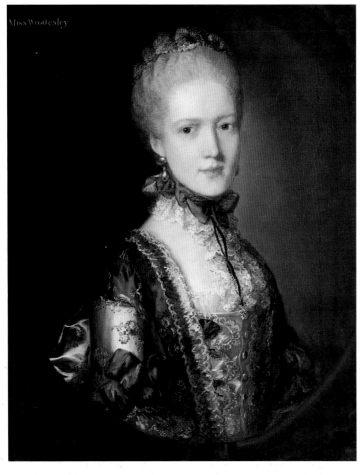

Miss Wrottesley

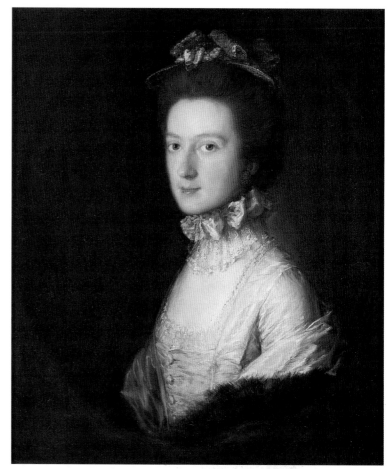

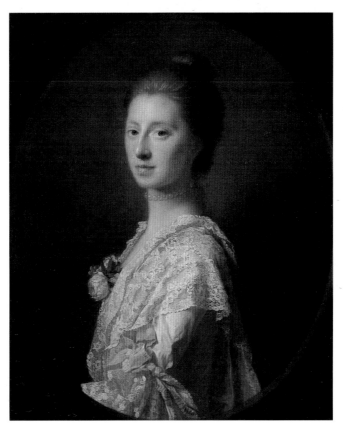

61 (*facing page top left*) *Mary Wrottesley*, 1764–65, oil on canvas, 762 × 635 (30 × 25). By kind permission of the Marquess of Tavistock and the Trustees of the Bedford Estate.

62 (*facing page top right*) *Caroline Russell*, late 1760s, oil on canvas, 762 × 635 (30 × 25). By kind permission of the Marquess of Tavistock and the Trustees of the Bedford Estate.

63 (*facing page bottom left*) Sir Joshua Reynolds, *Caroline Russell*, 1759–61, oil on canvas, 1,270 × 1,010 (50 × 39$^3/_4$). By kind permission of the Marquess of Tavistock and the Trustees of the Bedford Estate.

64 (*facing page bottom right*) *Caroline Russell*, late 1760s, pastel on grey paper, 319 × 243 (12$^9/_{16}$ × 9$^9/_{16}$). Private collection, U.S.A.

65 (*above left*) *Elizabeth Wrottesley*, 1764–65, oil on canvas, 762 × 635 (30 × 25). By kind permission of the Marquess of Tavistock and the Trustees of the Bedford Estate.

66 (*above right*) *Elizabeth Wrottesley*, c.1764–65, oil on canvas mounted on panel, 761 × 635 (30 × 25). Melbourne, National Gallery of Victoria, Felton Bequest.

67 (*left*) Allan Ramsay, *Mrs Bruce of Arnot*, c.1766–68, oil on canvas, 748 × 620 (29$^1/_2$ × 24$^1/_2$). Edinburgh, National Gallery of Scotland.

her head towards the spectator. Highlighting directs attention to her face and upper chest, more particularly as the surroundings are dark and undifferentiated. Paint is handled fluidly, ambiguously. The delicacy of touch allows canvas ground partly to create shadow deepening towards the left ear; and throughout there is no fixing linearity. The curves and planes of the face are intimated through tone, subtly directional brushstrokes creating a controlled unfixedness, enticing us to look attentively, as we might if conversing with an actual person. The gaze, enhanced by catchlights in the eyes, engages with that of the spectator, the mouth appears as though it were on the verge of speaking or smiling. Attention is directed to the representation of the person, too, by eschewing any adventitious matter; even apparel is played down. By comparison with his drawing of the same sitter (pl. 64), or by an analogy with two contemporary portraits of Elizabeth Wrottesley, in which both are recognisably the same person (pls 65, 66), one can imagine that this must be a good likeness.

Reynolds's version of Russell looks to be someone else. Indeed he is doing exactly what he advocates, raising and improving his subject by 'approaching it to a general idea', that 'general idea', perhaps, being to do with the dignity and status appropriate to a member of one of Britain's most powerful aristocratic families. One could go even further and infer that Gainsborough, in his particularity, reduces Caroline Russell to a common humanity that negates her status, although (as we shall see) in picturing her as an individual of refined sensibility, the portrait contains its own rebuttal. The crux of the issue is the extent to which likeness is central to successful portraiture. Reynolds would argue that it can be discounted because it is only of particular temporal significance. What mattered was that nobody should fail to *recognise* his sitters, and for this it was necessary that they assume a character. This, in its turn, conformable with Reynolds's thinking, raised them into a public role and away from the particularity of private life. One might, however, argue that even if accuracy of likeness might be immaterial for future generations, this did not invalidate its importance for those familiar with the appearance of the sitter.

Reynolds was known to have difficulty in getting a likeness. With regard to Caroline Russell, as Richard Wendorf records, Reynolds's great *Marlborough Family* (pl. 90), exhibited in 1778, in which she features as the Duchess, was not universally approved. When 'the Duchess of Bedford complained to him that his portrait of her daughter . . . was not a good likeness, he simply bowed, thanked her for her approbation, and pretended not to be able to hear her distinctly even though she continued to repeat her disapproval of the painting'.[34] In a letter of 1762, expressing his approval of Allan Ramsay, the Marquis of Kildare wrote that 'when I went there he had not a picture of anyone I ever saw but I knew, as for Mr Reynolds, I call'd there a few days before, and did not know anybody'.[35]

Therefore, Reynolds's claims, made from a platform which imbued them with real authority, would have exasperated his rivals, who might suspect self-interest. For Gainsborough this was particularly the case, because his main selling point was precisely the extraordinary likenesses of his portraits to their originals. Ozias Humphry expanded upon this in his *Memoirs*, writing how in Bath,

his general practice was in Portraiture, in which he had peculiar Excellence, and frequently produced Pictures of surprizing Resemblance and Perfection. Likeness alone was all he avowed to aim at; from this circumstance it must often have happened, that, altho' his pictures were exactly like, and to the parties for whom they were painted and their Families highly satisfactory at the time, whilst the prevailing modes were daily seen, and the Friends approved and beloved in them; yet the satisfaction arising from their fixed resemblance was lessening daily, as the fleeting Fashions varied and were changing from time to time.[36]

When Gainsborough felt that he had failed to hit a good likeness, he would offer, it appears, either to rework the portrait without reimbursement, as with the George Lucy portrait of 1761, or to paint a new one on the same terms, as in spring 1771, when, as we have seen,

he engaged in a frank correspondence with the Earl of Dartmouth over his perceived failure to catch a likeness of Lady Dartmouth. It is here that we can make a connection with Humphry's *Memoirs*.[37]

Upon leaving Bath, Humphry had gone to London, where he had received much kindness from Joshua Reynolds, who had allowed him to copy from his collection of old masters, as well as from his own paintings, and who had evidently been speaking to him, too, of more theoretical matters to do with the fine arts. In the fourth *Discourse* Reynolds warned against modern dress, advocating a fashion 'more permanent, which has annexed to it no ideas of meanness from its being familiar to us'. Five years later, he continued the theme:

> He . . . who in his practice of portrait painting wishes to dignify his subject, which we will suppose to be a lady, will not paint her in the modern dress, the familiarity of which alone is sufficient to destroy all dignity. He takes care that his work shall correspond to those ideas and that imagination which he knows will regulate the judgement of others; and therefore dresses his figure something with the general air of the antique for the sake of dignity, and preserves something of the modern for the sake of likeness.[38]

That is, the artist resorts to a compromise not unlike that adopted by Gainsborough with *Lady Ligonier*. But we can also suspect that Ozias Humphry had been a receptive listener to Reynolds in the 1760s; for, while obviously admiring Thomas Gainsborough, he argues that the likeness of his portraits became increasingly less striking as their costume fell out of fashion. This opinion was rational, as it can be irritatingly difficult to 'know' someone dressed out of their customary way, but it was not universally held. Jean André Rouquet (whose opinions are closely associated with Hogarth's) argued that 'every attribute, which under pretence of completing the picture, diverts our ideas, and makes us mistake the likeness, is an error, a weakness, a hasty mistrust of our capacity of allowing sufficiently the principal intention of the work, namely resemblance', and, he went on, in a passage which anticipates with no little foresight the portrait practice of Reynolds, 'would it be easy to you to know the picture of your wife, or of any other woman that is dear to you, in the pagan image of a mad Woman, just escaped from Olympus?'[39] In December 1770, Gainsborough's friend Nathaniel Dance attacked the presumption that, somehow, the type of antique garb Reynolds promoted was 'timeless', in a couple of satirical prints (pl. 68). These purported to record newly discovered reliefs from Hadrian's Villa and Pompeii, which startlingly revealed that the Ancients had sported English fashions of the 1770s.

68 Nathaniel Dance, *Prints purporting to show the fashions of the ancients*, 1770. Sudbury, Gainsborough's House.

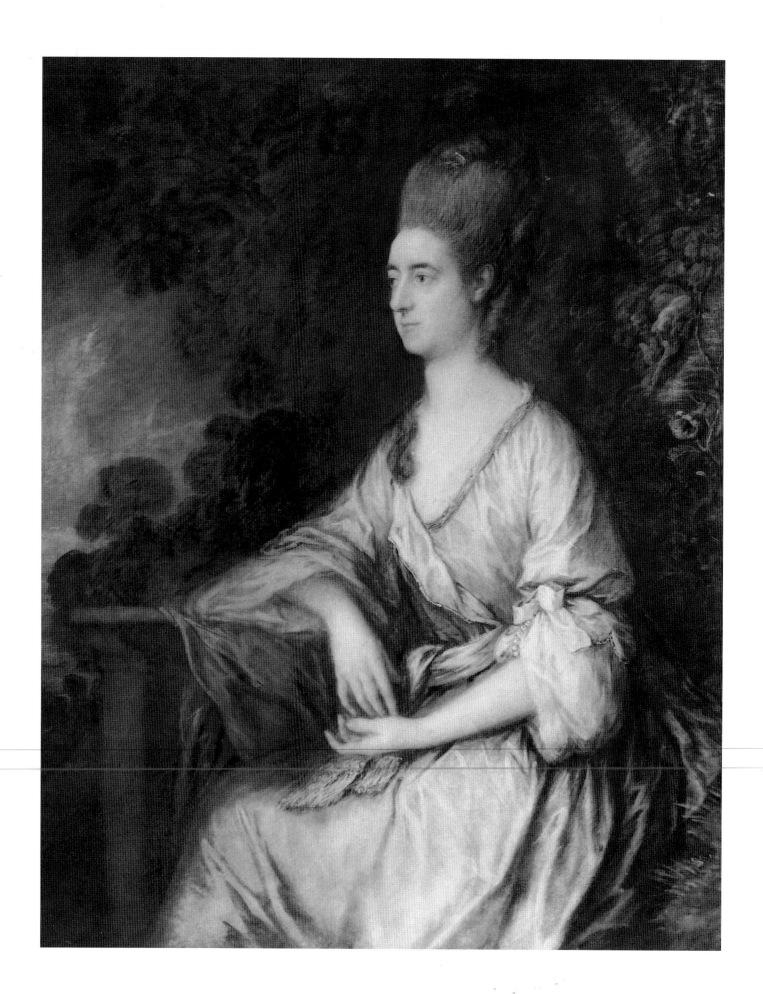

70 *Lady Dartmouth*, *c.*1771, oil on canvas, 762 × 635 (30 × 25). The Earl of Dartmouth, on loan to Gainsborough's House, Sudbury.

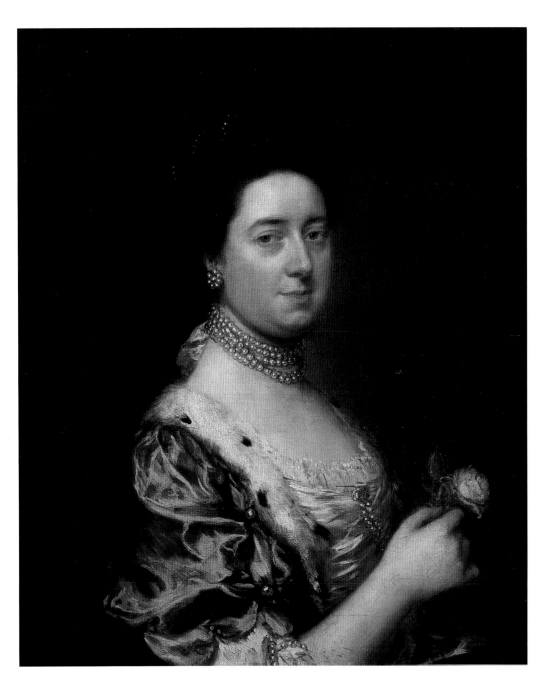

Gainsborough was in this camp. The Dartmouth letters focussed around an unsuccessful portrait in which Lady Dartmouth had directed that she should be represented in the kind of generalised clothing Reynolds promoted (pl. 70).[40] On 8 April 1771 the artist was 'extremely willing to make any alterations your Lordship shall require when her Ladyship comes to Bath for that purpose, as I cannot (without taking away the likeness) touch it unless from the Life'. And, he went on,

> I should fancy myself a great blockhead if I was capable of painting such a Likeness as I did of your Lordship, and not have sense to see why I did not give the same satisfaction in Lady Dartmouths Picture . . . I don't know if your Lordship remembers a few *impertinent* remarks of mine upon the ridiculous use of fancied Dresses in Portraits . . . but . . . I will venture to say that had I painted Lady Dartmouths Picture dressed as her Ladyship goes, no fault (other than in my Painting in general) would have been found with it.

69 (*facing page*) *Lady Dartmouth*, 1769, oil on canvas, 1,244 × 187 (49 × 38). Earl of Dartmouth.

Here, then, the likeness was much assisted by Lady Dartmouth's wearing familiar clothes. This contradicted Humphry and Reynolds, and raised the insoluble question of the nature of the facially recognisable. To recall Gainsborough's portraits of Caroline Russell or Elizabeth Wrottesley was to infer that, to a large degree, it was in the accurate illusion of a copy. The example of caricature pointed to key features – Wilkes's squint, Charles James Fox's five o'clock shadow – being enough to confirm particular identity. On the other hand, there was evidence enough, particularly in contemporary novels, in which a common trope had people failing to recognise relatives or old friends, that the identification of individual faces was no straightforward process.

As the Reverend John Penrose's remarks on Bath society indicate, this was an era in which looking and being looked at was central to social ritual.[41] What one saw, nevertheless, if this 1771 quotation from Sylas Neville's *Diary* is characteristic, tended to resolve itself in general terms:

> Much struck with the beauty of a young lady of Norwich, one of my fellow-Travellers, a complexion a pretty brown enlivened with red, skin bluish, her eyes a most beautiful dark blue & have a most engaging sweetness, her fine arched eye-brows & long lashes a fine dark brown, her hair of the same colour, mouth of a proper size & lips vermillion . . . her face, if it has any defect, is rather too broad . . .[42]

One could not imagine any very particular set of features from this. Reynolds might have had general habits in mind when he made his pronouncements upon likeness, the argument that a portrait could only have lasting value if purged of particularity emerging naturally from this perception. It must, though, have been different under conditions of private intimacy, and it is under these circumstances that Gainsborough's dealings with some clients have to be imagined. For instance, he did carry out his offer 'even to paint an entirely new picture' of Lady Dartmouth, onto a smaller canvas; she sports a contemporary interpretation of Van Dyck dress, and holds a rose (pl. 70). In comparison with the failed portrait, there does appear to be a greater particularity of feature here, in the chins, or the hair not being piled so high as almost to supersede the contemporary fashion, and the face is less of a generalised mask. Indeed, in his next communication, on 13 April, the artist wrote that, if he were to experiment with 'the amazing Effect of dress' in the original picture, he would 'be vastly out in my notion of the thing if the Face does not immediately look like,' before showing that he was acutely conscious of the effect that Reynolds's academical pronouncements were having upon taste, in promoting a fashion for generalised garb in portraiture: 'My Lord I am very well aware of the Objection to modern dresses in Pictures, that they are soon out of fashion & look awkward; but as that misfortune cannot be helped we must set against it the unluckiness of fancied dresses taking away Likenesses, the principal intention and beauty of a Portrait.'

Dartmouth's reply must have been moderately intransigent, for it provoked Gainsborough into exasperation:

> Here it is then nothing can be more absurd than the foolish custom of painters dressing people like Scaramouches, and expecting the likeness to appear. Had a picture voice, action, etc. to make itself known as Actors have upon the Stage, no disguise would be sufficient to conceal a person; but only a face confined to one view and not a muscle to move to say, 'Here I am' falls very hard upon the poor Painter who perhaps is not within a mile of the truth in painting the Face only.

These comments point to the great artificiality of the painted portrait, the fact of its manifesting, perhaps, the least informative aspect of the individual. A contemporary analogy might be the contrast in the ability of photography and film to communicate a complete idea of a person's appearance. 'Thus', writes Reynolds, 'if a portrait-painter is desirous to raise and improve his subject, he has no other means than by approaching it to a general

idea.' This expresses the division between him and Gainsborough. The latter tried hard to explain his case to the Earl of Dartmouth by means of a musical illustration.

> A Tune may be so confused by a false Bass – that if it is ever so plain, simple and full of meaning, it shall become a jumble of nonsense, and just so shall a handsome face be overset by a fictitious bundle of trumpery of the foolish Painter's own inventing. For my part (however your Lordship may suspect my Genius for Lying) I have that regard for truth, that I hold the finest invention as a mere slave in Comparison, and believe I shall remain an ignorant fellow to the end of my days, because I never could have patience to read Poetical impossibilities, the very food of a Painter; especially if he intends to be KNIGHTED in this land of Roast Beef, so well do serious people love froth. But, where am I, my Lord? This is my free Opinion in another Line with a witness – forgive me my Lord, but I'm a wild goose at best – all I mean is this, Lady Dartmouth's Picture will look more like and not so large when dressed properly; and if it does not, I'll begin another.

Reynolds, then, was capable of causing considerable irritation. Gainsborough, and to an extent, Joseph Wright, were unusual in remaining aloof from the fashion for broad, matt surfaces, and generalising draperies – for women at any rate – that Reynolds established in portraiture. As we have noted, others, George Romney, Francis Cotes (until his death in 1770), Zoffany, and later on Beechey and Hoppner all painted more or less within those parameters. This was in large part because Reynolds's example and utterances were given great weight by virtue of his position and reputation. Gainsborough acknowledged and damned this with his reference to knighthood, roast beef and froth.

The sarcasm exposes a conscious rivalry with Sir Joshua Reynolds. While this rivalry was complex, from around 1770 or so its existence was generally acknowledged. James Northcote entered Reynolds's studio as a pupil and resident assistant in 1771, remaining there for four years. He recalled that 'Sir Joshua Reynolds had a high opinion of Gainsborough, and very justly, but he and Gainsborough could not stable their horses together, for there was jealousy between them', and that 'Sir Joshua, I know, looked upon Gainsborough with high jealousy, but with profound respect.'[43] Reynolds was also of the view 'That it was impossible for two painters in the same department of the art to continue long in friendship with each other'.[44] An awkward relationship between the pair was intimated in the *Middlesex Journal*'s review of the 1772 Royal Academy exhibition:

> No one need be informed of Mr. Gainsborough's excellence in portrait painting; and it may safely be affirmed, that his performances of this year will lose him none of the fame which he has so justly acquired by his former productions. He seems, however, to have one fault although a fault on the side of excess, his colours are too glaring. It would be well for him if he would borrow a little of the modest colouring of Sir Joshua Reynolds.[45]

The language implies a moral censure: the colouring is 'glaring', not modest, like Reynolds's. W. T. Whitley quotes another writer who was exercised by Gainsborough's having made everything too purple,[46] and pointed out how Gainsborough himself was preoccupied with the same problem, although whether or not in response to press criticism is hard to say.[47] That year Gainsborough wrote to Garrick:

> When the streets are paved with Brilliants, and the Skies made of Rainbows I suppose you'll be contented, and satisfied with Red blue & yellow – It appears to me that Fashion, let it consist of false or true taste will have its run, like a runaway Horse; for when Eyes & Ears are thoroughly debauch'd by Glare & Noise, the returning to modest truth will seem very gloomy for a time . . . maintain all your light, but spare the pure abused Colors, til the Eye rests and recovers – keep up your Music by supplying the place of *Noise* by more Sound, more Harmony & more Tune . . .

Yet Gainsborough's own paintings had become so gaudy as to be offensive to some. And if we return to the final paragraph of the letter the sense of self-contradiction remains: 'A Word to the Wise; if you let your Portrait hang up so high, only to consult your Room, and to insinuate something over the other Door, it can never look without a hardness of Countenance and The Painting flat, it was calculated for breast high and will never have its Effect or likeness otherwise.'[48] In 1757 William Mayhew had been told to 'place your picture as far from the light as possible; observing to let the light from the left', and, in 1758 had been delivered a 'dissertation upon pencil and touch'.[49] Garrick is warned that, to appear at its best, his portrait has to hang at a certain height. This would be consistent with the exceedingly refined and subtle handling that was Gainsborough's trademark.

We can begin to offer an explanation for his advocating subtlety and at the some time exhibiting gaudiness when we contemplate eighteenth-century exhibiting conditions (pls 71, 72). At that time, when placement and lighting were in the hands of a hanging committee, the effects of fine handiwork stood every chance of being rendered invisible. As Gainsborough wrote of the Society of Artists' exhibition to Garrick, in 1766, 'I don't look upon it as it is conducted at present to be calculated so much to bring out good painters as bad ones. There is certainly a false taste and an impudent style prevailing which if Vandyke was living would put him out of countenance; and I think even his work would appear so opposed to such a glare.'[50] To counter this, one tactic would be to paint up temporarily, to exhibit portraits which would show up colouristically on the exhibition walls. It would get them noticed, and Gainsborough may have been temporarily willing to travesty his own art to highlight the way that the Royal Academy exhibition, in which the solid and linear art of Reynolds would more than hold its own, was an artificial and capricious environment that favoured some artists at the expense of others. He could always tone down the offending portraits, restoring their harmony, once the exhibition was over. It is noteworthy that in 1772 he also showed ten landscape drawings in imitation of oil painting, for they

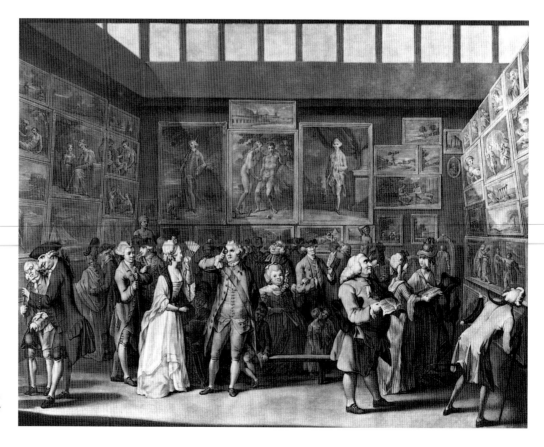

71 Richard Earlom after Charles Brandoin, *The Exhibition of the Royal Academy of Arts in the Year 1771*, 1772, mezzotint.

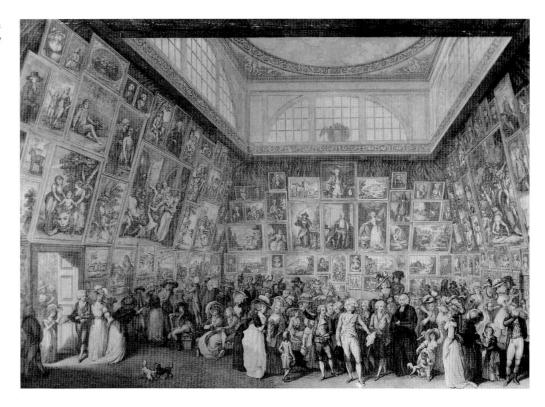

pointed up that the only way a drawing could compete in exhibition was by pretending to be something else, as well as undermining academic theories about the propriety of genres and media.[51] Exhibiting mattered to him. He had consistently sent work designed to get him noticed and to advertise his qualities to the Society of Artists, and this did not change with the founding of the Royal Academy.

The letters written to the Hon. Edward Stratford in 1771 and 1772 exactly illustrate this state of affairs, and additionally confirm that matters came to a head during these years. In the first, Gainsborough wrote:

> I am daubing away for the Exhibition with all my might, and have done two large Landskips which will be in two handsome frames (exclusive of 3 full length Portraits) and think . . . you ought to purchase them . . . the Landskips are the best I ever did, & probably will be the last I shall live to do. I wish that yours and Mrs. Stratfords Portraits had been whole lengths that I might have Exhibited you, & have got Credit; but half lengths are overlook'd in such a monstrous large Room and at a Miles Distance.[52]

He was putting aside commissioned work to make a splash in the exhibition with landscapes which Walpole tellingly thought 'very good but too little finished'. As two of the full-length portraits were of Lord and Lady Ligonier (pls 170, 171), who during the period of the exhibition were of intense public interest, on account of her adulterous affair with the Italian dramatist Vittorio Alfieri (culminating with the trial for criminal conversation on 27 June), we can imagine that these canvases would have attracted general scrutiny.[53] By February 1772 Stratford was, according to Gainsborough, 'damnably out of humour about his Pictures not being finished because the Frames hang up in his best Visiting Room in readiness. He writes every post, partly to shew me how Angry he is, and partly how well he can Write.' In May 1772, as we saw, Gainsborough was resorting to rueful charm: claiming still to have been so occupied about exhibition pictures as to have been unable to do anything about the commission, and making jokes about being knighted and hanging his diploma '*behind the door*'.[54]

73 *Wooded Landscape with Mounted Peasants,*
*c.*1771–72, gouache on paper mounted on
canvas, 1,003 × 1,280 (39¹/₂ × 50³/₈). Indianapolis Museum of Art, Gift of Mrs. Nicholas H.
Noyes.

The demands of the Academy were such that Gainsborough was prepared to delay commissions from people he judged to be sufficiently malleable (or perhaps, in Stratford's case, too mean to commission the full lengths he could easily have afforded). Gainsborough's problems came to a head during the exhibition of 1772. W. T. Whitley convincingly suggested that the artist was behind a paragraph in the *Public Advertiser* of 4 May:

> We hear that the Gentlemen on the Committee for managing the Royal Academy have been guilty of a scandalous meanness to a capital artist by secreting a whole length portrait of an English Countess for fear their Majesties should see it; and this only upon a conviction that it was the best finished picture sent this year to the exhibition. The same artist has been affronted in this manner several times before, from which they may depend upon his implacable resentment, and will hear from him in a manner that will very much displease them.[55]

While we do not know whose portrait would have affronted the royal gaze, we do discover that sitters' identities were of moment in the reception of their portraits, and that Gainsborough had had previous run-ins with the Hanging Committee. His resorting to the press to make his case was no exceptional tactic, and in 1770 Philip Thicknesse had published a pamphlet praising his friend as having 'exceeded all the modern Portrait Painters', contrasting his gifts with those of his rivals to the detriment of the latter.[56] It was here that he had claimed that to see a Gainsborough portrait was akin to meeting the person in the flesh, a claim which, as we saw, was repeated in that long piece in the *Town and Country Magazine* published, significantly, in September 1772 and very probably written by Thicknesse on Gainsborough's behalf. In terms of what Reynolds had been saying, for example, it is notable that the 'Gentleman' should opine that 'The very essence of portrait painting consists in likeness, we pay our money for that very circumstance. If the picture he is to paint of my daughter is like her, I gain my point by employing him; if not, it is not my

74 Detail of pl. 96.

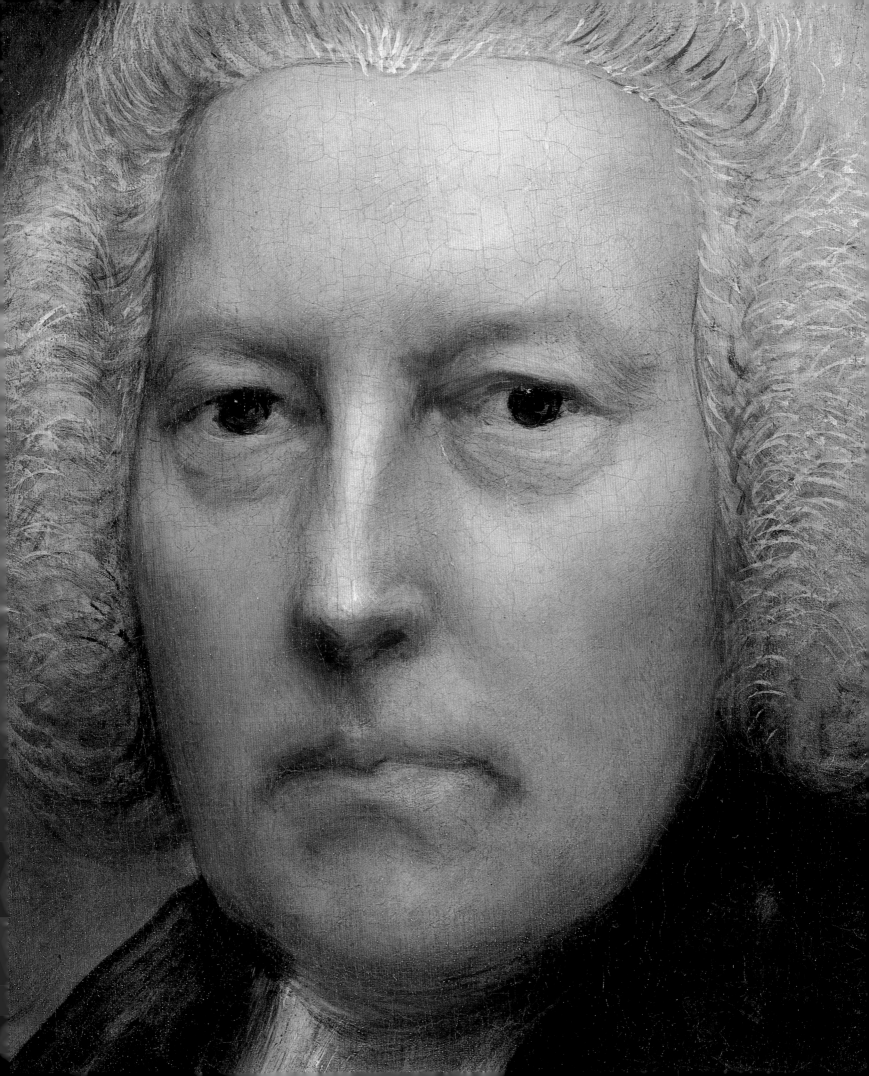

being told, that the picture has this or that excellence, which makes up for the disappointment.'[57] This piece puffed Gainsborough's virtues on Gainsborough's terms. The 'this or that excellence' had to be a hit at Reynolds.[58]

The years 1771 and 1772 were difficult for Gainsborough. In March and April 1771 his letters to clients exposed his irritation both at Reynolds's knighthood – he was sardonic about his own chances – and the way Reynolds's pronouncements in the *Discourses* were moulding fashionable taste.[59] Under these circumstances, what Reynolds had to say in the fifth *Discourse*, which he delivered on 10 December 1772, may have rubbed salt into Gainsborough's wounds. Evidently, some affront had been caused by the fourth *Discourse* in which he had meant 'to incite' his auditors to pursue 'the higher excellencies of the art', for, 'I fear that in this particular I have been misunderstood'. He compounded this apparent disingenuousness with insulting condescension: 'Some are ready to imagine, when any of their favourite acquirements in the art are properly classed, that they are utterly disgraced. This is a very great mistake: nothing has its proper lustre but in its proper place.' He went on to to detail what the 'proper place' for the kind of 'lower accomplishments' which Michelangelo looked down on as 'beneath his attention' was:

> I am of opinion, that the ornamental style, which . . . last year I cautioned you against it, considering it as *principal*, may not be wholly unworthy the attention of those who aim at the grand style, when it is properly placed and properly reduced.
>
> But this study will be used with far better effect, if its principles are employed in softening the harshness and mitigating the rigour of the great style, than if it attempt to step forward with any pretensions of its own to positive and original excellence.[60]

Gainsborough's was the quintessential 'ornamental style'. Reynolds maintained that it could have no pretensions 'to positive and original excellence', a position which, to a professional rival, would, in view of Reynolds's own frequent pictorial references to the Venetians and to Rembrandt, have smacked both of hypocrisy and abuse of the Presidency. And this time we know what his reaction was, because he was sent a copy of this *Discourse* by William Hoare. Gainsborough wrote to give his

> Respects to Mr. Hoare, and is much obliged for the sight of Sir Joshua's Discourse which he thinks amazingly clever, and cannot be too much admired (together with its Ingenious Author) by every candid lover of the Art. The truth of what he observes concerning Fresco, and the Great Style, Mr. G. is convinced of by what he has often heard Mr. Hoare say of the works of Rafaelle and Michel Angelo – But betwixt Friends Sir Joshua either forgets, or does not chuse to see that his Instruction is all adapted to form the History Painter, which he must know there is no call for in this country. The Ornamental style (as he calls it) seems form'd for Portraits. Therefore he had better come *down to Watteau* at once (who was a very fine Painter taking away the french conceit) and let us have a few Tints . . . Every one knows that the grand style must consist in plainness & simplicity, and that silks & satins, Pearls and trifling ornaments would be as hurtful to simplicity, as flourishes in a Psalm Tune; but Fresco would no more do for Portraits than an Organ would please Ladies in the hands of Fischer; there must be a variety of lively touches and surprizing Effects to make the Heart dance, or else they had better be in a Church – so in Portrait Painting there must be a Lustre and finishing to bring it up to Individual Life.[61]

The letter unfolds in an interesting sequence. From muted sarcasm, the tone moderates to the politeness appropriate to an intercourse between mutually respectful colleagues (and Hoare too may have felt that his achievements in pastel were belittled by the kinds of things Reynolds was saying). So, having established his ground on the familiar intimacy of friendship, Gainsborough can say what he thinks. He writes as a pragmatic and business-like person. The only field in which British artists can be guaranteed a living is portraiture. He

points up the incongruity of the idea of the grand style portrait by imagining it necessarily to be done in fresco, and making a mildly obscene joke around the virtuoso oboeist Johan Christian Fischer (who, ironically enough, would later become his son-in-law). At heart, perhaps, there is an acute sense that one should not attempt to imitate the generalising effects of fresco in oil paint on canvas, a medium and support which rather demand of artists, as traditionally they had, the kind of technical virtuosity seen in Watteau, and, before him, in Rubens and Van Dyck.

This suggests a real susceptibility to the manipulation of public opinion, and the way it might affect the reception of those works Gainsborough showed at the Academy exhibition. He set great store by these, while being famously detached from the business of the institution itself. The only two founding Academicians missing from the group portrait Zoffany exhibited, again in 1772, are Gainsborough (who, notwithstanding his frequent visits to London, might have been unavailable in Bath) and Nathaniel Dance. It may be significant, therefore, that in 1773 Walpole noted that 'Gainsborough and Dance having disagreed with Sir Joshua Reynolds did not send any pictures to this exhibition.'[62] This was not, on the face of it, unusual. George Stubbs chose to show at the Society of Artists in 1774, and even after then was irregular in sending work to the Academy. Joseph Wright appeared at the Royal Academy only in 1778, and along with Gainsborough withdrew his exhibits in 1784. The catalogue noted of his exhibiting two Shakespearian subjects at the Society of Artists in 1791:

> N.B. The Above pictures were exhibited last year in the Royal Academy, but having been placed in unfortunate situations, owing (as Mr. Wright supposes) to their having arrived too late in London, and having since received alterations, he is desirous they should again meet the public eye.[63]

Exhibitions were arenas for the display of professional rivalries. In light of their very great importance to Gainsborough, his declining to send work to the 1773 exhibition was an extreme step. It was, as Whitley has suggested, and all the evidence supports this, provoked by the way in which his pictures had been hung.[64] A feeling of victimisation would have been a natural consequence of both Reynolds's pronouncements, and hanging committees acting to their own agendas, and it is reasonable to conclude that matters came to a head over the winter of 1772–73. Gainsborough spelled out his reasons for withdrawing from exhibiting in a letter postmarked 1 April, and probably 1773, to Garrick: 'I don't send to the Exhibition this year; they hang my likenesses too high to be seen, and have refused to lower one sail to oblige me.'[65] In the event he would not reappear at the Academy until 1777, by which time he had been some years resident in London and had secured backing in the press.

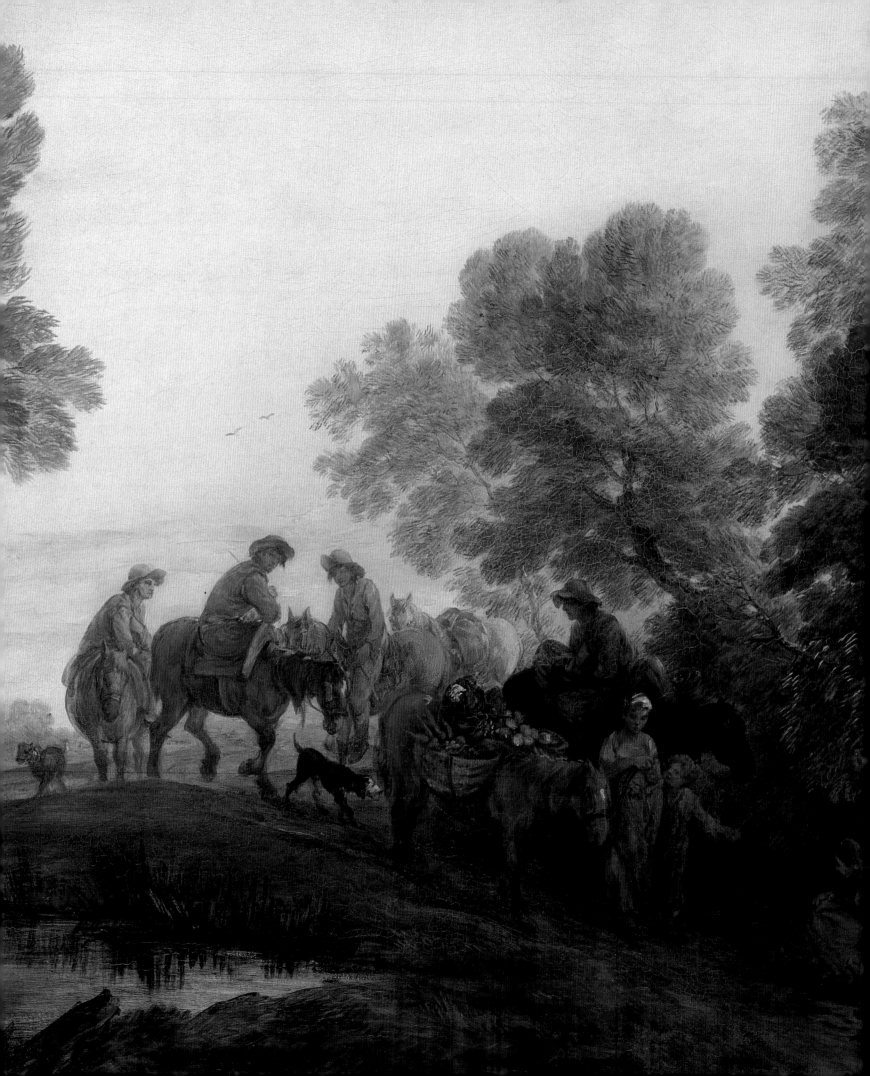

4 *London*

WE DO NOT KNOW WHY THOMAS GAINSBOROUGH decided, apparently fairly abruptly, to move from Bath to London in midsummer of 1774. Philip Thicknesse characteristically put it down to the artist's reaction to a row over a portrait of himself, which Gainsborough had shown little appetite for painting, let alone for bringing to completion.[1] But the motivation may have been more fundamental. By January 1775, Joseph Wright was in Bath, ready to fill Gainsborough's shoes, but to little avail. 'I have not had one Portrait bespoke', he wrote on the fifteenth, and went on, 'I have heard from London – and from several gentlemen here – that the want of business was the reason for Gainsborough's leaving Bath. Would I had known that sooner.'[2] If we believe the London papers, Wright's reputation was riding high. And while, perhaps (to develop a suggestion of Benedict Nicolson's), he was too strongly associated with the candle-lit subject-pictures in which he specialised, and his portrait manner was too direct for a Bath clientele that preferred to think of itself as being elegant and polite, as Hoare or Gainsborough painted it, there was probably some truth in what Wright had heard.[3]

If we chart Gainsborough's dated portraits, there was a comparative decline in the years immediately before 1774, with commissions picking up again in 1775 (although the numbers of undated Bath works advise caution).[4] Trade *may* have begun to slacken off, and the expense of maintaining rooms and an opulent lifestyle in the Circus may have begun to bite, despite the cushion of rental income from the original premises in the Abbey Churchyard.[5] The fracas with the Royal Academy and withdrawal from exhibiting may well have inspired the artist to think on the advantages to be had from a London base. It would give him more secure access to fashionable clients, whose presence in Bath could not readily be guaranteed. Gainsborough showed characteristic common sense in taking rooms in part of Schomberg House, Pall Mall, at £150 *per annum* (which figure must be set against his estimated rental income of £270–£300 in Bath after 1766).[6] Pall Mall was itself in an extremely fashionable part of town, close to St James's Palace. It was also at a sufficient distance from Soho and Leicester Fields, where other artists, notably Reynolds, tended to set up, as befitted Gainsborough's semi-detached relationship to the Royal Academy. Moreover, as 'he was withholding his work from public exhibition . . . one can safely assume that the two-storey annexe subsequently built upon the garden contained both a painting room and a private gallery'.[7] To display work thus to the fashionable individuals who frequented that area would go a considerable way towards overcoming the disadvantages of failing to exhibit at the Royal Academy, and Gainsborough's refusal to show at alternative venues points to his having calculated that, for now, he could do without this kind of dubious exposure.[8]

In London he continued to keep the company of musicians. The violinist Felice Giardini, whom he had first met at Ipswich, 'transformed musical standards in the 1750s' and in 1753 was singled out for his 'amazing Rapidity of Execution, and Exuberance of Fancy, joined with the most perfect Ease and Gracefulness in the Performance' (a description which could as well apply to one of Gainsborough's own performances).[9] As Ozias Humphry noted, 'Giardini, Abel, Bach and various other performers of the first Class from time to time . . . were induced to visit Bath', and before he left the city Gainsborough wrote of how much he had been 'unsettled by the continual run of Pleasure which my Friend Giardini and the rest of you engaged me in.'[10] Carl Friedrich Abel (pls 47, 85) was a virtuoso on the viola da gamba, acquainted with Gainsborough by the early 1760s (from when

dates his portrait), and a man whom the artist 'loved from the moment I heard him touch the string'; the composer Johann Christian Bach was closely linked with Abel in directing Mrs Cornelys's subscription concerts until 1768, when the two took them over themselves.[11] The impact of these concerts can be judged from Charles Burney's report:

> As their own compositions were new and excellent, and the best performers of all kinds which our capital could supply, enlisted under their banners, this concert was better patronised and longer supported than perhaps any one had ever been in this country; having continued for full twenty years with uninterrupted prosperity.[12]

One of the star performers was the oboeist Johann Christian Fischer (with whom Gainsborough was acquainted by 1772), who first played in London in June 1768, on 'an occasion which was additionally notable as that on which J. C. Bach first publicly played the pianoforte as a solo instrument'.[13]

These individuals were at the cutting edge of modern music. 'Certainly', writes Simon McVeigh, 'the Giardini–Bach–Abel–Fischer orbit was the most elite gathering possible, since they dominated concert life and had many royal connections: and above all they were not English.'[14] Their lifestyle partook of the bohemian. Recalling an aborted trip to London, probably in May 1772, Gainsborough wrote to the Hon. Constantine Phipps:

> I was hugging myself as I pass'd through Harley Street, that as I had not met one Fiddler or Hautboy Man, I should doubtless have leisure to wait upon you again, but, behold, not three doors from yours, I ran my head plump in Abel's fat guts. He promised I should hear a Man blow *half notes* upon the French if I would dine with him; I found Fischer, Bach & Dupont, all ready to make a finish of me for the Day I had to stay in Town, so that not a Friend, a Picture, or any thing I liked could I enjoy – except only a little Venus *rising from the Sea* in my way to my Lodgings, the same that was puff'd off at an Exhibition I believe for her hair was d——md red.[15]

It is worth observing with respect to Barry's *Venus rising from the Sea* (c.1772, National Gallery of Ireland, Dublin) that Gainsborough was obviously in London for the Royal Academy exhibition, although his noticing it only as 'an Exhibition' testifies to the distance he maintained from it. His capacity to relish the company of musicians would later generate exasperated censure from his friend William Jackson of Exeter. In 1778 Jackson wrote to their mutual friend Ozias Humphry:

> My old Friendship for Gainsborough I am afraid has suffered some abatement – his Oddities will at last get the better of his Good Qualities, which is ten thousand Pities! I am satisfied if that Man had been properly educated & connected, he would have been one of the first that ever lived. He has given Abel as many Pictures & Drawings as are worth as some hundreds of Pounds, & he in return has taught him to drink himself into a premature blind Old Age – Like Wilson, he will soon be considered as a Ruin, & if so, I hope a venerable one.[16]

Jackson (who in his book *The Four Ages* would confirm his petty-mindedness towards one who had been inordinately generous towards him) need not have worried. Gainsborough did not succumb to drink, although he retained his love of music to the extent that one obituarist (who Whitley thinks must have known him well) concluded that his 'musical taste was, perhaps, equal to that of any one of his contemporaries: and he himself thought he was not intended by nature for a painter, but a musician'.[17]

Competent as a performer, Gainsborough was subsequently mocked by William Jackson for his urge to acquire the instruments on which virtuosi such as Giardini had performed, on the presumption that it was not from the performer but from the instrument that such music came. He may, of course, simply have appreciated the exquisite workmanship and beautiful form of a superior instrument, one that, in the right hands, could produce only

sublime music.[18] Once installed in London he continued to keep the company of musicians. Alongside others, including Benjamin West and Cipriani (themselves foreigners), he was involved in creating transparencies for the new concert room Bach and Abel had set up in Hanover Square, turning it into 'the most elegant room in town', where the

> Pictures are all transparent and lighted behind; and that light is sufficient to illuminate the room without lustres or any candles appearing. The ceiling is domed and beautifully painted, with alto-relievos in all the piers. The pictures are chiefly fanciful. A Comic Muse by Gainsborough is most spoken of.[19]

This kind of effect would prove a necessary additional attraction with the inception of concerts at Wyatt's Pantheon in 1774, concerts which, moreover, 'adopted a blatantly anti-German stance by featuring Italian and English music'. The performing as much as the fine arts were implicated in the processes of commerce, and the root source of Jackson's disaffection with Gainsborough may have been to do with his affiliating himself with German musicians, thereby undermining the status of those wishing to maintain, as Jackson did, a British tradition.[20]

Thomas Gainsborough's choosing to associate chiefly with musicians rather than artists was characteristic of his deliberate refusal to share in the professional identity being established by other painters. Like Reynolds, he kept a distance, and this extended to the way in which each treated clients. Reynolds, we read, 'was not even a courtier', while Gainsborough, who could be a courtier when he wished, nevertheless admitted

> to being sometimes afflicted with laughter 'when painting grave portraits.' He moreover said that being at the Earl of R★★★★★'s where it was the custom to have daily morning prayers, he was loath to attend, for fear of laughing at the Chaplain, whose puritanical physiognomy had whimsically wrought upon his imagination.[21]

That he considered himself to exist on an equal footing with his more elevated sitters is evident from an anecdote which the landscapist Sir Francis Bourgeois related to the diarist Joseph Farington in 1799. Bourgeois had, one day,

> Called on him and saw a half-length portrait, and was struck with the haughty expression of the countenance, and observed it to Gainsborough, who expressed satisfaction at the remark, as it proved that He had hit the Character. Gainsborough said it was a portrait of Mr. Pitt, who He said came the day before to sit for his picture and on coming into the painting room sat down in the sitters chair, and taking out a book began to read.
>
> Gainsborough struck with the hauteur and disrespectful manner of Mr. Pitt [pl. 76] treated him in this way. – He took up his pallet and seeming to be trifling among his Colours, began carelessly to hum toll, roll de roll, on hearing which Mr. Pitt recollected himself *shut his book*, and sat in a proper manner.
>
> Gainsborough was very familiar and loose in his conversation to his intimate acquaintance; but *knew his own value*; was reserved; and maintained an importance with his sitters . . .[22]

This behaviour is different to that of Reynolds (of whom it was said: 'I never heard the words "*your ladyship or your lordship*" come from his mouth' and who thus maintained a distance), for it revealed that Gainsborough (who, as we have seen, was capable of being properly courteous) and the great coexisted in the same world. For Reynolds, membership of the profession of artist was what stamped him as worthy of proper respect.[23]

Sir Joshua Reynolds set so much store by social position that he was ready to embarrass his sister by having her ride around in the coach on which his arms were as prominent as they were on his fine Lowestoft china dinner service.[24] This was symptomatic of his attempt to dissociate the artist from any taint of mechanical craft, to demonstrate in as unambiguously material a way as possible that the artist could be first of all a member of polite society,

J. K. Sherwin after Thomas Gainsborough, *William Pitt the Younger*, 1789, Sudbury, Gainsborough's House.

his particular calling simply underpinning his right to that status, as did the landholdings of the aristocrat. Gainsborough sought a comparable distancing, but for subtly different reasons. Some are so straightforward as to be virtually banal. He had to make his living by portraiture, but much of the time this was drudgery, and, like anyone else whose employment is primarily geared towards getting money, Gainsborough was happy to leave it behind. As we have seen, he did not much socialise with other artists. However, he and James Barry (who 'used to say such things of lords and dukes, as never perhaps had been listened to with equal endurance from any tongue but his') were on good terms, with Barry singling out Gainsborough as one of the few of his contemporaries who were worth anything in his *Account* of the pictures with which he decorated the Great Room of the Society of Arts.[25] But theirs was not the company he chiefly kept.

77 *James Christie*, 1778, oil on canvas, 1,257 ×
1,003 (49$^{1}/_{2}$ × 39$^{1}/_{2}$). Los Angeles, The J. Paul
Getty Museum, Gift of J. Paul Getty.

At one remove, for instance, was the auctioneer James Christie, whose rooms were next
to Schomberg House and with whom the artist enjoyed a convivial relationship. In Christie's
portrait (pl. 77), which he exhibited at the 1778 Royal Academy, Gainsborough took the
opportunity to advertise his powers as a landscapist, for Christie is leaning against one such
painting – perhaps ironically, for landscape sales were sporadic at best. None the less, he
implies, the proper place for Gainsborough's works is in the company of the old masters
which were passing through the sale rooms. And we have noted that on visiting his paint-
ing room in 1770 Dorothy Richardson observed 'a miniature Copy of Vandykes famous
Picture at Wilton of Ld Pembrokes family', along with 'A Good Picture of two old Heads
by Rubens', and Prince Hoare (William Hoare's son) recalled his 'exhibiting his own work
with those of Rubens and Van Dyck'.[26]

This assertion of a relationship with the old masters in its turn defined the nature of his independence. Reynolds may never have addressed aristocrats by their titles. When he could, Gainsborough affected an easy familiarity. Attempting in 1768 to gain the Duke of Bedford's support for William Jackson in his attempt to be appointed one of the Receivers of the Land Tax for Devon, the artist wrote: 'Your Grace has doubtless heard his Compositions but he is no *Fiddler* your Grace may take my word for it', concluding with the apology, 'Your Grace knows that I am an *Original* and therefore I hope will be the more ready to pardon this monstrous freedom.'[27]

The position he was seeking to assume, it appears, was that of courtier, and it is in this wise that we might briefly inspect his own studio arrangements. Reynolds, we know, used drapery painters and studio assistants. Gainsborough took on his nephew, Gainsborough Dupont, as an apprentice in January 1772, expressly, it seems, to have him paint in his manner, in the way of Rubens with Van Dyck.[28] Hence, Northcote is remembered as saying of the great portrait *Queen Charlotte* (pl. 106), 'Oh! It delighted me when I saw it. The drapery was done in one night by Gainsborough and his nephew Gainsborough Dupont; they sat up all night, and painted it by lamp-light'.[29] Dupont was so adept at working in Gainsborough's manner that the portrait *Mrs Hatchett* (pl. 78), which he signed, would appear to be a fine Gainsborough of a fashionable young woman, were it not for a greater proliferation of directional brushstrokes than one might find in the latter. This arrangement did not exactly constitute a workshop in the traditional sense – as for example, Tintoretto had involved his family in the production of canvases – but Gainsborough was assuming a role different from other artists, one which might equate with that of the courtier as exemplified in the example of Titian, Rubens or Van Dyck.

Hence he wrote to the Honourable Edward Stratford in, probably, 1771: 'Mr Gainsborough presents his compts to Mr Stratford; He does not understand whether Mr Stratford means to have the Dog painted separate by Monsieur Dupont, or again put into Mrs Stratford's Picture to spoil it', and he assumed as easily familiar a manner with the Earl of Sandwich in 1784.[30] He came to play the part to perfection once he had met and developed an extremely friendly relationship with George III (pl. 105) in the 1780s. Commissions flowed, and, according to Henry Angelo, Gainsborough

> always professed an esteem for his majesty's judgement in the affairs of his own art. 'The King', said he, 'is a good connoisseur, and conversant in the works of the old masters; much more so, indeed, than many of his courtiers, who hold their heads so high upon the advantages of foreign travel; lordlings who for all their prate about contour, carnations, and gusto, prefer a racer to a Raffael, and a stud to the studio of Michael Angelo himself.[31]

Gainsborough told Francis Bourgeois that 'He talked bawdy to the King and morality to the Prince of Wales', and it is in respect of this relationship that Angelo wrote that 'Reynolds . . . was not even a courtier'.[32]

Gainsborough's desire for this role is clear from some of his paintings, notably the astonishingly intimate set of portraits that he did for the Duke of Bedford in 1764 (pls 33, 34, 71, 73, 74, 75); but in other ways too. From the late 1760s, for instance, he was painting a series of fine and complex landscape paintings. Same he gave away to friends, notably *The Harvest Wagon* (pl. 214), which, along with an extremely beautiful pastoral scene of 1773–74, ended up in the collection of Walter Wiltshire, the Bath haulage contractor. Others however were painted for or sold to highly select individuals. The earliest was commissioned by Lord Shelburne for Bowood; the next, for John, second Viscount Bateman; and the third was bought by Henry Hoare of Stourhead. By 1773 or so Gainsborough had expanded his landscape imagery into the first of the cottage door scenes, bought by the Duke of Rutland, who would subsequently purchase two further landscapes; while a replica of that first cottage door scene was painted for Gainsborough's friend Felice Giardini, and the fine landscape

78 Gainsborough Dupont, *Mrs Hatchett*, 1786, oil on canvas, 762 × 635 (30 × 25). New York, Frick Collection.

now at Bowood was painted for Carl Friedrich Abel.[33] He was, arguably, choosy with regard to the destinations of these pictures. Wiltshire, Giardini and Abel were friends. Viscount Bateman and the Duke of Rutland had sat for their portraits (as had, of course, Abel and Giardini).[34]

But this independence was always tempered with the necessity to make a living, and once Gainsborough had moved to London the output of painted landscape appears, temporarily, to have declined, presumably because of the necessity to concentrate on portraiture and to establish a position in an unfamiliar and competitive market. If we are right in supposing that work had begun to dry up in Bath after 1770 (which, together with 1769, had been a very good year), then we can begin to see an improvement after the move back to London. There are only five portraits definitely painted in 1773; by 1775 this number was up to fourteen, and trade thereafter remained steady to very good, reaching a peak in 1782, with

thirty-three securely dated commissions. And this level of business was achieved without bothering to exhibit until 1777; a choice which, in itself, shows the extent to which showing at the Academy was a mixed blessing.

Gainsborough was not the only artist to have the *chutzpah* to remain aloof. George Romney did very well without exhibiting at the Academy at all, although he did show at the Society of Artists between 1763 and 1769 and the Free Society of Artists from 1770 to 1772. On returning from a trip to Italy in 1775 he took a leasehold on some pretentious premises in Cavendish Square, a prestige address formerly occupied by Francis Cotes. Analysis of his sitter books from March 1776 to December 1795 (the one for 1785 is missing) reveals that he had some 1,500 patrons. One attraction was his price, which undercut both Reynolds and Gainsborough: in 1786, twenty guineas for a three-quarter length, against thirty and fifty guineas respectively. He earned 3,504 guineas in that year alone. In 1780 Horace Walpole had remarked on a 'great vogue' for Romney, and his managing so triumphantly without any institutional affiliation (in a parallel to the career of Robert Adam, kept out of the Royal Academy by William Chambers) confirms Marcia Pointon's conclusion that the 'virtuoso performance of a Reynolds or a Gainsborough launched by a sensational display at a Royal Academy exhibition was the exception rather than the rule'. She points out, however, that the Academy was central to a painter as a 'publicity agent', although, as we have seen, portraits tended to be 'judged more by the recognised status and quality of the subject than by the inherent success of the painting as a work of art'.[35]

Others were more circumspect about withdrawing from exhibition. Joseph Wright, who also painted portraits, sent mainly subject pictures to the Society of Artists. David Solkin has observed how the foundation of the Royal Academy provoked a shift in Wright's work from the 'polite' subject-matter of the 1760s, exemplified by the *Gladiator* (1765) or *An Academy by Lamplight* (1769) to 'a series of pictures of rustic smithies – a move that may have been at least partly motivated by a desire to distance himself as far as possible from the grand pretensions of the Royal Academy'. Solkin is right, however, to be equivocal.[36] In 1772, alongside versions of *A Blacksmith's Shop* (pl. 79) and *An Iron Forge,* Wright showed *An history, Miravan, a young nobleman of Ingria, breaking open the tomb of his ancestors in search of wealth* (pl. 80). Painted onto the 'domestic' scale of a half-length canvas, this was, none the less, a history painting which engaged with serious moral issues. It extrapolated its fable from obscure sources, but disclosed its content in a lengthy catalogue entry which revealed that the untold wealth Miravan sought in the tomb was the repose of death, which he had destroyed forever. That is, the composition invited contemplation both upon the consequences of unbridled greed, and upon what a morally proper behaviour should be, in a way that was entirely befitting a commercial society in which the spread of material wealth and its consequences were recognised as a cause for concern. Wright's work perfectly conforms with the advice Reynolds had laid out in the fourth *Discourse,* to seek out a subject 'supplied by the Poet or Historian', and to pick one 'in which men are universally concerned, and which powerfully strikes upon the publick sympathy'.

Miravan fits this bill, even down to the story's being one that, it appears, Wright partly fabricated himself, but helpfully detailed in his catalogue entry. In other ways, however, the painting continues the critique of academic artistic practice as it was then being defined, for its emphasis on lamplight and moonlight stamp it a 'Wright'. The setting is similar to those in which he was placing smiths and forges, and the composition is realised with a particularity of description at variance with the generalising that a history painter was supposed to attempt if a subject was to have universal meaning. Moreover, as mentioned above, the canvas would fit comfortably within a domestic interior rather than a public space, implying that this genre was now properly the focus of private contemplation, conformable to the ethos of a commercial society bound by ties of sympathy. Wright carried on sending comparable works to the Society of Artists – in 1773 exhibiting another *Iron Forge,* along with *A Captive King* and *An Earthstopper on the Banks of the Derwent,* and getting warm

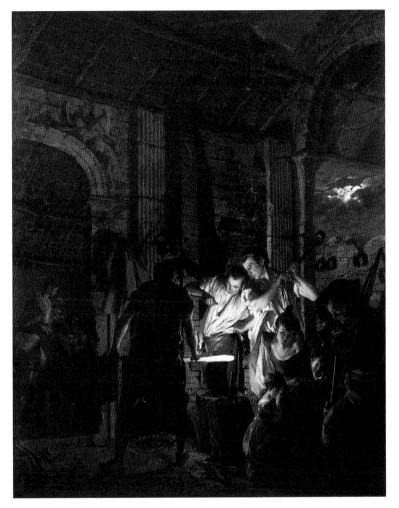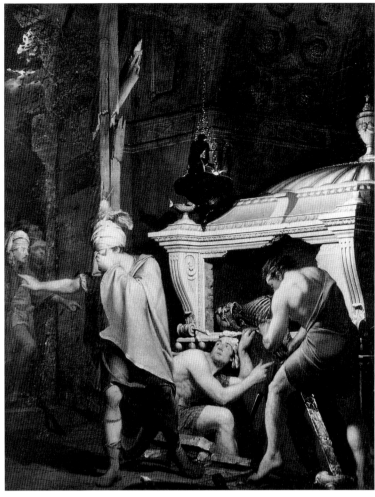

79 (*above left*) Joseph Wright, *A Blacksmith's Shop*, 1771, oil on canvas, 1,257 × 990 (49½ × 39). Derby Museums and Art Gallery.

80 (*above right*) Joseph Wright, *An history, Miravan, a young nobleman of Ingria, breaking open the tomb of his ancestors in search of wealth*, 1772, oil on canvas, 1,270 × 1,016 (50 × 40). Derby Museums and Art Gallery.

reviews. The *Morning Chronicle* thought that 'WRIGHT of Derby has even out-done himself this season.'[37]

In this year the Royal Academy was ornamented with one of Reynolds's own relatively rare excursions into history painting: *Count Hugolino and his Children in the Dungeon, as described by Dante . . .* (pl. 81), a large canvas picturing a tale of incarceration and potential cannibalism in terms general enough to offer a reproach to what some may have perceived as the anecdotalism of *Miravan*. Moreover, most literate people would have known the fable. None the less, the painting attracted a mixed reception. The *Middlesex Journal* thought 'such subjects unworthy a great pencil'; the *Public Advertiser* opined that 'if the same Excellence had been employed in a pleasing Subject, it would have enchanted, as it may now terrify, the Public'; while 'Florentius', writing in the *Morning Chronicle* wrote that if *Hugolino*, alongside another of Reynolds's exhibits, *Cenus and Cupid casting up Accounts*,

> were shown even in France or Italy, where you may be ever so little known, everybody would, at the first glance, judge them to be the rude disorderly abortions of an unstudied man, of a portrait painter, who, quitting the confined track where he was calculated to move in safety, had ridiculously bewildered himself in unknown regions, unfurnished with either chart or compass.[38]

While the contrast between the reception afforded Reynolds as history painter (for even the good reviews were qualified) and Wright raises questions about the roles and functions

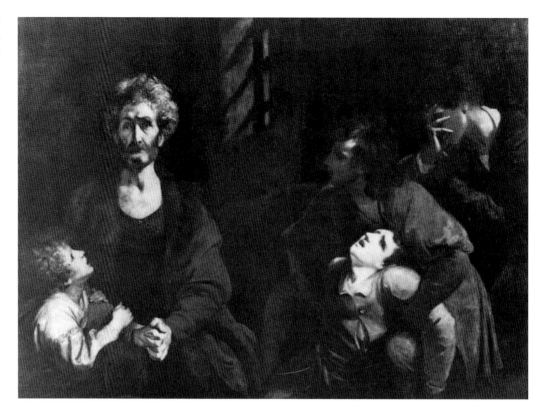

of the genres of art, it also serves to highlight the fact that even Reynolds could receive equivocal reviews.

It is germane here briefly to outline Wright's exhibiting tactics as the decade wore on. When he did get reviewed, it was very favourably. In 1776 he marked a major change of direction by showing at the Society of Artists an *Eruption of Mount Vesuvio* and a *Girandola*, which the *Morning Chronicle* complimented as comprising 'a sufficient exhibition to a judge of painting'.[39] He was next to exhibit in 1778, at the Royal Academy. He sent in a varied selection of work, demonstrating his range and ignoring those working subjects he had been despatching to the Society of Artists earlier in the decade. *Edwin* and *Sterne's Captive* pictured episodes from popular literature; *A Grotto and Banditti* and *Neptune's Grotto* showed Italian scenes in the way of C.-J. Vernet, overlain with a hint of J. H. Mortimer's domestications of Salvator Rosa; the *Eruption of Vesuvius* and *Girandola* offered spectacular versions of his trademark light effects. The critics (who had paid little attention to the Society of Artists) were enthusiastic. 'Wright's pieces', wrote one, 'possess a glow of warmth and colouring, superior to any in the Exhibition. Neptune's Grotto, at Tivoli, shows the most surprizing effect of colour indeed.' Another was ecstatic. 'This Artist is one of the greatest ornaments of the present exhibition.' The *Vesuvius* and *Girandola* were singled out as 'uniting, in a great degree, the characteristic excellencies of both the *Flemish* and *Italian* schools', and consequently doing what Reynolds maintained to be impossible.[40] Since this critique was penned by Gainsborough's ally Henry Bate in the *Morning Post*, it could well have been a sly joke. This was a pleasing reception, demonstrating that the risk of showing at the Royal Academy had been worth taking. Wright may have been prompted to do this by the example of Thomas Gainsborough.

During his self-imposed exile from the Academy, Gainsborough would have noticed that, despite the reception of *Hugolino*, Reynolds was getting a clear run in demonstrating his varied talents as a portraitist. In 1773 he had exhibited pictures of the Duke and Duchess of Cumberland to signal that he was gettting royal patronage, while in 1774 he would offer the extraordinarily inventive group portrait of the Montgomery sisters as *The Three Graces*

82 Sir Joshua Reynolds, *Georgiana, Duchess of Devonshire*, 1776, oil on canvas, 2,360 × 1,460 (93 × 57¹/₂). Courtesy of the Huntington Library, Art Collections, and Botanical Gardens, San Marino, California.

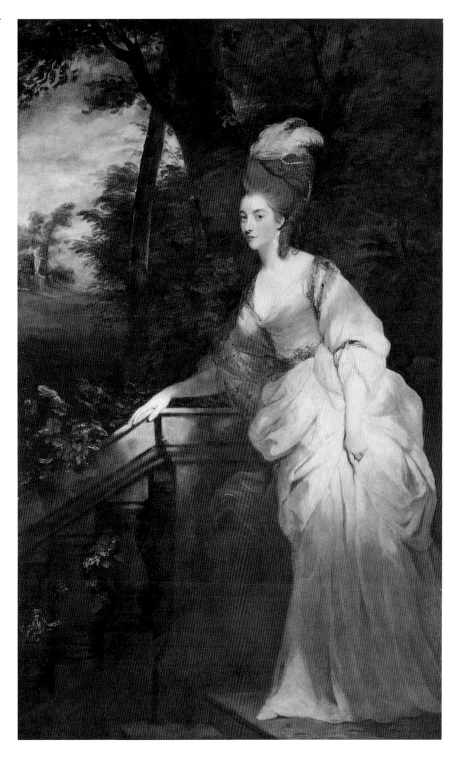

adorning a Term of Hymen (Tate Gallery, London). Aristocratic sitters were dominant in the remainder of his thirteen exhibits, where an *Infant Jupiter* ('expression admirable, goat bad' thought Horace Walpole) was a solitary reminder of his more exalted aspirations.[41] This pattern was maintained in 1776, with the exhibition of a spectacular full length of the latest fashionable beauty, the Duchess of Devonshire (pl. 82), and a portrait of the quintessentially elegant noble savage, Omai, whom James Cook had transported to England from the South Pacific. The latter was admired by Fanny Burney as 'so open and Frank Hearted', while in April 1776, although she acknowledged the Duchess of Devonshire to be 'young and

handsome', she found her so 'undressed and slatternly' that all 'turned back to stare at her'. This reconnects Reynolds's image with a person who was then living and comparatively unprotected from the public eye, a condition Burney was to comment on with some sympathy:

> I think her very handsome, & she has a look of innocence & artlessness that made me quite sorry she should be so foolishly negligent of her Person. She had hold of the Duke's arm, who is the very reverse of herself, for he is ugly, tidy, and grave. He looks like a very mean shop keeper's journey man.[42]

Gainsborough coincidentally exhibited full lengths of the Duke and Duchess of Cumberland in the 1777 Royal Academy, and a portrait of the Duchess of Devonshire in 1778 (on the rare occasions he and Reynolds painted the same people, Reynolds usually got in first).[43] If Gainsborough wished to maintain his roles as courtier and bohemian, then, with some irony, he needed to exhibit to effect at the Royal Academy, to display his achievements on the public stage; and this he did in 1777.

It is worth noticing how, in his seventh *Discourse*, delivered in December 1776, Reynolds satirised the habit of putting sitters into Van Dyck dress, and 'how common' this was 'a few years ago'.[44] One such example of that once popular fashion would have been Gainsborough's sensational portrait of Jonathan Buttall, *The Blue Boy* (pl. 83), which had been a hit at the Royal Academy of 1770. Spectacular in its treatment of the costume, and dramatic in setting the figure, it advertised to what good effect Gainsborough had been copying Van Dyck over the previous years.[45] Reynolds (who, we are reminded, 'employed it relatively often') went on to say, how, by using Van Dyck dress, 'very ordinary pictures acquired something of the air and effect of the works of Van Dyck, and appeared therefore at first sight to be better pictures than they really were'.[46] The artist Mary Moser considered Gainsborough 'beyond himself' in *The Blue Boy*, and Francis Hayman had thought the portrait 'as fine as Vandyke', so one has to wonder if Reynolds, alerted to Gainsborough's plans to re-exhibit in 1777, was getting in a pre-emptive strike by implicitly belittling a portrait generally regarded as exceptional.[47] One reason for his singling out Van Dyck dress in particular could be that he knew that Gainsborough planned to send his portrait *Mrs Graham* (pl. 84) to the 1777 Royal Academy; and Mrs Graham is shown wearing an outfit which reinvents seventeenth-century costume.[48]

Speculation apart, we do know that Gainsborough orchestrated his return to public scrutiny with considerable acumen and care. He now had guaranteed support in the press. This came, as W. T. Whitley was the first to show, from Henry Bate Dudley, whom, he thinks, Gainsborough probably knew by 1775 (although there is no reason why the acquaintance should not have dated from earlier or later).[49] In 1777 Bate was editor of the *Morning Post* (he went on to found the *Morning Herald* in 1780). As we shall see, in 1777 Gainsborough was meticulous in choosing to exhibit pictures which would have maximum effect, and Bate's review of the exhibition starts with him; for, as 'the pencil of this gentleman has evidently entitled him to the distinction, we have placed him at the head of the artists whose works we are about to review'.[50]

On the face of it, this went with the general opinion. Welcoming Gainsborough's return, the *Public Advertiser* found it 'hard to say in which Branch of the Art Mr Gainsborough most excels, Landscape or Portrait Painting', and the *Morning Chronicle* set him against Reynolds, and found him treading 'so close upon the heels of that Chief of the Science, that it is not always evident Sir Joshua has a superiority'.[51] Bate amplified his views. Having proclaimed the supremacy of Gainsborough, he passed on to Reynolds (whose dozen exhibits included the superb *Lady Bampfylde* (Tate Gallery, London)), and observed

> With reluctance . . . that Sir Joshua Reynolds's present productions are by no means equal in point of merit, to those which he has formerly exhibited upon a similar occasion. The

83 *The Blue Boy (Jonathan Buttall), c.*1770, oil on canvas, 1,178 × 1,219 (70 × 48). Courtesy of the Huntington Library, Art Collections, and Botanical Gardens, San Marino, California.

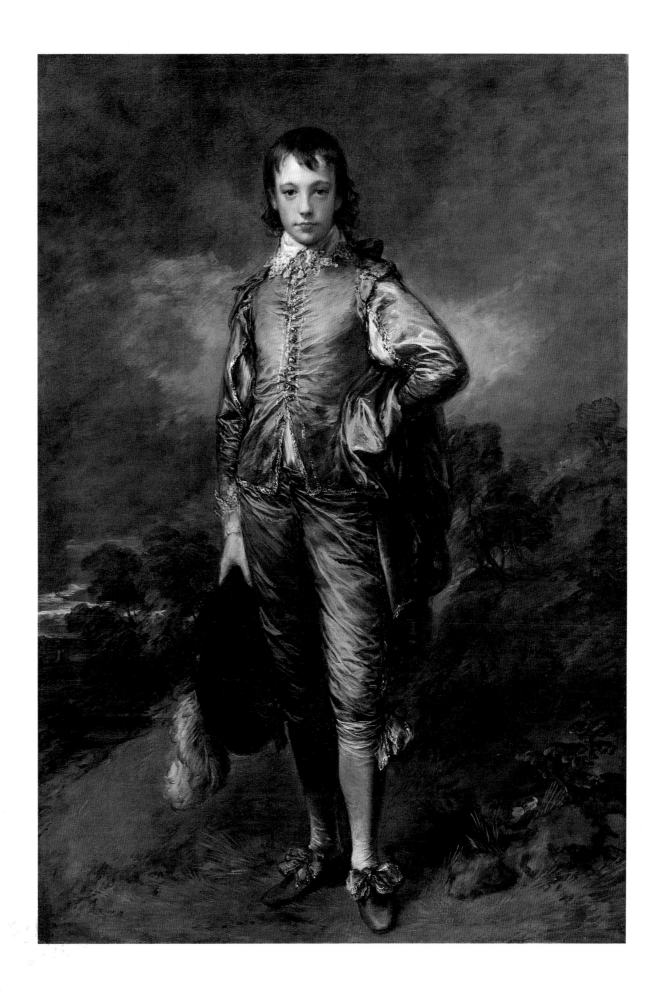

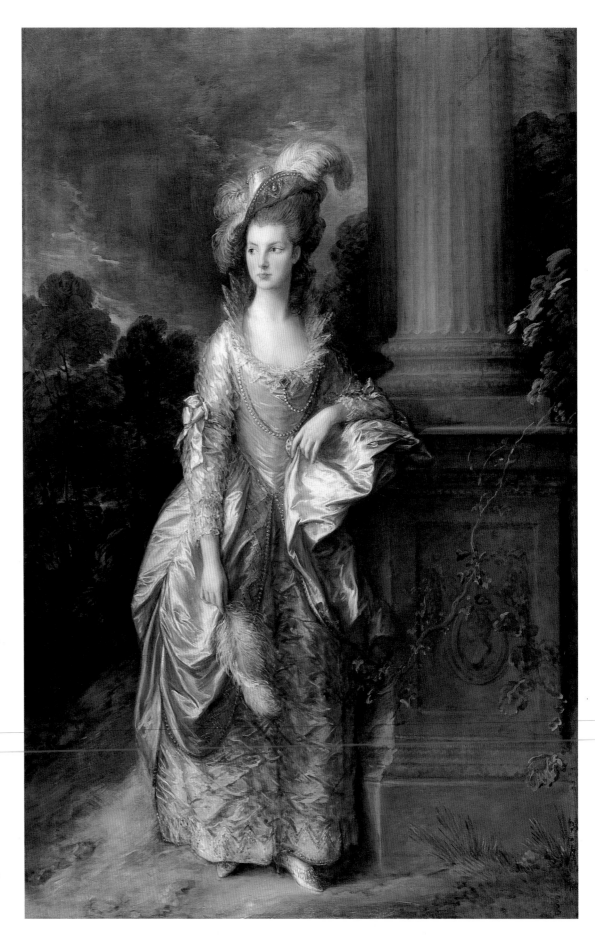

84 *Mrs Graham*, 1777, oil on canvas,
2,375 × 1,543 (93$^{1}/_{2}$ × 603/4).
Edinburgh, National Gallery of
Scotland.

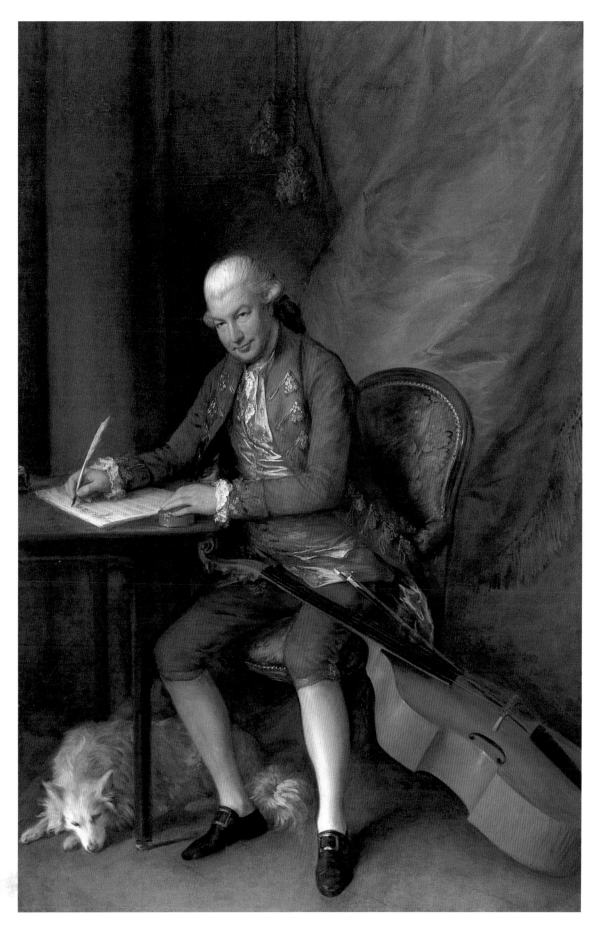

85 *Carl Friedrich Abel*, 1777, oil on canvas, 2,235 × 1,473 (88 × 58). Courtesy of the Huntington Library, Art Collections, and Botanical Gardens, San Marino, California.

critics have long found fault with his style of colouring, asserting, that its brilliancy must soon fly off; he seems determined, however, to obviate that objection in future, by giving all his portraits the *lasting* copper-complexion of a *Gentoo* family!

While the unpleasantness of these remarks was partly offset by his approving comments on *Lady Bampfylde*, commending 'the harmonious softness of colouring', but finding 'the drawing of the right arm very incorrect', they were calculated to do damage. The racist comparison would (then as now) have raised cheap laughs; but the more general comments on the colouring lock into widely expressed concerns about artistic techniques so unsound that some doubted whether Reynolds's paint surfaces would last more than a few years, as well as directing attention to the chromatic brilliancy of Gainsborough's exhibits.[52]

We should consider further the potential impact of a review like this. As Earlom's print after Brandoin's representation of the 1771 Royal Academy exhibition (pl. 71) shows (and we have already remarked), whether or not an exhibited work was noticed, let alone seen to any advantage, was a lottery. If the visitor arrived forearmed by a newspaper review, their attention would be directed to particular works. If they were following Bate, they would have looked first for the Gainsboroughs, ready to concede their superiority over the paintings of Reynolds. And, as many accounts of the exhibition pretended to be systematic and dispassionate, often stretching over several issues of a paper, then one such as this must alert us to its being central in the strategic management of Gainsborough's come-back. And it was doing it in a way that made the artist's own view of his position in the artistic hierarchy transparently clear.[53]

As we have said, he chose his exhibits carefully, and for various reasons. One was the way they would have reinforced doubts about Reynolds's colouring, while full-lengths of the Duke and Duchess of Cumberland were inviting exhibition-goers to make a mental comparison with the portraits of the same pair which Reynolds had exhibited in 1776, with Gainsborough even going so far as to echo the way in which Reynolds had posed the Duchess. The large landscape *The Watering Place* (pl. 190) was designed – among other things – to demonstrate its painter's artistic range and learning. It had the desired effect on many, including Horace Walpole, in whose opinion the picture was 'In the style of Rubens, and by far the finest Landscape ever painted in England, and equal to the great Masters'.[54] Of the portraits, *Lord Gage* (thought by Walpole to be 'very like and well') displayed Gainsborough's gifts for setting an aristocratic sitter elegantly at ease in a landscape.[55]

Mrs Graham (pl. 84) and *Carl Friedrich Abel* (pl. 85) were calculated to do a great deal more. Both sitters were prominent in the public eye. Both portraits exemplify Gainsborough's unequalled artistic *bravura* and inventiveness. *Mrs Graham* is a brilliant extemporisation on a theme of Van Dyck's. It has been pointed out that the pose reverses that of Van Dyck's *Countess of Chesterfield* at Longford Castle: but Gainsborough makes Graham active and alert, rather than passive and pensive, aggrandising her setting with two large columns and a dramatically lit, stormy background. This offsets the ivory pallor of the face in a manner more familiar from contemporary portraits of military heroes.[56] The inversion of a device designed for the parade of masculine virtues was characteristic of a virtuosity which extends over the whole of the painting. As the pose was improvised from a pattern of Van Dyck's, so the costume was a recasting of items that one might associate with Rubens. Gainsborough showed off his expertise in anatomy by endowing Graham with an extravagantly long neck and arms, yet disguised these so effectively that they are hardly noticeable. Paint was handled with cavalier aplomb. Apparently random brush strokes created effects of folding drapery and shimmering surfaces, with, in places, the medium thin enough to communicate the appearance of diaphanous cloth. The underdress is an apparent chaos of brush-strokes, with the creamy ochre ground visible in places, countered to her left by a more saturated vermilion. Surfaces are built up, while flesh is handled with incredible finesse; faint blushing in the cheeks accentuates their paleness and complements the greenish tint in mod-

86 Detail of pl. 84.

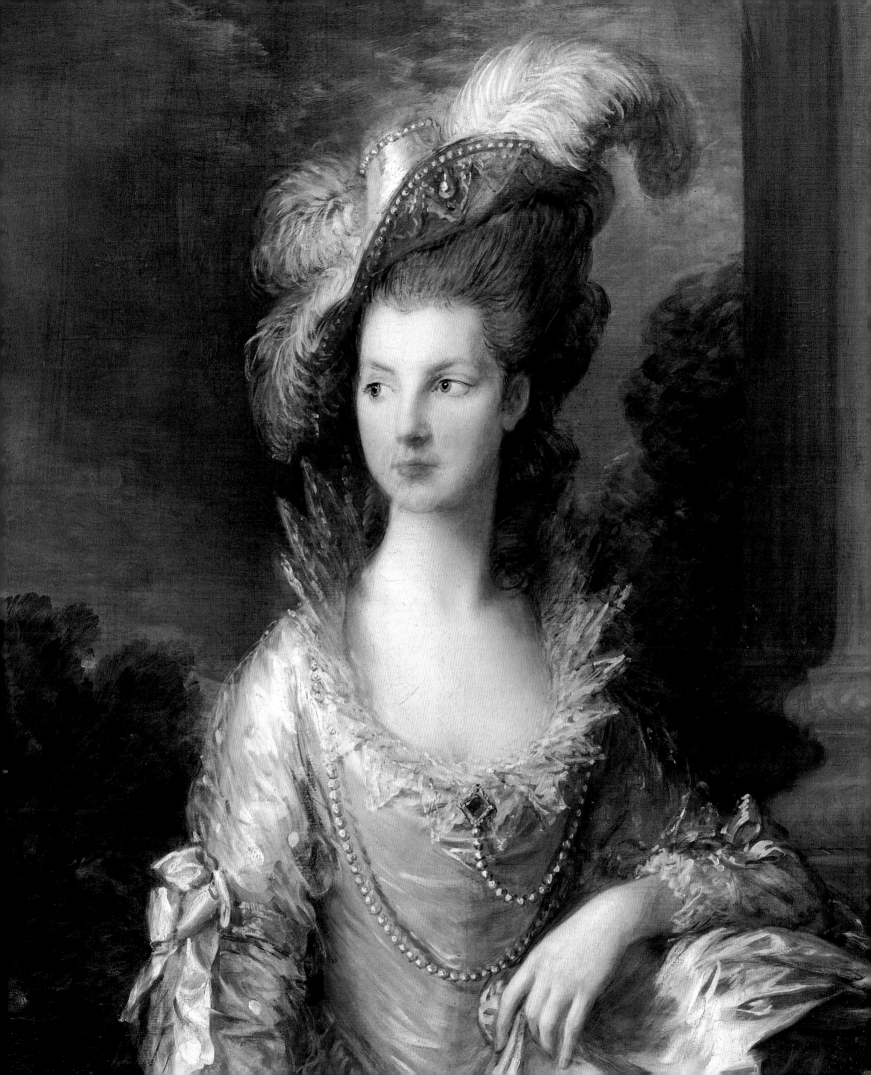

erately extensive but extraordinarily subtle shadows. Graham stands out because of the luxuriance of her costume; nevertheless Gainsborough has managed to make her appear folded into, as much as wrapped up in atmosphere. And within all this it appears to be clear that, if a comparison with Gainsborough's other portrait of the same sitter is any reliable guide (pl. 152), he preserved an excellent likeness of a person contemporarily acknowledged to be blessed with uncommon beauty. In addition – and here we might recall Bate on Reynolds's colouring – this is a chromatic and tonal *tour de force*. The blue of the sky, the silver of the bodice, and a skirt, in which at times the pigment is saturated to the point of sourness, are picked up in the local accents of blue eyes, pearls and ruby to combine in a complex and concentrated harmony.

Carl Friedrich Abel, a portrait of a musical superstar, is equally brilliant. Green curtain, gold waistcoat, red upholstery and blue jacket-lining, a play of primary and secondary colours, recall both the example of sixteenth-century Venetian painting (in particular Titian and Veronese) and an aesthetic tradition in which colouristic and musical qualities are regarded as positively complementary. 'In the distribution of colours', wrote Roger de Piles, 'there ought to be an agreement or harmony which has the same effect on the eye, as musick does on the Ear.'[57] In this light Gainsborough's painting engages in witty dialogue with its sitter, pointing up the harmoniously reciprocal connections between his own and Abel's respective arts. It also places itself in opposition to Reynolds who, in his fourth *Discourse*, had taken great pains to warn his auditors away from the seductive beauties of Venetian colouring, and, in so doing, had appeared deliberately to remonstrate with de Piles: 'Though it be allowed that elaborate harmony of colouring, a brilliancy of tints, a soft and gradual transition from one to another, present to the eye, what an harmonious concert of musick does to the ear, it must be remembered, that painting is not merely a gratification of the sight.'[58] In this portrait of Abel, then, Gainsborough, whom we have seen to have been exasperated by the fourth and fifth *Discourses*, seems to have set out to make a point, to define his distance from academic theory.

The portrait manages this in other ways. The format, one in which a (usually male) subject sits, engaged in private activities in an interior, was popular to the point of being hackneyed. Gainsborough had used it for *William Wollaston* (pl. 42), as did Reynolds, with *Warren Hastings* (pl. 87). What these portraits have in common is that each person is cogitative and inactive. By contrast, Abel is leaning forward, pausing in the act of composing: indeed, Malcolm Cormack has plausibly suggested that the shaft of light which falls both on his face and the curtain behind him is meant to emulate the 'flash of inspiration'. And while, following Cormack, the figure looks back to Roubiliac's famous *Handel* from Vauxhall, Abel is taut and restless in the way of some of Hogarth's portraits, for instance *Captain Coram* (pl. 133), rather than being relaxed and creative.[59]

In addition to these spectacular portraits, the landscape *The Watering Place* (pl. 190) was unprecedented in British art. In 1768, when Gainsborough urged Garrick to 'call *upon any pretence* . . . at the Duke of Montagu . . . to see his Grace's Landskip of Rubens', he meant Rubens's *Watering Place* (pl. 191), with which Gainsborough's later invention does have compositional connections. John Hayes points to 'the highlit trees growing out of a steep bank and the silhouetting of the foliage against the evening sky', and convincingly adduces the example of Titian as a reference both for the background and the handling of foliage.[60] This all goes to set this quite large landscape (just shy of six feet in breadth) within an extremely respectable old master tradition, ironically following Reynolds to the letter. In the sixth *Discourse* of 1774 he had commended the artist 'who borrows an idea from an antient, or even from a modern artist not his contemporary, and so accommodates it to his own work, that it makes a part of it, with no seam or join appearing' as one who 'can hardly be charged with plagiarism . . . an artist . . . should enter into a competition with his original, and endeavour to improve what he is appropriating to his own work.'[61] As we shall see, the cross references were employed to elevate a subject of a type which Gainsborough was rehears-

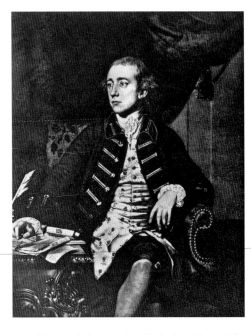

87 Thomas Watson after Sir Joshua Reynolds, *Warren Hastings*, 20 March 1777, mezzotint.

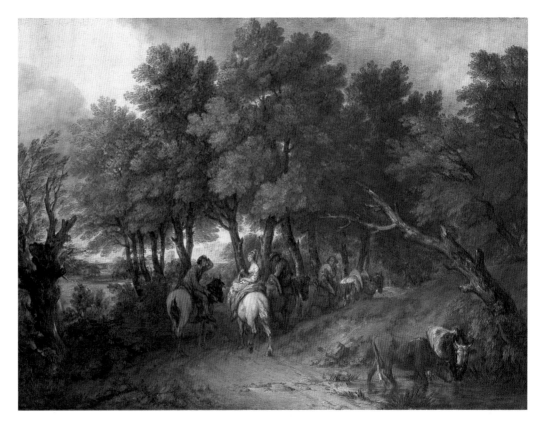

88 *Wooded Landscape with Mounted Figures*, 1767–68, oil on canvas, 1,213 × 1,702 (47³/₄ × 67). Toledo Ohio, Toledo Museum of Art; Purchased with funds from the Libbey Endowment, Gift of Edward Drummond Libbey.

ing in various media, initially graphite and watercolour, and, with *The Watering Place* specifically, soft-ground etching with aquatint (techniques recently introduced, with which he had been experimenting since the earlier 1770s).[62] It is realised as a type of England, with an independent peasantry enjoying an untroubled existence amidst uncultivated scenes, closely comparable to those in which portrait sitters were sometimes located; and the imagery is contentious in that it opposes the ideology of agrarian capitalism as manifested most dramatically at this time in the first great wave of engrossing, and the enclosures of common land such as Gainsborough's figures inhabit.[63]

If the return to the Royal Academy was a gamble, Thomas Gainsborough took every care to shorten the odds in his own favour. And, if only Henry Bate was completely partisan, other reviewers were prepared to be generous with their praise. *The Watering Place* was judged by a self-styled 'Italian Artist' to be 'inimitable. It revives the colouring of Rubens in that Line. The Scene is grand, the Effect of Light is striking; the Cattle very natural: But what shall I say of the Pencilling? I really do not know; it is so new, so very original, that I cannot find Words to convey any idea of it.'[64] The same writer was as eloquent in praise of *Carl Friedrich Abel*: 'an exceeding good portrait . . . from Top to Bottom a striking Likeness', in which 'the Accessories, though extremely natural and distinct, are kept in their proper subordination to the Figure'.[65] Abel would be easy to test for likeness, since many would have known him from his public performances, but this language is also couched in terms that suggest that Gainsborough had access to journalists besides Bate.

Although Gainsborough had managed his return to exhibiting as well as possible, subsequent years saw the recurrence of old problems and the development of new ones, as his relationship with the Royal Academy began to sour once again.

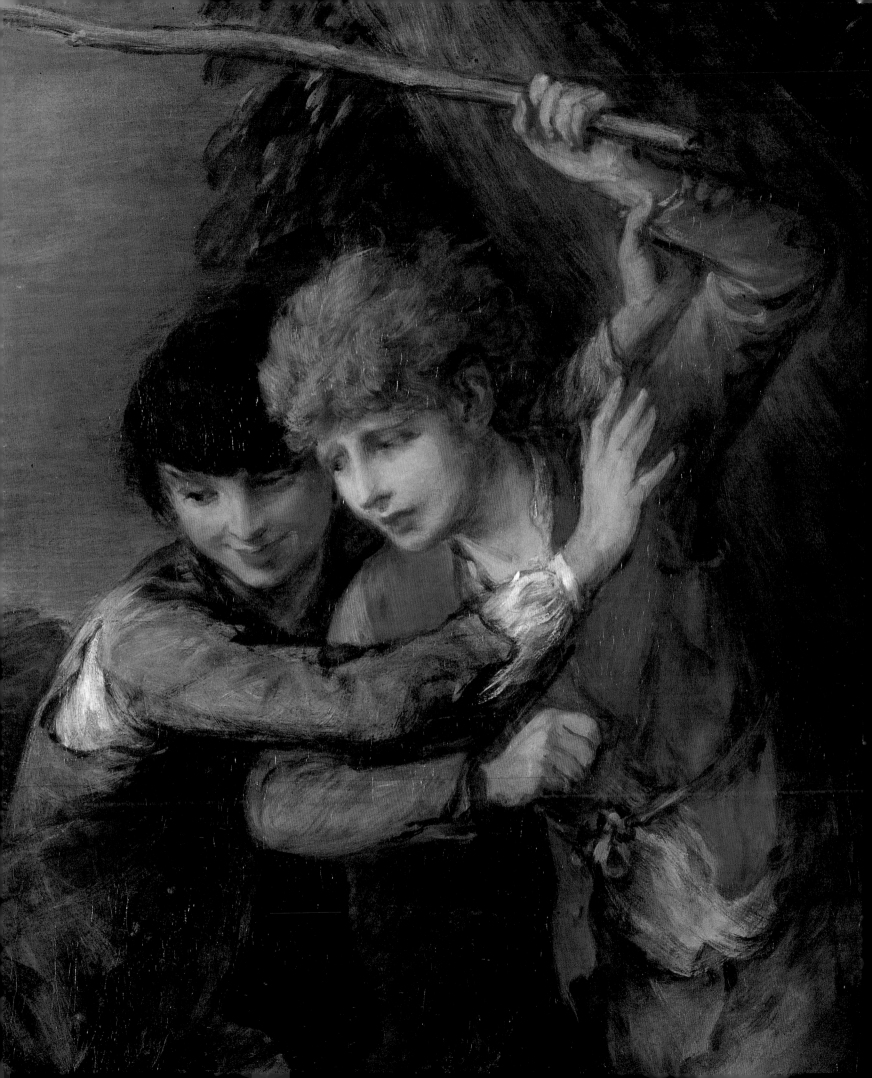

5 *Diversification and Defection*

Returning to the Royal Academy paid dividends. By the early 1780s, Gainsborough and Reynolds were popularly assumed to occupy the principal positions in the artistic hierarchy; so that when in 1783, the *Whitehall Evening Post* wrote of their 'maintaining an honest and laudable species of rivalry', this reinforced an assessment offered (not without ambiguity) the previous year in the *Morning Chronicle*, which noted that 'as usual there has been a proud rivalship between the pencil of the President and that of Mr Gainsborough; that the former has kept the superiority almost without the latter's having to acknowledge it'.[1] While journalists were far from disinterested in their writing, this kind of reporting does indicate the public stature that Thomas Gainsborough had rapidly consolidated after 1777.

Though the recognition was real enough, the issue is not unproblematic. In an *Essay on Landscape Painting* which J. H. Pott published in 1782 was a chapter entitled 'Hints for forming the Taste of an English School'. 'In considering Gainsborough's character as a painter,' he wrote, 'I feel strong inducements to give him preference to all his predecessors or contemporaries in this country' (and these contemporaries had included, it is worth pointing out, Richard Wilson). Pott's view over Gainsborough's landscapes was retrospective. He distinguished a first manner, in which Gainsborough had principally 'imitated Wynants' to give 'a faithful representation of English nature'. This gave way to a second, broader manner; which Pott understood as aiming 'at something more elevated', and one that still developed the lessons of the Flemings, but was now learning from such artists as Artois. The results of this change inspired Pott to hyperbole:

> Although in this latter manner he gives us little of the detail of nature in its more delicate graces, yet his works have encreased inconceivably in their merit and value . . . Nothing can be more charming, forcible, and harmonious than his colouring now is, his pencilling is broad and masterly, the light and shade wonderfully well managed, and the effect of his pictures is not to be equalled by any master, antient or modern.[2]

Various factors make this encomium remarkable, not least its choosing to single out Gainsborough as a landscape painter, when between 1777 and 1782 his chief exhibits at the Royal Academy had been portraits (although his landscapes were increasing as a proportion of the whole). This representation of Gainsborough has to be tallied with William Beechey's oft-repeated observation that at Schomberg House unsold landscapes 'stood ranged in long lines from his hall to his painting-room, and they who came to sit to him for their portraits, for which he was chiefly employed, rarely deigned to honor them with a look as they passed them'.[3]

Pott's classification of the landscapes is also noteworthy. Gainsborough, 'personally acquainted with his obituarists', according to Whitley, was remembered in the *Morning Chronicle* as having based his manner first on Wynants, then Ruisdael, before developing a kind of painting remarkable for 'a more powerful effect, with less labour'. The *Gentleman's Magazine* connected this style with Rubens. These accounts conform in general ways with William Jackson's discription of how his erstwhile friend's landscapes had evolved through three phases. Initially based on Ruisdael, Gainsborough's work had become characterised 'by an extravagant looseness of pencilling; which, though reprehensible, none but a great master can possess', and, eventually, 'a solid, firm style of touch'.[4] As Gainsborough would,

89 Detail of pl. 103.

late in life, remember his 'first imitations of little Dutch landskips', and as his obituarists and Jackson all knew him, these accounts might respond to his own view of his development. If so, then Pott, who, unusually, knew Gainsborough's earliest landscapes, could conceivably have based his account on what he heard from the artist himself.[5]

Gainsborough's disclaimer that he did portrait only 'to make the pot boil' may betray some anxiety.[6] As we have seen, he did not feel that his portraits showed well in exhibition conditions, and the problem would recur. If, as seems likely, J. H. Pott was acquainted with Gainsborough, then his well-informed and extravagant praise may have been intended to promote Gainsborough as the leading landscape painter of the day. Richard Wilson had dropped out of the reckoning, leaving London for Wales in 1781 and dying in 1782, so the position was notionally vacant. Indeed, at this period Gainsborough was formally relating his work to Claude and Gaspard, as well as Rubens, to advertise its very great seriousness.[7] In light of this, it may signify that, in its review of the 1780 exhibition, the *Morning Post*, in which Bate aired Gainsborough's gripes, followed its usual encomium with the complaint that 'It is to be lamented, however, that the generality of his beautiful landscapes could not have been placed in such light and at such distance for which they were so evidently painted.'[8] Pott's book, despite its limited impact, deserves note as a possible attempt to sway public taste.

This was necessary because, despite any claims the Royal Academy had to impartiality, exhibitions were competitive; and because a significant amount of published art criticism was, as we have seen, partisan.[9] To illustrate that first point we need note only that, after Gainsborough had made his spectacular return in 1777, Reynolds responded in 1778 by exhibiting the phenomenal *Marlborough Family* (pl. 90). Unmissable on a canvas measuring over 10 by 9 feet, this was a deliberate *tour de force*, a demonstration of the possibilities of grand-style portraiture in confirming the power and status of an aristocratic family, placing them in a setting designed not so much to represent Blenheim, as to put the spectator generally in mind of some of the staging in Veronese's compositions. The colouring, which has faded, would have been as fittingly brilliant, dominated by saturated reds and blues. Noticeable are the clear demarcations of masculine and feminine spaces, the sensitivity to children's behaviour, the managing of an hieratic group while keeping the essential element of simple domesticity properly subordinate.

As the *St James's Chronicle* put it, 'Sir Joshua has astonished the Publick with a wonderful Picture of the Marlborough Family.'[10] The *London Evening Post* followed this up, observing first that the exhibition was superior to the previous year's due to 'many capital paintings, among which those of Mr Mortimer, Mr Wright, and some others, who never exhibited in the Royal Academy before, bear a principal part'. However, the '*chef d'oeuvre* of the whole is Sir Joshua Reynolds's family of the Duke of Marlborough. It is impossible to speak too highly in praise of this piece.'[11] The praise was general. The *Morning Chronicle*, which thought this 'one of the finest grouped pictures that ever was exhibited', noticed Gainsborough's work at length, but equivocally. He was satirised for his portraits of demireps, upper-class courtesans like Grace Dalrymple (pl. 91), whose own painted faces were matched against the artist's transcriptions of them. And while the portrait of James Christie (pl. 77) was 'so striking a likeness that the name need not have been printed in the catalogue', other portraits were remarked for peculiarity of pose, and his exhibits in general for comparative lack of finish.[12] Only Bate, describing Gainsborough as the '*Apelles*' of the Royal Academy, capable of an 'exact similitude' in his likenesses, 'infinitely . . . superior' to Reynolds 'in the brilliancy of his colouring', and, moreover, 'a competitor of *Rubens*' in his landscapes, demurred from the general opinion.[13] Sheridan had mocked such partisan promotion, raising laughs from his character Puff in *The Critic*, played by Mr King, who proclaimed in respect of 'the Puff direct', that 'It is not in the power of language to do justice to Mr KING!'[14]

We have already read Bate complaining about the hanging of Gainsborough's landscapes. In 1781, now with the *Morning Herald*, he would warm to this theme. In this year, along

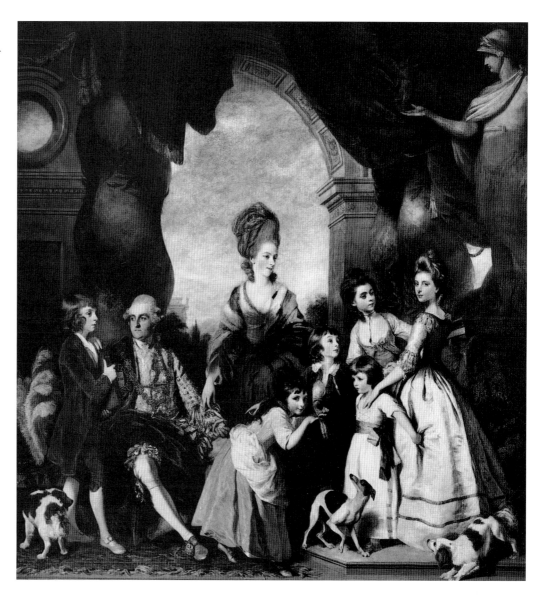

90 Sir Joshua Reynolds, *The Marlborough Family*, 1778, oil on canvas, 3,180 × 2,890 (125^1/$_4$ × 113^3/$_4$). Blenheim Palace, the Duke of Marlborough.

with major portraits of George III and Caroline, Gainsborough exhibited *A Shepherd*, which is now known only through Earlom's print (pl. 230), and varieties of landscapes, including coastal scenes (pl. 92). This was enough to make him 'the principal support of the present exhibition'. Since Gainsborough and Bate were in cahoots, this probably conveys Gainsborough's assessment of his own stature. For now, Bate, having praised the royal portraits to the skies, exceeded even his own hyperbole in calling *A Shepherd* 'evidently the *chef d'oeuvre* of this great artist, a composition in which the numberless beauties of design, drawing, and colouring are so admirably blended, as to excite the admiration of every beholder!'. Gainsborough, along with Reynolds, was in fact attracting general praise this year. The *Whitehall Evening Post*, which reprinted Bate's encomium, also credited the President with 'contributing very liberally towards enriching the present collection', and this was a common view.[15]

Bate was one of two critics to censure the hanging of Gainsborough's landscapes. His review went on to remark how the 'effect' of *River Landscape with Rustic Lovers* (pl. 97) was 'like that of his other productions . . . shamefully destroyed, by the picture being hung almost too close to the ground. – Strange, that the fame of an artist who is honoured by the most flattering marks of his Sovereign's favour, should here be sacrificed, on the pitiful shrine of

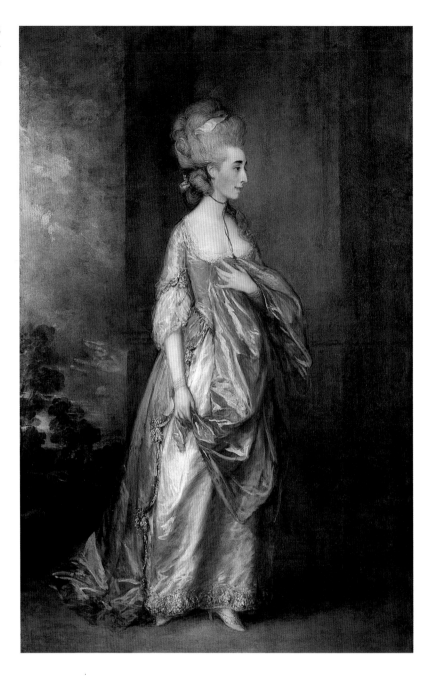

91 *Grace Dalrymple*, 1778, oil on canvas, 2,306 × 1,512 (91¼ × 60½). New York, The Metropolitan Museum of Art, Bequest of William K. Vanderbilt, 1920. (20. 155. 1).

ignorance, or jealousy!' This intemperate outburst intimates that a special relationship with the king should guarantee Gainsborough special treatment, were it not for the ungenerous sentiments of some of his fellow artists. Such partiality aroused the ire of a writer for the *London Courant*, who attacked Bate and put Gainsborough very firmly in his place, behind Reynolds. And then we are warned not to ascribe particular positions to particular newspapers, for this one additionally carried an Academy review which, like Bate's, had much to say on the poor hanging of Gainsborough's landscapes: sentiments which gain an edge if the artist was aspiring towards a public identity as a landscapist at this period. The passage is worth quoting at length. Noticing in particular *A Rocky Coastal Scene* (pl. 92), the reviewer wrote of its

> broad, bold, masterly stile; a capital landscape, freely coloured; and although more highly finished than is usual with this artist, yet his pictures can never be seen to advantage when the room is filled with company, as they are hung much too near the eye. Mr.

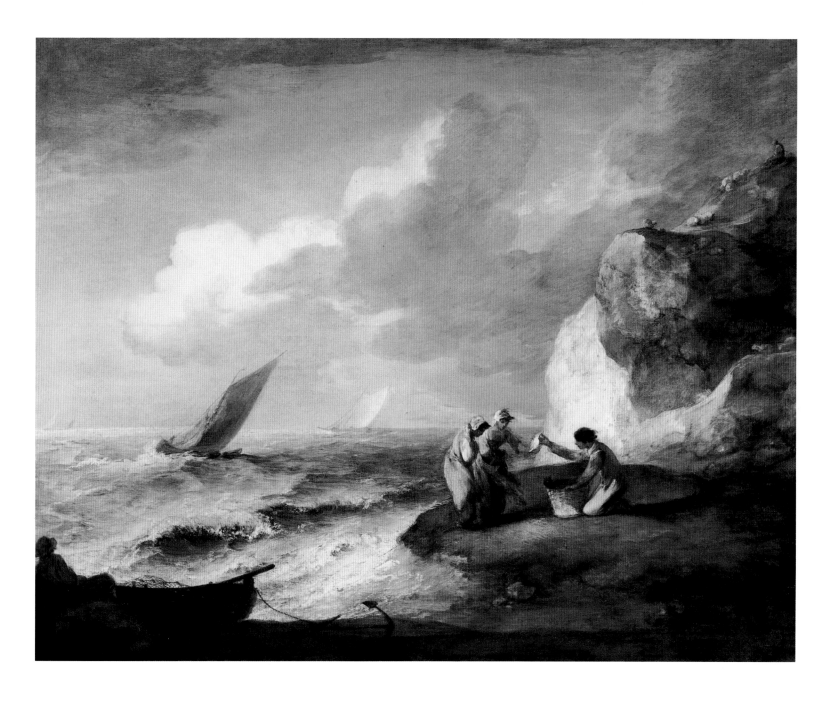

92 *A Rocky Coastal Scene*, 1781, oil on canvas, 1,003 × 1,270 (39½ × 50). By kind permission of His Grace The Duke of Westminster, OBE TD DL.

Gainsborough's character as a landscape painter has been materially and constantly hurt by this very visible defect. If they were too far from the eye, it might perhaps be equally bad; but an artist of this gentleman's merit should be particularly accommodated, though inferior artists suffer from it . . . The distance from the eye should not be in proportion to the size of the picture, but in proportion to the breadth of light and shadow, and the high finishing: and those pictures which are unavoidably hung high, should lean much more forward than they do at present.[16]

Gainsborough, as noted above, was intensely concerned that his pictures should be seen properly so that their unique qualities might be discerned. The comments on hanging here communicate a particular expertise, and one has to suspect that the artist had contact with the writer, if only because he is willing to have 'inferior artists suffer' in comparison with the preferential treatment proposed for him.

He certainly had some journalists in his pocket. In 1784, he withdrew his Academy

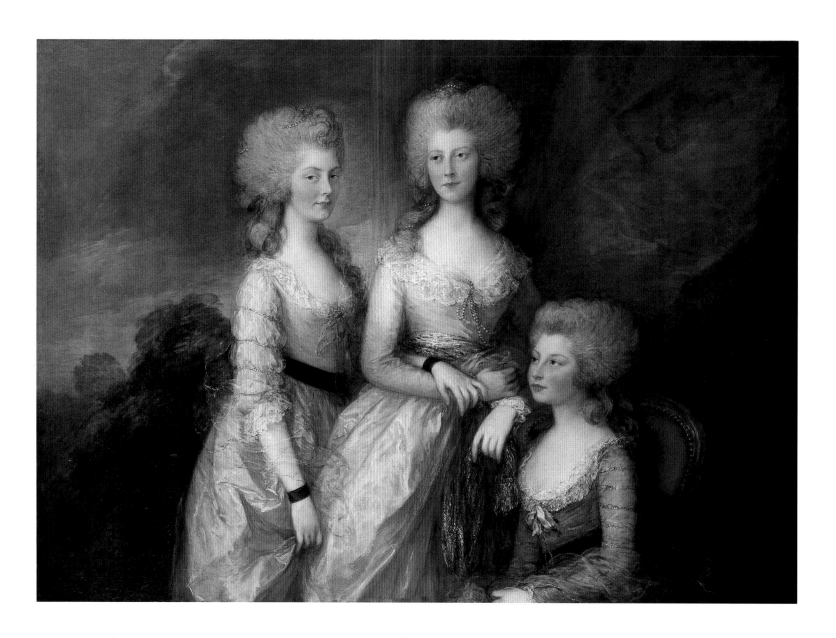

93 *The Three Eldest Princesses*, 1784, oil on canvas, 1,295 × 1,797 (51 × 70¼) (cut down, with addition of 115 mm on left; originally 2,540 × 1,790 (100 × 70½)). The Royal Collection. © Her Majesty Queen Elizabeth II.

exhibits, which included a full-length of the three eldest princesses (pl. 93), commissioned by the Prince of Wales. Referring to the decision by 'the *Royal Academy Inquisition*' (the type of language which the Academy had provoked since its inception, and which serves to remind us that many artists were involved in factional politics) not to accede to his request not to hang the painting above the 'line' (the cornice in the Great Room at Somerset House, which was conventionally taken as marking the proper height for the frame bottoms of full-length canvasses), a paragraph in the *Gazetteer and New Daily Advertiser* continued:

> It [the portrait] was painted for the Prince of Wales's state room on Carleton Palace, for a *height* already ascertained, as the frame which is to receive it is formed in the panels. The requisition the artist made, to hang it at the *same height* in the Exhibition-room, ought surely to have been attended to in so particular an instance, particularly when it is remembered that the *colouring* is *tender* and *delicate*, so that the effect must be destroyed by an injudicious elevation.[17]

This echoes what Gainsborough himself wrote when he withdrew his exhibits:

> as he has painted the Picture of the Princesses, in so *tender* a light, that notwithstanding he approves very much of the established Line for strong Effects, he cannot possibly

94 Gainsborough Dupont after Thomas Gainsborough, *The Eldest Princesses*, mezzotint. Sudbury, Gainsborough's House.

consent to have it placed higher than five feet & a half, because the likenesses & Work of the Picture will not be seen ay higher.[18] [my emphasis]

The opposing view was to be had from a notice printed in both the *Public Advertiser* and the *Whitehall Evening Post*, which pointed out that he had tried to dictate the hanging of his pictures to an unreasonable extent, while the *Morning Post* reminded readers that the

works of Sir Joshua Reynolds, who may justly be stiled the *Corregio* [sic] of the age, are distributed through the several rooms at different heights and distances. We cannot therefore discover why Mr. Gainsborough should arrogate to himself an advantage, not allowed to a person, who added to his rank as president, has certainly greater ability in his profession.[19]

The same paper had two days previously printed a piece probably written by John Hoppner which told Gainsborough's side of the story, even down to the royal portrait's being painted for a height of five feet six inches.[20]

I shall return to this incident below, but, for the moment, wish to make one essential point. The public exhibition, with rival painters competing, was a business in which a great deal was at stake. I have suggested that press reviews created a kind of alternative exhibition, directing the attention of readers who might become spectators towards particular canvasses in certain sequences. Consequently artists cannot be wondered at for having attempted to dictate the content of such writing. Gainsborough returned to the Academy only when assured of the backing of Henry Bate. In 1781 one squib reviewed the Royal Academy exhibition at length and made an interesting case for Gainsborough (perhaps in a parallel to the *Town and Country Magazine* in 1772).

This was *The Ear-Wig*, dedicated ironically to Sir Joshua Reynolds. This assumed a flippant tone, reserving extravagant praise for Gainsborough, whose *Richard Hurd, Bishop of Worcestor* (pl. 96), a commission from the Queen, was 'One of the finest portraits that has been seen', and whose royal portraits (pls 105, 106) were 'the best Portraits in the Exhibition, and want very little of perfection'. In contrast was Benjamin West, who had painted the same sitters, and had 'ascertained the exact proportion of his Majesty, with a compass and taylor's measure, from head to foot, and . . . produced a stuffed pillow', or, in part Reynolds. The latter's *Temperance* and *Fortitude* were 'perfectly sublime'. However, *The Death of Dido* (pl. 95) called 'for a criticism . . . more severe than any of his pictures have ever merited', and *Thais* was

95 Sir Joshua Reynolds, *The Death of Dido*, 1781, oil on canvas, 1,473 × 2,394 (58 × 94¼). The Royal Collection. © Her Majesty Queen Elizabeth II.

97 *River Landscape with Rustic Lovers*, 1781, oil on canvas, Oval, 1,226 × 1,632 (48¼ × 64¼). Private collection.

96 (*facing page*) *Richard Hurd, Bishop of Worcester*, 1781, oil on canvas, 762 × 635 (30 × 25). The Royal Collection. © Her Majesty Queen Elizabeth II.

censured as a demonstration of the artist's pettiness of character in having portrayed Emily Bertie, who had owed him money, as a famous prostitute.[21] As Reynolds set great store by his subject pictures these darts were aimed to wound, particularly as Gainsborough received further extravagant encomia.[22] *A Shepherd* was 'unrivalled', *River Landscape with Rustic Lovers* (pl. 97), 'charming', but 'prejudiced by being hung either too near or too far from the eye. The distance should be proportioned not to the size of the picture, but to the finishing, to the light, and to the shadow. This Gentleman's confessed abilities entitle his works to a preference of place.'[23] The wording is so close to that in the *London Courant* that W. T. Whitley very reasonably proposed that Mauritius Lowe (an unsuccessful history painter) wrote both pieces.[24] Bate's review of the 1781 exhibitions indicates that the grouses about hanging and the sentiments on viewing distances and finishing were coming from Gainsborough himself; and, as we saw, Bate stated what Lowe hinted at, which is that Gainsborough's having received royal favour entitled him to preferential treatment.

George III disliked Reynolds. The king's dealings with the Royal Academy were handled through William Chambers, his former tutor in architecture. Gainsborough, as we have seen,

was highly regarded by the king, who found him congenial; a contemporary described him as 'the Apollo of the Palace'.[25] Therefore, if an artistic hierarchy was to be erected according to social criteria, Gainsborough could assume that he stood at the top as Court Painter, the Van Dyck of his day. In consequence, the claims of the Royal Academy to regulate artistic status were called into question, as effectively as the Academy undermined its own *bona fides* by its treatment of some of the most significant contemporary artists – Robert Adam and George Romney (never admitted members), or Joseph Wright and George Stubbs. Wright was held in the highest public regard, yet saw Edmund Garvey elected R.A. over him in 1783 and declined to take up full Academicianship in 1784. As he wrote, he 'felt no inclination to become a member of a Society from whom I had repeatedly received the most humilating treatment, the most flagrant abuse'.[26] George Stubbs had been elected A.R.A. in 1780, and R.A. in 1781, at which year's exhibition he showed four enamel paintings. These were noticed favourably by papers which also commented on the technologically innovative collaboration with Wedgwood to produce large ceramic supports for the enamels.[27] Despite this Stubbs had the 'mortification' to discover the enamels in particular badly hung, and the quotations and subjects of the pictures left out of the catalogue, 'which conduct he considered as highly disrespectful . . . treatment he felt with particular sensibility', as designed to 'discredit the enamel pictures'.[28] Stubbs never submitted a Diploma Picture and therefore never took up his Academicianship.

The Academy would have countered that Stubbs, a mere horse painter, occupied a low rank in the artistic hierarchy, and that recognition of his technical merits in electing him R.A. should not be taken to obscure that fact. Wright's situation was more complicated. He was recognised as one of the foremost British artists, but in a line which, as has been shown above, the Academy was not fitted to accommodate. The sheer quality of his illusionistic effects would have sat uneasily with an institution that advocated a generalising approach to nature, and would have called into question the precepts that, with increasing reservations, Reynolds had been promoting in the *Discourses*.[29]

Gainsborough, in his own way, was as much a maverick. He insisted on being taken on his own terms by electing usually neither to moderate nor to adjust his handling in order to combat exhibiting conditions (Reynolds's was, by contrast, 'hard' enough not to suffer comparably); hence the complaints about bad hanging. The paintings were designed to appear to best effect in particular situations. He wanted his handling of paint to be admired, alongside the effects it achieved. Of the landscapes exhibited in 1781, one critic wrote, 'they appear, when near, like mere sketches, and everything is found in their effect'; another noted of *A Shepherd* that the 'Freedom of pencil is amazing'.[30] He was, as he would have wished, attracting plaudits for his *bravura*, his vivacity, qualities natural to a courtly art, as well as to a courtier. And because of his unique relationship with George III, he expected special treatment.

In 1783 he achieved this to an astonishing degree. He proposed to exhibit fifteen portraits of the royal family (probably commissioned by the queen), ovals, on canvases measuring around 22⅜ by 17⅜ inches (59 × 44 cm). These were to be hung *en bloc*, to form a composite group portrait, three deep by five wide (pl. 98). As one journalist put it, 'The King, Queen, and Royal Family (the Bishop of Osnaburgh excepted) painted by Gainsborough, make a conspicuous shew opposite the entrance to the room.'[31] John Wolcot wrote of Gainsborough's being 'mounted on thy painting throne', and looking 'contemptuous down' on 'other brushmen down', before

> My eyes, broad staring wonder leads
> To yon dear nest of royal heads!
> Now each the soul of my attention pulls!
> Suppose my friend, thou givest the frame
> A pretty little bible name.
> And call'st it *Golgotha, the place of Skulls?*[32]

Bate claimed that Gainsborough could now be installed 'at the head of the science', as 'unrivalled painter, who has done, by his matchless performance, so much honour to his country', but others were determined to put his presumption in its place.[33] The *Public Advertiser* denigrated his royal portraits in comparison with those of Reynolds, and advised him to stick to rural scenes.

> ... the Triumph of Gainsborough is 34 and 35: The Landscape, and the Boys with Dogs fishing [*sic*]. These are the Scenes in which the Friend of Gainsborough and the Art will always wish to see him occupied – in which he works evidently and successfully *con amore*. – Portrait Painting he seems to struggle through with the Impatience that indicates it to be considered as a task of Duty.
>
> The Landscape appears to him a Labour of Love, on which his Imagination and Pencil never tire, and never leave, but to resume with augmented Rapture.[34]

This reasoned judgement wittily turned Gainsborough's distaste for portrait back on him, and implicitly belittled those which he had sent to the Academy. This is of interest, because he had made uncommon efforts to get them hung as he wished.

He wished the block of royal portraits to be the first thing to meet the exhibition-goer's gaze and achieved this by means of threats:

> Mr. Gainsborough presents his compliments to the Gentlemen appointed to hang the pictures at the Royal Academy; and begs leave to *hint* to them, that if the Royal Family, which he has sent for this Exhibition (*being smaller than three quarters*) are hung above the line along with the full-lengths, he never more, whilst he breathes, will send another picture to the Exhibition. This he swears by God.[35]

It was of course the prospect of royal displeasure which would have got him his way. Once that was assured, he adopted a tone of relaxed largesse in a note to Francis Milner Newton, Secretary to the Royal Academy: 'I wd beg to have them with the Frames touching each other in this order [illustrated with a sketch]. The Names are written behind each Picture. God bless you hang my Dogs and my Landskip in the great Room. The sea Piece you may fill the small Room with.'[36]

Genial puns notwithstanding, this was a display of extraordinary presumption. Gainsborough was, presumably, using the king's influence to direct precisely where his works should go. The fine work in the royal portraits would have been lost had the Academy's Hanging Committee taken them compositely as a picture larger than full length, and therefore to be skied, so Gainsborough was not acting solely out of ambition. If the reception of Gainsborough's exhibits is a true indicator, then he did very well. One journalist, as we saw, thought *Shepherd Boys with Dogs Fighting* (pl. 103) a 'Triumph'; a second called it 'The best if not the very best picture in the room'; and a third was rhapsodic:

> any panegyric upon it is but *actum agere*. His praise is lost who stays till all command; yet what we want in compliment, we shall make up in sincerity, honestly protesting how much we admire it – that it is equally transcendent in all its part, that the dogs are as good as anything in Schmiders [*sic*], and the two boys appear to us *Murillo* in his best manner!

The writer then illustrated the propriety of the composition by pointing out 'the preservation of the characteristic appearance, so well discriminating both the Boys and the Dogs – the one being a shepherd and a Shepherd's Dog; the other a Butcher's Boy, and a Butcher's Dog!'.[37]

This was an astute critique, recognising the sophistication of this representation of a rural incident. *A Shepherd* (pl. 230), which had caused such a sensation in 1781, was the first of the works in which Gainsborough had moved the figure onto the larger scale. This was followed up with *The Girl with Pigs* (pl. 231), bought by Reynolds (although later sold on),

98 *The Royal Family* (ensemble of fifteen por-
traits), 1783, oil on canvas, each *c.* 590 × 440 (23¹/₄
× 173/8). The Royal Collection. © Her Majesty
Queen Elizabeth II.

99 William Hogarth, *The First Stage of Cruelty*, 1751, etching with some engraving. London, British Museum.

100 (*far right*) William Hogarth, *The Second Stage of Cruelty*, 1751, etching with some engraving. London, British Museum.

101 (*above*) M. Rota after Titian, *The Death of St Peter Martyr*, engraving. London, British Museum.

102 *Titian, The Vendramin Family*, 1543–47, oil on canvas, 2,057 × 3,010 (81$^{1}/_{16}$ × 118$^{1}/_{2}$). London, National Gallery.

103 *Shepherd Boys with Dogs Fighting*, 1783, oil on canvas, 2,235 × 1,676 (88 × 66). London, Kenwood House, Iveagh Bequest.

who called it 'by far the best picture he ever painted, or perhaps ever will'.[38] These paintings set themselves into an Old Master tradition most characteristically exemplified by the paintings of Murillo; and in so doing they expanded their pretensions well beyond the representation of low-life subjects. (As we shall see, *A Shepherd* associates itself with the figure of Christ as shepherd.) The reviewer quoted above was aware of this, connecting the dogs to Snyders (presumably a typesetter misread the manuscript) and the boys to Murillo.

In fact, *Shepherd Boys with Dogs Fighting* juxtaposes a subject adapted from the first two of Hogarth's *Stages of Cruelty*, with colouring and composition from Titian: the former from

The Vendramin Family (pl. 102) (in which the small boy's costume is green and scarlet, and which Gainsborough had copied) and the latter from *The Death of St Peter Martyr* (pl. 101).[39] Thus a modern moral subject is cast in the idiom of an admired master – one, moreover, whose reputation as a supreme colourist and handler of oil paint could transfer kudos by association. This, therefore, was a modern art locked into a British tradition, but referring to the masters in ways that attributed to them importance very different from that suggested by Reynolds. Rather than representing a zenith to which a modern art might aspire but never reach (while containing a variety of artistic lessons), this alternative recognised an historical distance of a kind that created problems in conceiving of this kind of a relationship. Titian's world was not Gainsborough's. Nevertheless, his art, like that of Ruisdael, Rubens. Claude and Watteau dealt with problems of composition and the handling of paint, achieving effects which could be understood as ahistorical; and it was therefore here that lessons could profitably be had.

A longer and more detailed analysis of these issues will be offered below, but if Gainsborough was an ironist, then we ought to note the self-effacing humour with which he wrote about *Shepherd Boys with Dogs Fighting* to Sir William Chambers, as the 1783 exhibition opened:

> I sent my fighting dogs to divert you. I believe next exhibition I shall make the boys fighting & the dogs looking on – you know my cunning way of avoiding great subjects in painting & of concealing my ignorance by a flash in the pan. If I can do this while I pick pockets in the portrait way two or three years longer I intend to turn into a cot & turn a serious fellow; but for the moment I must affect a little madness.[40]

Gainsborough's 'cunning way of avoiding great subjects' was to paint ostensibly humble ones in their lieu. Yet the inverted pastoral of *Shepherd Boys* (for they should be looking after not ignoring their flocks) in combination with a setting evolved from that of a saint's martyrdom is profoundly problematic. Gainsborough claims only to 'affect a little madness'. He invites us to consider that this may indeed be a great subject, but not in the academic tradition advocated by Reynolds. There had been intimations of this, through the updating of Murillo, the aggrandising of cottage scenes into sequestered but impressive woodland settings that somehow have the air of sixteenth-century Venetian painting, and in other ways besides, which we may mark as part of a continuing dialogue with the academic.

In this context it is extremely significant that in autumn 1783 Gainsborough made a tour, certainly to the Low Countries, and probably to Paris too. In Antwerp he may have copied Rubens's *Descent from the Cross*. He later claimed to have seen 'most of the celebrated works of Poussin', and Bate inserted this notice into the *Morning Herald* for 5 November 1783: 'Gainsborough is working on a magnificent picture [*The Mall*; pl. 104] in a style new to his hand; a park with a number of figures walking in it. To the connoisseur the most compendious information is to say that it comes nearest to the manner of Watteau, but to say no more it is Watteau far outdone.' This suggests that he had also visited France.

Interestingly, Bate would later deny that this version of *The Mall* was Watteauesque and would inform the public that 'the imitation' was 'strictly from nature' while 'the style of colouring' possessed 'every originality'.[41] As Bate was Gainsborough's mouthpiece, this revision confirms what the letter to Chambers suggested: that Gainsborough had the most serious artistic aims, but a great anxiety to conceal this. For the courtier all art must appear as effortless as the *bravura* of his handling of paint.

The Mall does make obvious allusions to the art of Watteau, with its concern with sophisticated leisure, its colouring, its parade of small figures in a park, and its setting up of apparent interrelationships through glances and sidelong looks. It understands the element of play, of artificiality, central to the *fête champêtre*, but recasts this in the representation of an actual place where the polite and others were wont to parade, stare and flirt. Gainsborough used previous art to give profundity to modern subjects, to indicate, by the 1780s, a real seri-

104 *The Mall*, 1784, oil on canvas, 1,206 × 1,470 (47¹/₂ × 57⁷/₈). New York, Frick Collection.

ousness about the practice of painting itself. That is one of the reasons that the tensions between Gainsborough and the Academy became so extreme. Royal Academy exhibitions were a necessary evil as a space to reveal his art to the public, and yet were inimical to the kind of painting that he created. This and similar problems disadvantaged others as well.

On 30 April 1783 the *Public Advertiser* carried a piece (signed from 'Strawberry-Hill' and therefore pretending to be by Horace Walpole) lamenting that 'from some Motive or other, Littleness, Inattention of the Time, or petty Cavil, several good Masters are this Year absent from their Duty – their Duty, natural at least, if not positive, in Support of the common Cause common to every Englishman, the ARTS in BRITAIN!'. The paper named George Barret, the Sandbys, Nathaniel Dance, Romney and Wright. At the same time the paper noted the opening of 'Mr Barry's historical Exhibition' at the Adelphi. Barry had an ambiguous relationship with the Academy. Although he had exhibited nothing since 1776,

he had none the less been elected Professor of Painting in 1782 (although two years were to elapse before he delivered any lectures). He timed the opening of his decorations at the Adelphi to coincide with the opening of the Academy exhibition, and published *An Account of a Series of Pictures* to go with it, lamenting the state of affairs which allowed history painting to languish while portraiture flourished.[42]

Barry complained how, 'from our too eager attention to the trade of portraits, the public taste for the arts has been much depraved, and the mind of the artist often shamelessly debased'. And yet, the 'comparatively contemptible' business of portrait has gained some 'a rank and consequence'. 'Here then', he continued,

> is a situation strongly tempting a shewy man, to proceed a step farther, at obtaining a more universal admiration, if it can be obtained by mean hypocrisy, and all the disingenuous resources and quackery which must necessarily, and as he may think will probably, support an artificial consequence thus founded upon the unstable bases of folly and vanity.[43]

There was only one target here. Barry further attributed the suppression of history painting to foster the self-interest of portraitists to 'wretched cabals and misrepresentations', to imply corruption within the Academy itself.[44] Yet, he magnanimously conceded, there were exceptions which proved this rule. Some portraits

> in great measure compensate for the heaps of inconsequential trash, or pot-boilers (as they are called) which are obtruded upon the public-view; this may be lamented but cannot be helped, as an exhibition must be made up of what the painters are employed about. I am happy also to observe that some of our portrait painters are, besides their excellence in the line of their profession, no less remarkable for their unsullied honour and probity . . .[45]

He let his readership know who these might be, writing, 'I am no stranger to the merit of the fine portrait of Mr Abel at his desk, in the act of composing' (which insight into the specific subject he may have had from Gainsborough, painter of that portrait) or mentioning a portrait of 'Mr Hone', presumably the Nathaniel Hone who had been obliged to withdraw his *Conjuror*, an incisive deconstruction of Reynolds's compositional borrowings, from the exhibition of 1775.[46]

Barry thus included his friend Gainsborough in a group expansive enough to include the late Hogarth and Mortimer, detached from and oppositional to the more powerful cliques within the Royal Academy. Gainsborough could arouse violent antipathy himself. In the farce *The Royal Academicians* (published in 1786 but referring to the events of 1783 and 1784), John Williams (writing as Anthony Pasquin) has the character 'Truth' claim that Wright's disaffection stemmed from the elevation of 'Garbage' (as he styles Garvey) to R. A. over him (which was so) and that Romney feared being shown up by Reynolds. Gainsborough is styled 'Dawborough'. His

> private objection to exhibiting his pictures arises from more contracted and mean motives. *viz. fear* and *jealousy*: indeed, his whole conduct has been uniformly such a glaring insult to the rest of his fraternity, that if they were not the most stupid assemblage of all God's creatures, they would instantly expel him from a situation that he *affects* to treat with derision, though the first honours of his *narrowed existence* have derived from that *particular source*.[47]

By the time this was written Gainsborough had withdrawn his work from the Academy exhibition for a second and last time, amidst a great deal of controversy.

The root cause, as we saw, was another royal portrait, a full-length of the three eldest princesses (pl. 93), intended for the 1784 exhibition, with Gainsborough once more anxious it should not be skied. Again he wrote to the Academy, but now his tone was conciliatory.

He offered his 'Compts to the Gentlemen of the Committee, and begs pardon for giving them so much trouble', and asked, that if they could not comply with his request, that they send his pictures back.[48] This they did. The difference was that this time the commission had come not from the king but from the Prince of Wales. Gainsborough had no protection. The Prince of Wales retaliated against this snub by neglecting to arrive at the Academy dinner: 'The Prince of Wales', wrote Dr Johnson, 'had promised to be there, but when we had waited an hour and a half, sent us word that he could not come.'[49]

News of Gainsborough's decision, taken on 10 April, broke slowly, suggesting that a reconciliation was being attempted. As late as 20 April the *Gazetteer and New Daily Advertiser* anticipated that the 'approaching Exhibition will have unusual merit. Gainsbrough has his magnificent picture of a park, with a variety of figures in the manner of Watteau', to suggest that hope remained, for the paper was evidently in direct touch with the artist (yet to disclaim the Watteau connection). Three days later, it announced that

> An event has taken place which must concern every admirer of the *fine arts* in the kingdom. The celebrated Mr. Gainsborough, whose labours have so much contributed to enrich the *Royal Academy* for several seasons past, has been under the necessity of *withdrawing* his performances from this year's exhibition! The occasion of this step, it is said, was a refusal on the part of the *Academical Council* to hang *one* particular picture in a situation capable of showing its *effect*! A *number* of portraits and other paintings were left to the discretion of the hangers on condition that this *numerical* picture had some indulgence shewn it; but the *arbiters* who composed the *inquisition of taste* were regardless of the request, and decreed that it should be fixed at an *established height* called the *full-length line*. A wretched rule indeed! Which judges painting by the *size* of the canvas, and not by the *degree* of colouring; the *softness* or *strength* of which ought only to determine the *light* in which it should be placed!

It is not hard to see how the Academy might feel disinclined to show flexibility towards a member who had never been anything more than semi-detached. This was an incident of a different order to Wright's electing to send no more work, for Wright had been playing by the rules.

Since the language of the *Gazetteer* was virtually duplicated by Bate in the *Morning Herald* of the same day, where, as above (p. 100), we read also of 'the *Royal Academy* INQUISITION' and of Gainsborough's '*tender* and *delicate*' colouring, one has to wonder if Gainsborough was writing the copy himself. The Academy hit back through the *Public Advertiser*. Here, Gainsborough was described as 'fastidious, too tenacious of Claims, which probably were exorbitant', and it went on (in a way that supports the notion of last-minute negotiation), 'The Fact was this – He sent Word that Pictures of such and such specific Dimensions would come from him; and he at the same Time directed, that they should all have such and such particular Situations in the Room. Those Directions were in part offered to be complied with. Entirely to follow them was impossible.'[50] The considered view of another insider, for W. T. Whitley states that John Hoppner was writing for the paper until 1786, appeared in the *Morning Post* on 26 April.[51] Regretting Gainsborough's no-show, the piece nevertheless pointed out that, had he been granted the concessions he demanded, then 'Sir Joshua Reynolds, West, Copley, Loutherbourg . . . might claim an equal right of indulgence.' The row rumbled on. The partisan *Gazetteer* lamented the 'shabby principles' of the Royal Academy, along with the 'miserable envy which has been the means of driving from the rooms Mr Gainsborough, Mr Romney, Mr Barry, Mr Stubbs, Mr Wright, and others'. The *Morning Post* called the exhibition 'very superior to the last, nothwithstanding the secession of so eminent an artist as Mr Gainsborough'.[52]

In the event, Gainsborough resorted to displaying his work in his own gallery, but in late July, when, as Whitley observed 'all the fashionable people had left London'.[53] Bate gave a full account of the display in the *Morning Herald* none the less, and from now on this was

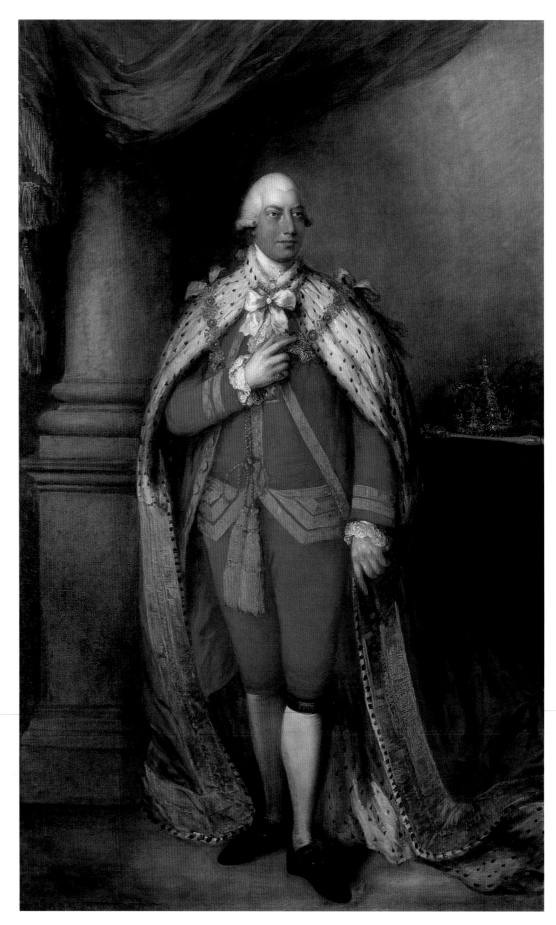

105 *King George III*, 1781, oil on canvas, 2,388 × 1,587 (94 × 62¹/₂). The Royal Collection. © Her Majesty Queen Elizabeth II.

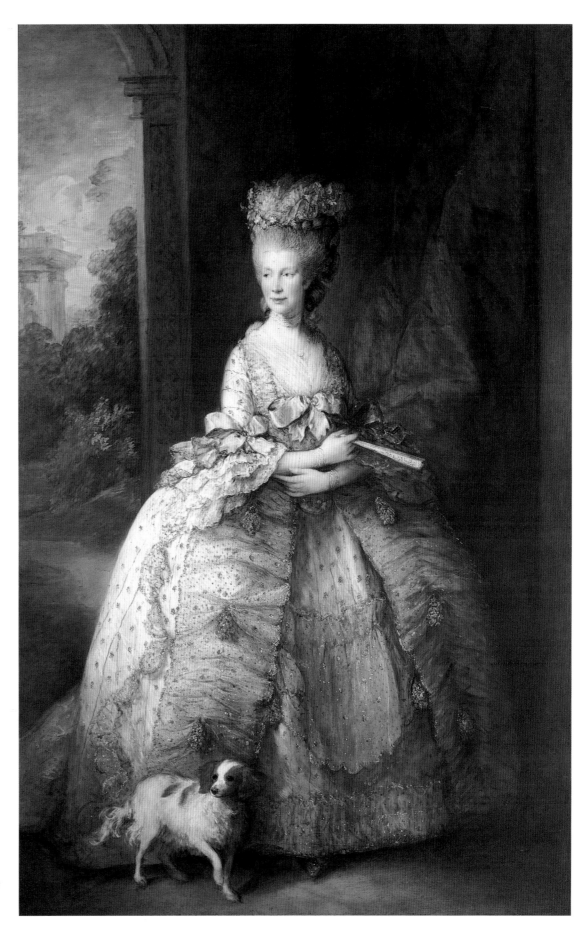

106 *Queen Charlotte*, 1781, oil on
canvas, 2,388 × 1,587 (94 × 62¹/₂). The
Royal Collection. © Her Majesty
Queen Elizabeth II.

how the artist presented his work to the public.[54] It was an obvious solution, for it gave Gainsborough absolute control over hanging and lighting, and focussed visitors' attention without the distraction of others' works, with the proviso that it was far less easy to out-paint the opposition in a one-man show. In 1785 Joseph Wright followed suit: 'My exhibition in London will open some time about 16 April for I am obliged to get the start of the Royalists.'[55] Meanwhile, a writer styling himself Timothy Tickle was carrying out an extremely well-informed and sustained attack on the Royal Academy for its treatment of Wright and Gainsborough, an attack which laid bare the depths of enmity and profound disagreements which co-existed among the artists.[56] By now Gainsborough had sustained another, very real setback.

He wrote about it to the Earl of Sandwich in November 1784, when he sent him a version of his portrait of the queen, on which a fair amount of work had been done by his nephew and apprentice, Gainsborough Dupont:

> I have not a word to say as to the young man's performance; but hope that if your Lordship should not think it well enough for the intended purpose, that your Lordship's cook-maid will hang it up as her own Portrait in the kitchen and get some sign-post gentleman to rub out the crown and sceptre and put her on a blue apron, and say it was painted by G—— who was very near being King's Painter only Reynold's Friends stood in the way.[57]

Allan Ramsay, who had been King's Painter, died in August 1784. Gainsborough (who, as late as 1786, Sophie de la Roche noted, 'always paints the Royal Family') evidently believed he would succeed him.[58] Reynolds utilised all the influence he could muster to get the position for himself. Edgar Wind notes that he resorted to 'threats. A pithy sentence in a letter from Johnson to Reynolds sheds light on these manoeuvres: "I am glad a little favour from the court has intercepted your furious purposes. I could not in any case have approved such publick violence of conduct".'[59] Once he had the job he was petulantly angry about the mean stipend that came with it, finding it 'a place of not so much profit with His Majesty's rat catcher'.[60]

A letter from Dr Johnson to Reynolds clarifies the latter's position.

> That the President of the Academy founded by the King, should be King's painter is surely very congruous. You say the place ought to fall into your hands *with asking for*, I suppose you meant to write *without asking for*. If You ask for it I believe You will have no refusal, what is to be expected *without* asking, I cannot say.
>
> Your treatment at court has been capricious, inconstant, and unaccountable. You were always honoured, however, while others were employed. If you are desirous of the place, I see not why You should not ask it. That sullen pride which expects to be solicited to its own advantage, can hardly be justified by the highest degree of human excellence.[61]

Reynolds was 'always honoured' with his knighthood. The unknighted Gainsborough, however, had been 'employed' and had enjoyed the greater part of the king's protection and favour. Gainsborough, moreover, while treating the Academy cavalierly, had conspicuously begun to expand his range and demonstrate his virtuosity in varieties of Old Master idioms – indeed, he would develop his fancy pictures, such as *A Shepherd* (pl. 230) had been, and eventually move on to Biblical subjects, with a late *Hagar and Ishmael* (pl. 291). By the 1780s he was attempting even a mythology, *Diana and Actaeon* (pl. 273). Reynolds, who had claimed this ground for the Academy, was, according to Northcote, 'not . . . a courtier', and 'poison' to the royal sight.[62] However, if the designation of 'Royal' Academy was to mean anything, it was only proper that Reynolds become King's Painter.

In comparison, Gainsborough, the courtier, had Dupont playing Van Dyck to his Rubens. This was an opposing and alternative view of the roles of art and the artist within society. These differences manifested in many ways. Of their manner of painting, 'Timothy Tickle' wrote,

Mr. Gainsborough's pictures are said to possess one quality in common with those of Vandyke; they may be viewed at three, or at thirty feet distance with the same effect on the spectator's eye. The works of his rival, the President, are strangers to this qualification. If, therefore, Gainsborough's requisition [in 1784] had been complied with, one of Reynolds's pictures must have been placed in a similar situation, in which case it would have resembled the lime and rough cast upon a country hovel when compared with nature, or with Gainsborough, and the President's assumed superiority would have suffered by the comparison.[63]

This is as much a social as an aesthetic critique, placing Reynolds on a par with the plasterer, while Gainsborough's place is with Van Dyck. The opposition between them was chronic and deep-rooted, and to understand it, we must understand Gainsborough's own attitudes, and their formation in the milieu of the St Martin's Lane Academy.

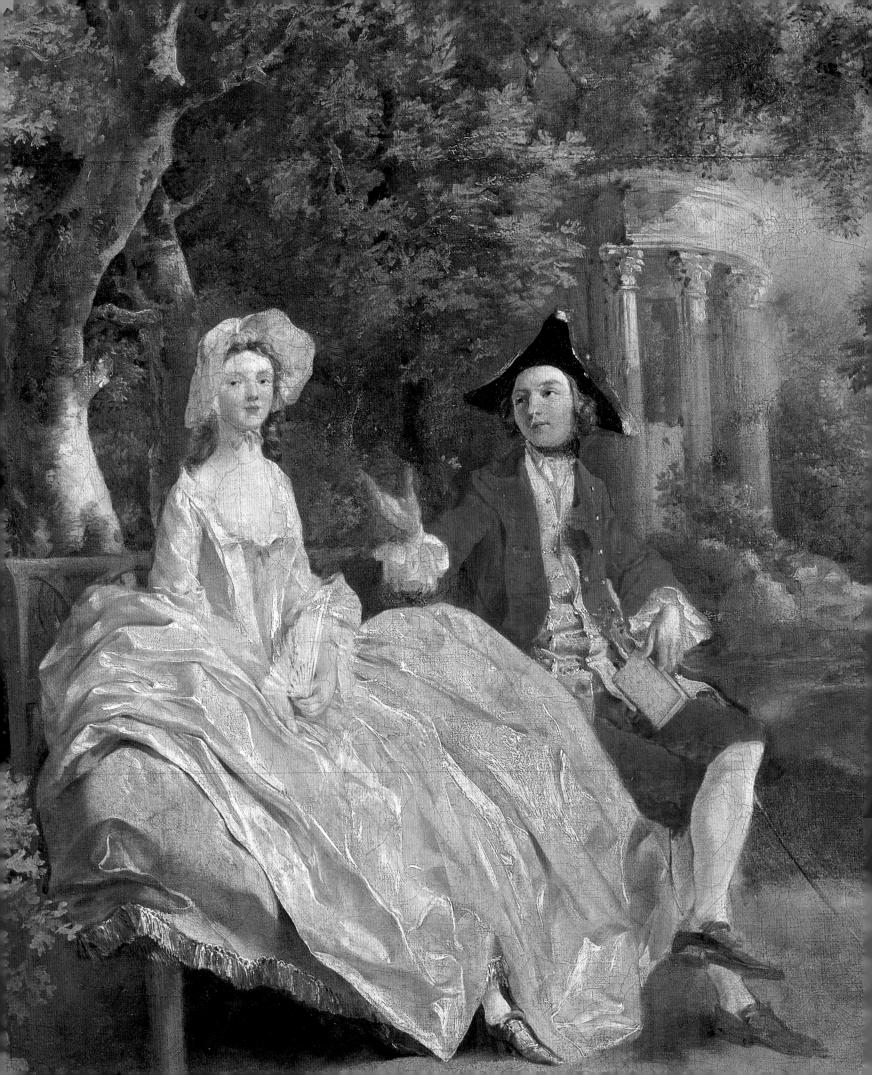

6　St Martin's Lane and Modern Painting

WHEN GAINSBOROUGH WAS DYING FROM CANCER IN 1788, he wrote to Sir Joshua Reynolds to seek reconciliation:

> I am just to write what I fear you will not read after lying in a dying state for 6 months. The extreme affection which I am informed of by a Friend which Sir Joshua has expresd induces me to beg a last favor, which is to come once under my Roof and look at my things, my woodman you never saw, if what I ask [now?] is not disagreeable to your feeling that I may have the honor to speak to you. I can from a sincere Heart say that I always admired and sincerely loved Sir Joshua Reynolds.[1]

Reynolds subsequently recounted how the visit he made effected an accord both personal, and, to a degree, artistic.

> A few days before he died, he wrote me a letter, to express his acknowledgements for the good opinion I entertained of his abilities, and the manner in which (he had been informed) I always spoke of him; and desired to see me, once more, before he died. I am aware how flattering it is to myself to be thus connected with the dying testimony which this excellent painter bore to his art. But I cannot prevail on myself to suppress that I was not connected to him by any habits of familiarity; if any little jealousies had subsisted between us, they were forgotten, in those moments of sincerity; and he turned towards me as one, who was engrossed in the same pursuit, and who deserved his good opinion, by being sensible of his excellence. Without entering into a detail of what passed at this last interview, the impression of it upon my mind was, that his regret at losing life, was principally the regret of leaving his art; and more especially as he now began, he said, to see what his deficiencies were; which, he said, he flattered himself in his last works were in some measure supplied.[2]

That final passage backs up the impression that Gainsborough had begun to explore new artistic directions: the shifting of his figures on to the larger scale, the incorporation of old master references into his handling and imagery. It may be that, after 1784 and that final rupture with the Royal Academy, he had settled into a kind of semi-retirement in which, as Reynolds's final sentence intimates, he was able to paint experimentally and seriously. Nevertheless, there was a significant subtext in Reynolds's writing of 'deficiencies' being 'in some measure supplied'. These had to be deficiencies in terms of something, and, he made it plain, that something was the academic ideology which the President had been developing since the late 1750s.

Reynolds's fourteenth *Discourse* was uniquely devoted to the art of a contemporary, the recently deceased Thomas Gainsborough. Reynolds laid out his stall early on. An analysis of Gainsborough's art was to serve as his perorations on other painters had previously done; the intention was 'not so much to praise or blame him, as to draw from his excellencies and defects, matter of instruction to the Students'. He had stated previously that 'perfection in an inferior style may be reasonably preferred to mediocrity in the highest walks of art'. While he might now be inviting 'ridicule' in showing a preference for 'the humble attempts of Gainsborough to the works of . . . regular graduates in the great historical style . . . we have the sanction of all mankind in preferring genius in a lower rank of art, to feebleness and insipidity in the highest.'[3] While this aimed to put Gainsborough in his place, that place

was hardly one with which the latter had had any contact during the final four years of his life.

David Brenneman has astutely observed that a guiding motive behind the fourteenth *Discourse* was to bring the late Thomas Gainsborough back into the academical fold. This was why Reynolds dubbed him 'one of the greatest ornaments of our Academy'.[4] He reintegrated the maverick in a particularly subtle way, as we discover from considering the manner in which he wrote about Gainsborough's handling of paint. Reynolds commented particularly on

> all those odd scratches and marks, which, on a close examination, are so observable in Gainsborough's pictures, and which even to experienced painters appear rather the effect of accident than design; this chaos, this uncouth and shapeless appearance, by a kind of magick, at a certain distance assumes form, and all the parts seem to drop into their proper places; so that we can hardly refuse acknowledging the full effect of diligence, under the appearance of chance and hasty negligence.

He went on to underline how Gainsborough's implicit impropriety (social as well as pictorial, for it was 'uncouth') was redeemable on the grounds not of innate facility, but only as the mark of a sophisticated painterly expertise itself arrived at after a great deal of hard work: 'painters know very well that a steady attention to the general effect, takes up more time, and is much more laborious to the *mind*, than any mode of high finishing or smoothness, without such attention. [author's emphasis]'[5] Reynolds was bent on presenting Gainsborough's practice as conforming to the academic precepts he himself had been laying down, but this had to be heavily qualified; so that, as has been demonstrated, in general he wrote of Gainsborough in the terms that he previously had of Rubens, as a painter supreme in the mechanical part of the art, but lacking in its intellectual aspects. Thus Gainsborough's '*handling, the manner of leaving the colours*' signalled 'the work of an artist who never learned from others the usual and regular practice belonging to the art; but still, like a man of strong intuitive perception . . . found out a way to accomplish his purpose'.[6] Reynolds's language echoes what Vasari had written of Titian's late style:

> the Works he did about this time, are so full of strokes and spots, after a certain bold Manner, that they seem nothing near, but look very well at a distance. Which Manner of his several *Painters* endeavouring to imitate, have made very gross, coarse pieces. This way, though it seems easie, is the most laborious of all; but is made to hide the pains of the painter.[7]

Titian's late paintings, like Gainsborough's, are perceptually anarchic close to, but at a proper distance reveal astonishing illusionism. Although each artist's work appears effortless, even to the point of seeming to display 'negligence', this is far from the case. Their efforts are possible only because informed by great experience and much hard work. Thus, perhaps taking his hint from that last interview, for Gainsborough appears to have been responsive to Titian during the 1780s, Reynolds suggests by allusion that his place in the pantheon equates with the Venetian artist's position in High Renaissance art.

This is not without moment. In the eleventh *Discourse* Reynolds had remarked how, although Vasari 'seems to have had no great disposition to favour the Venetians, yet he every where justly commends *il modo di fare, la maniera, la bella pratica*', and how on 'Titian in particular, he bestows the epithets of *giudicioso, bello, e stupendo*'. That is, despite the preeminence of the Roman painters in general, and Michelangelo in particular, Vasari was prepared to concede some merit to the Venetians, and especially to Titian. Reynolds himself had earlier taken a comparable, if more extreme position. 'For my own part,' he had said in 1771, and here we must remember that his opinions, in particular on Veronese, underwent considerable modification as the years went by,

when I speak of the Venetian painters, I wish to be understood to mean Paolo Veronese and Tintoret, to the exclusion of Titian; for though his style is not so pure as that of many other of the Italian schools, yet there is a sort of senatorial dignity about him which . . . seems to become him exceedingly.[8]

Titian too is presented as a kind of maverick: a painter who belongs to no school and therefore remains untainted by the meretricious colouring and luxurious sensuality of Venetian painting. To connect him to Gainsborough is to permit the latter a comparable liberty within an all-embracing Academy. The final *Discourse* supplies a proper perspective on this, however. Written (as were Vasari's *Vite*) in praise of Michelangelo, Reynolds at the end conceded that, while he could not aspire to be even an 'imitator', he was at least an 'admirer' of an artist whose eminence was such that 'to kiss the hem of his garment, to catch the slightest of his perfections, would be glory and distinction enough for an ambitious man'. If this is how Reynolds stands with Michelangelo, then Gainsborough must be comparably placed against Titian. This accords with the tenor of the comment in the fourteenth *Discourse* that, 'If ever this nation should produce genius sufficient to acquire to us the honourable distinction of an English School, the name of Gainsborough will be transmitted to posterity, in the history of the Art, among the very first of that rising name'.[9] Things are only just beginning; and the fourteenth and fifteenth *Discourses* bring Gainsborough and Reynolds into an harmonious relationship as allied in a common cause. This cost their author considerable intellectual pain.[10] We have remarked the real depth of the ideological divide, and to have kept it quite so exposed after Gainsborough's death would have undermined the whole Academic project. We must now explore what the differences were.

I earlier linked *Shepherd Boys with Dogs Fighting* (pl. 103) with Hogarth's *Stages of Cruelty* (pls 99, 100); and Hogarth is someone to whom Gainsborough regularly referred. John Hayes spotted that *The Shrimp Girl* (after which painting Bartolozzi, to whose work Gainsborough had 'ever been so partial', had made a lubricious stipple engraving (pl. 215), which Mrs Hogarth published in March 1782) is perched in the shaded rear of the 1785 *Harvest Wagon* (pl. 216), much in the way that the Rake was translated from Bedlam to the 1767 version of that composition.[11] Although there was a mania for collecting Hogarth's prints in the 1780s, Gainsborough's allegiance was more profound.[12] We have noted the connection between *James Quin* and *Simon Lord Lovat*, while a later wooded landscape (pl. 109) lifts the groping figure from Hogarth's *Noon* (pls 108, 110). Significantly, in the 1780s, Gainsborough's acknowledgements extended to painting. The wonderful late portrait *The Hon. Charles Wolfran Cornewall* (pl. 111) looks to works such as *Captain Coram* (pl. 133) and *Archbishop Herring* (Tate Gallery, London) both in pose and in demonstrating how to paint black fabrics. These links need to be taken seriously. By marrying the Hogarthian with the Titianesque in *Shepherd Boys with Dogs fighting*, Gainsborough produced an extraordinarily interesting improvisation on the modern moral subject, and this must in its turn point to the possibility of his expressing artistically a degree of continuing allegiance to what he had learned at St Martin's Lane.

This would hardly have been surprising. Hogarth dominated the St Martin's Lane Academy, and, as John Hayes has suggested, could readily have had a significant impact on an impressionable teenage art student, who subsequently remained in contact with his teachers.[13] During the mid-1750s, when the wish of a majority of the artists, including Hayman, to form an Academy, forced Hogarth into an uncomfortable isolation in which, among other things, he had to endure the poisonous graphic satires of Paul Sandby, Gainsborough was well out of it in Ipswich. None the less, circumstantial evidence aligns him with Hogarth. His inscription on the portrait of William Mayhew (pl. 26) 'Gainsboroug de Ipswich Pinxit 1757' is reminiscent of Hogarth's writing 'William Hogarth Anglus pinxit' on one of his own portraits.[14] Then there was the connection with Joshua Kirby. Sandby included Kirby amongst the Hogarth faction in his satirical prints. Kirby sold Hogarth's prints in Ipswich, and when he was preparing his own book, *Dr Brooke Taylor's Method of*

108 and 110 (*above*) William Hogarth, *Noon* and detail, 1738, etching and engraving.

109 (*above right*) *Wooded Landscape with Peasants and Donkey around a Camp Fire*, 1777–80, 1,207 × 1,498 (47¹/₂ × 55). London, Tate Gallery.

Perspective Made Easy (1754), was in close contact with Hogarth, who supplied him with a spoof frontispiece. Kirby dedicated his book to Hogarth, and, for his part, was invited in February 1754 to lecture to the St Martin's Lane Academy.[15] Kirby's dedication was fulsome enough, praising Hogarth's 'extensive Knowledge and Genius in the Art of Painting', and acknowledging 'the great Obligations which I am under for your Friendship and Favour'. In addition, Kirby was prominent amongst those who 'rallied to Hogarth's defence' when he came under attack from, among others, Paul Sandby (again) later that year.[16]

Gainsborough was brought into this project in two ways. Firstly, he supplied a print, an etched view of a church, finished off for him by J. Wood (pl. 20), which Kirby described as 'an Example of a Landskip by a very great Genius in that way', to confirm his reputation as a landscapist at St Martin's Lane.[17] Secondly, he subscribed for a copy of the book, along with some significant others. These included the Reverend John Clubb (*sic*), Nathaniel Acton, John Gravenor, Samuel Kilderbee, Richard Savage Lloyd and Richard Savage Nassau, all of whom had sat to him or were to do so in Ipswich.[18] Now it may be that Kirby and Gainsborough had the same friends, but it is possible that the latter had been soliciting subscriptions for the book, much as he would later take some liberties in attempting to get the patronage of the Duke of Bedford for William Jackson. John Clubbe, whose name heads the list, was a drinking friend of Gainsborough's and was, in his turn, to dedicate his own jokey treatise *Physiognomy* to Hogarth in 1763, and to express a view of portrait painting that reads very much as akin to Gainsborough's.[19] Clubbe's dedication was even more fulsome than Kirby's, and aimed particularly at giving due praise to Hogarth's art. The timing of the publication is most significant. Wilkes had savagely and effectively attacked Hogarth in The *North Briton* XVII, published during September 1762, and again in May 1763, with back up from satirical prints by, among others, Paul Sandby yet again. Hogarth took this particularly badly, and eventually suffered a paralytic seizure in July 1763.[20] Clubbe surely

111 *The Hon. Charles Wolfran
Cornewall*, 1785–86, oil on canvas,
2,280 × 1,485 (89 × 58), Melbourne,
National Gallery of Victoria, Everard
Studley Miller Bequest, 1962.

meant the dedication as a public expression of support from one of Hogarth's 'many Thousand Admirers'. He wrote of how, in Hogarth's 'Portraits of FOLLY, all, but the Subjects of them, confess; and your more *moral* Pieces, none, but the abandoned, disapprove', which he conceivably aimed at Hogarth's attackers. And while the *North Briton* was reappearing in May 1763, so was Gainsborough's extremely Hogarthian *James Quin* (pl. 32) on show at the Society of Artists.

There are further reasons for suspecting that Gainsborough was stating an affiliation to the Hogarthian. Some time around 1763–64 he wrote a letter to the Earl of Hardwicke. This is customarily understood as an expression of his antagonism to topographical landscape painting, and its text reads:

> Mr. Gainsborough presents his Humble respects to Lord Hardwicke; and shall always think it an honor to be employ'd in anything for his Lordship; but with respect to *real Views* from Nature in the Country he has never seen any Place that affords a Subject equal to the poorest imitations of Gaspar or Claude. Paul Sanby is the only Man of Genius, he believes, who has employ'd his Pencil that way – Mr. G. hopes Lord Hardwicke will not mistake his meaning, but if his Lordship wishes to have any thing tolerable of the name of G, the subject altogether as well as figures etc. must be of his own Brain; otherwise Lord Hardwicke will only pay for Encouraging a Man out of his way and had much better buy a picture of some of the good Old Masters.[21]

We, too, should take care not to mistake Gainsborough's meaning in a letter in which such phrases as 'the poorest imitations of Gaspar or Claude' or 'good Old Masters' cry out to be taken with a pinch of salt. Gainsborough trained under artists dedicated to establishing the reputation of modern British art, for whom the common prejudice towards the old masters was a major obstacle. The fulsome tone reads almost as parodic; and Gainsborough appeared to take up the kind of position assumed by Joshua Reynolds in his *Idlers*, advocating an elevated, academic kind of landscape painting, rather than the naturalism implicit in '*real Views*' (possibly a pun, directing us not to mistake his own meaning), which is at least peculiar. Such landscapes must, of necessity, be art of a considerably lower rank, a perception which is to be applied, by implication, to its practitioners. Of these, Gainsborough mentions only Paul Sandby. So it is conceivable that this letter is meant as a species of private retaliation.

Gainsborough allied himself with the Hogarthian in other ways besides. He wrote to William Jackson, at that point contemplating exchanging music for painting, that

> There is a branch of Painting next in profit to portrait, and quite in your power without any more drawing than I'll answer for your having, which is Drapery & Landskip backgrounds. Perhaps you don't know that while a Face painter is harrassed to death the drapery painter sits and earns 5 or 6 hundred a year, and laughs all the while –

The passage is reminiscent of Hogarth on the

> jour[n]ey men called Back ground & Drapery painters . . . these still life men in this one branch only do them in with great care and perfection at [as] easy a rate as enables the master to despatch a great deal of business and if industrious get more money in a week than ye greatest genious in any other branch of the art in 3 months.

Hogarth was not shy about broadcasting his opinions, and it is very likely that he made an impression on the young Gainsborough.[22]

Therefore, Gainsborough's putting the *Shrimp Girl* into the late *Harvest Wagon*, or elevating the *Stages of Cruelty* to the Titianesque in *Shepherd Boys with Dogs Fighting* is significant. The latter instance recalls Mrs Thrale's story of Hogarth's saying 'the connoisseurs and I are at war you know; and because I hate *them* they think I hate *Titian* – and let them!'.[23] The case is strengthened by the portrait *John and Henry Trueman Villebois* (pl. 112) which, like the *Shepherd Boys*, dates also from 1783. Gainsborough has the two boys build-

112 *John and Henry Trueman Villebois*, *c*.1783, oil on canvas, 1,549 × 1,295 (61 × 51). Private collection.

ing a house of cards – an allusion to the transience of childhood and the fragility of human ambition. It was thus that Hogarth had employed the motif in a portrait of children entitled *The House of Cards* in 1730, and it was to be repeated by others.[24] These, as we saw, may have included the young Gainsborough in the painting of *Children building Houses with Cards* (pl. 8), which was done for Vauxhall Gardens.[25] This connection links the older artist to his student days at a time when his aesthetic differences with the particular academicism of Sir Joshua Reynolds were a central issue. To understand something of these, it is logical to investigate the painterly environment of the St Martin's Lane Academy, as Gainsborough might have responded to it.

The extent to which the young Gainsborough was enmeshed in the milieu of Hogarth and Gravelot is evident from his 'quoting' Plate 3 of *Industry and Idleness* (pl. 114) in a view of Hadleigh church (pl. 113) exactly contemporary with that series (on which Joshua Kirby may have collaborated). In particular, in Gainsborough's *Conversation in a Park* (pl. 118); a

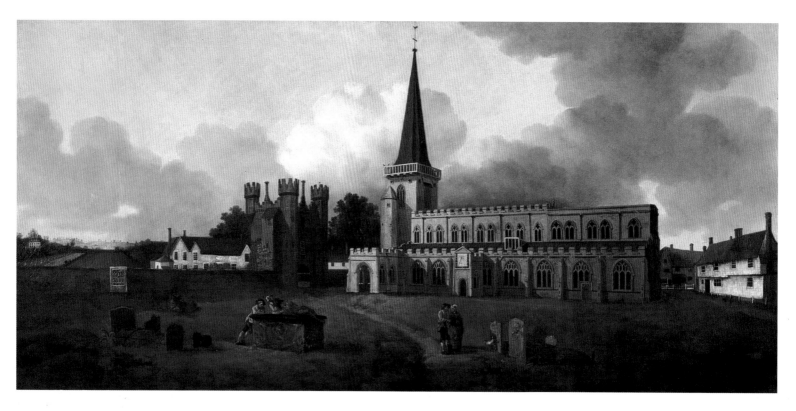

113 (*above*) *St Mary's Church, Hadleigh,* *c.*1748–50, 914 × 1,905 (36 × 75). Private collection.

114 William Hogarth, *Industry and Idleness III: The Idle 'Prentice at Play in the Church Yard during Divine Service,* 1747, etching and engraving. London, British Museum.

portrait of an anonymous couple of *c.*1746–48 (Louvre), both the subject and the focussing upon a moment of private communication are matched in one of Gravelot's rare paintings, *Le Lecteur* (pl. 116); self-consciously 'French', too, is the brilliant and virtuoso fluidity with which the paint is handled, and, in particular, the pink frock is rendered. Indeed, the connection with Gravelot may well extend beyond this. Gainsborough had problems attaching men's legs to their torsos. *John Plampin* (pl. 128) is the quintessential instance of this, but it is apparent in other works too: for instance, *Mr and Mrs John Kirby* (National Portrait Gallery, London). In the Louvre painting, nothing like this is detectable, and one has to suspect, as Hugh Belsey has observed, that Gravelot drew the figures and Gainsborough did the paint-

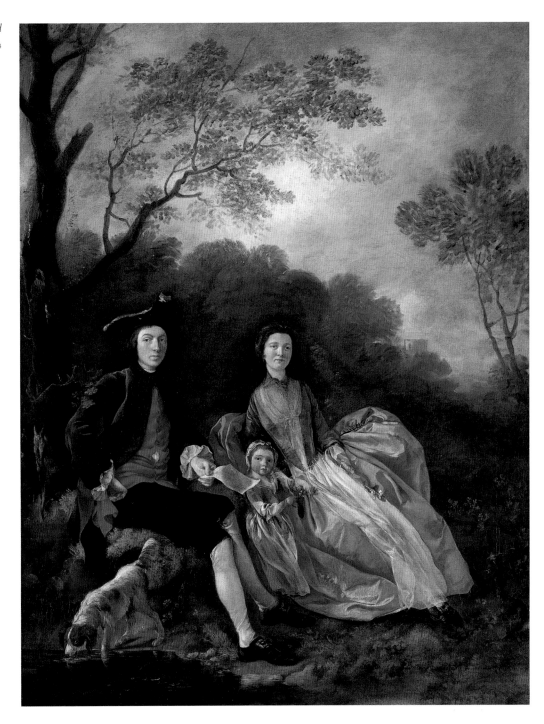

115 *Portrait of the Artist with his Wife and Daughter, c.*1748, oil on canvas, 921 × 705 (36¼ × 27¾). London, National Gallery.

ing.[26] This might explain why there is more interaction between the couple than is usual in comparable portraits by Gainsborough, such as the self-portrait with wife, daughter and dog (pl. 115). In addition to this, the body language, alongside an element of gentle satire, shows real alertness and sympathy towards Hogarth.

The young man, splendid in scarlet and gold, has been so struck by a passage in the book in which he keeps his place with an incongruously large hand, as to gesture with an expression of real sensibility on his face towards a woman who must be his spouse, as indicated by the crossed tree trunks (a device Gainsborough used in *The Gravenor Family* (pl. 124)) and what may be a Temple of Hymen in the background.[27] She turns to look out of the picture plane. However, the contrast with *Le Lecteur*, where in an interior a man reads and

116 Hubert François Gravelot, *Le Lecteur*, c.1745, oil on canvas, 311 × 234 (12¼ × 9¼). London, Marble Hill House.

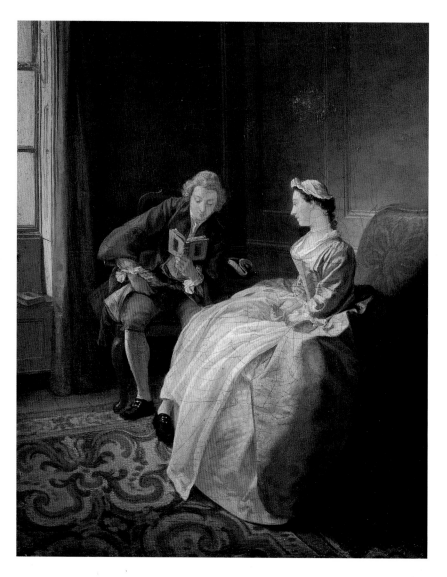

117 William Hogarth, *Marriage à la Mode II: Shortly after the Marriage*, c.1743, oil on canvas, 699 × 908 (27 × 35). London, National Gallery.

118 (*facing page*) *Conversation in a Park*, c.1746–47, oil on canvas, 921 × 705 (30 × 26½). Paris, Louvre.

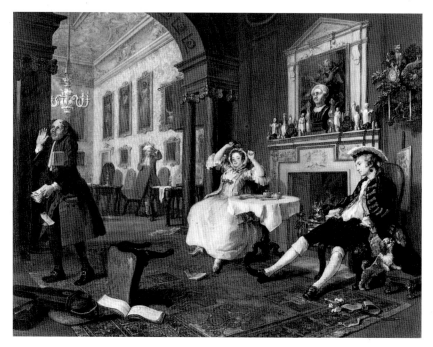

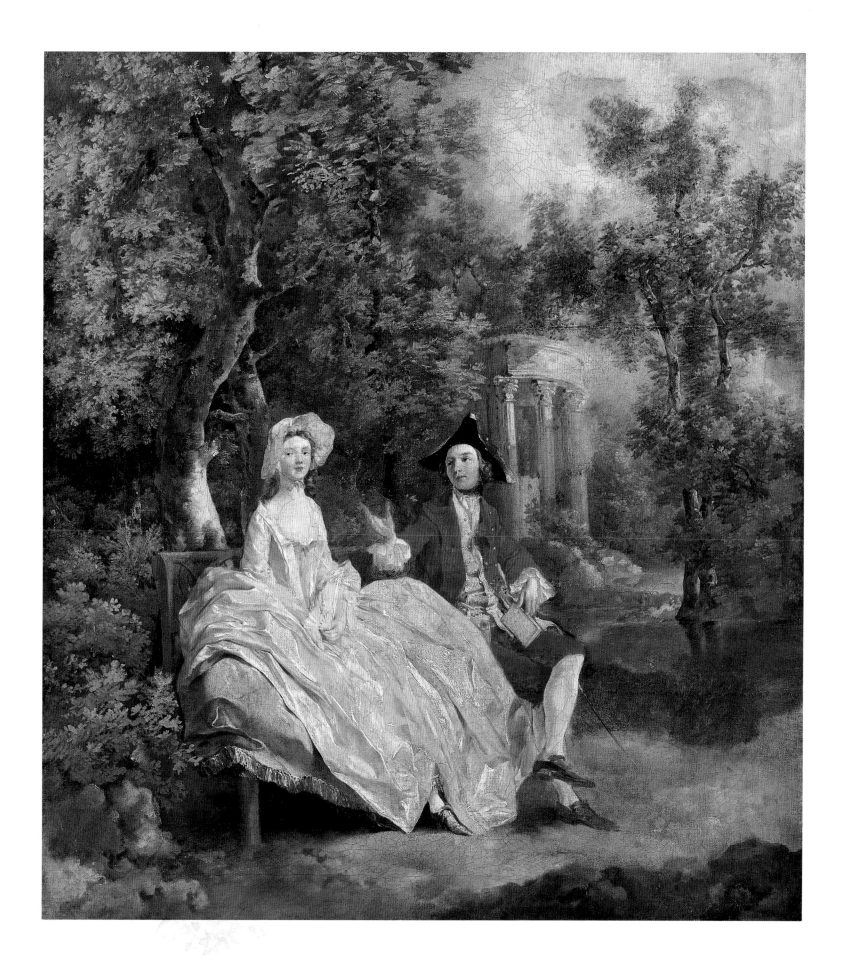

a young woman listens, attentive and demure, alerts us to the complexity of Gainsborough's invention. The imagery develops that of the second scene of *Marriage à la Mode* (pl. 117), in which the countess stretches alluringly, but to no avail. The sense of sexual invitation is raised further by the open fan in her lap, for this is an unusual detail. If women in portraits hold fans – an example would be a conversation piece by Joseph Nollekens (Yale Center for British Art, New Haven) – they are generally closed. This applies even to Hogarth's notorious Mother Needham in Plate 1 of *The Harlot's Progress*, or his old maid in *Morning*. When a fan is opened, as in *Evening* (pls 119, 120), it refers to an iconography of sexual desire and passion. In his play *The Old Batchelor*, Congreve has Belmour ask, 'Who would refuse to kiss a lap-dog, if it were preliminary to the lips of his lady?', to which his friend Sharper replies, 'Or omit playing with her fan'.[28]

One prototype for Gainsborough's couple appears in Watteau's *Le Pèlerinage à l'isle de Cithère* (pl. 121), where, as one might expect on the Island of Love, the woman whom one man helps from the ground still has her fan open in her lap (pl. 122). This was one of many inventions of Watteau's lifted by George Bickham for *The Musical Entertainer* (1737) (pl. 123), where he used it as a headpiece to the song, 'The Compassionate Maid', some of the lyrics to which are:

> I'll on your bosom lye;
> While you're with looks expiring,
> My blissful Death desiring,
> My Soul with joy shall fly.
> With balmy melting Kisses,
> I'll crown my dying Blisses,
> Whilst you in Pity, cry;
> 'My Love, I'll not be cruel,
> 'But in this am'rous Duel,
> 'We'll both together dye.'

Gainsborough's young woman, then, is more interested in the virility than the intellect of a beau whose frustrating failure to react to her raises the spectre of the effeminacy that is always (as we shall see) a risk with sensibility. This is an English *fête galante*, in the way of Hogarth's parodies of that genre in *Before* and *After* (Fitzwilliam Museum, Cambridge). Gainsborough's sexually allusive iconography would be of a piece with his recalling his student days in a letter to his friend the actor John Henderson warning him not to 'run about the streets of London, fancying you are catching strokes of nature, at the hazard of your constitution. It was my first school, and deeply read in petticoats I am.'[29] If, as seems highly likely, this was a marriage portrait, then the artist must have been on excellent terms with his sitters. As a collaborative work, this, as much as the dubious wit of its content, shows him to have been completely in tune with, immersed in the St. Martin's Lane *milieu*.

At times the affiliation was more direct. It is a commonplace to connect such portraits as *The Gravenor Family* or *Mr and Mrs Andrews* with Hayman's portraits of Jonathan Tyers and members of his family (pls 124, 25, 125); while Gainsborough's charming *Girl with a Book seated in a Park* (pl. 126) is in the same idiom as Hayman's *Mary Chauncey* (Yale Center for British Art, New Haven) or, more particularly, Dandridge's *A Lady reading 'Belinda' beside a Fountain* (pl. 127). The complete and responsive assimilation within this pictorial culture is, perhaps, most explicit in *John Plampin* (pl. 128).[30] While Plampin's pose is often connected to Watteau's *Antoine de la Rocque* (who also sits on a bank), an image disseminated through Lépicié's 1734 engraving (pls 129, 130), and used by Hayman in his portraits *Philip Thicknesse*, and of *David Garrick and William Windham*, it probably has different referents.[31] It turns up as Hogarth's drunken rake, and as Hayman's boozy sailor in *The Wapping Landlady* (pl. 131), another of the Vauxhall paintings.[32] Its indecorousness is pointed up by contrast with Gainsborough's portrait of Vauxhall's proprietor, Jonathan Tyers, with his family (1740;

119 and 120 William Hogarth, *The Four Times of Day: Evening* and detail, 1738, etching and engraving. London, British Museum.

121 Antoine Watteau, *Le Pèlerinage à l'isle de Cithère*, 1717, oil on canvas, 1,290 × 1,940 (50³/₄ × 76¹/₂). Paris, Louvre.

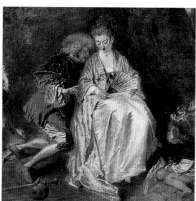

122 Detail of pl. 121.

123 *The Compassionate Maid*, from George Bickham, *The Musical Entertainer*, 1737–38. Gainsborough's House, Sudbury.

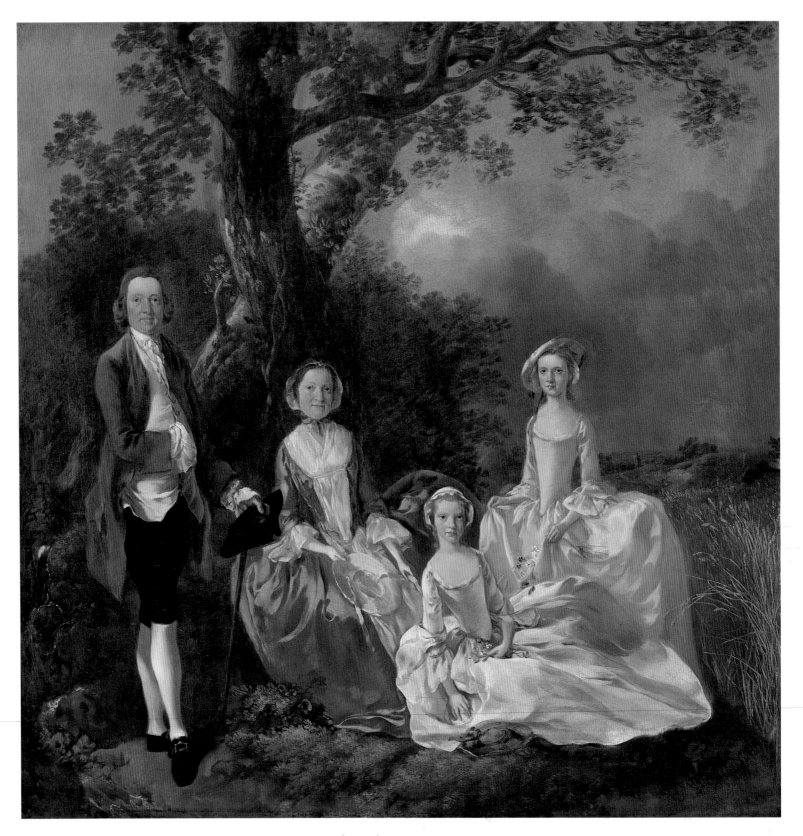

124 *The Gravenor Family, c.*1752–54, oil on canvas, 902 × 902 (35^1/$_2$ × 35^1/$_2$). New Haven, Yale Center for British Art, Paul Mellon Collection.

125 Francis Hayman, *Margaret Tyers, and her Husband, George Rogers*, c.1750–52, oil on canvas, 902 × 697 (35^1/$_2$× 27^1/$_2$). New Haven, Yale Center for British Art, Paul Mellon Collection.

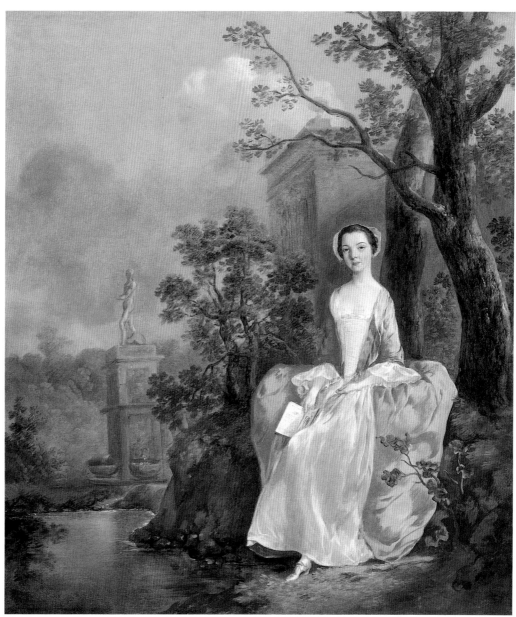

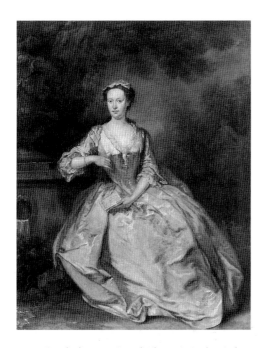

127 Bartholemew Dandridge, *A Lady reading 'Belinda' beside a Fountain*, 1740–45, oil on canvas, 525 × 425 (20^3/$_4$× 16^3/$_4$). New Haven, Yale Center for British Art, Paul Mellon Collection.

126 (*above right*) *Girl with a Book seated in a Park*, c.1750, oil on canvas, 758 × 667 (29^7/$_8$ × 26^1/$_4$). New Haven, Yale Center for British Art, Paul Mellon Collection.

National Portrait Gallery, London), in which Tyers has his legs as firmly crossed as Gainsborough himself in that early portrayal of his family, or the young man in *Conversation in a Park*, discussed above. So one might associate Plampin with notions of drunkenness and rakishness, notions reinforced by the raffish elegance of a suit hardly equating with the rustic and sober garb of, say, Robert Andrews (pl. 25) – which is probably why the pointer, a gun dog, is sniffing this foppish creature warily, stiff with suspicion at finding it reclining in the Suffolk countryside. (Plampin was, incidentally, in due course as ground-breaking as Andrews when it came to innovative agricultural practice.[33]) And since Plampin would have been perfectly alert to the content of his portrait, there was, presumably, a degree of sympathetic collusion between him and Gainsborough. John Clubbe wrote of the portraitist that 'he cannot always be in a fit disposition to make his observations; for his skill depends upon his seeing and feeling, accompanied with a certain happy sagacity arising from both'; and John Bensusan-Butt thought that this sounded like Gainsborough. It certainly seems to be something that was realised in Plampin's portrait.[34] The genial and jokey informality, in this and other portraits, such as *The Reverend John Chafy* (pl. 179) is to be found also in some of

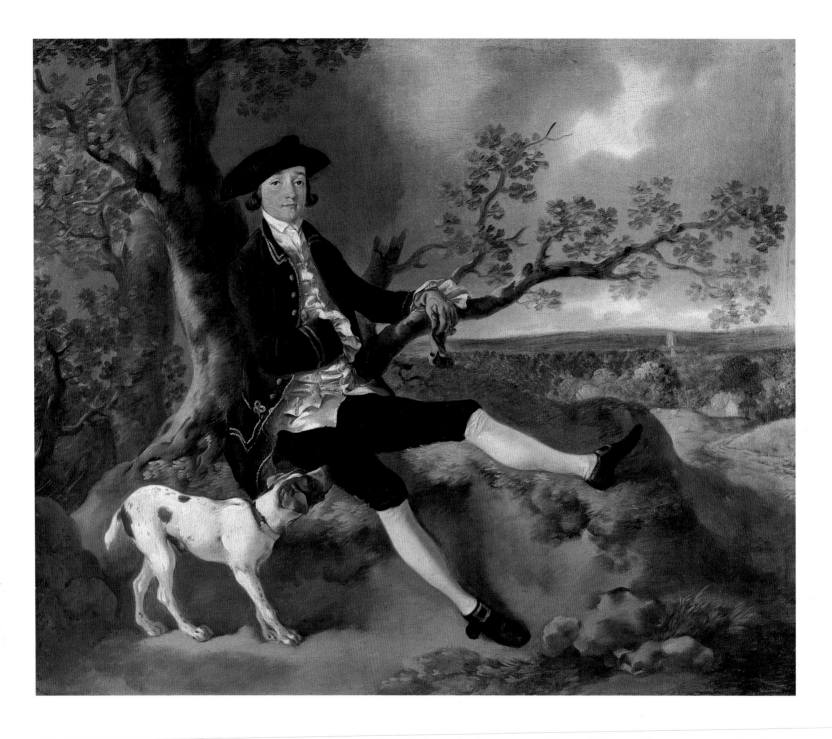

John Plampin, c.1753–55, oil on canvas, 502 × 603 (19³/₄ × 23¹/₄) London, National Gallery.

Hayman's portraits and shows both artists working within an idiom of convivial intimacy with their sitters.[35]

The artists who painted at St Martin's Lane and relaxed at Slaughter's Coffee House were characterised by Mark Girouard as 'Young, cheerful and rebellious', chafing 'against the Palladian dictatorship so long imposed by Lord Burlington and his friends'.[36] Ronald Paulson has contrasted them with the Roman Club, which included the painters Arthur Pond and George Knapton, as having been 'united by a mutual impatience with the authority and idealism of Renaissance-derived academic dogmas . . . and a desire to return to nature: human nature and native English empirical nature'; and, he maintained,

questions of academic theory, rules and stereotypes all came to focus for the Slaughter's group in the economic situation of the English artist. There was no dominating patron

after Burlington . . . They were fully aware that only by displaying their original works as *works of art* could they hope to undermine the prejudices of powerful connoisseurs.[37]

Hogarth had invented, and laid great store by, what he dubbed 'modern moral subjects', scenes from contemporary life with a profound content. The implication was that historical subjects – for instance the mythologies of Titian – might have had real resonance in their own time, but could hardly retain it in a society so different from that of sixteenth-century Italy as that of mid-eighteenth-century Britain. Hence the famous incident when Hogarth 'put this question, if any at this time was to paint a portrait as well as Van Dyck would it be seen and the person enjoy the benefit? They knew I had said I could. The answer made by Mr Ramsay was positively No . . . Upon which I resolved if I did do the thing, I would affirm I had done it.'[38]

The proof was *Captain Coram* (pl. 133). Save, perhaps, for the bravura of its handling, this great portrait appears to have very little direct connection to Van Dyck. Neither aristocratic nor hieratic, it represents a contemporary merchant who appears impatient to get about his business. The link lies in Hogarth's developing the monumental portrait in ways analogous to Van Dyck's in the previous century, finding how to picture the contemporary and yet realise an image that gives the illusion of communicating a fair amount to those ignorant of the sitter's history (which, as we shall see, accords neatly with what Roger de Piles had to say of Van Dyck himself). This is precisely what happens when we discern sophistication, elegance and glamour in Van Dyck's portraits (however ahistorical this may be), and it is intriguing to witness Gainsborough in later portraits, such as *The Hon. Charles Wolfran Cornewall* (pl. 111), taking Hogarthian prototypes and realising them in a manner learned in part through the study of Van Dyck.

Hogarth's modernity was formed, additionally, in reaction to a society which accorded old masters exaggerated respect, to the economic detriment of contemporary art. Hence in *Beer Street* (pl. 132), an epitome of the positive imagery of urban renewal, one of the multifarious signifiers of this process is the consigning of George Turnbull's *Treatise on Ancient Painting* (1740) for waste paper. This is, in fact, slightly two-edged, for, despite his respect for

132 (*left*) William Hogarth, *Beer Street*, 1751, etching and engraving. London, British Museum.

129 and 130 (*top far left*) Lépicié after Antoine Watteau, *Antoine de la Roque* and detail, 1734, engraving. London, British Museum.

131a and b (*bottom far left*) A. Benoist after Francis Hayman, *The Wapping Landlady, and the Tars who are just come ashore*, 1743, engraving. London, British Museum.

the masters, Turnbull still expressed sentiments conformable to Hogarth's own, writing, for instance, how pictures 'which neither convey into the Mind Ideas of sensible Laws and their Effects and Appearance, nor moral Truths, that is, moral Sentiments and corresponding Affections, have no meaning at all', and was concerned with actual rather than abstracted appearances.[39] Moreover, Turnbull quotes de Piles on the value of sketches by the masters, and the latter is one author Hogarth took very seriously indeed.[40]

If Hogarth featured Turnbull's book in a print, one might infer that he would have vented his opinions on Turnbull publicly, and that these and the book itself would have been generally discussed by the artists. The late 1730s and the 1740s saw a spate of publication of treatises on painting. The Dutch artist Gerald de Lairesse's *The Art of Painting* (Amsterdam 1707) was reissued in translation in 1738. Roger de Piles's *Dialogue upon Colouring* (Paris 1699) was translated in 1711, followed by his *The Principles of Painting* in 1743, and a second edition of the 1706 translation of his *The Art of Painting* in 1744. The Slaughter's crowd would have talked about these books, as Hogarth came to rely heavily on de Piles in forming his own ideas, and even if the young Gainsborough did not join in the discussion, he may well have been an attentive listener.

So, if de Lairesse writes that 'the *common and usual Dress* of a Person is a great addition to *Likeness*; for no sooner is the Dress altered, but the Look does the same', we discover a possible underpinning for the position Gainsborough took up in his dispute with the Earl of Dartmouth. De Lairesse, too, stressed the centrality of a good *rapport* between artist and sitter for a successful portrait.[41] The Hogarth circle understood likeness to be the portrait's chief concern. 'Everything should contribute to resemblance . . . render the portrait like the original, or, if we may be permitted the expression, the original like the portrait', wrote Jean Andre Rouquet, a conduit for Hogarthian ideas; and, as we saw, Roger de Piles concurred: 'the greatest perfection of a portrait is extreme likeness', itself 'the essence of portaiture'.[42] And, either directly or at second hand, his theories appear to have had a real impact on Thomas Gainsborough. There is one vicarious piece of evidence for this. Philip Thicknesse famously tells how his curiosity to meet Gainsborough was whetted by his and many others besides having been duped by the painted effigy of a 'melancholy faced countryman, with his arms locked together, leaning over the garden wall' (pl. 134), which they took to be a real person. There is a fascinating prototype for this, for de Piles recounts Rembrandt's having fixed a portrait of his maid (which painting entered Britain in 1742) in a window, to the same effect.[43]

While it is unlikely that Gainsborough was an assiduous student of art theory, he presumably listened to what the artists were talking about, and thus could have become alerted to the kinds of ideas that de Piles professed, as, for instance: 'The essence and definition of painting is, the *imitation of visible objects, by means of form and colours.* Wherefore the more *forcibly* and *faithfully painting imitates nature,* the more directly does it lead to its *end;* which is; *to deceive the eye;* and the surer proofs does it give us of its *true idea.*'[44] A literal reading would conclude from this that the principal aim of art should be to create an illusion that serves in some way as a surrogate for the thing represented, so that, ideally, we may discover 'the portrait' to be 'like the original, or . . . the original like the portrait'. In *The Art of Painting* this axiom was repeated: 'Painting is an art which by means of design and colours, imitates all visible objects on a flat superficies.'[45] Moreover, any prejudices towards contemporary costume in portrait might have been reinforced by what de Piles had to say of Van Dyck:

> He drew several portraits of a sublime character; he dispos'd of them so, that it gave them an equal degree of life and grace. He always dressed them according to the fashion of the times, from which he drew what was most for the advantage of painting, and shew'd by it that nothing was too hard for art and genius, which can make the most ungraceful things beautiful.[46]

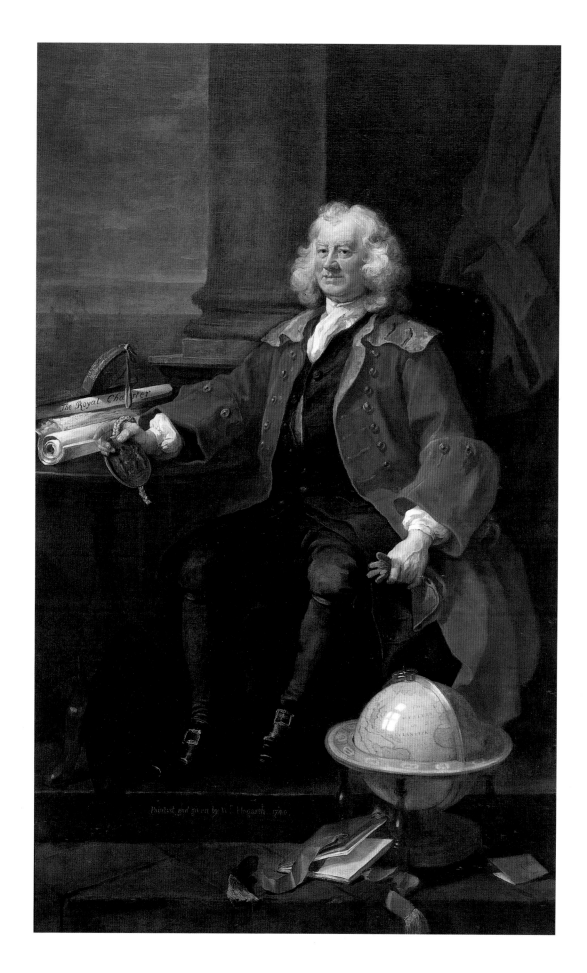

133 William Hogarth, *Captain Coram*,
1740, oil on canvas, 2,387 × 1,470 (94 ×
58). London, Thomas Coram Foundation
for Children.

Tom Peartree, c.1752, oil on panel. Ipswich Borough Council Museums and Galleries.

This was an aesthetic that understood that the pictorial could never equate directly, or in any straightforward fashion, with the linguistic. It is evident from his later remarks that Gainsborough would have found it sympathetic. De Piles defined 'Grace' as 'what pleases and gains the heart, without concerning itself with the understanding', while Gainsborough maintained that, in painting, 'there must be variety of lively touches and surprizing Effects to make the Heart dance', in a letter in which, as he often would, he wrote of painting in terms of music.[47] This was a favourite analogy of de Piles:

> There is a harmony and dissonance in the kinds of colours, as there are in the tones and degrees of light, and in a composition of musick, the notes must not only be true, but in the performance the instruments must also be agreeable: And as all Musical instruments do not agree with one another . . . so there are colours that will never appear together without offence to the sight.[48]

Gainsborough had this kind of chromatic cacophony in mind in 1772, when he wrote to Garrick about the rash of garish painting (probably designed to make works show up at exhibition) which had developed in the early 1770s, and implored him to 'maintain all your Light, but spare the poor abused Colors, till the Eye rests and recovers – Keep up your Music by supplying the place of *Noise*, by more Sound, more Harmony & more Tune, and split that curs'd Fife and Drum'.[49] That this kind of comparison had become commonplace is suggested by Sterne's description of the blood rushing into the face of Shandy senior, 'he must have reddened pictorically and scientictically speaking, six whole tints and a half, if not a full octave above his usual colour'.[50] Colouring, for de Piles central to the imitation of nature, was the attribute of Venetian painting: 'Venetian painter, expert musician, tunes and plays the instrument well', wrote Marcho Boschini, champion of the painterly.[51]

For the St Martin's Lane painters, the attraction of ideas such as de Piles articulated possibly lay in the way that they lent weight to an anti-academic outlook that was already central to their aesthetic. If painting, like music, had a direct sensory impact, this went to confirm what was waiting to be learned from Joseph Addison's essays on the 'Pleasures of the Imagination'. This, Ronald Paulson writes, would 'have been an important document for Hogarth because, among other reasons, it ignored the genres'.[52] Addison wrote of sight's

being 'the most perfect and most delightful of all our Senses', that 'Sense which furnishes the Imagination with its Ideas', for, 'we cannot . . . have a single Image in the Fancy that did not make its first Entrance through the Sight; but we have the Power of retaining, altering and compounding those Images . . . into all the varieties of Picture and Vision that are agreeable to the Imagination'. He went on to propose that

> The Pleasures of the Imagination, taken in the full Extent, are not so gross as those of Sense, nor so refined as those of the Understanding. The last are, indeed more preferable, because they are founded on some new Knowledge or Improvement in the Mind of Man; yet it must be confest that those of the Imagination are as great and transporting as the other . . . Besides, the Pleasures of the Imagination have this Advantage, above those of the Understanding, that they are more obvious, and more easy to be acquired. It is but opening the Eye, and the Scene enters. The Colours paint themselves on the Fancy, with very little Attention or Thought or Application of Mind in the Beholder. We are struck, we know not how, with the Symmetry of any thing we see, and immediately assent to the Beauty of an Object, without inquiring into the particular Causes and Occasions of it.
>
> A Man of a polite Imagination is let into a great many Pleasures, that the Vulgar are not capable of receiving. He can converse with a Picture, and find an agreeable Companion in a Statue.

So beneficial were those pleasures of the imagination to be got through sight that, unlike 'those of the Understanding, which are worked out by Dint of Thinking, and attended with too Violent a Labour to the Brain', they had 'a kindly influence on the Body, as well as the Mind', and, therefore, could be only commended.[53] In the fourth of these essays, Addison ruminated upon the inferiority of art in comparison with nature, famously commenting that 'there is generally in Nature something more Grand and August than what we meet with in the Curiosities of Art'.[54] It would follow, then, that an art that aspired towards imitating the appearances of nature had of itself to be highly valued. This would have sat very well with the sorts of conclusions available to be drawn from an uncritical reading of de Piles.[55]

From the emphasis on imitation, the insistence that deception was the end of art, it took no great leap to subvert the academic hierarchies of subject-matter. 'A Painter may be very skilfull in his art, and yet know nothing of history', maintained de Piles, illustrating his point through the Venetians, 'whose chiefest care was about the essence of their art; that is, in the imitation of nature'. He went on to write, in a rather self-contradictory way,

> 'tis not to be disputed, but that this essence of art, in the pictures of the Venetian painters, had been accompany'd with those ornaments that certainly render such things more valuable, I mean the truth of history and chronology, they would have been much more estimable even than they are now. We must, however, confess, 'tis by this essence only that the painters ought to instruct us, and that we ought to prefer the imitation of nature in their pieces to all other excellences whatsoever. If they instruct us, so much the better; if they don't, we shall still have the pleasure of viewing a kind of creation that will both divert and move us.
>
> When I would learn history, I would not go to a painter for it . . . I would read those books that treat of it expressly . . .

In light of this, it is not unexpected that de Piles should write of Titian that there 'never was a more universal Painter'. The 'path he struck out is the surest; because he has exactly imitated nature in its variety with an exquisite taste, and fine colouring'.[56]

If the spectator was affected not by what was represented, but by the manner of the representation, then subject might not necessarily be central to a work of art. Arguably, then, in the London art world of the 1740s, it made more sense to take modern subjects, which

all might recognise. As Addison's faculty of imagination was perceived to function in tandem with understanding, so the desired effect of a painting should be, according to de Piles, to excite enthusiasm, 'a transport of the mind, which makes us conceive things after a sublime, surprising and probable manner', and which, joined with truth, 'raises the soul to a kind of admiration, mix'd with astonishment, and raises the mind with such violence, as leaves it no time to bethink itself'.[57]

De Piles had originally advanced these views in the context of the debate that had raged through the French Academy in the later seventeenth century, a debate about whether one privileged the abstraction of line over the materiality of colour. Line demands that the representation be taken as an intellectual rather than sensual signifier. Colour, it was argued, addressed the sight directly, and stimulated the senses, not the mind. This mattered if painting was to be considered a liberal art, along with rhetoric or poetry. Representation should serve to trigger chains of ideas pre-existing in the intellect, before the technical manner by which that representation was achieved might be admired. Philip Sohm, writing of the seventeenth- and eighteenth-century critiques of the tradition of 'painterly' brushwork originating in sixteenth-century Venice and, arguably, maintained by Thomas Gainsborough, notes that Marco Boschni, defender of Tintoretto,

> would have agreed . . . that 'those in the know are pleased more by this way of painting', but this was not the consensus during the seventeenth and early eighteenth centuries when many writers found that painterly brushwork appealed more to the public than to the learned. This judgement derived from a time-honoured prejudice in rhetoric and poetics that the public appreciates outer, sensory display (*elocutio*) while the learned consider content (*inventio*).[58]

This is precisely the distinction between line and colour; but, as has been brilliantly pointed out by Jacqueline Lichtenstein, de Piles, for whom '*Drawing* is the Foundation of *Colouring* and subsists before it; yet it does so, only that it may receive its whole Perfection from it', was able to subvert any epistemology that championed drawing as the fundamental characteristic of painting:

> If drawing cannot . . . characterize painting, it is precisely because it is the genre common to all the arts . . . painting is not content to show the visible; it makes the invisible visible and paints feelings, emotions, not just the exterior form of the human body. Painting is not merely a reproduction of the real. If it represents reality, it does so in the sense that classical philology assigned this term, defining it as a sign rather than an image.

Lichtenstein mentions a blind sculptor, who worked from touch, so that de Piles was able to infer that sight was not central to drawing as it was to painting. To appreciate painting 'we need only eyes, wit, good sense – the general traits of society', and, she writes, 'Piles is not judging the representation of reality but the reality of a representation'. That is, the terms by which paintings are to be apprehended and judged are exclusive to that art.[59] This offers an alternative to a linear style, in which the images are merely cyphers for literary ideas.

In this view, handling, brushwork, was what formed the essence of painting; hence, as we saw, Gainsborough's writing to William Mayhew in 1758,

> You please me much by saying that no other fault is found in your picture than the roughness of the surface, for that part being of use in giving force to the effect at a proper distance, and what a judge of painting knows an original from a copy by; in short being the touch of the pencil, which is much harder to preserve than smoothness.

And it was precisely this centrality of handling to Gainsborough's art that Reynolds recognised and understood, by writing of Gainsborough's style in the way Vasari had of Titian's.

This was characteristically perspicacious. Brushwork, performance, was absolutely that which distinguished the Venetian painters. With respect to Vasari's 'Life of Titian', Philip Sohm writes that 'whereas Vasari assumed that his "bold sweeping stokes and patches of colors" cannot be viewed from nearby, Boschini accepted the chaos as a legitimate form in itself because without it the eye would not be able to enjoy the harmony that distance brings'.[60] Thus, painting parades its materiality, its place within the world of fine objects – glasswork, furniture – but surpasses them through that materiality creating an illusion to which the spectator in some way reacts. And, as we may infer from Addison's 'Man of a polite Imagination', who is 'let into a great many Pleasures that the Vulgar are not capable of receiving', there will be social distinctions in the capacity to perceive art. It will be indexed, as it were, to refinement.

It is highly likely, then, that the young Gainsborough was bred up to a tradition of art inimical to the kind of academicism Reynolds later professed, and one which (and here, de Piles's ambiguity and vagueness about history painting ought to be borne in mind) was under few constraints regarding which subjects painters chose. Although Hogarth and Hayman were drawn to paint historical subjects when they could, the main focus, in the 1740s, was upon modernity. And while Anglicanism forbade the painting of religious subjects, doubts about the pertinence of mythologies had been expressed since the late seventeenth century. Addison satirised them, as did Hogarth in recasting the subject of Diana and Actaeon as *Strolling Actresses dressing in a Barn* (pl. 282).[61] In 1759 Dr Johnson opined that 'I should grieve to see Reynolds transfer to heroes and to goddesses, to empty splendour and airy fiction, that art which is now employed in diffusing friendship, in reviving tenderness, in quickening the affections of the absent and continuing the presence of the dead'.[62] William Hogarth articulated his own opinions (presumably already familiar to those who had been in contact with him) in *The Analysis of Beauty*, published, not without controversy, in 1753.[63]

Throughout the *Analysis* Hogarth was, in an Addisonian way, concerned to emphasise the centrality of common sense to aesthetic judgements, to articulate a 'practical aesthetics' opposing 'the theoretically pure notions of Shaftesbury, where the human body can only be beautiful if divorced from function, fitness, and utility'.[64] Hence, Hogarth writes,

> they are in a much fairer way, ladies as well as gentlemen, of gaining a perfect knowledge of the elegant and beautiful in artificial, as well as natural forms, by considering them in a systematical, but at the same time familiar way, than those who have been preposess'd by dogmatic rules, taken from the performances of art only: nay I will venture to say, sooner and more rationally, than even a tolerable painter, who has imbibed the same prejudices.[65]

This potentially discredits any academic theory, and, audaciously, allows a sound judgement to anyone, irrespective of their sex, to decry that attitude, which, with entire etymological propriety, can allow the virtue supposedly inspired by the contemplation of works of art, to men only.[66] Anyone can make an informed judgement. It is common sense. 'Who but a bigot, even to the antiques,' wrote Hogarth, 'will not say that he has not seen faces and necks, hands and arms in living women, that even the Grecian Venus doth but coarsely imitate?'[67]

It is unsurprising then, to find that the best art concerns itself with its own world; and the implication is that this has ever been so. Van Dyck, though 'one of the best portrait painters in most respects ever known', did not adjust nature to conform to some abstracted aesthetic. There 'seems not to be the least grace in his pictures more than what the life chanced to bring before him'.[68] Others, for instance Francesco Algarotti (esteemed enough in England to be fellow of both the Society of Arts and the Royal Society), also maintained that the capacity to judge pictures was not exclusive to the learned.[69] This view chimed with the outlook of the exponents of progressive mercantilism, as later expressed by James

Buchanan in 1770, who maintained that 'The knowledge of things, is acquired in thought and attentive observation; and of arts, by practice and experience.'[70]

Allan Ramsay, who by 1753, when he published his essay 'on Ridicule' appears to have patched up any disagreements with 'the incomparable HOGARTH', advocated something similar.[71] To 'a thing called POETICAL TRUTH, which is required in those images, which are presented to the fancy, either to beautify or illustrate compositions in poetry', and which 'pass commonly by the name of *allegories, metaphors*, or similes', he opposed 'men of a lively and orderly fancy, to whom every word produces the idea', and who consequently found 'every incongruity of that sort . . . immediately manifest'.[72] This was a pragmatic aesthetic, one that finds meaning in the everyday, and matches that habit of judging from appearances that one would expect in a predominantly mercantile and commercial society. In *A Dialogue on Taste*, Colonel Freeman, a man who admits preferring *Hudibras* to Virgil, claims that 'of late, philosophy has put on a more familiar air, and is not ashamed to have it known that she is nothing else but common sense and experience methodized'. This, he argues, applies as much to the judging of painting.

> Your Lordship has only to hide yourself behind the screen in your drawing-room, and order Mrs. Hannah to bring in one of your tenant's daughters, and I will venture to wager that she shall be struck with your picture by La Tour, and no less with the view of your seat by Lambert, and shall, fifty to one, express her approbation by saying they are *vastly natural*. When she has said this, she has shewn that she knew the proper standard.[73]

Writing in 1773 to the charismatic clergyman Dr Dodd (later to be hanged for forgery) of the portrait he had painted of him, we saw that Thomas Gainsborough said

> [if] I thought it possible to make it ten times handsomer, I would give it a few touches in the warmth of my gratitude, though the ladies say it is vastly handsome as it is; for I peep & listen through the keyhole of the door of the painting room on purpose to see how you touch them out of the pulpit as well as in it. Lord! says one, what a lively eye that gentleman has![74]

This suggests at least an acquaintance with the system that Ramsay has Colonel Freeman propose. The Colonel then goes on to say that

> The same country girl . . . will, for the same reason, be charmed with Hogarth's March to Finchley, as that is a representation, though not of persons, yet of general manners and characters, with which we may suppose her to be acquainted. And if she is less struck with the historical pictures of different ages and countries, though equally well painted, it is . . . because the subject and manners, there meant to be represented, are to her unknown, and must pass with as little observation and remark as a good portrait of a person whom she had never seen . . . It requires first eyes to see, and then judgement to compare the exhibited image with that of the absent object, which is stored up in the resemblance, and is plainly a reflective and compound operation of the mind.[75]

As did Hogarth, Ramsay recognises that art is historically specific. And if Gainsborough was developing his 'hatching' manner of the later 1750s from Ramsay's example (who, significantly, has Colonel Freeman praise La Tour), at a period when it is clear that in the factional infighting among the artists Ramsay was allying himself with Hogarth, then, as his joking to Dodd implies, he was as alive to Ramsay's ideas as much as to his art.

Broadly speaking, then, Gainsborough's artistic milieu helped form the kind of painter he became and the sort of painting he professed. He possessed real business acumen, an awareness of the worth both of himself and his work. Hogarth, instigator of the Engravers' Copyright Act, was absolutely alert to the necessity to operate *intelligently* within a fickle market, so that, as David Bindman has pointed out, 'in the 1740s and 1750s . . . Artists, and Hogarth is . . . the prime example, were tending to retreat from the simple exploitation of

7 Faces and Lives

APORTRAIT WHICH AIMS TO COMMUNICATE LIKENESS will also claim to be an accurate representation of a person in a particular time and place and will necessarily manifest a concern with modern life. The portrait of the aged Duchess of Montagu (pl. 135), which Gainsborough painted in about 1768, appears a straightforward representation of his sitter, with her skin wrinkled and slightly sagging, bagging under the eyes, and the skull apparent beneath the flesh. This is, on the face of it, an honest representation of age, in its way a complement to the youthful beauty of the later *Mrs Graham* (pl. 84). Yet it is not straightforward. The Gainsborough landscape on the wall (a motif we notice, too, in the portrait of Uvedale Price (Alte Pinakothek, Munich) marks this as a household of taste; the red curtain in the left background, with its courtly antecedents, points up the sitter's pedigree; and we notice, too, the opulence of her costume, for she is not wearing widow's weeds, and the fact that she is holding a rose – as does the far younger Lady Innes in Gainsborough's portrait of her (pl. 136) and Susanna Gale in Reynolds's painting (pl. 58). The flower may be meant to invite us to contemplate the passage from youth to age, the transience of beauty. If we notice these details, understand them to raise questions, then we are reminded that no portrait ever tells a simple story.

The very act of sitting for a portrait will involve role-playing, but there are different ways in which this can be carried out, or represented. Reynolds was amazingly inventive when it came to picturing people. To show Mrs Hale as Euphrosyne, the Grace 'Good Cheer' (pl. 137), offered an improbable fiction which was found entirely plausible, and which forms an instructive comparison with his exactly contemporary portrait of Susanna Gale, which, while adapted from Van Dyck's *Marchesa Elena Grimaldi*, none the less appears strictly contemporary.[1] If his male sitters are fictionalised, it is to perform an exalted version of their own calling. Captain Orme – who attained no great distinction – is presented as martial hero, dramatically lit and posed as the Apollo Belvedere, taut but calm as he restrains a horse made anxious by the battle raging in the background (pl. 138).[2] When Gainsborough, rather later, attempted his own variation on the theme, the result was *Colonel St Leger* (R.A. 1782) in which St Leger, posed with the crossed legs familiar from innumerable portraits, leans against his horse as though it were a tree (pl. 140). By contrast, Reynolds's earlier version of the same sitter has him solitary against dark cloud, brilliant in red and white, clutching his sword, and appearing to address someone to his right (pl. 141).

Gainsborough was quite conscious of his limitations. In 1768 Garrick commissioned a picture of Shakespeare. At the beginning Gainsborough was sanguine about it. 'I intend, with your approbation, my dear Friend, to take the Form from his Picture & statues just enough to preserve his likeness *past the doubt of all blockheads*, at first sight, and supply a *Soul* from his Works.' It was not long before things went awry, and he wrote to Garrick that

> I have been several days rubbing in & rubbing out my design for Shakespeare and damme if I think I shall let it go or let you see it at last – I was willing like an Ass as I am, to expose myself a little out of the simple Portrait way, and had a notion of showing where that inimitable Poet had his Ideas from, by an immediate Ray, darting down upon his Eye turn'd up for the purpose; but G—— damn it I can make nothing of my Ideas there has been such a fall of rain from the same quarter . . .[3]

135 *Mary, Duchess of Montagu, c.*1768, oil on canvas, 1,257 × 1,003 (49$\frac{1}{2}$ × 39$\frac{1}{2}$). Bowhill, Duke of Buccleuch and Queensbury.

In the end he abandoned the project, and used the canvas for a portrait of his friend, the musician Johan Christian Fischer.[4]

The 'simple Portrait way' did allow for a degree of invention, but not in the manner of Reynolds. We might contrast the latter's version of St Leger with Gainsborough's *An Officer of the Fourth Regiment of Foot* (pl. 146). Rather than action we see inaction. Gainsborough's officer, head set off by the dark cloud customary in pictures of warriors, is elongated, leaning

137 Sir Joshua Reynolds, *Mrs Hale as 'Euphrosyne'*, 1766, oil on canvas, 2,360 × 1,460 (93 × 57$\frac{1}{2}$). Reproduced by the kind permission of the Earl and Countess of Harewood and Trustees of the Harewood House Trust.

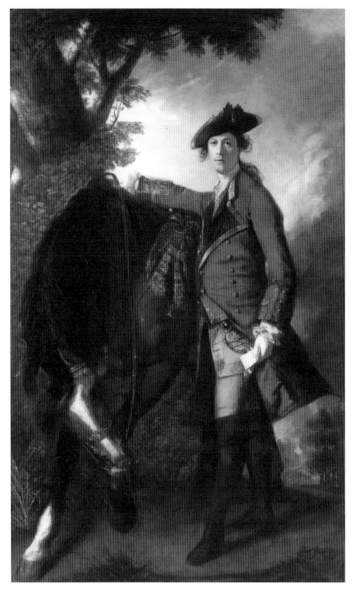

138 (*above*) Sir Joshua Reynolds, *Captain Orme*, 1756, oil on canvas, 2,400 × 1,473 (94¹/₂ × 58). London, National Gallery.

139 *An Officer of the fourth Regiment of Foot*, 1776–80, oil on canvas, 2,301 × 1,561 (88¹/₂ × 59). Melbourne, National Gallery of Victoria, Felton Bequest, 1922.

on a rock with polite insouciance, left arm virtually cradling the bayonet end of his weapon. Gainsborough has painted with exquisite control, thinly, virtually monochromatically in large areas, and with great restraint in the clothing. Effect is had through spare and subtle colouring: the relation of the vermilion of the cummerbund to the red of the coat, the contrasts of blacks with white, the way the silver gorget reflects highlights. There may be a narrative here, to do with duty involving serving overseas, as that vessel, sailing dangerously close to the shore, may hint, and how this conflicts with the instincts of the private man, as the sitter's gazing down and out to our right, in an apparently melancholy fashion, suggests. The dog, its coat textured through a succession of linear strokes, suggests, as we shall see below, a man of sensibility, a person prepared to extend affection to the brute creation. But rather than embrace the animal, as Gainsborough had shown the third Duke of Buccleuch doing with his dog (pl. 245), this officer has his sit still and obedient, to point up a potential divide between public duty and private inclination.[5]

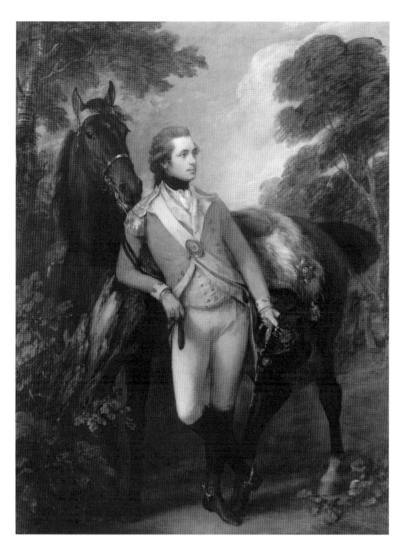

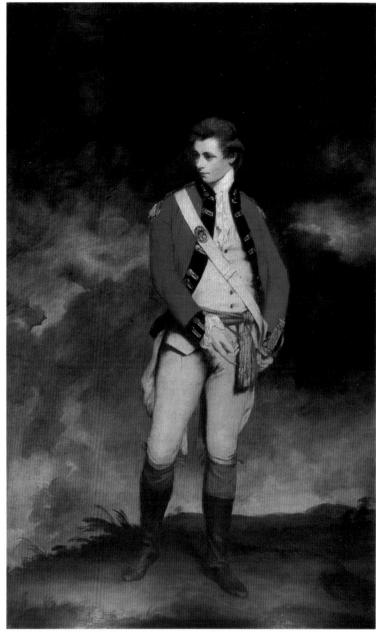

140 *Colonel St Leger*, 1782, oil on canvas, 2,360 × 1,460 (97^1/$_2$ × 73^1/$_2$). The Royal Collection. © Her Majesty Queen Elizabeth II.

141 (*right*) Sir Joshua Reynolds, *Colonel St. Leger*, 1778, oil on canvas, 2,360 × 1,460 (93 × 57^1/$_2$). Waddesdon Manor (The National Trust).

One can only speculate about this content, although it would fit easily with popular literary clichés. However, it is sigificant that Gainsborough does not show his officer playing a martial role, but, rather as an individual, whose shock of black hair, long nose and weak chin point to no glamorisation having taken place. This, however refined in its execution, is a portrait of modernity, and upon this it depends for its effect. In part this is implicit in the artist's concern with likeness, for, as I have suggested, to aim to communicate the impression of a particular individuality is to engage with what is perceived of the historical actuality of the person themselves. Thus, after Reynolds had posed the actress Sarah Siddons as the Tragic Muse in 1784 (pl. 142), Gainsborough responded in 1785 with a portrait of her dressed as she went (pl. 143). Given the circumstances of those years, this must have been meant as a deliberate corrective.[6]

Reynolds's painting, brown and extraordinary, enthrones Mrs Siddons upon the clouds, posed in the way of Michelangelo's Isaiah, wearing fictional garb, and gazing with a rapt

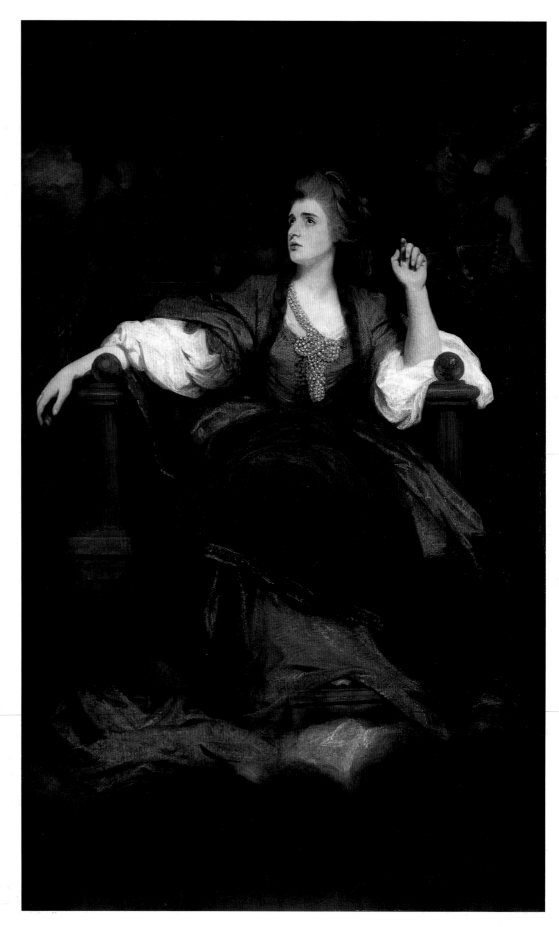

142 Sir Joshua Reynolds, *Mrs Siddons as the Tragic Muse*, 1784, oil on canvas, 2,360 × 1,460 (97¹/₂ × 73¹/₂). Courtesy of the Huntington Library, Art Collections, and Botanical Gardens, San Marino, California.

143 (*facing page*) *Mrs Siddons, c.*1783–85, oil on canvas, 1,264 × 997 (49³/₄ × 39³/₄). London, National Gallery.

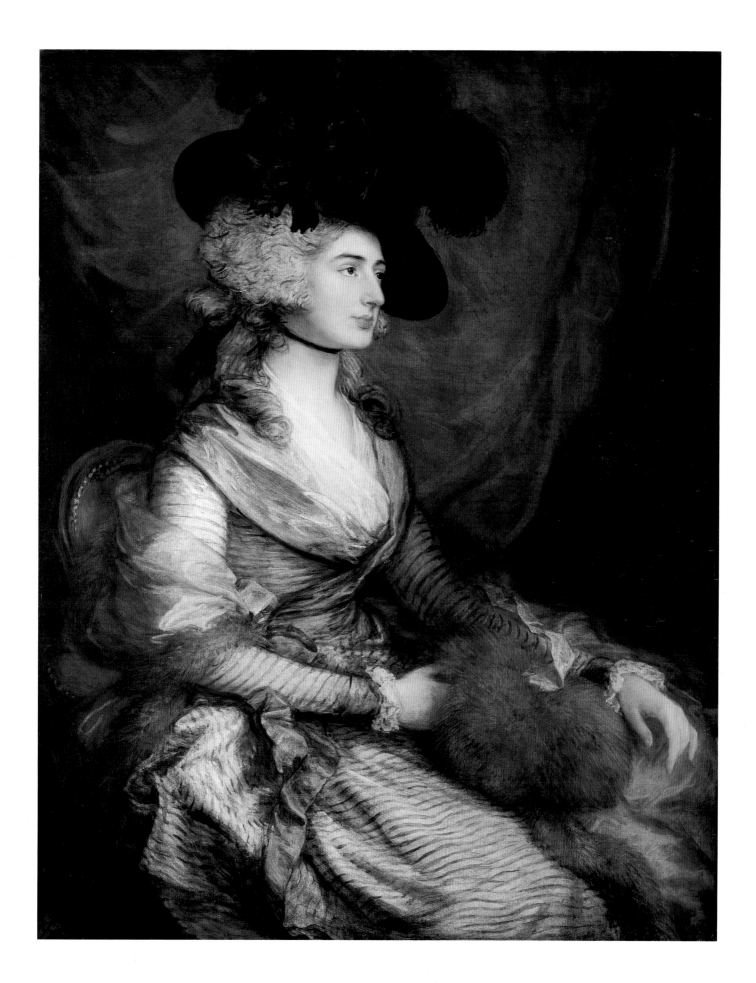

expression into the heavens. David Mannings points to the figures of Pity and Terror looming behind her, and notes how the impact of Reynolds's invention was so widespread that 'the sitter was wheeled along the stage as the Tragic Muse in a production of Garrick's *Jubilee* at Drury Lane in 1785', to indicate close 'links . . . between painting and stage practices', and, it should be said, something unstable in the status of Reynolds's inventions if they could so readily be recreated as *tableaux vivants*.[7] All that this painting appears to share in common with the Gainsborough is the sitter. In the latter, rather than parade as an historical invention, she sports the latest fashion, 'a blue and white striped wrapping gown tied at the waist with a blue silk sash; she holds a fox-fur muff and the same fur edges her yellow silk mantle', and the 'black beaver hat' is set at a 'stylish angle'.[8] Absolutely of her moment, Siddons's dazzling clothes are painted with *brio* to match, with the whole set off by a heavy red curtain. Henry Bate picked up on all of this when he reported on the picture:

> The resemblance is admirable, and the features are without the theatrical distortion which several painters have been fond of delineating. In addition to the great force and likeness which the portrait possesses, the new style of the drapery might be mentioned. Mrs. Siddons's dress is particularly *novelle*, and the fur around her cloak and fox-skin muff are most happy imitations of nature.[9]

It may seem odd for a man to pay so much attention to the detail of fashion – although Gainsborough, whose sister was a milliner, was professionally astute enough to be highly alert to such things – but, in her novel *The Sylph*, the Duchess of Devonshire had her character Henry Woodley proclaiming of his beloved that her 'dress became her the best in the world; a riding habit of stone-coloured cloth, lined with rose colour, and frogs of the same', showing that fashionable men were alert to such things.[10] Their own sartorial excesses were as much meat for satirical prints as those of women, and if a 'single dress might cost £50 in materials alone', then it was incumbent upon people to take notice.[11] It is interesting that neither Reynolds nor Gainsborough managed to sell their respective paintings, although in view of Siddons's eminence, it probably did neither artist damage to have her portrait on display in his studio. Whitley writes of Gainsborough's canvas that

> More than a year after it was finished a critic, who had just returned from visiting the studio at Schomberg House, remarks that 'the unpurchased portrait of Mrs. Siddons – with all the graces of private station – still adorns the ante-room, and will it adorn it for some time, we fear, so prevalent is the striking form of action and character over the mild and unimpassioned department of private life'.[12]

As Reynolds had so effectively propagandised against contemporary fashion, to present an alternative to his version of the actress in a costume which was 'particularly *novelle*' was to advocate an alternative within a tradition which could be vindicated through the example of Van Dyck, or justified by referring to the precepts of de Lairesse. Despite his claims for the historical style of portraiture, Reynolds was in fact selective in applying it. With the exception of the Polynesian Omai, he painted men in the costume of their calling, and, paradoxically, when he paints Mrs Siddons in that style, the result is extremely historically specific. To understand the painting we have to tease out its specific iconography – which David Mannings has demonstrated is not straightforward. By contrast, Gainsborough's portrait *appears* to communicate far more directly, perhaps because there is less involved in recognising what he represents. We need guidance as to what kind of a gown she wears, but see it as a gown, nevertheless. This apparent capacity fits with the way that Samuel Johnson had written of the ends of portrait as residing in 'diffusing friendship, in reviving tenderness, in quickening the affections of the absent, and continuing the presence of the dead'.

That is, portraits tended to serve a socially utilitarian function. As Marcia Pointon has written, the 'Bedford family spent more in a month on payments to upholsterers and

furniture-makers than they paid Gainsborough for a portrait.'[13] Jean André Rouquet wrote of 'the custom of frequently making a present of one's picture', and they tended to be commissioned by people other than the sitter.[14] As the author of 'An Apology for Portrait Painting' wrote in 1771:

> Whoever is delighted with his own picture must derive his pleasure from that of another. Every man is always present to himself, and has, therefore, little need of his own resemblance, nor can desire it, but for the sake of those whom he loves, and by whom he hopes to be remembered. The use of the art is a natural and reasonable consequence of affection; and though like other human actions, it is often complicated with pride, yet even such pride is more laudable than that by which palaces are covered with pictures which, however excellent, neither imply the owner's virtue not exalt it.[15]

If the sitter were dealing directly with the artist, it was with a specific aim in mind, as when, in 1763, Caroline Fox asked Ramsay to paint her 'as a dignified grey-haired woman, a letter writer and reader, dressed in warming furs and distanced from us by her social position and experience of life' for the gallery at Holland House, in which were displayed the images of 'the extended Richmond–Fox family, augmented by friends and mentors and presided over by ancestors'.[16]

Although some control over the image was exercised, what tended to attract attention was, as we have seen, not how the representation was achieved, but the identity of the sitter, as is indicated by the prevailing habit of writing her or his name onto the canvas. When Dorothy Richardson visited Gainsborough's studio in 1770, she simply listed the portraits along with notes on sitters' costumes, and the Reverend John Penrose's comment upon the portrait of Lady Waldegrave was that she was 'no such flaming Beauty in my eyes'.[17]

This is not to claim that aesthetic considerations played no part, for the willingness to pay the prices asked by Gainsborough or Reynolds signals an awareness of quality

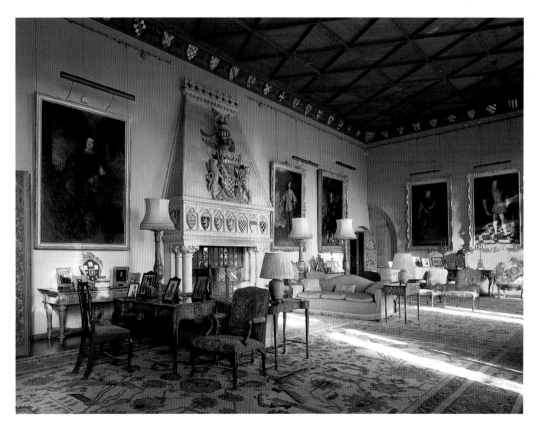

144 View of the portraits of the dukes of Norfolk at Arundel *in situ*.

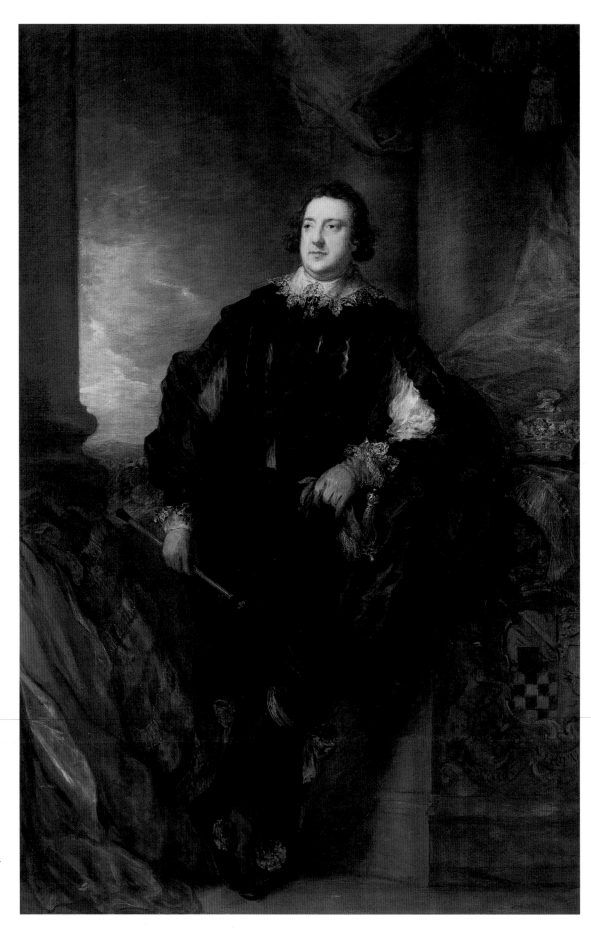

145 *Charles Howard, eleventh Duke of Norfolk*, 1784–86, oil on canvas, 2,299 × 1,524 (90$\frac{1}{2}$ × 60). London, National Portrait Gallery.

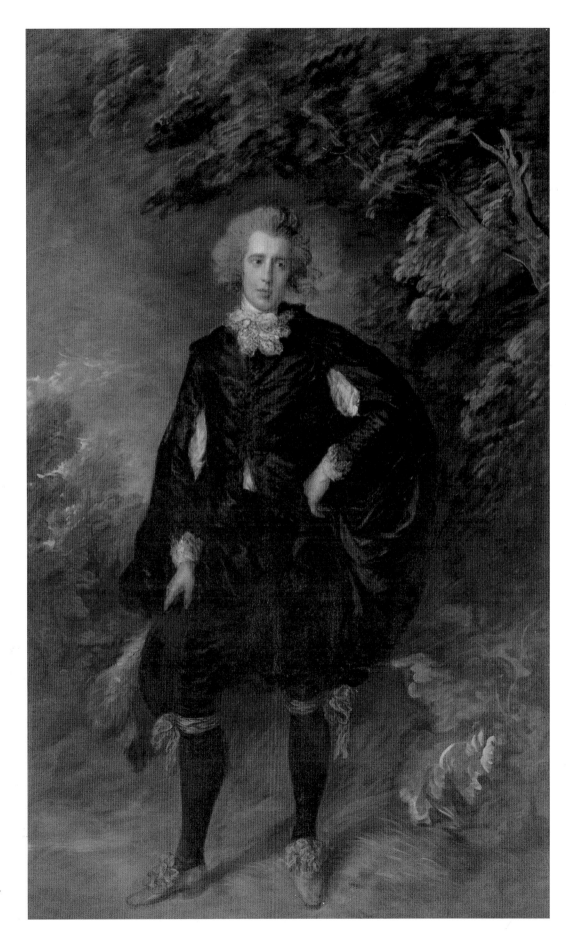

146 *Bernard, twelfth Duke of Norfolk*, 1788,
oil on canvas, 2,235 × 1,372 (88 × 54).
Arundel Castle, Duke of Norfolk.

differential (while the possession of such a portrait was itself an unimpeachably polite display of one's disposable income). Marcia Pointon has analysed the importance of pictorial display to ancestral dynastic assertiveness, so that at Arundel Castle it is significant that the drawing room contains, in addition to works by Van Dyck and Mytens, portraits of the eleventh and twelfth Dukes of Norfolk by Gainsborough (pls 144, 145, 146).[18] Both full-lengths, each shows the sitter in Van Dyck costume, and each is a *tour de force*. In the portrait of the eleventh Duke, despite the colouristic splendour of a red drape at bottom left answering the gold cloth flung across the columns, what is striking is how far Gainsborough's handling of paint, although evolved from the study of Van Dyck, is very different from it, and, indeed, manifests a delicacy that one would associate more with Watteau. This lends both portraits an air of modernity augmented by the contemplatively melancholic expressions which suit aristocrats posing as men of feeling. They fit snugly with the seventeenth-century work, to proclaim the dynastic continuum and confirm 'the eighteenth-century restoration of the family prestige'.[19] Gainsborough would have been engaged because only he could paint in this manner, making the point unambiguously and, in the process, linking the contemporary with a Stuart past.

We would not, however, take the eleventh and twelfth Dukes as anything but eighteenth-century gentlemen in fancy dress, and it is within their own contemporary circumstances that the portraits are most usefully set. At times we can discover something of these. One of Gainsborough's most direct portraits, for it was done at speed, was of Ignatius Sancho (pl. 147), who, despite being born on a slave ship, was able to rise to celebrity. As Reyahn King writes,

Sancho's letters . . . reveal an amiable, well-read man whose . . . wit was always combined with an elaborate courtesy . . . and in the midst of family and financial concerns, he attempted to retain both Shandean mockery and religious faith. Luck and his ability to attract aristocratic patronage, to charm the fashionable world and earn for himself a respectable niche within London's artistic circles, ensured for Sancho not only a life of comparative comfort but also allowed his character and inclinations full rein in a way normally impossible for black men in British eighteenth-century society.[20]

In eighteenth-century British art it was usual to represent people of African origin as servants, or, in Hogarth's case, as members of the urban throng.[21] The closest comparison to Gainsborough's portrait may be Reynolds's fine but unfinished painting of an unidentified African (pl. 148).[22] Gainsborough apparently completed the picture 'in one hour and forty minutes, November 29th 1768', while the Duchess of Montagu, wife of Sancho's patron, was sitting to him, which testifies to his extraordinary technical mastery, for there is nothing slapdash about it. He portrays Sancho as he did other creative men, such as De Loutherbourg or George Colman (pl. 149).[23] Sancho's gaze and expression suggest someone deep in contemplation, and the similarity to portraits of the artist's friends may mean that a sympathetic *rapport* was struck up by the two men, who both used charm and good nature to make their way. King writes of Gainsborough's rare success in managing Sancho's skin tone, and points out how the 'hand in waistcoat' pose confirms him a gentleman.[24] The portrait matches the status Sancho had attained, and the regard in which he was held. That it is also highly unusual equally accords with historical circumstances.

As we have seen, Mrs Graham was famous for her beauty, and, perhaps shortly after her marriage at the age of seventeen in 1774, Gainsborough painted a half-length of her in which that beauty becomes his subject through the concentration of light on the face and upper chest (pl. 152). Aside from noticing that between 1774–75 and the second portrait in 1777 (pl. 84) her face thinned a little, this is another case in which two portraits of the same sitter demonstrate his excellence in likeness. The earlier picture begs attention for the brilliance with which it has been realised and for the extremely expressionistic handling of her costume, a contrast with flesh in places painted so thinly that a beige canvas ground serves

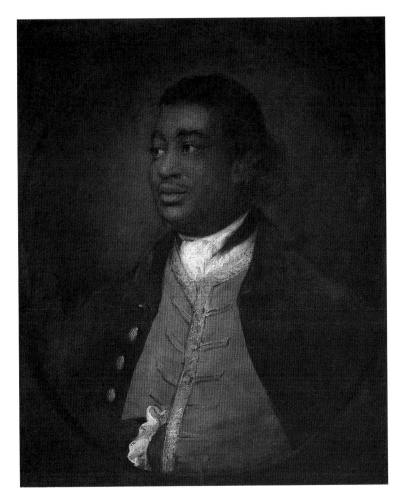

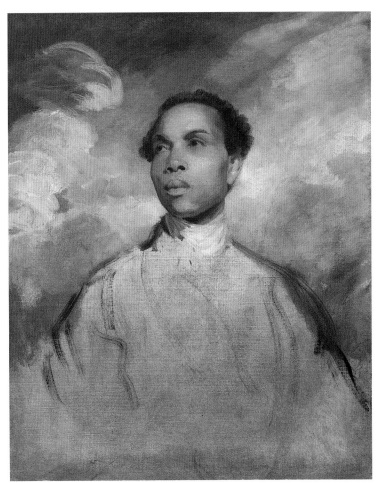

147 (*above left*) *Ignatius Sancho*, 1768, oil on canvas, 737 × 622 (29 × 24). Ottawa, National Gallery of Canada.

148 (*above right*) Sir Joshua Reynolds, *Study of a Black Man*, *c.*1770, oil on canvas, 787 × 650 (31 × 25¹/₂). Houston, The Menil Collection.

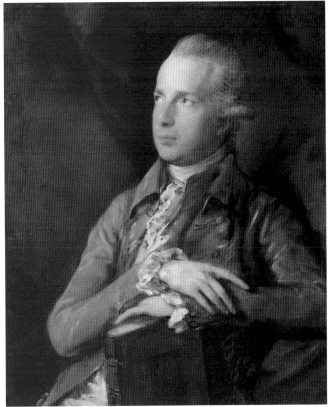

149 *George Colman*, mid-1770s, oil on canvas, 724 × 592 (28¹/₂ × 23¹/₄). London, National Portrait Gallery.

152 (*facing page*) *Mrs Graham, c.*1775, oil on canvas, 895 × 690 (35¼ × 27⅛). Washington, National Gallery of Art, Widener Collection.

partly as a shade about the nose and left eye, and down the left-hand side of the neck.[25] A red has been scumbled in to give warmth to the face and is used to outline the join of the lips and the fullness of the mouth. One wonders to what extent – in light of the delicacy of this handiwork – the touch of the brush was a surrogate for actual contact, for Gainsborough took a keen interest in women (asking William Jackson, for instance, to 'make my Compliments to one Lady who is *neat about the Mouth* if you can guess), and Thicknesse claimed to have 'detected' him 'spoiling a Lady's picture on purpose to have her chatt while she set for another to *be better* done'; or he might have intended an analogy between the beauty of his work, and of his sitter.[26]

For Gainsborough a successful portrait demanded empathy between himself and his sitter, yet most of the time he was painting to get money, and on occasion it is quite clear that he would do as little as necessary to satisfy a client. *The Hon James Donnithorne* (pl. 151) was painted in the early 1760s and evidently at some speed, as the area of uncovered canvas and the extraordinarily summary treatment of the books to the rear suggest. While the painting does resolve at a distance, the head is very large and, prospected close to, loosely painted, with undefined brushwork. Perhaps Gainsborough, often the courtier in his dealings with the greater aristocrats, was manifesting a suitable (if, considering his own practice, slightly incongruous) disdain for trade, for some of the paperwork is labelled as 'Accounts', and the sitter is holding a letter addressed to 'Mr Donnithorne, Esq., Merchant, London'. A later

150 (*below left*) *Anne, Countess of Chesterfield,* 1778, oil on canvas, 2,184 × 1,549 (86 × 61). Los Angeles, The J. Paul Getty Museum, Gift of J. Paul Getty.

151 (*below right*) *The Hon. James Donnithorne,* 1760s, oil on canvas, 2,032 × 1,549 (80 × 61). Wolverhampton Art Gallery.

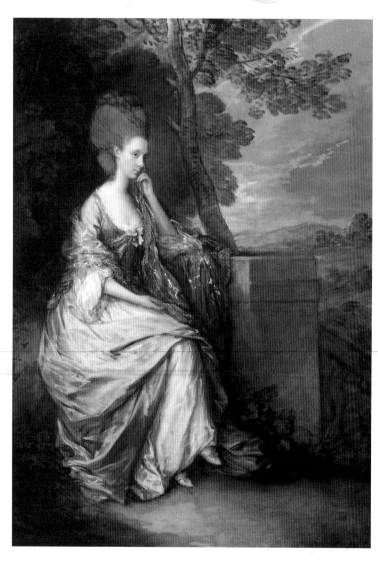

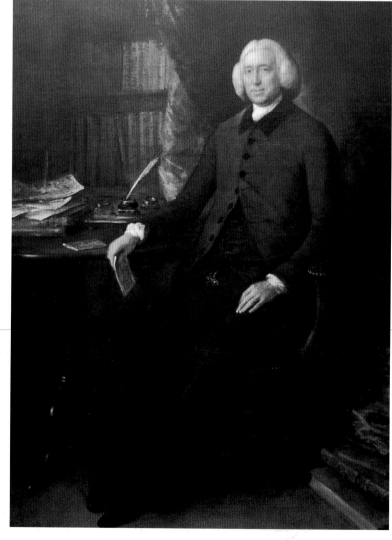

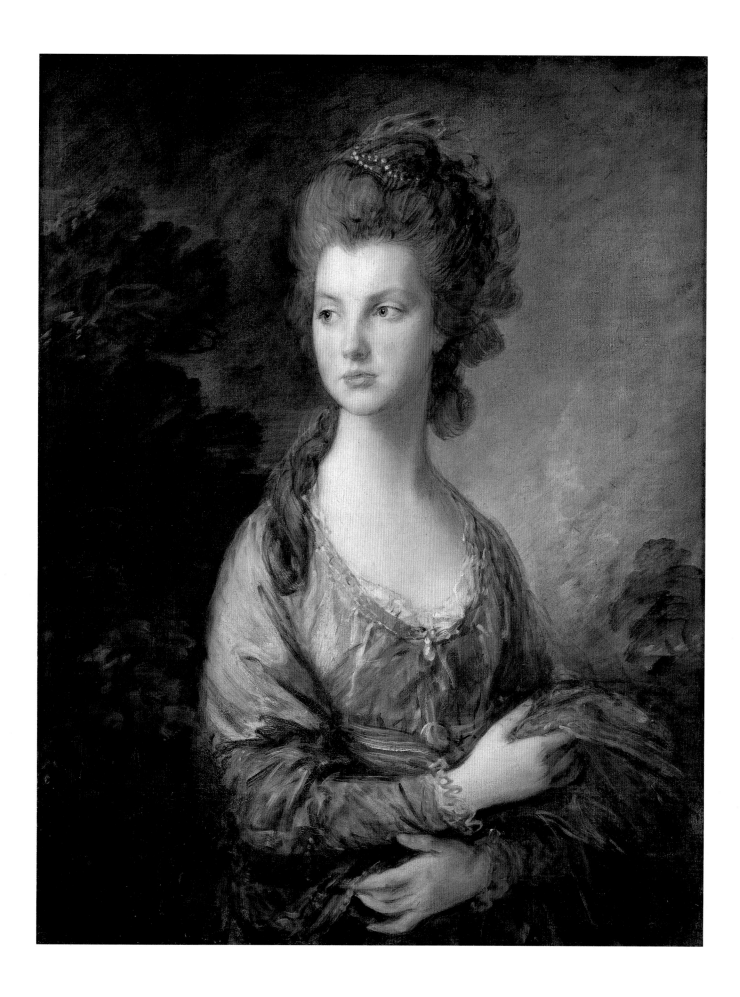

female equivalent would be the likeness of *Anne, Countess of Chesterfield* (pl. 150) exhibited at the 1778 Royal Academy exhibition. This is probably one of the works of which one journalist wrote that they appeared 'as if the drapery and subordinate parts were unfinished: the very hands in some of them insubstantial and informal; in fact he seems solely to have taken pains with the heads of his figures'.[27] Here, although the head has been done quite carefully, the drapery gives the impression of being virtually a lay-in, colours glowing, unmediated and pure.

So, while Reynolds portrays his sitters according to pre-existing conceptions, Gainsborough was willing to take them more or less as they appeared, and the variety in his portraits will mirror the variety in his encounters with sitters. From surveying Reynolds's portraits the spectator can get an idea of a society organised into hierarchies ordained by rank, age and sex, in which women can achieve status only by association with their spouses, or through role-playing; but with Gainsborough this is less easy, although, as we shall see, on occasion it appears as though sitters did contribute ideas as to how they might be shown. *Sir Edward Turner, Bart.* (pl. 153), one of those portraits done in the Bath painting room, has the sitter leaning against the chair, standing in the customary cross-legged manner. Turner himself is painted with care and apparent sympathy; while the work in the face is quite rough, it still communicates the impression of unexceptionably fleshy middle-aged features. But what catches the eye is the suit, embroidered with myriad tiny flowers, the painting of which must have taken some time. Of this extraordinary outfit Aileen Ribeiro writes:

> Turner had recently come into a fortune and must have spent a considerable amount on this coat of French silk, grey brocaded in white, black and gold; attractive enough as a pattern, the effect in a three-piece costume is of an *embarras de richesse*, Such suits survive in museums, but it is rare to see them in portraits . . . It would be interesting to know what Gainsborough thought of his somewhat *nouveau-riche* taste in costume, but he has painted him in a stylish enough pose . . .[28]

There is a conundrum here, because Gainsborough, alert to the qualities of fabrics, might have been intrigued by the cloth if not the suit. As the picture dates from a time when he had to take care not to alienate sitters, one can, nevertheless, speculate that it communicates something of Turner's own taste. It does remind us that the portrait will be always the result of a species of negotiation between artist and sitter, and sometimes the latter will be dominant.

Thomas Gainsborough will have been less able than usual to dictate terms in 1783–85, when the King's brother the Duke of Cumberland, whose likeness alongside that of the Duchess (pl. 154) he had exhibited in 1777 and unfinished portraits of whom were begun at the request of the Prince of Wales in 1783, requested a painting of himself, his wife and her sister.[29] In this beautifully painted scene, the Duke and Duchess stroll in the grounds of Cumberland Lodge, Windsor Great Park, enjoying an elegant and healthy amusement in a composition which domesticates the *fêtes galantes* of Watteau. Pausing from her drawing to look on for a moment is Lady Elizabeth Luttrell, sister to the Duchess. Her presence adds an element of harmonious interaction such as we see in many other group portraits of members of the same family – an example would be Wright's slightly earlier *The Reverend D'Ewes Coke, his Wife, Hannah, and Daniel Parker Coke, M.P.* (pl. 157), in which, rather than enjoy elegant parkland, the trio, armed with drawings and an umbrella, prospect their grounds, seeking for themselves and for their landscape the improvement which, Gainsborough shows, royalty never can require.[30]

In the case of the Cumberland painting, we must take care not to take portraiture entirely at face value. Elizabeth Luttrell was 'notorious for her low moral conduct, her gambling and her ridiculing of George III and Queen Charlotte'.[31] In 1770 the Duke of Cumberland had cut as unseemly a public figure (pl. 158). That July great mileage was had from his trial for criminal conversation with Lady Grosvenor. One deposition – also picked up by the

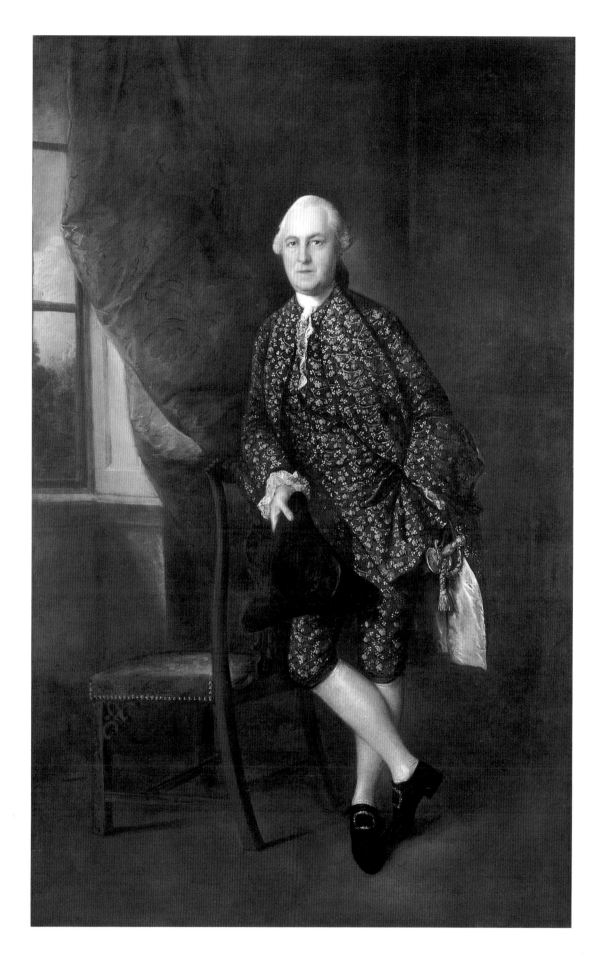

153 *Sir Edward Turner, Bart.*, 1762, oil
on canvas, 2,286 × 1,524 (90 × 60).
Wolverhampton Art Gallery.

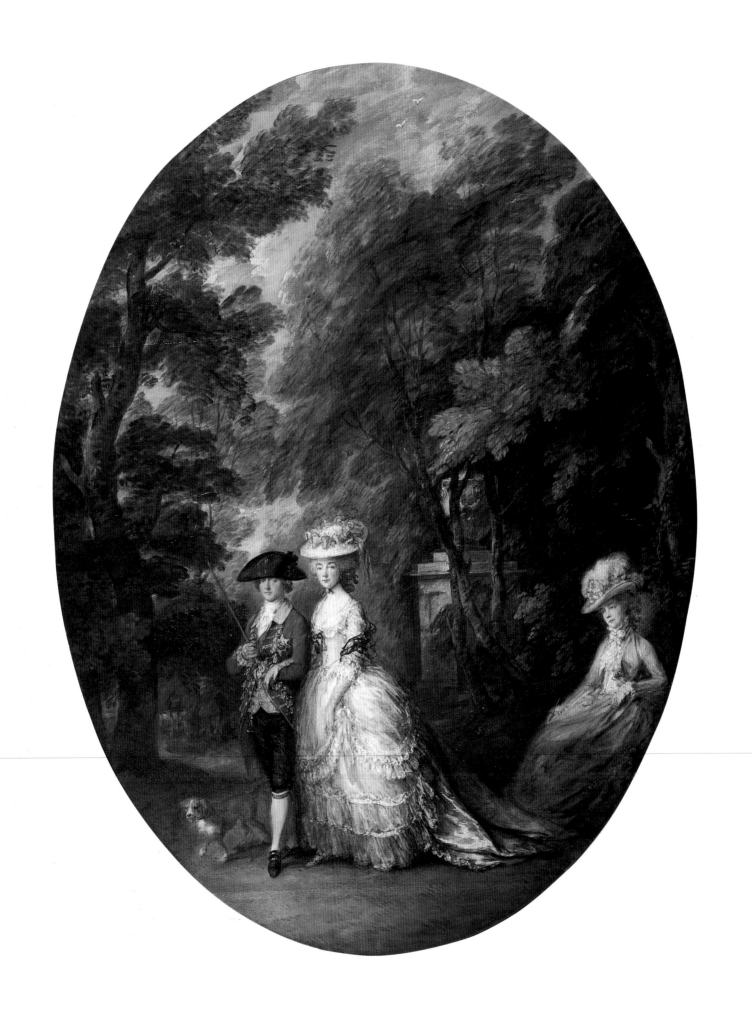

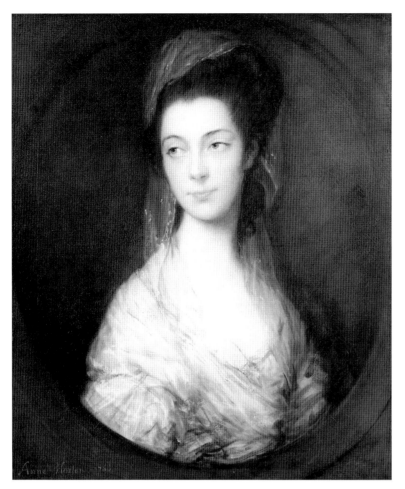

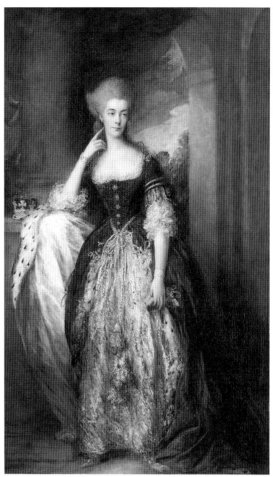

155 (*above left*) *Mrs Horton*, 1766, oil on canvas, 495 × 632 (19$^1/_2$ × 24$^3/_4$). Dublin, National Gallery of Ireland.

156 (*above right*) *Ann, Duchess of Cumberland*, 1783, 1,726 × 1,019 (68 × 38$^1/_2$). The Royal Collection. © Her Majesty Queen Elizabeth II.

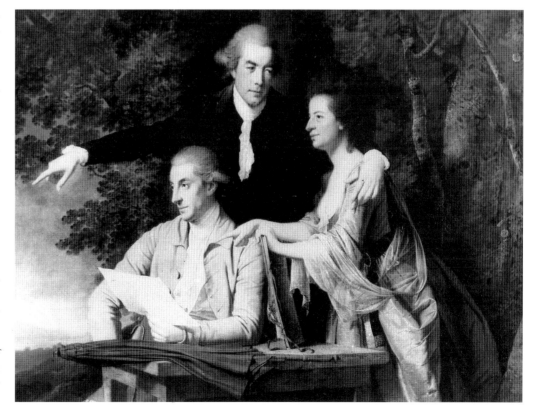

157 (*right*) Joseph Wright, *The Reverend D'Ewes Coke, his Wife, Hannah, and Daniel Parker Coke, M. P.*, c.1781–82, oil on canvas, 1,524 × 1,778 (60 × 70). Derby Museums and Art Gallery.

154 (*facing page*) *The Duke and Duchess of Cumberland*, 1783–85, oil on canvas, 1,638 × 1,245 (64$^1/_2$ × 49). The Royal Collection. © Her Majesty Queen Elizabeth II.

For the Oxford Mag

A certain personage in the Character of a Fool as he performd it at Whitchurch & elsewhere.

Mss Roberts sitting naked in Ld Grosvenors lap at the Hotel in Leicester fields.

159 'Lord Grosvenor and a Prostitute' from *Trials for Adultery*, 1780.

Gentleman's Magazine – explained how the Duke had carried out his liaison by pretending to be one Morgan, 'a country 'Squire not very *sound* in his *understanding*', which Cumberland's reprinted love-letters rendered more than plausible, and that servants of Lord Grosvenor tracked them to an inn at St Albans, and, 'upon breaking down the door at the inn, found the D. of C. sitting at the bed-side along with Lady G—— with his waistcoat loose, and the Lady with her Dresden unbuttoned, and her breasts wholly exposed: that on their entering, her ladyship made towards the door of communication with the next room, but in the attempt fell . . .'.[32] Gainsborough (who had exhibited a portrait of Lady Grosvenor at the Society of Artists in 1767) would, presumably, have taken as much interest in the case, as, predictably, did the *Town and Country Magazine*, which exulted in the Duke's atrocious orthography, pretending to advertise for a lost parcel of letters, 'most of them beginning with *My dere letel angel*', along with a rejoinder from 'One of the female Coterie', which claimed that, to the person of sensibility, the letters 'can only amount to a declaration of *a refined Platonic Love*', and that the incident at St Albans was a mere 'indiscretion'. To exhibit the double standards of the great, its August 'Tête-à-Tête' exposed the adultery of the Duke of Grosvenor himself, more of whose adventures were commemorated in a print in 1770, showing him in a hotel room, frolicking with a naked prostitute (pl. 159).[33]

The pair entered the popular consciousness through satirical prints and in literature; in a novel of 1771 Lady Grosvenor is 'the Brimstone that went off with the Duke of C——'.[34] And there they stayed. In 1777 the *Morning Post* published a poem on the Gainsborough portraits of the Cumberlands, then on display at the Royal Academy, which explicitly referred back to to the Duke's letters, and in a survey of monumental records supposed to date from 1960, but published in 1780 (in which year the episode was reprised in *Trials for Adultery*), part of the inscription on the tomb of the Duke of Cumberland reads: 'His Failings . . . frequently partook of Criminality.'[35] The reputation enjoyed by the Duke and Duchess of Cumberland was not the virtuous and agreeable one that Gainsborough's painting of them implied, and rather than the sizeable animal that peers engagingly up at the Halletts as they enjoy their morning walk (pl. 241), the Cumberlands are accompanied by an apparently independent lap-dog. The Duke was excoriated in 1771 for appearing 'at a summer watering-place playing the same shameful part with another woman', and in 1781 the Duchess of Pembroke was contemplating the prospect of a visit from the pair as 'perfectly disagreeable as well as expensive'. At the same time the Duchess was being lampooned in one of the squibs aimed at Dr Graham's Temple of Health and Hymen, 'famous for its "Medico-Electrical Apparatus" and its "Grand Celestial State Bed" which had a dome lined with mirrors . . . [and] played music'.[36] Amongst those the poem *Celestial Beds* had

Graham's magic school' were the Duchess of Devonshire, and 'C—— with peerless grace,/(The glory of the Luttrell race).'[37] This was no compliment. Dr Graham's establishment had the reputation of being an aristocratic brothel, as Gainsborough, who lived next door, would have known.[38]

By considering Gainsborough's 1760 portrait of Ann Ford, we can further see the extent to which a single portrait can be reintegrated into a range of recoverable histories. *Ann Ford* (pl. 161) was by far his most ambitious portrait to date. It adapted the Hastings/Donnithorne format to a female sitter in a display of brilliant brushwork and colouristic *bravura*, with the silver sheen of the dress counterpointing the red of the curtain. On 23 October 1760, Mrs Mary Delany visiting Gainsborough's picture room, was struck by 'Miss Ford's picture, a whole length with her guitar, a most extraordinary figure, handsome and bold; but I should be very sorry to have any one I loved set forth in such a manner'.[39] The picture was strikingly unusual. When women were pictured in domestic interiors, they were usually shown engaged in some appropriate domestic task, as Reynolds shows the Countess of Albemarle knotting (National Gallery, London), or as an object of display, as Gainsborough presented Mrs Siddons. It might attest to the exceptional and risky character of *Miss Ford* that Gainsborough showed the canvas in his painting room, but not at exhibition. She crosses her legs 'above the knee, a masculine freedom', according to a contemporary conduct book, 'for such a free posture unveils more of a masculine disposition than sits decent upon a modest female'.[40] If the painting took risks, this was appropriate to the turn of events in Ford's own life at the time.

Ann Ford was a talented musician, playing the English guitar, viola da gamba, and musical glasses, and she was additionally blessed with a fine singing voice. Her performances were confined to private houses, and she conceived a desire to appear in public. To prevent this her father had her arrested twice, but she was eventually successful.[41] The concerts she gave were advertised for March and April 1760 and October 1761, so Ford probably returned to Bath (where she had been living) in the interim, for she was given protection by Lady Elizabeth Thicknesse, wife of Gainsborough's mentor Philip, who after his wife's death was to marry Ford himself. Gainsborough could have painted her after April 1760. He had probably known her for a while, for both he and Ford were in Bath in 1758 when he had painted Lord Villiers, son of the third Earl of Jersey, whose circle included William Whitehead (quoted above on Gainsborough's manner); and he would go on to paint the third Earl himself some time around 1760.[42] From Whitehead we learn of Ford's close links with the Jersey circle, and how she was causing a sensation amongst its members. He wrote on 16 November 1758: 'I have seen Miss Ford, nay almost lived with her ever since I have been here. She has a glorious voice and infinitely more affectation than any Lady you know. You would be desperately in love with her in half an hour, and languish and die over her singing as much as she does in performance.'[43] This was a singer of such sensibility as to affect even herself. And Whitehead was not alone in succumbing to her charms, for, as we shall see, she also captivated the aged and ailing Earl of Jersey.

She was pressurised into confining her performances to the domestic arena principally because she wished to perform instrumentally; for the opposition to women singing in public was less rigid. The advertisement for the first concert announced that she would 'play a Solo on the Viol da Gamba'.[44] This was a radical move. Despite its *visual* association with the female body (Ronald Paulson makes acute observations on the correspondences between the shapes of the instruments and those of their player), this was an instrument conventionally reserved to male performers.[45] The English guitar which Gainsborough shows in her lap was, however, 'a solo instrument used almost exclusively in the home and played virtually always by women'.[46] Ford was not alone in finding her wish to perform in public obstructed. In 1776 a Miss Brown wished to play Polly Peachum in *The Beggar's Opera*, only to be seized by her father 'before the play began. This had such an effect on her that soon after she came on first . . . she fainted . . . but she recovered and did very well.'[47] The stigma

that attached to actresses was not normally applied to female singers, and Elizabeth Linley, whose portrait together with her sister Mary by Gainsborough (pl. 176) was exhibited at the Royal Academy in 1772, was so acclaimed a performer that in 1773 Fanny Burney wrote that the 'applause and admiration she has met with can only be compared to what is given to Mr Garrick'.[48] None the less, after her marriage to Richard Brinsley Sheridan, her husband, despite his chronic penury, decided that she should no longer sing in public. Dr Johnson was with him. 'Would not a gentleman be disgraced by having his wife singing publicly for hire? No, Sir, there can be no doubt here. I know not if I should not *prepare* myself for a publick singer as readily as let my wife be one.'[49]

Ford, then, had to proceed with unusual determination. Her problems were compounded by the Earl of Jersey. He had been as captivated by her as the rest of his circle, to the tune of offering her £800 *per annum* to come into his keeping. This she refused. He consequently attempted to sabotage her first public concert by arranging an alternative entertainment, to which he induced many of her invited guests to go instead – in spite of which she still made £1,500.[50] This calculated snub may very well have inspired her to write, and, early in 1761, to publish, *A Letter from Miss F––d, to a Person of Distinction*, a pamphlet in which she told her side of the story.

She recounts Jersey's offer, and how, rather than prostitute her person, she had determined on consolidating her reputation by moving from private to public performance. The outlandishness of this idea was compounded by her offering the *only* subscription concerts in London between 1756 and 1763. And these were 'quite outside the mainstream', with 'fashionable and sizeable' audiences 'perhaps more attracted by the scandal than her music'.[51] Ford's squib induced Jersey to publish *A Letter to Miss F––d*, which in its turn provoked a second edition of hers. This came with a print (pl. 160) in which particular details – the guitar in her lap, the three-legged table – are based on Gainsborough's portrait. In this clumsy caricature the handicapped aristocrat woos Miss Ford by singing 'Believe my sighs my vows my dear &c', misremembered from the popular Vauxhall song, 'The Slighted Lover'. She, rather puzzlingly, replies 'si tutti de olberi'. Her father looks on. The caged songbird alludes to her confinement, and the boar's head to the only present Jersey had ever given her. He explained that 'my Lord *Meleager* made his *Atalanta*, his beloved Mistress, a first and only present of a Boar's Head'. Atalanta was a huntress who, taking part in the Calydonian

160 Plate from *A Letter from Miss F––d*, second ed., 1761.

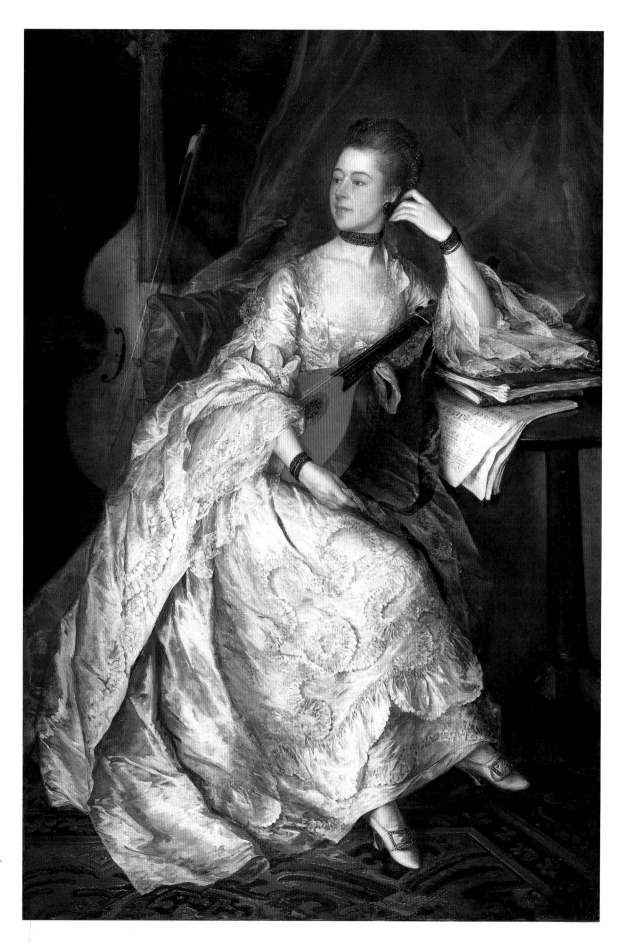

161 *Ann Ford (Mrs Philip Thicknesse)*, 1760, oil on canvas, 1,969 × 1,346 (77¹/₂ × 53). Cincinnati Art Museum, Bequest of Mary M. Emery.

boar hunt, had been first to strike the prey, for which masculine feat she had received from Meleager the head and skin as a prize. Jersey implies that, in failing to play the part for which he had her destined, Ford had stepped as far beyond the boundaries of the feminine.[52]

The world relished this scandal. *A Letter from Miss F——d* sold five hundred copies in five days.[53] In addition, the January and February 1761 editions of the *Gentleman's Magazine* treated readers to long excerpts from both pamphlets, and the publication of *A Dialogue occasioned by Miss F——d's Letter to a Person of Distinction* kept things in the public eye.[54] The participants in this dialogue were Frank and George; the former taking sides with Jersey and Ford's father, the latter admiring her principles, and concluding: 'let us wonder . . . that she should, with determined resolution, renounce her father and her father's house; correct her passions, her pity, and every female weakness; resign her views of wealth and pleasure, of grandeur and pre-eminence; and endeavour to earn the bread she eats in the humble station of a public singer.'[55] As we may guess from Dr Johnson's remarks on the 'publick singer', this was someone of dubious reputation, far beneath her who sings for the delight of a public. And, amazingly, Ann Ford had willingly renounced everything, to take a course of action that must make her a social pariah.

Ford herself would have none of this: 'I have the satisfaction to find many sensible people of opinion, that a young woman may sing in public, or (to use your L——d——p's own words) be a public singer, with virtue and innocence; and be looked upon in as favourable a light as a surgeon or midwife, who can pay his court to a man of quality, who he knows had designs against the honour of his n——ce.'[56] The 'surgeon or midwife' she meant was her uncle, whom Jersey had urged to be his pimp. But, bearing in mind the presence of Laurence Sterne's Dr Slop in the public mind at that time, her words also lock into a more general debate about male midwives. Roy Porter has written on the extent to which their manual diagnostic attentions were considered improper and dangerous. In 1764 Philip

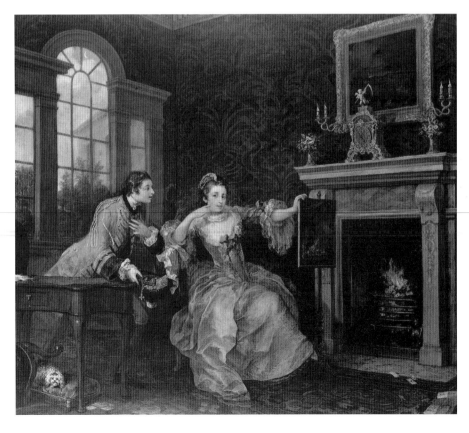

162 (*below left*) William Hogarth, *The Lady's Last Stake*, 1758–59, oil on canvas, 914 × 1,054 (36 × 41¹/₂). Buffalo, New York, Albright-Knox Art Gallery, Seymour H. Knox Fund through special gifts to the fund by Mrs. Marjorie Knox Campbell, Mrs. Dorothy Knox Rogers, and Seymour H. Knox, Jr., 1945.

163 (*below right*) Louis François Roubiliac, *Handel*, 1735, marble. London, Victoria and Albert Museum.

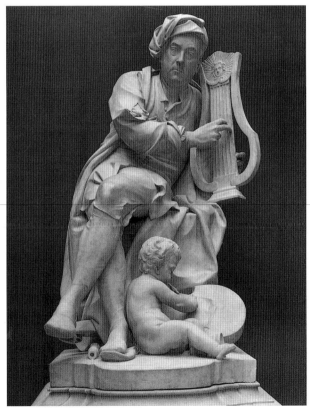

Thicknesse contributed to the controversy with a pamphlet, *Man-Midwifery Analysed: and the Tendency of the Practice detected and exposed*.[57] Thicknesse aimed to halt 'the indelicate, unchaste, and unnecessary transactions', which, as there was 'very little difference, except the sex, between men and women', there was nothing 'relative to midwifry, but a woman can learn, and execute, with more propriety and safety than men'.[58] His medical example offered a parallel to Ford's wishing to enter the masculine realm of public performance.

Thomas Gainsborough painted Jersey, knew Ford, was friends with Thicknesse, and kept the company of musicians. He would have been privy to the details of the whole affair, and a formal analysis of his painting will show how responsive he was to them. It is noteworthy, for instance, that he represents Ford in a pose of cogitation. While this has a genealogy which reaches back to works such as Dürer's *Melancolia* or Palma Vecchio's *Lutenist*, he would have had more recent models available to him.[59] On 20 March 1760 Reynolds had begun a portrait of Laurence Sterne (pl. 14), whose *Tristram Shandy* was a popular sensation, as a 'profitable speculation', and had the portrait at the engraver, Fisher's, by 21 April.[60] Ford could be imagined to mirror the thinking Sterne, although the awkwardness of her situation is indicated through Gainsborough's also referring to Hogarth's *The Lady's Last Stake* (pl. 162), in which the protagonist also crosses her legs in a 'masculine' manner. This painting had caused a stir in 1759, and was to return to public view at the 1761 exhibition of the Society of Artists. Its appeal lay in its being impossible to tell whether a 'virtuous married Lady' would succumb to the wily blandishments of the young officer, who is proposing that she 'part with her honour . . . to regain the loss she had suffered by gambling at cards'.[61] She is caught on the horns of this dilemma because she is permitted no occupation and is reduced to passing her time in whatever ways she can.

Ann Ford's own history illustrated the problems of escaping this confinement, and Gainsborough acknowledges this not only by referring to Hogarth, but also to Roubiliac's sensational statue of Handel (pl. 163), for the angle of the body and crossed legs compare in

164 (*below left*) Arthur Devis, *A Lady in Blue*, 1757, oil on canvas, 559 × 356 (22 × 17¼). London, Tate Gallery.

165 (*below right*) Joseph Wright, *Mrs Gwillym*, 1766, oil on canvas, 1,270 × 1,016 (50 × 40). St Louis Art Museum (Miss Martha I. Love in Memory of Mr Daniel K. Catlin).

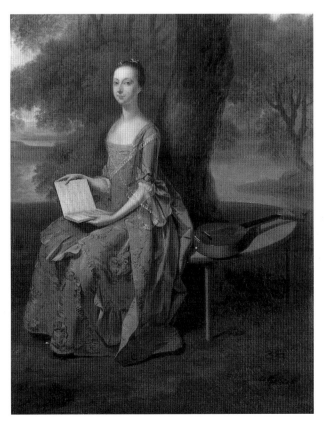

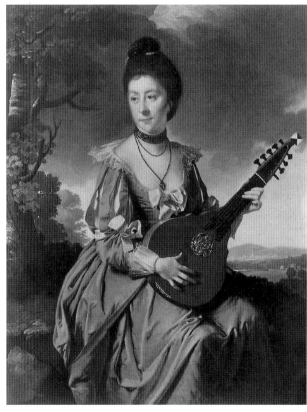

each. Handel's Orphean lyre is appropriately contrasted to Ford's English guitar; as we saw, this was an instrument played by women, usually in the house. None the less, in a contemporary portrait (pl. 164), Arthur Devis showed a young woman who has laid down her guitar on the bench on which she sits in order to study sheet music; while the exterior location and fancy dress in Joseph Wright's 1766 portrait of Mrs Robert Gwillym (pl. 167) detach her from the immediate here and now to defuse any threat her musical aspirations might represent – and she is playing her instrument. By contrast, Ford appears to embrace, to enfold hers, insinuating a fitting phallic symbolism, appropriate to her having presumed to take on a masculine role.[62] Ford's other main instrument, the 'masculine' viola da gamba appears a looming presence beyond the curtain, its distancing perhaps metaphorically alluding to the very serious and risky lengths she has to go in order to perform upon it, the gloom in which it is enveloped offering a telling contrast to the high illumination and virginal purity of her frock. Gainsborough's portrait *Ann Ford* represents the circumstances of her biography in extremely sophisticated ways.

Once he had gained the confidence of his sitter, Gainsborough's preferred way of doing a portrait was to outline the figure on to the canvas, and paint directly; but preparatory drawings exist for *Ann Ford* (pls 166, 167), indicating something of the pains he took about the picture. One of these has her actually playing the guitar, a motif generally familiar from

166 (*below left*) *Ann Ford*, 1760, pencil and watercolour, 335 × 257 (13³/₁₆ × 10¹/₈). London, British Museum.

167 (*below right*) *Ann Ford*, 1760, drawing. Private collection.

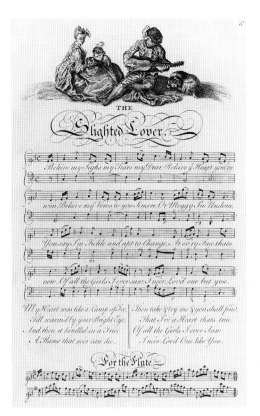

168 'The Slighted Lover', from George Bickham, *The Musical Entertainer*, 1737–38. Sudbury, Gainsborough's House.

169 G. B. Cipriani, *Ann Ford*, 1760–62, pencil, 143 × 148 (5¹⁄₂ × 5³⁄₄). Oxford, Ashmolean Museum.

such paintings as Watteau's *La Gamme d'Amour*, integrated into the British vernacular by George Bickham in, tellingly, his headpiece to the song 'The Slighted Lover' from *The Musical Entertainer* (pl. 168); so perhaps Gainsborough and Ford planned to build in the reference (noted with respect to the print with the second edition of *A Letter from Miss F––d*) from the start. However, to paint her performing, even in domestic surrounds, would have been asking for trouble, as compounding and commemorating exactly what had caused so great a scandal in the first place. Even the near contemporary *Carl Friedrich Abel* (pl. 47) represents the virtuoso on a three-quarter canvas, pausing from performance, and is in fact less assertive than the full-length of Ford. In another of the drawings he made while negotiating these aesthetic minefields, Gainsborough had her cogitating on a *chaise longue*, guitar in lap, cat at her feet. A near contemporary portrait of Ford by Gainsborough's friend Giovanni Cipriani (pl. 169) suggests that she took a keen interest in her own representation, for the thinking pose and guitar head resting on a folio of sheet music are reminiscent of Gainsborough's portrait.[63] In 1758, Sir Charles Hanbury-Williams wrote that he thought her 'Mad with Vanity and Pride'.[64]

When Thomas Gainsborough eventually realised her portrait, the subtlety of his imagery was of a piece with his modernism. His sitter's physical beauty devastated men, and the portrait to a degree objectifies this: impressing upon us the flawless complexion; raising her to the rank almost of a precious object, bedecked in ribbons, pearls, beautiful materials, rare handiwork; showing the fabrics with dazzling lustre. The pose has conventionally been linked to Van Dyck's *Lady Digby*.[65] On closer inspection the connection appears tenuous. Deborah Cherry and Jennifer Harris found *Ann Ford* 'indebted' to *Lady Digby*, and went on to note Gainsborough's 'inventive and original use' of that model in changing 'the position of the legs and left arm', and transforming 'the major axes of the figure . . . into a network of spiralling curves'.[66]

While pose, setting and presentation were calculated to impress, Gainsborough maintained a nearer focus when it came to rendering Ford's features. Here he developed lessons from Allan Ramsay, for the subtle shading of the face and the highlighting of the nose are also noticeable in Ramsay's celebrated portrait of Margaret Lindsay, his second wife (pl. 27), and Ramsay, too, was intent on celebrating the rich materiality of expensive clothing. So *Ann Ford* presents an edgy compromise of intimacy and distance, the latter established through the aristocratic associations of the Van Dyckian 'type' and low viewpoint, apparently presenting us with something like Ford's view of herself, while articulating the problems that surrounded her being able to promote this.

Gainsborough painted women on something approximating to their own terms on other occasions. The full-length portraits of Lord and Lady Ligonier (pls 170, 171) were done over July 1770. He drapes an arm over his horse and has enough of an equine cast to his own features to imply a physiognomic comparison within a tradition that runs back through Charles le Brun to the Renaissance, given a little edge by Gainsborough himself, who on one occasion proposed to be 'as serious and as stupid as a horse'.[67] By contrast, the 21-year-old Lady Ligonier is alert and possessed of real intellectual powers, as we discover from her having been drawing sculpture, more usually the province of a male art student. This was noticed at the time. One reviewer observed that she 'has a remarkably piercing eye, and sensible and polite countenance', while, by contrast, the 'horse, being represented as near to the spectator as the gentleman, and being a large object, and of light colour, attracts the eye as much as the gentleman does . . . and it is to be feared that such people as effect to be witty, will say the horse is as good a man as his master'.[68] By July 1770 she had had an affair with her husband's head groom, whom, in late 1770 or 1771, she replaced with the Italian dramatist, Vittorio Alfieri. This tempestuous and spectacular liaison climaxed in a great public scandal in May 1771, when visitors to the Royal Academy could have seen these Gainsborough portraits. The inevitable trial for criminal conversation took place that June. Much later she would write to Alfieri that he had been 'the cause of my delivery from

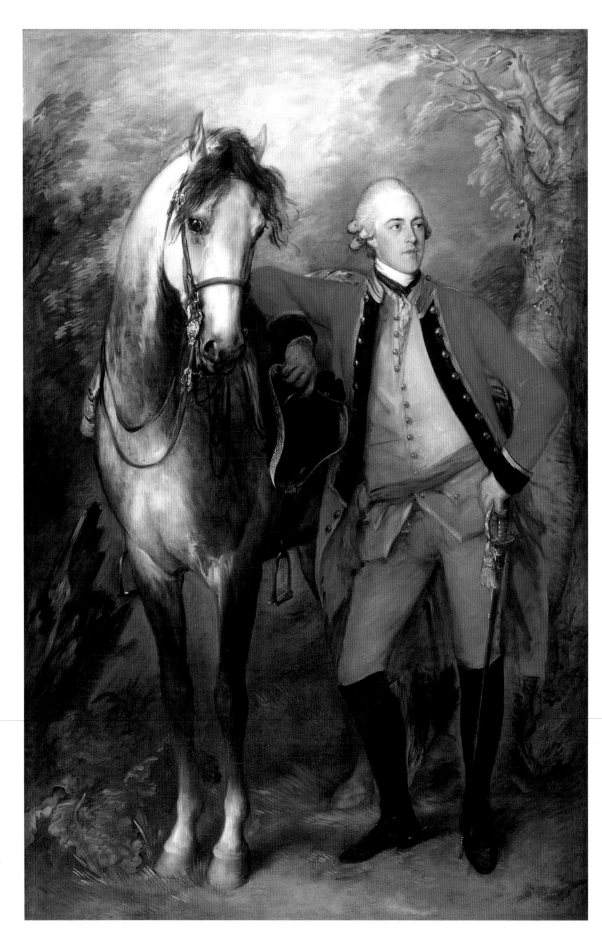

170 *Lord Ligonier*, 1770, oil on
canvas, 2,375 × 1,562 (93$\frac{1}{2}$ × 61$\frac{1}{2}$).
Courtesy of the Huntington
Library, Art Collections, and
Botanical Gardens, San Marino,
California.

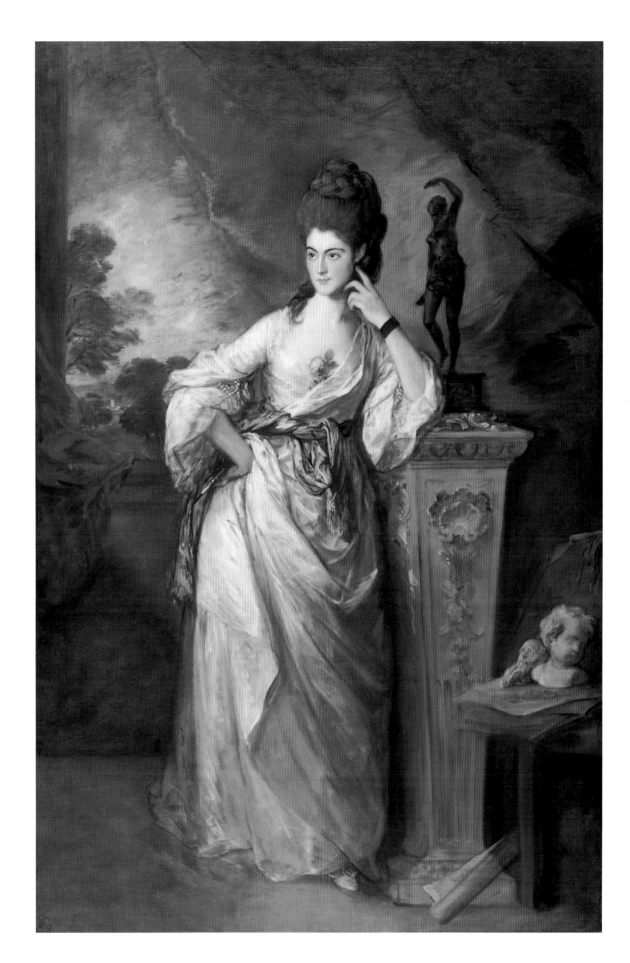

171 *Lady Ligonier*, 1770, oil on
canvas, 2,362 × 1,549 (93 × 61).
Courtesy of the Huntington
Library, Art Collections, and
Botanical Gardens, San Marino,
California.

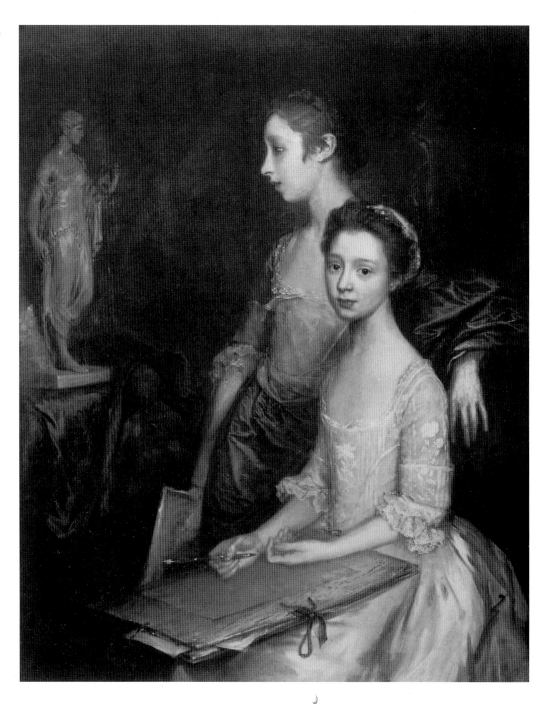

172 *Mary and Margaret Gainsborough*, c.1763–64, oil on canvas, 1,272 × 1,017 (49¹/₂ × 39¹/₂). Worcester Art Museum, Worcester, Mass.

173 Detail of pl. 176.

a world in which I never was formed to exist'.[69] Presumably Gainsborough learned something of his sitters' circumstances and built some of these into his imagery. Her independence compares with that enjoyed in 1778 by Mrs Drummond, whom he portrayed learning to draw, following a system he had developed to teach Lord Mulgrave.[70] Evidently he did not distinguish between the artistic capabilities of women and men.

Unlike many of his contemporaries, then, Gainsborough appears to have been capable of ignoring gendered proprieties when it came to painting portraits, and instead presented sitters on what he understood to be their own terms. But this was not unproblematic, as we discover by considering the portrait of his daughters of 1764 (pl. 172), in which, though they have finished studying for the day, the twelve-year-old Margaret is still drawn to contemplate the statuette of the Farnese Flora, which in itself shows theirs to be serious work. In March that year, Gainsborough explained that

I'm upon a scheme of learning them both to paint Landscape, and that somewhat above the common Fan mount style. I think them capable of it, if taken in time, and with proper pains bestow'd. I don't mean to make them only Miss Fords . . . to be partly admired & partly laugh'd at at every Tea-Table; but in case of an Acccident that they may do something for bread.[71]

The 'partly admired & partly laugh'd at' focusses the ambiguity of Ford's position, in the same way as his giving the management of his own financial affairs into the hands of his wife, to curb her complaints about his profligacy, went wrong: 'as a punishment for so unmanly a condescention . . . it was a further incouragement to Govern me, and invert the order of Nature in making the Head the foot and the foot the Head'.[72]

Gainsborough accepted the world as he saw it, but social conventions made his pragmatic decision to let Margaret Gainsborough manage his money an 'unmanly' action, tantamount to inverting a natural order of things. Hence, in a satirical print directed against the Duke of Devonshire (pl. 174) while the Duchess campaigned for C. J. Fox at the 1784 Westminster election, the Duke changes a nappy and the portrait above his head equates his domestication with being cuckolded. Gainsborough recognised the shifting natures of the male and female spheres and summarised them with his remark about Ford being 'partly admired and partly laugh'd at'.

Perhaps he was acknowledging how her career as a professional musician had ended in anti climax. Her first subscription concert took place at the Little Theatre in the Haymarket, tickets cost half a guinea, and, as we saw, she made money. Despite the efforts of the Earl of Jersey, respectable company attended. Prince Edward enjoyed a cup of tea, and his equerry, Colonel Brudenel, 'handed her to the stage door'.[73] Accompanied by well-known male instrumentalists, Ford sang songs by Italian composers, and her renderings of Handel 'displayed such exquisite sensibility, that many of her friends burst into tears'.[74] In contrast, for the final concerts of October 1761, Ford had 'engaged the large Room, late Cox's Auction Room', planned to fit it up 'in a manner proper for genteel Company', and proposed 'to sing some favourite English songs, and accompany herself on the Musical Glasses', with admission reduced by three-quarters to half a crown.[75] In comparison with previous effusions she was now described as singing 'well', with 'a good voice', giving her audience 'a varied entertainment'.[76]

Gainsborough's comment on Ford may reflect a sympathetic if detached recognition that there was no rational reason why men and women should have their respective roles so categorically defined for them, fitting the contemporary confusion as to what those roles actually were; for as Britain was transforming itself into a commercial society attitudes were fluctuating and unstable. As has been observed, documentary sources 'suggest that contemporaries saw gender in a more complex, pluralistic and even idiosyncratic way than has been assumed previously', and it has been maintained that it took until 1800 to form the kind of world in which Jane Austen's heroines are immured.[77] If David Hume believed that 'nature has given *man* the superiority above *woman* by endowing him with greater strength both of mind and body', then in 1764 the self-styled 'Philo-Pegasus' disagreed: 'Many *Ladies* I could mention, as well ancient as modern, who, in every *Branch of Science*, have equalled and sometimes excelled, the most famous *Philosophers, Mathematicians*, and *Poets*', and concluded accordingly that the '*Moderns* are actuated by a spirit of *Jealousy*, when they deny their *Daughters* the Means of a *Liberal Education*.'[78] Vicesimus Knox joked that when he advocated giving women a 'classical education' he meant not 'Greek and Latin; but . . . the French and English classics', and then two pages on conceded that if 'a young lady in easy circumstances appears to possess a genius and inclination for learned persuits, I will venture to say, she ought, if her situation and connections permit, be early instructed in the elements of Latin and Greek. Her mind is certainly as capable of improvement as that of the other sex.'[79]

As we saw, William Hogarth had been as pragmatic in allowing women parity with men in making aesthetic judgements. The second of the two plates with which he illustrated the 'Line of Beauty', which, he maintained, contained within itself the quintessence of nature at its most beautiful, the supremely elegant forms of the lead couple in the dance demonstrate that he appeared prepared not to discriminate between the sexes (pl. 38). Ronald Paulson has pointed out how Ford's figure conforms with the serpentine pattern of the Line of Beauty and resonates with the shapes of the musical instruments.[80] However, we inevitably see her from the equivocal viewpoint which Gainsborough took towards his sitter. In the real world she would never expect to achieve parity with male performers; the half guinea subscription to Ford's first concerts must be set against the three guineas Felice Giardini asked for in 1754–55, or the five that Mrs Cornelys charged for the concerts performed by Bach and Abel in 1764–65.[81] As all these were his friends, Gainsborough would have been quite aware of how the dice were loaded, and, in light of Ford's tribulations as a female performer, it is notable that 'Peers of Lord Sandwich's circle were prominent in musical circles and not averse to demonstrating their talents to a fee-paying audience on charitable occasions.'[82]

It is also true that in his portrait of Ford, Gainsborough was able to embody her own history while inviting us to admire his own wit, skill and artifice in so doing. Ford's charms were defined by men. Around 1753 Jean André Rouquet wrote how 'in England the picture of a fine Woman is this; she must have a fine white skin, a light complexion, a face oval rather than round, a nose somewhat longish but of a fine turn . . . her mouth graceful without a smile'.[83] Ann Ford conforms to this specification, and, as Ramsay had done in his portrait of his wife, Gainsborough enhanced her charms by following Hogarth, who maintained that 'When the head of a fine Woman is turned a little to one side, which takes off from the exact similarity of the two halves of the face, and somewhat reclining, so varying still from the straight and parallel lines of a formal front face; it is always look'd upon as most pleasing.'[84] Her autonomy was compromised in other ways besides. We noted that her image was connected to 'The Slighted Lover' from George Bickham's *The Musical Entertainer*. In another of these lyrics, 'The Melodious Songstress' (pl. 175), the title character sits, fan in lap, sheet music to one side, and viola da gamba behind her, in the way of *Ann Ford*, while a suitor on his knees anticipates the satirised figure of Lord Jersey (pl. 160). And as Jersey professed himself besotted beyond reason, so does the lyric to this song – 'We dye by pleasure not by pain, / While thus you pierce the heart' – exalt the enchanting powers of

175 'The Melodious Songstress', from George Bickham, *The Musical Entertainer*, 1737–38. Sudbury, Gainsborough's House.

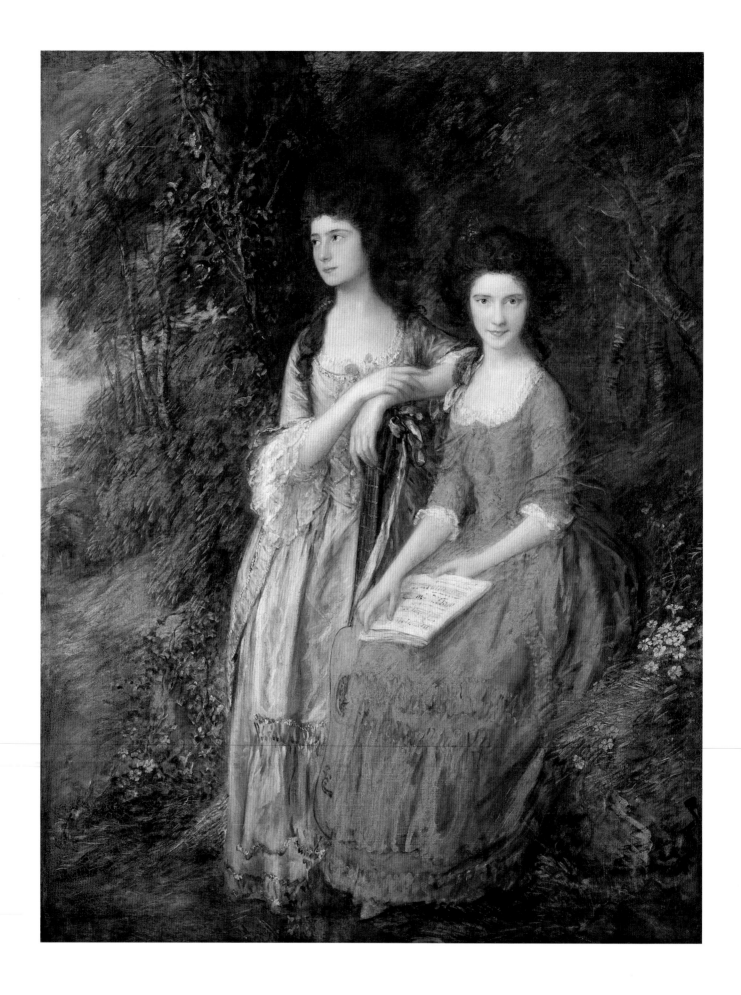

the female voice. Other song titles, such as 'Love and Music' and 'The Submissive Admirer', confirm the convention of chanteuse as siren, which in Ford's case had, in the late 1750s and 1760, been the role she had actually played.[85] There is a series of complex and shifting negotiations at play here. Ann Ford's portrait by Gainsborough tells something of the shifting social roles of men and women around 1760 and later. By dint of simply being a likeness it relates a particular history, and in addition displays its sitter as both creative and compromised, as she connects both with Roubiliac's *Handel* (pl. 163), and Hogarth's *The Lady's Last Stake* (pl. 162). The portrait engages with and is predicated upon perceived actualities (however questionable these be) for Gainsborough deals with the contemporary, and only exceptionally (as with *The Duke and Duchess of Cumberland* (pl. 154)) presents an imagery which strains credulity. It would not have occurred to him, as it might have done to Reynolds, to have painted Ann Ford in the character of Euterpe.

This is a modern art which engages in actualities manifested as appearances, while articulating the extraordinary complexities that underlie those appearances. It will be the same across genres. If, now, we turn to landscapes, we can spot a generic connection between the lovers in the 1755 *Landscape with a Woodcutter and Milkmaid* (pl. 193), the *Landscape with a Milkmaid and Drover* of 1766 (pl. 55), and the pair in the *Landscape with Rustic Lovers* of around 1774 (pl. 218), as readily as the disconnections in the character and handling of the terrain. The contrast would parallel that between *Ann Ford* (pl. 161), seated in a plausible interior, and *The Linley Sisters* (pl. 176), equally famed for their musical talents, and blended into a refined version of nature to confirm them as people of exquisite sensibility; and it is one we must now move on to explore.

176 *The Linley Sisters*, 1772, oil on canvas, 2,004 × 1,530 (78³/₈ × 60¹/₄). By permission of the Trustees of Dulwich Picture Gallery.

8 Figuring Landscape

ALLAN CUNNINGHAM RECALLED THAT Gainsborough used to sit by his wife of an evening 'and make sketches of whatever occurred to his fancy, all of which he threw below the table, save such as were more man commonly happy, and those he preserved, and either finished as sketches or expanded into paintings'.[1] Landscape was his preferred subject, as it had been from the beginning (pl. 178). Philip Thicknesse remembered how

> he told me, that during his *Boy-hood*, though he had no idea of becoming a Painter then, yet there was not a Picturesque clump of Trees, nor even a single Tree of beauty, no, nor hedge row, stone, or post, at the Corner of the Lanes for some miles round about the place of his nativity, that he had not so perfectly in his *mind's eye*, that had he known he *could use* a pencil, he could have perfectly delineated . . . the first effort he made with one, is of a group of Trees . . . and they are such as would not be unworthy of a place at this day, in one of his best landscapes.[2]

When he was dying, Gainsborough wrote of feeling 'such a fondness for my first imitations of little Dutch Landskips that I can't keep from working an hour or two of a Day'.[3]

If we follow Angelo, this creating of landscape imagery might have been a kind of therapy, to ameliorate the effects of the drudgery of face painting, a notion which Gainsborough himself was keen to promote:

> I'm sick of Portraits and wish very much to take my Viol da Gamba and walk off to some sweet Village when I can paint Landskips and enjoy the fag End of Life in quietness and ease. But these fine Ladies and their Tea drinkings, dancings, *Husband huntings* and such will fob me out of these last ten years, & I fear miss getting Husbands too – But we can say nothing to these things you know Jackson, we must jogg on and be content with the jingling of the Bells, only d——mn it I hate a dust, the Kicking up of a dust, and being confined *in Harness* to follow the track, while others ride in the waggon under cover, stretching their Legs in the straw at Ease, and gazing at Green Trees & Blue skies without half my *Taste*, that's damn'd hard.[4]

This letter repays some scrutiny. Gainsborough often pictured figures slouched in wagons (pl. 178). This is evidently an experience to be envied, an exquisite laziness, a cruel contrast to the labour of the horses pulling these wagons, who are forced to be amused by the jingling of the bells of the harness. It is with these beasts that he associates himself. And while his expressed desire to be off to some sweet village has a sympathetic appeal – and he did go so far as to paint the Reverend John Chafy playing his 'cello in the countryside (pl. 179) – it was never a real option. Indeed, the Chafy portrait is a confection, an elegant valedictory to a clergyman about to marry and remove from Suffolk to Wiltshire.[5] And though he might have been sick of portraits, he was serious about them; that much is clear from the letters to the Earl of Dartmouth.

He opens his letter to Jackson by invoking the topos of rural retirement, the valorising of musical and painterly leisure over the cart-horse labour of portrait painting in the town. From what follows, it is plain that the kind of figures we repeatedly find in Gainsborough's landscapes are rather more than cyphers meant to humanise scenes of nature (pl. 181). This appears to contradict what William Jackson wrote of how in 'a picture, there is no distinction between going to work, or milking, or returning from it', how figures are simply *staffage*,

177 Detail of pl. 189.

178 *A Pathway through a Wooded Landscape with a Farm in the Distance*, c.1747, pencil on white paper, 290 × 346 (10⅝ × 13⅝). Sudbury, Gainsborough's House.

179 *The Reverend John Chafy*, 1750–52, oil on canvas, 762 × 635 (30 × 25). London, Tate Gallery.

180 (*above*) *Wooded Landscape with Peasant asleep in a Cart*, 1760s, watercolour and bodycolour with traces of pencil on brown paper, 281 × 380 ($11^{1}/_{16}$ × $14^{15}/_{16}$). Oxford, Ashmolean Museum.

181 *Rocky Wooded Landscape with Waterfall, Castle and Mountain*, 1787–88, black chalk and stump heightened with white on grey prepared paper, 226 × 320 ($8^{7}/_{8}$ × $12^{5}/_{8}$). London, British Museum.

just as Gainsborough advanced this idea in his correspondence with him.[6] Jackson's side of this is missing, but from Gainsborough's replies he had evidently been suggesting that the latter attempt elevated subjects:

> I admire your notions of most things and do agree with you that there might be exceeding pretty Pictures painted of the kind you mention. But are you sure you don't mean instead of the flight into Egypt, my flight out of Bath! Do you consider my dear maggotty Sir, what a deal of work history Pictures require to what little dirty subjects of coal horses & jackasses and such figures as I full up with; no, you don't consider anything about that part of the story . . . But to be serious (as I know you love to be) do you really think a regular Composition in the Landskip way should ever be fill'd with History, or any figures but such as fill a place (I won't say stop a Gap) or to create a little business for the Eye to be drawn from the Trees in order to return to them with more glee – I did not know you admired those *tragicomic* Pictures, because some have thought that a regular History Picture may have too much background and the composition hurt by not considering what ought to be principle.[7]

Gainsborough is sensitive on the subject of history pictures, which, as he later wrote to William Hoare, 'there is no call for in this country', and evidently formed his ideas on how they ought to look from those that Hogarth and others had contributed to the Foundling Hospital, in which the figures dominated, in contrast to the apparently insignificant figures in many of his own landscapes. However, his claim that they merely 'create a little business for the Eye to be drawn from the Trees in order to return to them with more Glee', to share the pleasures of those in the wagon who stretch 'their Legs in the straw at Ease, and [gaze] at Green Trees and Blue Skies' is open to question. In part this is because he is trying to tease Jackson out of an opinion that he should elevate his art. But there are other reasons. The great delight of contemplating nature's beauties 'at Ease' is shared both by artist and by many of his painted figures; which signals their having attained a condition akin to that mythically prevailing during the Golden Age. Hence, as the reading of that first passage, where he was 'sick of Portraits', suggests, the figures could signify. The shepherds and woodcutters who were placed within landscapes became subjects of major compositions in their own right. Gainsborough was capricious on the subject – 'don't be in a hurry to determine anything about *me*, if you are, ten to one you are wrong', he warned Jackson – and his words and images demand circumspect inspection.

That much is evident from a full survey of his landscapes as has been provided by John Hayes.[8] Here we discover the range they took and the increasing bank of pictorial references to which Gainsborough resorted as his career progressed. Gainsborough's landscapes evolve, as contemporaries noted, as increasingly sophisticated works of art. Hayes detects a considerable influence of Rubens in the *Wooded Landscape with Mounted Figures* (pl. 88), painted for the Earl of Shelburne at Bowood, to hang in his drawing room alongside canvases by Pocock, Deane, Barret and Wilson, and intended 'to lay the *foundation of a school of British landscape*'.[9] In the same wise, the painting of *Open Landscape with Mounted Peasants* (pl. 203), commissioned for Stourhead by Henry Hoare in 1773, was hung in the picture gallery alongside works such as Poussin's *Rape of the Sabines* (Metropolitan Museum of Art, New York) and Carlo Dolci's *Salome with the Head of John the Baptist* (City Art Gallery and Museum, Glasgow).[10] These were major patrons, as was the Duke of Bedford, whose landscapes commissioned in 1755 are to be discussed below (pls 193, 194). Visting Woburn in 1780, Thomas Pennant thought it 'a treasure of paintings'. In the Dining Room he noted 'four pieces representing *Alexander's* campaigns by old *Parocel*' and 'A LANDSCAPE, by Mr *Gainsborough*; containing cattle, figures, and an antient tree; a piece that would do credit to the best masters'.[11] Gainsborough's landscapes are incorporated into *ensembles* that advertise the cultivation, the civilised values of those who, in all three instances here, have elected to commission them.

182 *Wooded Landscape with a Cottage, Sheep and a reclining Shepherd*, 1747–48, oil on canvas, 432 × 543 (17 × 21³⁄₈). New Haven, Yale Center for British Art, Paul Mellon Collection.

As objects of cultural capital, then, their content might be assumed also to be of some moment. It would, for instance, be difficult to look at *A Shepherd* (pl. 230), or the reclining shepherd in the fine, rolling early landscape (pl. 182), and not be put in mind of pastoral conventions. As Dr Johnson wrote in 1750,

> There is scarcely any species of poetry that has allured more readers, or excited more writers, than the pastoral. It is genuinely pleasing, because it entertains the mind with representations of scenes familiar to every imagination, and which all can equally judge, whether they are well described. It exhibits a life, to which we have always been accustomed to associate peace, and leisure, and innocence: and therefore we readily set open the heart for the admission of its images, which contribute to drive away cares and perturbations, and suffer ourselves without resistance, to be transported to elysian regions, where we are to meet with nothing but joy, and plenty, and contentment; where every gale whispers pleasure, and every shade promises repose.[12]

183 *Peasant and Donkeys outside a Barn,* c.1755–57, oil on canvas, 495 × 597 (19¹/₂ × 23¹/₂). Private collection.

Johnson's matches Gainsborough's language of contentment in nature. And despite the problematic nature of the genre, it is not hard to find literary equivalents to what Gainsborough pictures here:

> Fair Spring o'er Nature held her gentlest sway;
> Fair Morn diffused around her brightest ray;
> Thin mists hung hovering on the distant trees,
> Or roll'd from off the fields before the breeze.
> The shepherd Theron watch'd his fleecy train,
> Beneath a broad oak . . .[13]

Rustics resting against trees while keeping watch over their animals were commonplace;

184 Richard Wilson, *Ego fui in Arcadia*, 1755, oil on canvas, 1,092 × 1,359 (43 × 53$\frac{1}{2}$). Trustees of the Hon. William Byng.

185 C. Grignion, *Designs by Mr Bentley for Six Poems by Mr Gray: 'Elegy in a Country Church-yard'*, 1753, engraving.

hence George Smith's writing of how 'Two shepherd-boys beneath an holly's boughs/Sat on the grass and watched their grazing cows', instead of painting the motif into one of his landscapes.[14]

Such a shepherd boy appears beneath a tree in that Gainsborough landscape of *c*.1747–48 (pl. 182), while in the shade of a wood across the valley is a cottage from which further figures emerge. Thus we see early established motifs which recur throughout his landscapes. Gainsborough was very unusual in showing the proletariat as enjoying the same kind of leisure, idleness, the chance to enjoy looking at the sky and trees, that the artist wished for himself. Oil paintings by others seldom show the poor completely at leisure (the only unambiguous representations of idleness I have come across are some thumbnail sketches of figures lounging around in an anonymous sketchbook of *c*.1740).[15] The problematic nature of the issue is revealed by Hogarth. The reward of idleness in *Industry and Idleness* is murder by the state. In *Beer Street* the bestowal of proletarian leisure is heavily qualified, for most of the drinkers are simply pausing for a pint while on their way to somewhere else (pl. 132). The moral is, leisure is to be bought by labour, and then employed to proper effect. Thus it is that Mr and Mrs Andrews are placed to one side of a scene painted to demonstrate why he is enabled to engage in country sports, and she to sport fashionable attire (pl. 25).

In the mid-1750s, Gainsborough painted a *Peasant and Donkeys outside a Barn* (pl. 183) in which a rustic, so distinctive in profile as to be very possibly a portrait, rests contemplatively on his staff at the *end* of the day, that is, after his labours have concluded, for the church tower allows us to place the sun as low in the west. This figure is a type who appears to have been central to Gainsborough's ideal of the rustic, for he is reprised in the late *Woodman* (1787, destroyed; pl. 186), by which the artist set real store, and which was profoundly admired by George III, who thought it 'a masterpiece of the pencil'.[16] In the earlier painting, leisure is again consequent upon work. It has to be earned, as Andrews has earned his. The peasant is a ploughman, and he also has a team of donkeys for transporting goods; he has a variety of means of making a living. His figure is also dignified by association. In keeping with the contemplative mood, the pattern for his pose originates in Poussin's *Et in Arcadia Ego* (Louvre, Paris), which in 1755 had been adapted to a generalised classical figure by Richard Wilson in his *Ego fui in Arcadia* (pl. 184). Wilson might have been quoting, as perhaps did Gainsborough, one of Bentley's illustrations to the 1753 edition of Gray's *Elegy*

186 P. Simon after Thomas Gainsborough, *The Woodman*, 1791, stipple engraving. Sudbury, Gainsborough's House.

THE WOODMAN.

Engraved from the original Picture in the Collection of the Right Hon.ble the Earl of Gainsborough.

(pl. 185). We might suspect that the unbookish Thomas Gainsborough may have done no more than look at the pictures in a recent edition of this enormously popular poem, in order to make a pictorial reference to confirm the elegiac pastoral mood of a figure who, like Gray's, engages in contemplation at the end of the day. As Robert Andrews's cross-legged pose confirms the unaffected dignity of the gentleman, so does Gainsborough's peasant achieve real dignity and independence. Differing material circumstances do not militate against this, and this was a conception to which he held.

187 *Wooded Landscape with Figures, Donkeys, Pool and Cottage, c.*1748, oil on canvas, 660 × 950 (26 × 37³/₉). Vienna, Kunsthistorisches Museum.

To advance the enquiry, I shall analyse two early landscapes of around 1748, a *Wooded Landscape with Figures, Donkeys, Pool and Cottage* (pl. 187), and *Gainsborough's Forest* (pl. 189). In the first, we prospect a sunken track in woodland. To the right is a cottage, smoke issuing from its chimney, with a spinning wheel before the door. A little way beyond it lounge what we take to be the inhabitants of that cottage, a woodcutter and his wife. Beyond them, a man sits and keeps an eye on a small herd of donkeys. In *Gainsborough's Forest*, as befits a rather larger canvas, things are correspondingly busier. Various pedestrians and mounted travellers pass through woodland where other people get on with other things. The woodman, having graded his timber according to size, binds a bundle of faggots, while his dog sleeps, and the donkeys that will cart the load browse in the middle distance. He alone works. A youth has paused in digging sand to court a girl – hence his dog's inquisitive stance – and she, one imagines, owns that cow. People do enough to get what they need, and then they enjoy their own society.

Thanks to Jeanette Neeson we can recognise what Gainsborough represents not only as images of the Suffolk woodland, but additionally as giving an account of the economy of the forest commoners. They show what the first great wave of enclosures, which took place between 1760 and 1770, was to obliterate: an economy based on barter and exchange, rather than money. Not only did common right allow commoners to graze animals and keep horses, but,

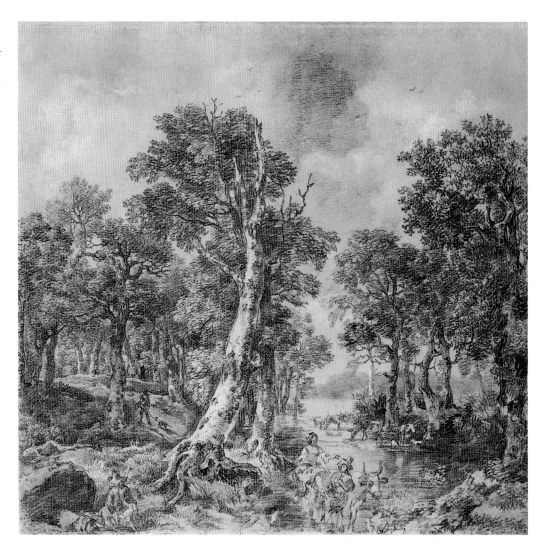

188 Copy after Ruisdael, *La Forêt*, late 1740s, black and white chalks on buff paper, 408 × 422 ($16^1/_{16}$ × $16^5/_8$). Manchester, The University of Manchester, The Whitworth Art Gallery.

The fuel, food and materials taken from common waste helped to make commoners of those without land, common-right cottages, or pasture rights. Waste gave them a variety of useful products, and the raw materials to make more. It also gave them the means of exchange with other commoners and so made them part of the network of exchange from which mutuality grew. More than this, common waste supported the economies of landed and cottage commoners too. It was often the terrain of women and children.[17]

As commoners were not wage slaves, so, as we see in these landscapes of Gainsborough, they could work or not as they chose.

In the smaller painting the woman spends some time spinning — it may be that they run a small flock of sheep — her man gathers timber, their neighbour has a herd of donkeys. In consequence they are independent. In *Gainsborough's Forest* the forest common supplies fuel, sand for cleaning or building, and food both for animals and humans, who can consume milk from the cow and trap the ducks on the pond to the right. The composition has been developed out of Ruisdael — it is instructive to compare the arrangement of the terrain with Gainsborough's red chalk copy after the latter's *La Forêt* (pl. 188), in which many of the same elements are evident — and besides this one is drawn to notice much else. The brilliance of the descriptive handling of paint is striking: sometimes licked, sometimes dragged across the canvas, to communicate a sense of the textures of plant surfaces. The sky, grand with cumulus, casts a fine cool light. All this, as has often been remarked (not least by the

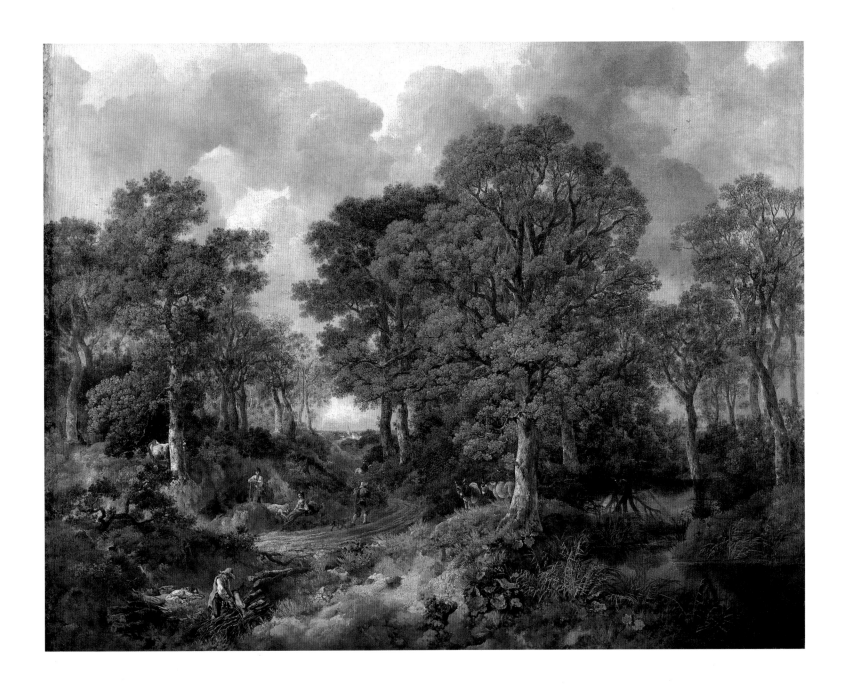

189 *Gainsborough's Forest ('Cornard Wood'),* c.1746–47, oil on canvas, 1,219 × 1,549 (48 × 61). London, National Gallery.

artist himself, as we saw), was developed from a study of seventeenth-century Dutch landscape.[18] And this has an added significance, for that kind of art was understood to imitate nature unfiltered through any kind of aesthetic screen. For Horace Walpole the result was 'the drudging mimicry of nature's most uncomely coarseness'; for Joshua Reynolds, in one of the *Idlers* he directed against Hogarth, 'a literal truth and a minute exactness in the detail . . . of nature, modified by accident'.[19] Gainsborough's paintings must consequently be viewed as presenting an illusion of the actual appearance of that part of Suffolk then known as the 'Woodlands', with, in *Gainsborough's Forest,* the perspective closed with the sight of Great Cornard church, to add authenticity to the view.[20] The oak was a national symbol, as in 'hearts of oak', and the travellers passing through this scene connect Gainsborough's landscape in imagination with the larger prospect of Britain, showing it as characteristic of the beauties, and therefore the virtues of the nation, and accordingly celebrating the patriotic virtue of the economy of the forest commoners.[21]

This was a type of imagery Gainsborough maintained, although the terms in which he

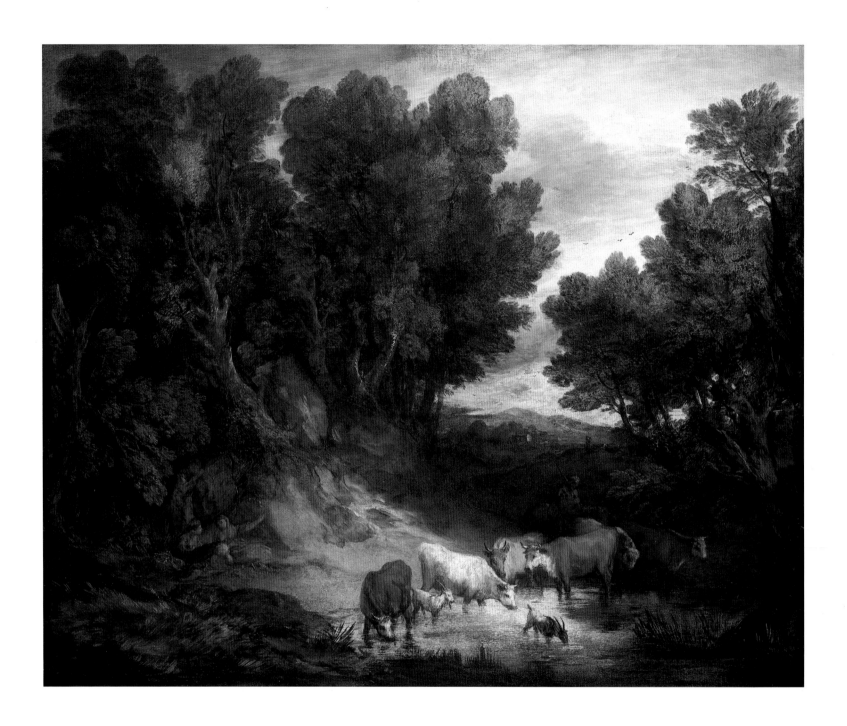

realised it evolved. In 1766 he pictured a milkmaid chatting to a drover (pl. 55) in a setting that reveals a close and analytical study of Jacob van Ruisdael. The grand composition of *The Watering Place* (pl. 190) develops elements – the pond, the perspective to a distant village – established in *Gainsborough's Forest*. In the evening shade a herdsman comes towards us, driving a flock of sheep and goats with no great urgency, for they pause to drink, while, to the left, four figures repose. One rests on a rock, one sits, and two recline upon the ground: a woman making a rhetorical gesture (possibly adapted from Claude) and a child lying before her in the pose of a river god. Ann Bermingham recognised that this painting described 'an unmediated and organic relationship between man and nature', and, in a brilliant insight, that 'The life of these country people seems to be their own, for the paintings do not suggest that they work to pay rent or to receive wages . . . Labor and production are organised not to the demand of an expanding market but according to the simple needs of the laborer.'[22]

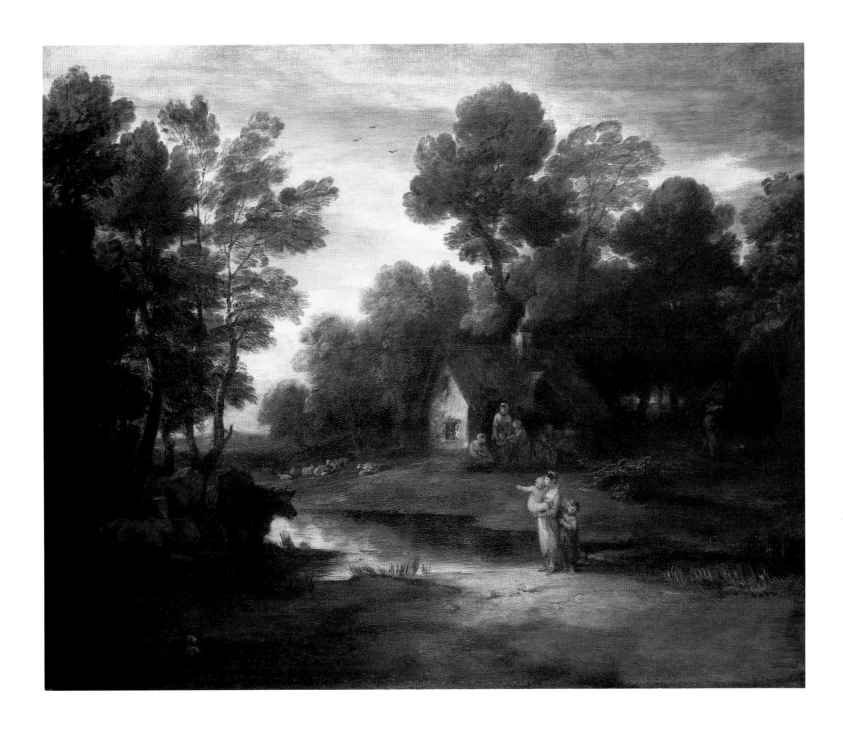

192 (*above*) *Wooded Landscape with Cattle by a Pool and a Cottage at Evening*, 1782, oil on canvas, 1,204 × 1,476 (47⅝ × 58⅛). Sudbury, Gainsborough's House.

190 (*facing page top*) *The Watering Place*, 1777, oil on canvas, 1,473 × 1,803 (58 × 71). London, National Gallery.

191 (*facing page bottom*) Sir Peter Paul Rubens, *The Watering Place*, late 1610s, oil on panel, 981 × 1,340 (38⅝ × 52¾). London, National Gallery.

As we saw, this painting is to be set within an old master tradition, and, to a degree, is a response to Rubens's own *Watering Place* (pl. 191), while the imagery more generally is worked into the tradition of bucolic pastoral, probably further validated by referring to the seventeenth-century Italian painter Pier Francesco Mola.[23] This elevation by association is intriguing in light of the fact that Gainsborough has peasantry and gentry inhabit the same world, for in his own picture, Dr Ralph Schomberg stands meditatively in a terrain also of earthen banks and distant mountains (pl. 45). The imagery is maintained in later works. In a cottage scene of 1782 (pl. 192) there is a small flock of sheep, the family before the door, the woodman looming through the shadows with a bundle of faggots to augment the wood-pile, and the adolescent girl taking two children off to inspect their cattle. Although this group is ragged enough to suggest that prosperity may be elusive, the figures nevertheless enjoy an economic independence apparently comparable with that of their forebears in the

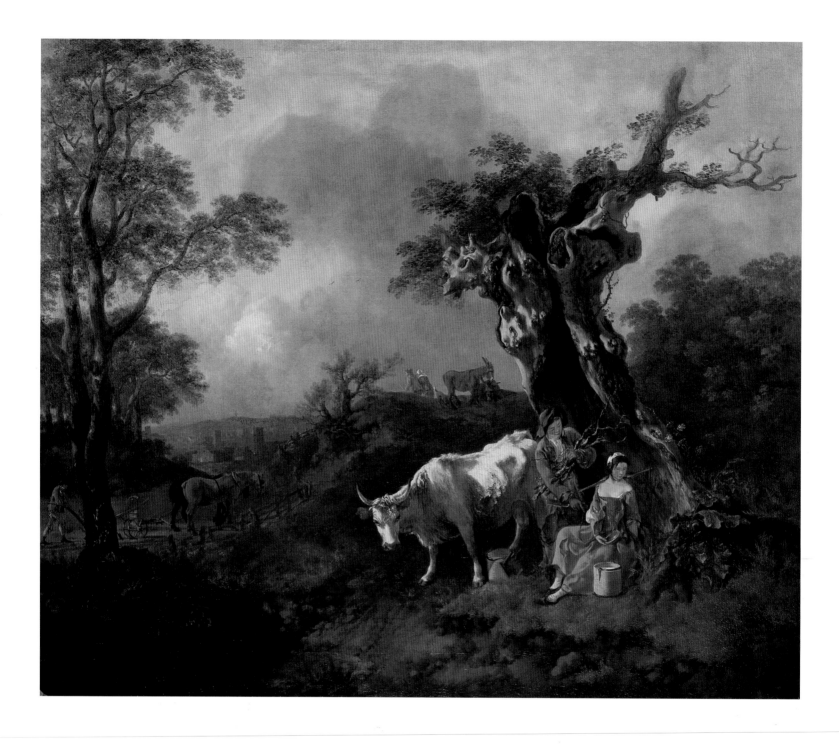

193 *Landscape with a Woodcutter and Milkmaid*, 1755, oil on canvas, 1,067 × 1,282 (42 × 50¹⁄₂). By kind permission of the Marquess of Tavistock and the Trustees of the Bedford Estate.

landscapes of 1748. This conclusion has to be qualified: *Gainsborough's Forest* could plausibly be seen as representing a particular place, but the later works can not. The conscious artifice which steadily pervades Gainsborough's later landscapes means that although they might be taken as representing some notional 'England', they do so at an increasing remove from actuality. This we can analyse by taking a more focussed look at Gainsborough's subject matter.

A good starting point is with the landscapes painted for the Duke of Bedford in 1755 (pls 193, 194), one of which, as we saw, was approvingly noticed by Thomas Pennant. These were furniture paintings, overmantels for chimney pieces, but this was not unusual for landscapes, and to attract patronage from the Duke of Bedford was noteworthy. One, showing a woodcutter, milkmaid and ploughman, was bought for 21 guineas in May, the other, rep-

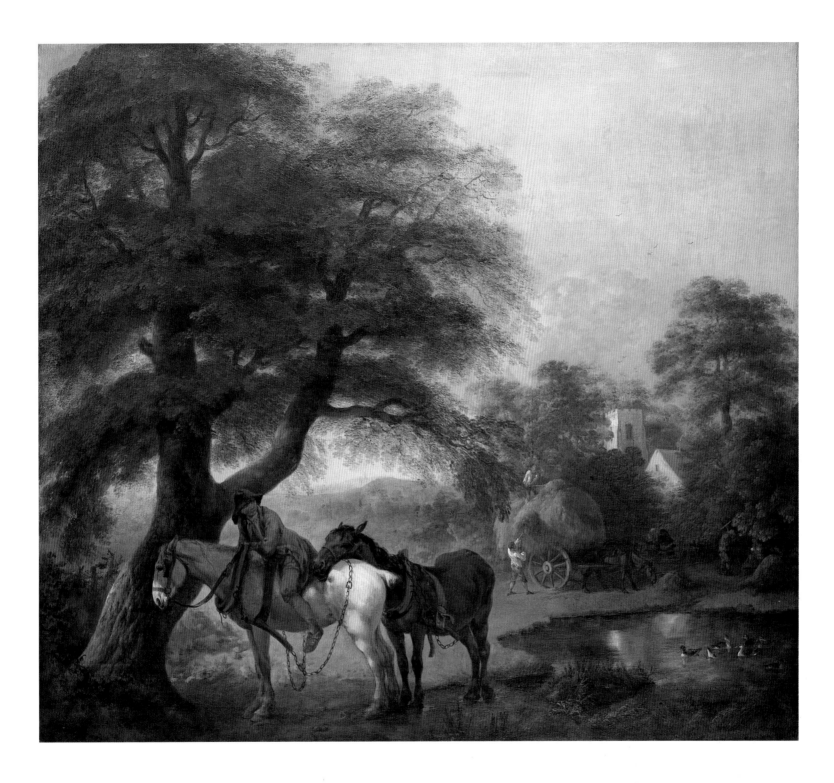

194 *Landscape with Haymakers*, 1755, oil on canvas, 921 × 1,022 (36¼ × 40¼). By kind permission of the Marquess of Tavistock and the Trustees of the Bedford Estate.

resenting haymaking, for 15 guineas, in July: prices which show up well against what Gainsborough was then getting for portraits.[24] In the earlier canvas, highlighting and scale draw the eye to the woodman asking for a dish of milk from a woman whose cow yields so abundantly that her pail runs over. Behind are donkeys, and a couple heading towards Ipswich, described in the distance. All these characters occupy common land, which is separated by a fence from an enclosed field on which a solitary labourer toils.[25] To this, Keith Snell has added that 'The contrast of the ragged clothes of the man ploughing, with the finery of the milkmaid (with her full pails of milk), and the well dressed woodcutter, is worth noting. In the enclosed section of the painting, the only indication of material well-being is in the

197

horse and the plough – both belonging to the farmer.'[26] While the common supplies the material needs of all, the enclosure does this only for the farmer who employs the ploughman. The picture is very beautifully and scrupulously worked, as well as being sophisticated in its imagery, for that central motif originates in the courtly art of Watteau, mediated through Bickham's headpiece to the Vauxhall song 'Jenny the Pedler and the amorous Jockey', and it is evident that approval is to be directed towards the benefits of the moral common economy.[27]

The haymaking scene reinforces this message. Equally delicately handled, it pictures haymaking around the village duckpond in green and gold. Only the pair loading the wagon does any work. Otherwise, a youth slides from his nag, but with no hurry, and, in the background two old women leaning on a gate inspect things, and, to their left, another man rests on his rake to chat to a girl enjoying the shade. There is a sense of heat and indolence. Haymaking was common enough as a subject in English georgic poetry, as in Thomson's 'Summer', where the whole village is deployed over the meadow, as an army over a battlefield:

> all in a row
> Advancing broad, or wheeling round the field,
> They spread their breathing harvest to the sun,
> That throws refreshful round a rural smell;
> Or, as they rake the green-appearing ground,
> And drive the dusky wave along the mead,
> The russet hay-cock rises thick behind
> In order gay: while heard from dale to dale,
> Waking the breeeze, resounds the blended voice
> Of happy labour, love, and social glee.[28]

We do get the 'happy labour, love, and social glee', albeit in a minor key. But, unlike the earlier figures of, for example, the *Dixton Manor Haymaking* (pl. 195), these are no battalions of labourers fighting the earth for its fruits; even the horse idly ruminating at the haycock speaks of natural abundance easily had. This is an imagery of ease and contentment, of a population living symbiotically with its surroundings. The paintings together make it plain that this way of life is to be preferred to that of the ragged wage labourer, the ploughman, whose lack of independence is signified by his working within an enclosure. They vindi-

195 *Dixton Manor Haymaking*, c.1725–33, oil on canvas, 1,130 × 2,870 (44^1/$_2$ × 113). Cheltenham, Museum and Art Gallery.

cate, celebrate the moral common economy, and, as the persistence of this kind of imagery intimates, this was a position Gainsborough maintained.

This makes these paintings particularly interesting as articulating one position in the debate that accompanied the first great wave of parliamentary enclosures between 1760 and 1780. Between 1750 and 1759 Parliament passed 87 enclosure acts; between 1760 and 1769, 304; and between 1770 and 1779, 472.[29] This was a contentious episode. Most agrarian history written before 1985, when Keith Snell published his ground-breaking *Annals of the Labouring Poor*, was concerned to counter the idea that the imposition of the money economy, signalled by the first wave of enclosures, ushered in the pauperisation and proletarianisation of the rural poor. The supplanting of the moral with the money economy, it was claimed, created employment; and the sharp increase in rural poverty and destitution so remarked on in the later eighteenth century, was consequent not upon the enclosures but upon an increase in population.[30] This interpretation has now been challenged further by Jeanette Neeson who argues that the enclosure movement 'extinguished common right from most of lowland England in the late eighteenth and early nineteenth centuries, its loss played a large part in turning the last of the English peasantry into a rural working class'.[31]

To support this one need only turn to the sentiments expressed in the numerous tracts and pamphlets generated by improvement. In 1772 a writer styling himself a 'Country Gentleman' enumerated what most thought the result of enclosures would be:

> the great farmer dreads an increase in rent, and being constrained to a system of agriculture which neither his inclination or experience would tempt him to; the small farmer, that his farm will be taken from him, and consolidated with the larger; the cottager not only expects to lose his commons, but the inheritable consequence of the diminution of labour, the being obliged to quit his native place in search of work; the inhabitants of larger towns a scarcity of provisions; and the kingdom in general the loss of people.

Such fears were, in this writer's view, groundless. The money economy would be good for all. Certainly small farmers would have to quit their holdings to become wage labourers, but, in this writer's experience, 'they have afterwards earned a very comfortable living, and rejoiced in the necessity which compelled them to it'.[32]

He was writing from the position of the interested parties, normally the principal landowners in a parish, who would instigate enclosure. It has been observed how

> Enclosure by Act made it possible to enclose the whole of the open fields, together with the commons and any suitable waste land, at one and the same time, and thus facilitated an important and rapid improvement in farming efficiency. The Act also conferred legal sanctity and finality on the new arrangements, and lastly made it possible for the owners of the greater area of land to force the hand of other proprietors in the village who might be opposed to the change.[33]

Enclosure was promoted in the name of efficiency and profit. With open fields, held in common by all landowners of a village, consolidating holdings into individual farms would let farmers experiment, employ advanced agricultural practices such as might increase their profits and, therefore, properly reward enterprise. Common waste – heaths and woodlands (the subjects of Gainsborough's landscapes) – was under no regular system of husbandry, and was, therefore (in opposition to Gainsborough's iconography), a resource seen hardly to be exploited to the national good.

Thus, in 1776, Matthew Peters computed that, in theory, over 2.25 million acres of common would remain even *after* the New Forest and Forest of Dean had been reserved for the shipyards. Of this, he proposed to put out one third to pasture, and the remainder to 'tillage, timber, and coppice wood for the use of farms'. It made sound economic sense, for if the 'present use of . . . Heaths, is to keep a few ragged sheep in the summer, or breed a poor stunted sort of cattle, scarcely fit for the clothier or the market', then better they

should be converted to 500-acre farms, with the Lord of the Manor, whose property waste legally was, 'paying to those who have a right of common by way of purchase, such sum as 12 men on oath may award'. Rents and productivity would rise. Commoners would get money in compensation for loss of right.[34] In this view money was the principal instrument of circulation and exchange, the main measure of value. Traditional rights were nothing before law, here the Enclosure Act. Common right, time-honoured and customary, presumed the regulation of relationships between members of rural communities by means other than laws designed to protect and preserve the ownership of property, and, furthermore, fostered the functioning of a rural economy geared towards ends incompatible with the maximising of productivity to the greatest profit of the enterprising individual. And as commoners received no wage, they could work or not, as they chose. In the golden age of pastoral poetry, humanity had had no need to work, and Schlegel would later maintain that laziness was 'the one divine fragment of a god-like existence left to man from Paradise', much as Gainsborough imagined the bliss of reclining in a wagon at ease.[35]

The improving interest was not without opposition. In 1767 one writer accused landlords of becoming 'little better than tyrants or bashaws . . . who when they had less wealth were more sensible of their dependence and connections, and could feel both for the poor and the public upon every emergency'.[36] Another writer that year agreed with the 'Country Gentleman' that improvement was depopulating the countryside and turning independent proprietors into wage labourers – something to deplore. By 'annihilating the cottages' the poor are 'turned out of doors', a 'most abominable practice'. He writes how the monopolisation of land, 'which was dealt out in common to all, by the great father of all, as to exclude multitudes from their least share of it . . . is one of the sorest evils under the sun'.[37] He was not alone in resorting to apocalyptic language. Nathaniel Kent, 'an enthusiast for agrarian experiments, including those of the King and Queen at Windsor', argued that

> agriculture, when it is thrown into a number of hands, becomes the life of industry, the source of plenty, and the fountain of riches to a country; but that monopolized, and grasped into few hands, it must dishearten the bulk of mankind, who are reduced to labour for others instead of themselves; must lessen the produce, and greatly tend to general poverty.

Engrossing, the handmaiden of enclosure, negated this desirable situation, was attended with 'great cruelty to individuals' and culminated in 'considerable private loss and public calamity'.[38] Kent articulates the ideological divide between the promoters of benevolence and the economic rationalists, a divide manifest, too, if we contrast the paintings of the rural poor by Gainsborough and Stubbs (pls 208, 209).

Moral outrage at developments that presented agriculture in terms of investment potential and labour as units of productivity spread into popular literature. In Frances Brooke's novel *The History of Lady Julia Mandeville* (1763, sixth edition 1773), an engrosser has 'made his estate a scene of desolation, his farms are in the hands of a few men', and the village 'is reduced to about eight families; a dreary silence reigns o'er their deserted fields'. The contrast to the 'merchants and ingrossers, proud, lazy, luxurious, insolent', who have brought about this catastrophe is the character of Lord Belmont, who follows the kind of practice advocated by Kent. He

> encourages industry, and keeps up the soul of cheerfulness amongst his tenants, by maintaining as much as possible the natural equity of mankind on his estate. His farms are not large, but moderately rented; all are at ease and can provide happily for their families, none rise to exorbitant wealth. The very cottages are strangers to all that approaches want . . .[39]

The old economy is set up against the new, to condemn it. This was a theme taken up to devastating effect by Oliver Goldsmith.

196 Detail of pl. 194.

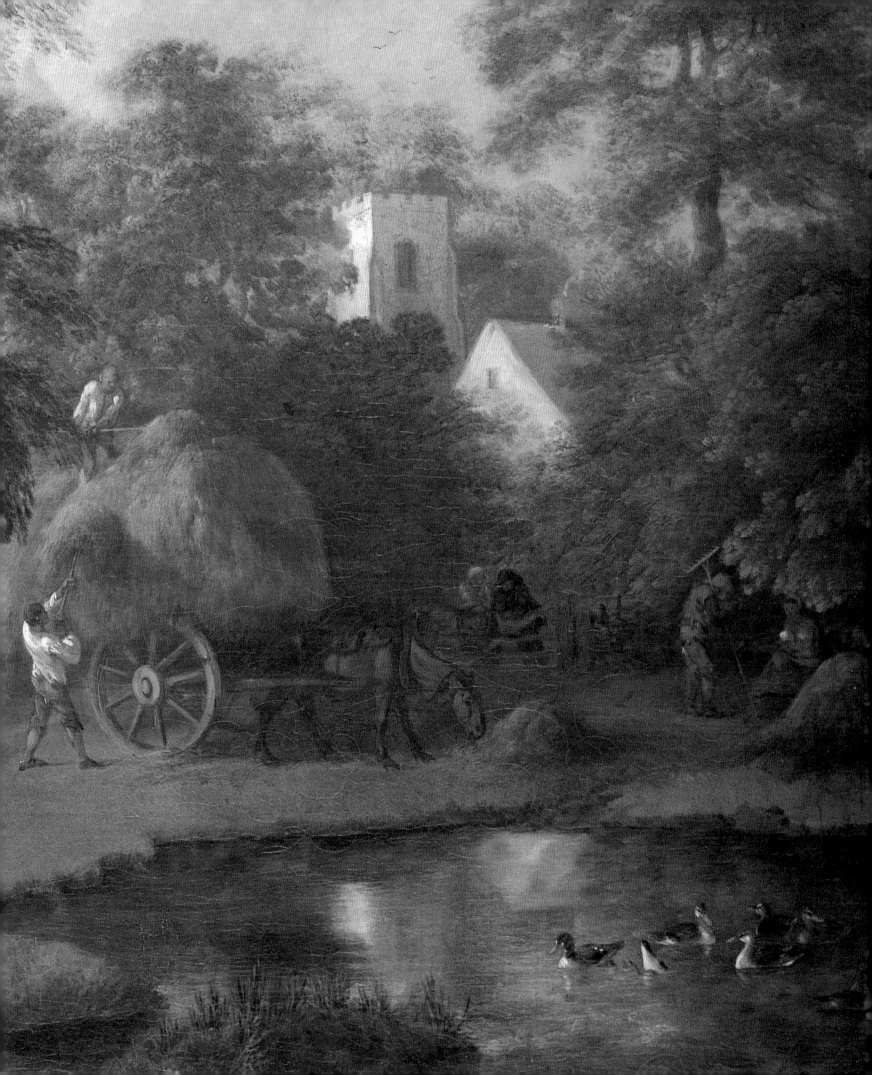

His poem *The Deserted Village* (1770) was hugely popular, and reached its seventh edition by 1772. Auburn had been the 'loveliest village of the plain;/Where health and plenty cheered the labouring swain', where 'Toil remitting lent its turn to play,/And all the village train from labour free/Led up their sports'. Goldsmith writes of the sounds 'when oft at evening's close,/Up yonder hill the village murmur rose' –

> Then as I past with careless steps and slow,
> The mingling notes came softened from below;
> The swain responsive as the milkmaid sung,
> The sober herd that lowed to meet their young;
> The noisy geese that gabbled o'er the pool . . .

And we realise that correspondences to these sounds are implicit within Gainsborough's landscapes with the swains, milkmaids, cattle and jingling harness. But now, in Auburn, 'One master only grasps the whole domain,/And half a tillage stings thy smiling plain', and 'now the sounds of population fail'. Silence overpowers social noise. The peasantry are forced to migrate, and, along with them, 'the rural virtues leave the land'.[40] As in *Lady Julia Mandeville*, the sign of the new order is silence in the countryside.

Goldsmith claimed that the poem was based on a wealthy merchant's turning out the inhabitants of a village 'about fifty miles from town', and advertisements in the press together with an essay by John Scott insisted that *The Deserted Village* was documentary.[41] Gainsborough's landscape drawings and paintings of the late 1760s began to concern themselves repeatedly and variously with an imagery of migration (pls 258, 73), and John Hayes has written of how, with Improvement, the 'simplicities of rural life, the labours of the countryman, and the concept of a sturdy, independent peasantry were all invested with a heightened sentiment', and of how this was expressed both by Goldsmith and Gainsborough.[42]

We may understand more of Gainsborough's response by contemplating the landscape of *c.*1768–71 commissioned by John, second Viscount Bateman, now at Kenwood (pl. 199). Here a procession of mounted figures, led by a girl and young boy on foot, moves out of the painted space to our right. In the left background is a cottage, against the walls of which sitting figures rest their backs while a woman with a bundle of sticks disappears through its door. In the right hand corner there is a pair of beggars. The paint is worked with supreme finesse, and the effects – translucent foliage against a luminous sky, reflections on the pond's surface – are breathtaking. This has to be an evening scene, for the figures slouched against the cottage wall enjoy that leisure after working. Less familiar is the group of beggars; an old woman with a girl who clutches a pitcher collapsed at her side, almost sunk into the rich gloom that complements the light playing over the cottage. In between are the weary and mounted figures, the children leading a nag overloaded with vegetables (carrots, turnips, cabbages), so that it might be that these are now wage labourers, returning from market, having bought what previously the common supplied. They occupy a middle station between independence and penury. The small boy notices the beggars and gestures towards them to alert the red-haired girl to their plight, but she turns her head away and chooses not to notice them. The rural virtues leave the land.

This extraordinary imagery did have precedents: Hogarth's old maid in *Morning* who neglects to be charitable as she enters the church, Laroon's huntsmen happily ignoring a cripple, Sterne's Lady Baussier, and more suggestively, Joseph, in a *Flight into Egypt* by Joos de Momper (pls 197, 198) who elects to ignore a beggar precisely as Gainsborough's young girl does; but it is still one over which we should ponder.[43] Gainsborough was a person whose name 'caused the aged features of the peasantry to light up with a grateful recollection of his many acts of kindness and benevolence', someone whose 'susceptible mind and . . . benevolent heart, led him into repeated acts of generosity'.[44] Uvedale Price recalled that, while 'at times severe and sarcastic . . . when we have come near to cottages and village scenes with groups of children, and objects of rural life that struck his fancy, I have observed

197 and 198 Joos de Momper (1564–1635), *Flight into Egypt* and detail, oil on canvas, 1,140 × 1,640 (45 × 64 1/2). Oxford, Ashmolean Museum.

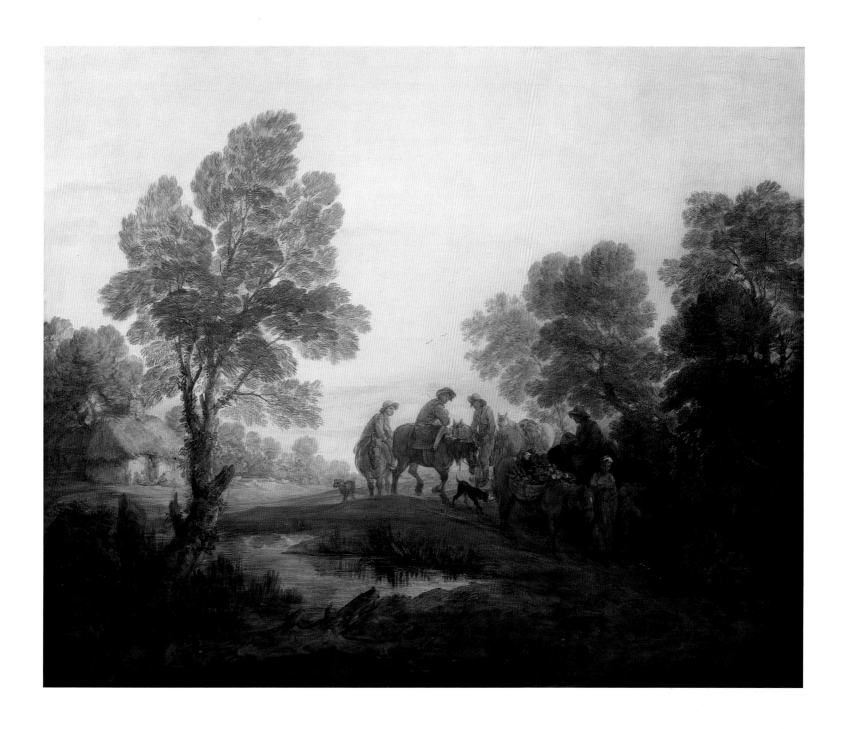

199 *Evening Landscape: Peasants and Mounted Figures*, c.1768–71, oil on canvas, 1,194 × 1,461 (47 × 57¹⁄₂). London, Kenwood House, Iveagh Bequest.

his countenance to take on an expression of gentleness and complacency'.[45] In addition, Gainsborough, unlike many artists, was a believer, a churchgoer, someone who wrote, 'I generally view my Works of a Sunday tho. I never touch.'[46] Here, the motif of charity denied might put the religiously inclined in mind of the preferred alternative, as embodied in the parable of the Good Samaritan, upon which Laurence Sterne wrote his third sermon, 'Philanthropy Reconsidered'. This begins by stating that there 'is something in our nature which encourages us to take part in every accident to which man is subject', for, as Adam Smith had written, 'How selfish soever man may be supposed, there are evidently some principles in his nature which interest him in the fortune of others, and render their happiness necessary to him, though he derives nothing from it but the pleasure of seeing it.'[47] To do good or to see good done are sources of pleasure. In his sermon, Sterne dramatises the parable, having the Samaritan think, 'Good God! What a spectacle of misery do I behold!', and going

to administer succour and dress the wounds with oil, as Francis Hayman represented the scene in the large altarpiece he had painted for Cusworth Hall in 1751–52 (pl. 192). Sterne closes with language comparable to Smith's: 'I think there needs no stronger argument to prove how universally and deeply the seeds of this virtue of compassion are planted in the heart of man, than in the pleasure we take in such a representation of it.'[48]

It is the *sight* of the representation of compassion that provokes pleasure. Gainsborough's *seeing* 'cottages and village scenes' caused him to take on 'an expression of gentleness and complacency'. In this system of morality, sight is the key sense, so that Sterne has the Samaritan moved to action because he beholds a 'spectacle of misery', and, in the painting, the girl elects not to see what ought to provoke comparable compassion. We, as polite spectators of such art, are confirmed in our own virtue by reacting properly to what Gainsborough shows us, displaying pity and tenderness at the sight of the beggars, and dismay that the child chooses not to succour them by giving them what she appears to have in abundance. We might then go on to contemplate the consequences of this pictorial metaphor for the moral economy's succumbing to the money economy. In a Protestant society, secular paintings, contemplated within the privacy of the house, could assume the moralising functions which religious ones in churches served for Roman Catholics. Hence, in his *Beggars on the Road to Stanmore* (1771), Zoffany models his group on a Holy Family with St John, while Gainsborough in another of his scenes with progresses of peasants (pl. 203) included a begging woman strongly reminiscent of Raphael's *Alba Madonna*.[49]

Gainsborough's response to the shock of the new complements Richard Wilson's in his near-contemporary *Dinas Bran from Llangollen* (pl. 201). Here, part of the estate of Sir Watkin Williams-Wynn is shown, with figures scattered around, while flocks graze among the trees in the middle distance. Some of the people chop timber, or break branches for fuel (as the poor were legally entitled to do), others fish the river. In the middle distance is the village, with its church tower hinting towards the Christian underpinning of all this. In the companion piece, *A View near Wynnstay* (pl. 202), nature is so abundant that, in contrast to Gainsborough's children, the peasantry feed a dog from their basket.[50] The paintings present Williams-Wynn as a paternalist landlord in the old tradition (as described by Frances Brooke with respect to Lord Belmont), as befitted his descent from a Welsh king of the ninth century. Significantly, the great landords, including Gainsborough's patron, the fourth Duke of Bedford, were not agricultural improvers.[51] One such, the fourth Duke of Rutland, was to purchase the first of the cottage door scenes which Gainsborough began painting in the 1770s (pl. 204).

200 Francis Hayman, *The Good Samaritan*, 1751–52, oil on canvas, 1,987 × 1,222 (78$^{1}/_{4}$ × 48). New Haven, Yale Center for British Art, Paul Mellon Fund.

201 (*below left*) Richard Wilson, *Dinas Bran from Llangollen*, 1770–71, oil on canvas, 1,803 × 2,448 (71 × 90$^{5}/_{8}$). New Haven, Yale Center for British Art, Paul Mellon Fund.

203 *Open Landscape with Mounted Peasants*, c.1773, 1,219 × 1,473 (48 × 58). Private collection, courtesy of Pyms Gallery, London.

202 (*facing page bottom right*) Richard Wilson, *View near Wynnstay, the Seat of Sir Watkin Williams Wynn Bt.*, 1770–71, oil on canvas, 1,804 × 2,447 (71 × 96³/₄). New Haven, Yale Center for British Art, Paul Mellon Collection.

These were paintings which focussed on what had often been incorporated into landscape. In this scene, a woodman, carting a bundle of faggots heavy enough to make him stoop, and accompanied by his dog, returns to a hovel. Around its door is a group of figures it seems hardly adequate to contain. In the distance are open woodland and grazing sheep. Described in 1773 as a 'scene of beauty and domestic love', this is a virtuoso performance. In the distant trees one discerns the fine brushwork used with such delicacy in the foreground of the Kenwood painting, but now worked, built up to communicate density and mass in the foliage. The sky is gold, darkening to the left, and the window panes reflect the sunset in creamy yellow. Save for the woodman, the figures are all beautiful, and handled with great mastery, so that, as Hayes writes, 'the smaller children look like putti who have escaped from a Correggio altarpiece'.[52] In colouring, the painting is additionally reminiscent of Rubens. A later horizontal version of the theme again shows the cottage and its

204 *The Woodcutter's Return*, 1772–73, oil on canvas, 1,473 × 1,232 (58 × 48¹/₂). Belvoir Castle, the Duke of Rutland.

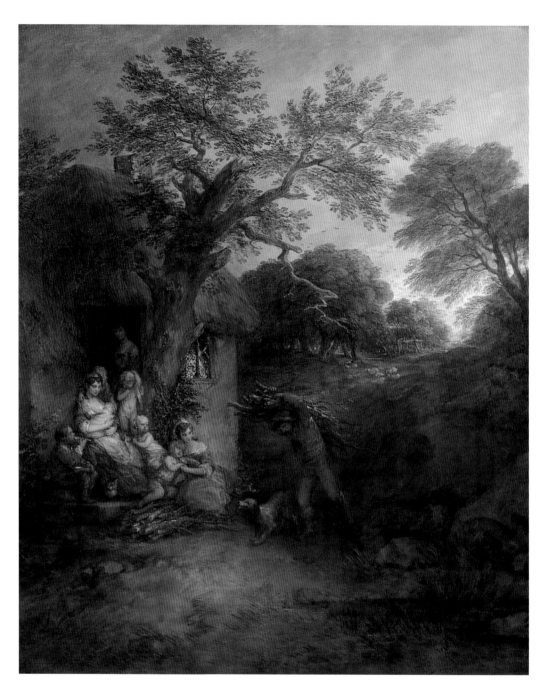

family as a functioning economic unit (pl. 205). The ebullience of the women and children is offset by the stooped and grimly anonymous woodcutter accepting, in the way of a Christ carrying the cross, the burden of labour as the price of independence. In one of the last, the labourer sits outside the cottage, relaxed and blowing smoke rings (pl. 206). His hovel now merges into the forest in a setting painted to hint at some of the landscapes of Titian.

Roy Porter has commented that forests were 'bywords for lawlessness' and quotes Arthur Young on the inhabitants of Wychwood Forest in Oxfordshire: 'The vicinity is filled with poachers, deer-stealers, and pilferers of every kind: offences of every description, about so much that offenders are a terror to all quiet and well-disposed persons', confirming that the forest became a refuge for the independent peasantry.[53] William Gilpin, who knew the New Forest intimately, was eloquent on the subject:

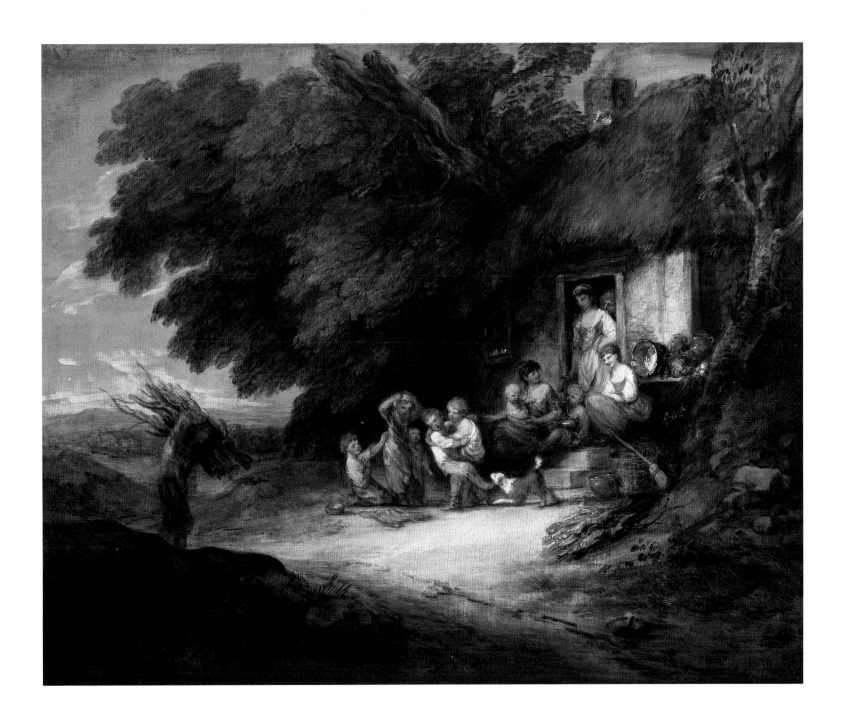

205 *The Cottage Door*, c.1778, oil on canvas, 1,225 × 1,492 (48¼ × 58¾). Cincinnati Art Museum, given in honor of Mr. and Mrs. Charles F. Williams by their children.

206 (*following page*) *Peasant smoking at a Cottage Door*, 1788, oil on canvas, 1,956 × 1,575 (77 × 62). Gift of Mrs. James Kennedy. UCLA at the Armand Hammer Museum of Art and Cultural Center, Los Angeles.

the forest is continually preyed on by the incroachments of inferior people . . . who build their little huts, and inclose their little gardens and patches of ground, without leave, or ceremony of any kind. The underkeepers who have constant orders to destroy all these enclosures, now and then assert the rights of the forest by throwing down a fence; but it requires a legal process to throw down a house of which possession has been taken.[54]

Moreover, these 'inferior people' were indolent, surviving on furze cutting and poaching rather than labouring for a wage, and yet eventually getting parish rights. Gilpin, however, tempered his censure.

in some circumstances, these little tenements (incroachments as they are, and often the nurseries of idleness), give pleasure to a benevolent heart. When we see them, as we

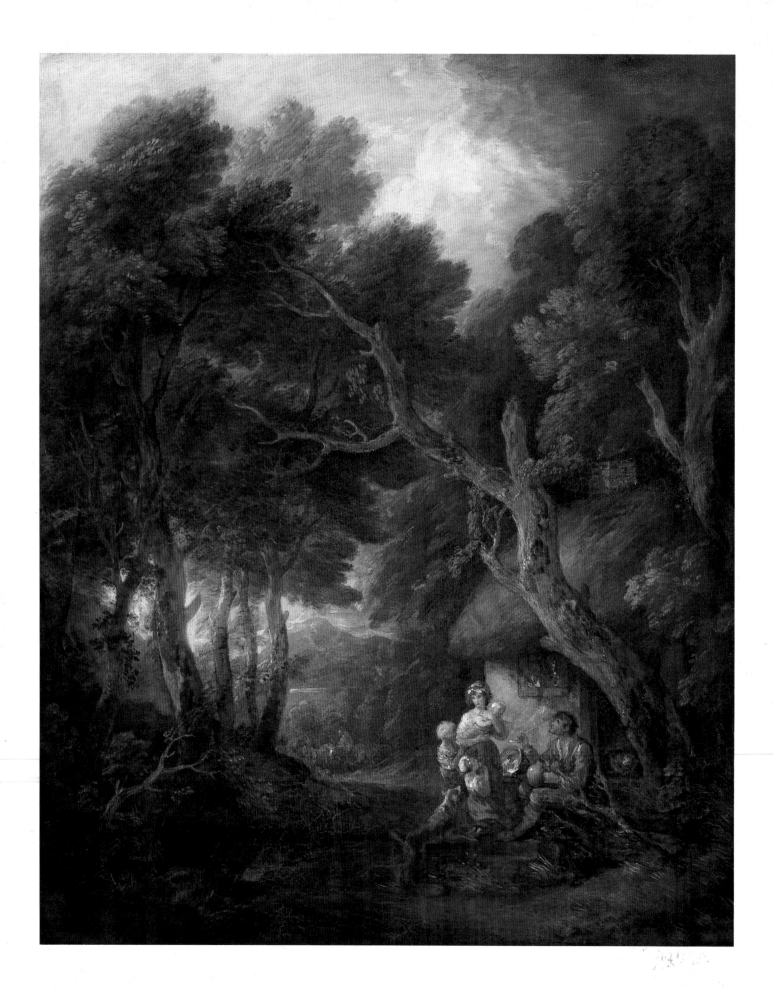

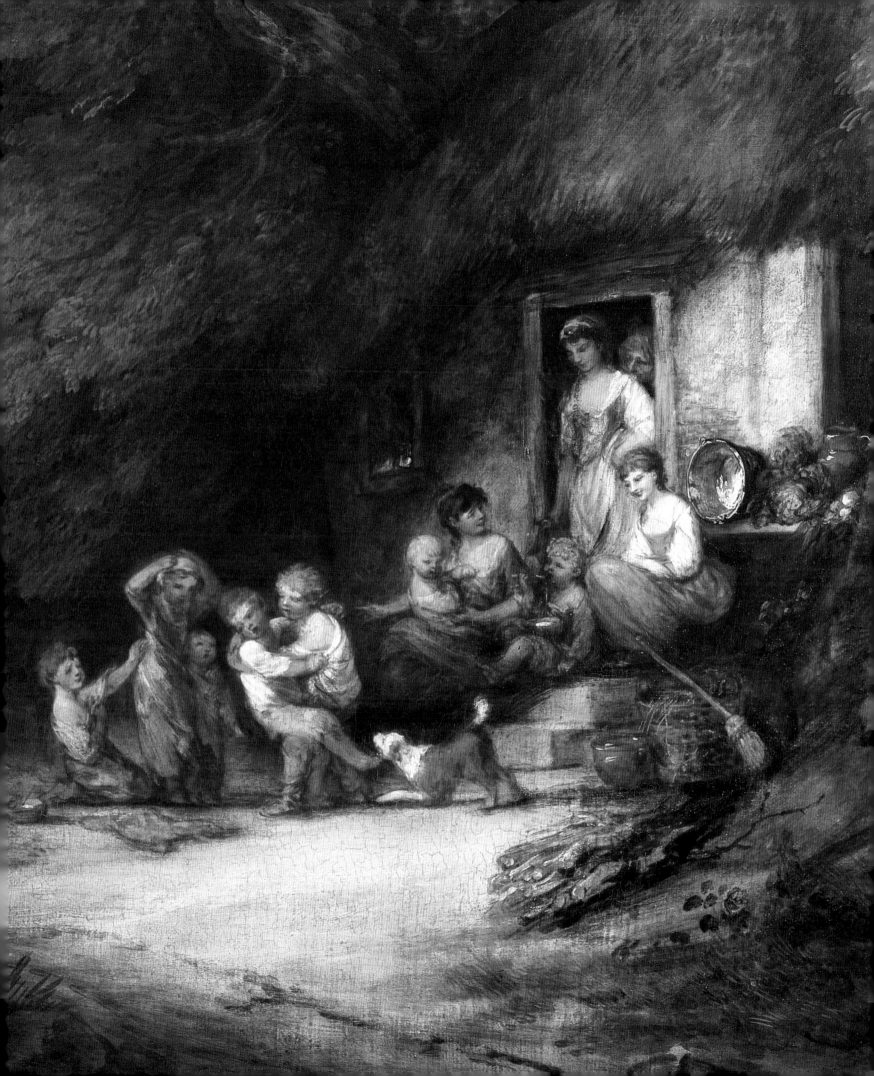

sometimes do, the habitations of innocence, and industry, and the means for providing for a large family with ease, and comfort, we are pleased at the idea of so much utility and happiness, arising from a petty trespass on a waste, which cannot in itself be considered an injury.[55]

Gilpin's description corresponds very closely to what Gainsborough paints, and his language reveals its anarchic potential. Because the forester had 'the temptation of plunder' he was in danger of becoming 'a supple, crafty, pilfering knave' of the type Arthur Young had ruefully described at Wychwood Forest.[56] Yet to the 'benevolent heart', censure gave way to humane sympathy. Gilpin is, as we shall see, defusing the imagery of its threat by employing the language of sensibility, but the threat has to be recognised before we can analyse Gainsborough's tactics for defusing it.

Gainsborough opposes a view which saw the poor as destined for wage-labour, whose idleness had to be castigated as a species of luxury, a misuse of time, such as, according to the *London Magazine* in 1754, 'enervates the people . . . debauches their morals . . . destroys their substance'.[57] Matthew Peters maintained that luxury had infected 'the lower people', who manifested 'mere idleness; being possessed of a false, delusive idea of liberty, as having a right to work, or not, as they themselves may be disposed'.[58] The deleterious effects of enclosure and engrossing were disputed: 'diminution of tillage inhabitants in one place; the consequent increase of them in another', countered one writer.[59] Josiah Tucker complained that the 'poor . . . being left to do whatever is right in their own Eyes, become the more desirous of Parish-Pay as a Pension to support them in Laziness and Indolence, and as a Refuge against that Want, which Vice and Extravagance have drove them to'.[60] Hence, argued the Reverend John Howlett, the wage economy was justified simply because it compelled the poor to work.[61] Yet wages brought their own problems. As one writer of 1772 put it, 'If a person can get sufficient in four days to support himself for seven days, he will keep holiday the other three', and the Country Gentleman agreed that if the wage were too large the labourer would 'no doubt keep Saint Monday and Saint Tuesday'.[62]

The natural obligation of the poor was, then, to work for wages, as it was the horse's to pull the plough. Hence we notice the contrast between Gainsborough's and Stubbs's picturings of them (pls 208, 209). The latter's haymakers and reapers work in an ordered manner and, in comparison with Gainsborough's ragged louts, are kempt, smooth, and astonishingly clean, posed to itemise working procedures. In these landscapes there is very little noise, save for the voice of the master, whose viewpoint we adopt in *Haymakers* (pl. 208).[63] Stubbs, whose connections may have given him some sympathy with the gentry, took pains to display the landscape of improvement as entirely natural and therefore entirely right, by placing mature oaks at intervals along the tall hedge that marks the enclosure in *Reapers* (pl. 209). Oak trees grow slowly, and thus transfer ideas of longevity to this scene of new agricultural practice. In addition, they would (as we have seen) normally be seen as patriotic emblems.[64] Stubbs's and Gainsborough's landscapes occupy ideologically opposed positions. In *Gainsborough's Forest* (pl. 189), the poor are scattered around and about and enjoy the liberty that was anathema to the improving interest.

There is one instance in which the risks inherent in Gainsborough's landscapes were recognised and acknowledged. *The Harvest Wagon* of 1767 (pl. 214) is an extremely problematic composition. It abounds with incongruous quotes from high art. The figure effortlessly holding the horse originates with the classical statues of the horse-tamers on the Quirinal Hill in Rome, mediated through such paintings of Reynolds's as *Captain Orme* (pl. 138). The figure leaning out to help the girl into the cart appears to have been adapted from Raphael's *Fire in the Borgo* (pl. 210), and his fellows are grouped in a manner loosely developed from Rubens's Antwerp *Deposition*. The man with the pitchfork is based on Hogarth's *Rake in Bedlam* (pl. 211), and the wagon has stopped to offer a lift to the artist's daughter, Margaret, as shown in a portrait of her (pl. 213).[65] The figures tend to be clad in earth

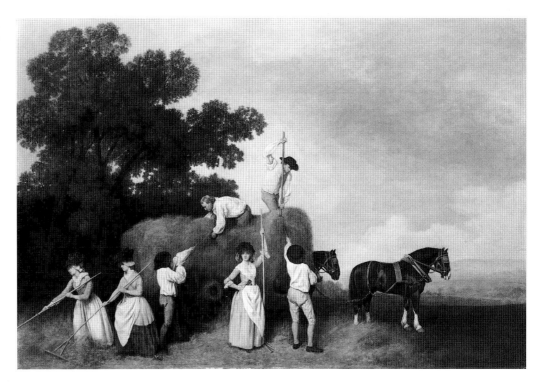

208 George Stubbs, *Haymakers*, 1785, oil on panel 895 × 1,352 (35¼ × 53¼). London, Tate Gallery.

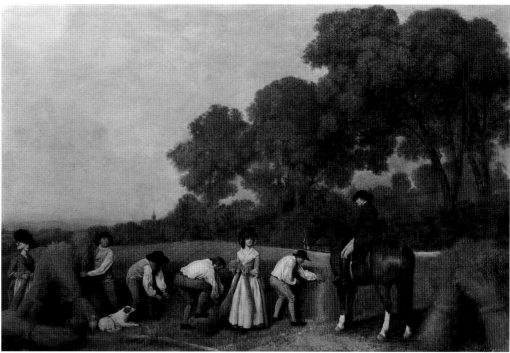

209 George Stubbs, *Reapers*, 1785, oil on panel, 900 × 1,370 (35½ × 53⅞). London, Tate Gallery.

colours, warm and reddish, and are far more solid than their surrounds. The background, finished with pink and purple hills, is lit by a golden light, and the sky is equally thin, a grey violet. This is an evening light, with birds flying home to roost, and the foliage is painted to appear translucent.

This is a quirky image. The high art sources appear incongruous in a low-life subject, which itself is hard to unravel. Usually harvest does not take place in forests, although there is a small quantity of straw strewn in the cart, and it could be, as John Barrell has suggested (although some dispute it), that the peasants are *en route* to their harvest supper.[66] They seem

210 Raphael, *The Fire in the Borgo* (detail), begun 1514. The Vatican Museums.

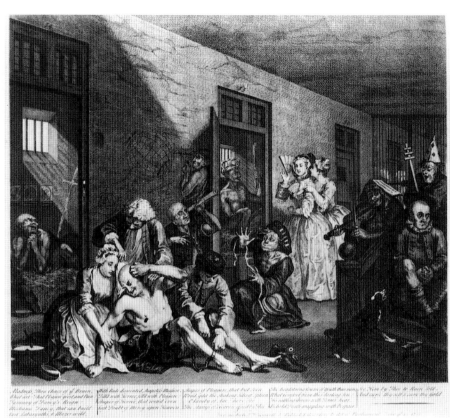

211 (*right*) William Hogarth, *The Rake's Progress VIII: The Rake in Bedlam*, 1735, etching and engraving. London, British Museum.

214 *The Harvest Wagon*, 1767, oil on canvas, 1,148 × 1,194 (47½ × 57). University of Birmingham, Barber Institute of Fine Arts.

212 (*facing page bottom left*) Francis Wheatley, *The Harvest Wagon*, 1774, oil on canvas, 1,283 × 1,016 (50½ × 40). Nottingham, Castle Museum and Art Gallery.

213 (*facing page bottom right*) *Margaret Gainsborough*, early 1770s, oil on canvas, 762 × 635 (30 × 25). London, Tate Gallery.

disconnected. The two fighting for the barrel of liquor are distinct from the group of women, the central one of whom appears to meet the approval of the salacious gaze; while one wonders what a figure dressed as expensively as Margaret Gainsborough (she has gold buckles on her shoes) is doing adrift in a forest. When Francis Wheatley extemporised on this composition, he made significant adjustments (pl. 212).[67] Wheatley's cart is clearly heading towards its destination down a rutted and therefore oft-frequented route. It has stopped to respond to a plausible traveller. A convincing amount of straw is spread around. The figures are pleasingly neat and ordered, and rather than two louts brawling over a barrel, a swain woos a maid. Instead of the capricious suggestiveness of Gainsborough's handling, Wheatley lays down his paint evenly, creamily textured, to make what was diaphanous appear solid, of the real world.

216 (*right*) *The Harvest Wagon*, 1784/5, oil on canvas, 1,219 × 1,499 (48 × 59). Toronto, Art Gallery of Ontario. Gift of Mr. and Mrs. Frank P. Wood, 1941.

215 F. Bartolozzi after William Hogarth, *The Shrimp Girl*, 1782, stipple engraving. London, British Museum.

Gainsborough never again essayed such anarchy in a rural subject. His later pictures tend to have some narrative, and, as John Barrell has noted, the later *Harvest Wagon* (pl. 216) is altogether more subdued, and, together with the Wheatley, confirms that his was a subject-matter which condoned what others condemned, took the Goldsmithian view of enclosure and engrossing, and which, when figures of woodmen, shepherd boys and cottage girls with broken pitchers were moved on to the scale of life, invited our approval and sympathy.[68] But then, they could do this with some impunity simply because they were works of art, not snapshots of actuality. That, at the extreme, was represented by the grim cottage interior (pl. 217) which Philip Thicknesse attached to his *Account of the Four Persons found starved*

217 Philip Thicknesse, *A View of the Poor House of D—— in Herts addressed to the Overseers of England*, from *An Account of the Four Persons found starved to Death at Duckworth in Hertfordshire*, second ed., 1769, London, British Museum.

218 *Landscape with Rustic Lovers, c.*1773–74, oil on canvas, 1,194 × 1,473 (47 × 58). Formerly Hackwood Park Collection.

to Death at Duckworth in Hertfordshire, in which he suggested that with a proper system of paternalism such tragedies would not develop. According to Thicknesse, to 'succour and relieve the distressed is a great and God-like act; and it is undoubtedly the duty, and in the power of every individual to do it: And yet in no kingdom are the poor so hardly dealt with than in this; especially in extensive, but obscure Parishes, where scarce any gentleman reside.'[69] Gainsborough's landscapes were fictions. They represented no place and were therefore at a comfortable remove from what people might recognise from daily experience.[70] Very few were bought, and those that did find their way to private houses either went to friends and intimates, or to a select group of patrician connoisseurs, who, by incorporating Gainsborough's canvases into collections of old master paintings indicated their cultural status. That they had very little connection with reality is to be understood from his habit in Bath of working from little models of landscapes in which mirror served for water, broccoli for wood, and coal for rocks.

It is difficult not to spot the coal in the landscape he reputedly painted in 1774 for his friend Walter Wilshire, as a pendant to *The Harvest Wagon*, but the transformation is extraordinary (pl. 218). The composition, and the mood of pastoral tranquillity, look to the Claude of such paintings as *The Herdsman* (National Gallery of Art, Washington), and the invention, in which a drover moves his untroubled beasts out of the picture space, while to the right a youth props himself up against a rock to talk to a girl who has a full pail of milk, is realised with very great art.[71] The youth has dark curls and a flushed face, and the girl a fine profile, also flushed. We are invited to admire the invention that places the principal figures partly in shadow. The background is extraordinarily subtle, glazes laid upon swirling glazes, with little touches of impasto, dabs of ochres and creams on the light-reflecting surfaces of foliage. Textures, the shagginess of the cows' coats, and colours, the scarlet of her skirt, have been

attended to, and the grand character of the wooded landscape puts one in mind of the Venetian pastorals of Titian or Giorgione, an association boosted by the hint of a castle (such as we see in their paintings) in the central woodland. A later landscape – the *River Landscape with Rustic Lovers* of 1781 (pl. 97), reputedly exchanged with Oldfield Bowles for a violin – has been connected with the contemporary French art of Fragonard and of Hubert Robert by John Hayes.[72] Hayes notes, too, how imagined scenes in which are set Italianate buildings are linked to Gaspard Poussin.

Gainsborough's subjects if transposed to actuality, represented as documentary, would have been extremely risky. But they were not. They comprised part of his extremely inventive artistic practice. The rural paintings did, however, attempt to make a moral point. They managed this partly through the exclusivity of their market: particular friends, or certain patricians who themselves could be said to represent those highly cultivated and humane individuals under whose aegis the poverty and destitution attendant upon developing agrarian capitalism would be averted. And this, to a large degree, was because they have to be understood within the terms of the sensibility which from mid-century became the true index of gentility, and which Janet Todd has defined as 'the movement discerned in philosophy, politics, and art, based on the belief in or hope of the natural goodness of humanity'.[73] Dr Schomberg and the people in *The Watering Place* can inhabit the same landscape of the imagination, but this does not imply a parity of station. We do not look upon Dr Schomberg as we do the rustic figures, as an object of sensibility. However, to appreciate much of what Gainsborough's art was about, we need to know more about the phenomenon of sensibility.

219 Detail of pl. 190.

9 *Painting Sensibly*

WHEN REYNOLDS CENSURED HOGARTH FOR PAINTING 'low and confined subjects', thus warranting a praise 'as limited as its object', this was a blanket condemnation which potentially tarred many of his contemporaries with the same brush. Gainsborough painted these people, and so did Joseph Wright in such compositions as his Blacksmith's Forges (in which, as in Gainsborough's late *Shepherd*, they are presented as dignified and monumental; see pl. 79). Reynolds himself was not averse to painting 'low and vulgar subjects', of course, for in 1774 he painted two street urchins in the roles of *Cupid as Link Boy* (pl. 221) and *Mercury as Cutpurse* (pl. 222), as homoerotic child pornography for the third Duke of Dorset.[1] Indeed, scenes from proletarian life were popular – for example, the cottage subjects of Francis Wheatley, or inventions such as Hugh Robinson's *Boy flying a Kite*.[2] More often than not these fitted into conventions invented in the Low Countries during the seventeenth century, and maintained by such artists as Chardin, whose scenes of domestic industry might be compared, for instance, to Henry Walton's *A Girl plucking a Turkey* (pl. 223). Other painters, notably Henry Robert Morland, used the subjects of young females doing house-work, parading their beauties to imply a potential for gratification that was frequently sought in actuality. Samnel Richardson's Pamela managed to fight off Mr B., but the author of one conduct book felt bound to warn young Gentlemen

> that when they visit or dine with a Friend, they keep within the Bounds of Decency to the Women-Servants; sly kisses, toying, and catching at them, with other Fooleries as they pass to and fro on their Business, are mightily unbecoming . . . Half a Guinea genteely flip'd down a Girl's Stays has melted the most obdurate Heart, and moulded her to such Purposes, as has render'd her very unfitting for a sober Family.[3]

Gainsborough's images of the poor, particularly of poor children, however, cannot be accommodated within these idioms. While he was supremely capable of portraying children – his niece Susan Gardiner (pl. 225), or Lady Georgiana Spencer (pl. 224) – as individuals, even the imagery of his child portraits can raise real questions. Portraits of his daughters, for example, appear imbued with a profound solemnity alien to the innocent pleasures of childhood. They grope towards a butterfly almost as though we are meant to think them as short-lived as it (pl. 228). When Margaret Gainsborough is, in an unfinished and cut-down painting, represented as a gleaner (pl. 227), receiving a bundle of wheat from her sister, the conception seems far more authentic than, say, Zoffany's *Blunt Children* (Birmingham Museums and Art Gallery), in which his sitters play at being haymakers, yet one wonders why Gainsborough painted his daughter in such a condition of ragged penury.[4] She was, of course, a handy model. But in the light of his own religious convictions (and we have already quoted Sterne on the importance of imaginative empathy), he might here display an under-standing of the capriciousness of a fate that might indeed upset the fortunes of his own family. The painting dates from around 1758–59, when his own career was on the cusp.

Thereonafter, compositions in which the figures of the poor are so physically dominat-ing vanish from Gainsborough's output until the 1780s, when *The Shepherd* or *The Girl with Pigs* appear, alongside cottage scenes. While ragged, and evidently penurious, these figures are at some remove from actual conditions. Arthur Young records 'a cottage almost tum-bling down, the wind blowing through it on every side. On a bed, which was hardly good enough for a hog, was the woman very ill and moaning . . . her infant . . . dead in a cradle

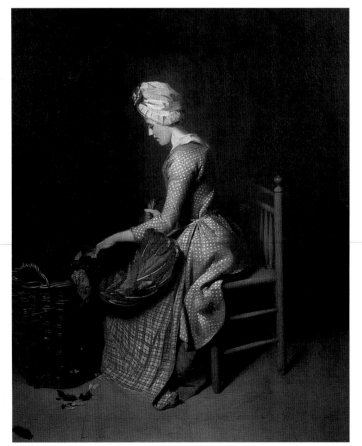

221 (*above left*) J. Dean after Sir Joshua Reynolds, *Cupid as Link Boy*, 1777, mezzotint. London, British Museum.

222 (*above right*) J. Dean after Sir Joshua Reynolds, *Mercury as Cutpurse*, 1777, mezzotint. London, British Museum.

223 Henry Walton, *A Girl plucking a Turkey*, 1776, oil on canvas, 724 × 610 (28¹/₂ × 24). London, Tate Gallery.

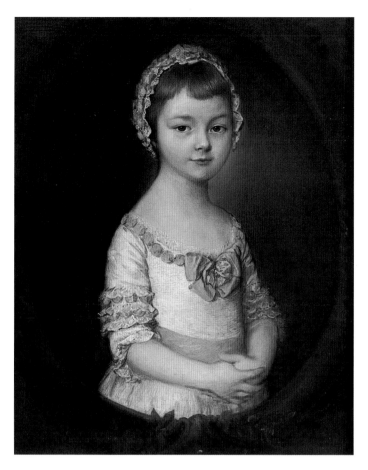

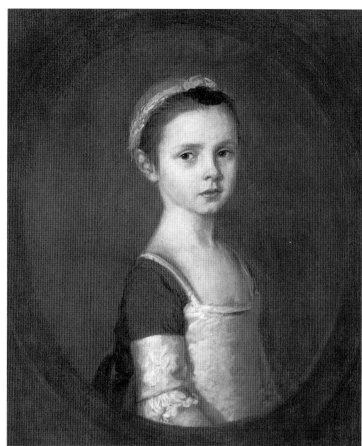

224 (*above left*) *Lady Georgiana Spencer*, 1763, oil on canvas, 737 × 603 (29 × 23³/₄). Althorp.

225 (*above right*) *Susan Gardiner*, c.1758–59, oil on canvas, 620 × 510 (24¹/₂ × 20). New Haven, Yale Center for British Art, Paul Mellon Collection.

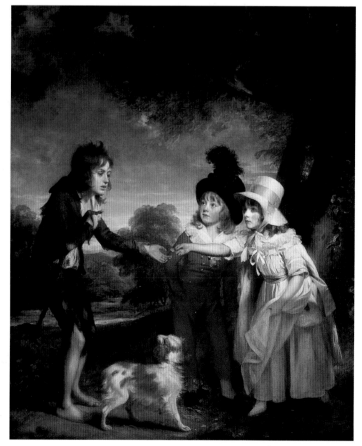

226 Sir William Beechey, *The Children of Sir Francis Ford giving a Coin to a Beggar Boy*, 1793, oil on canvas, 1,805 × 1,500 (71 × 59). London, Tate Gallery.

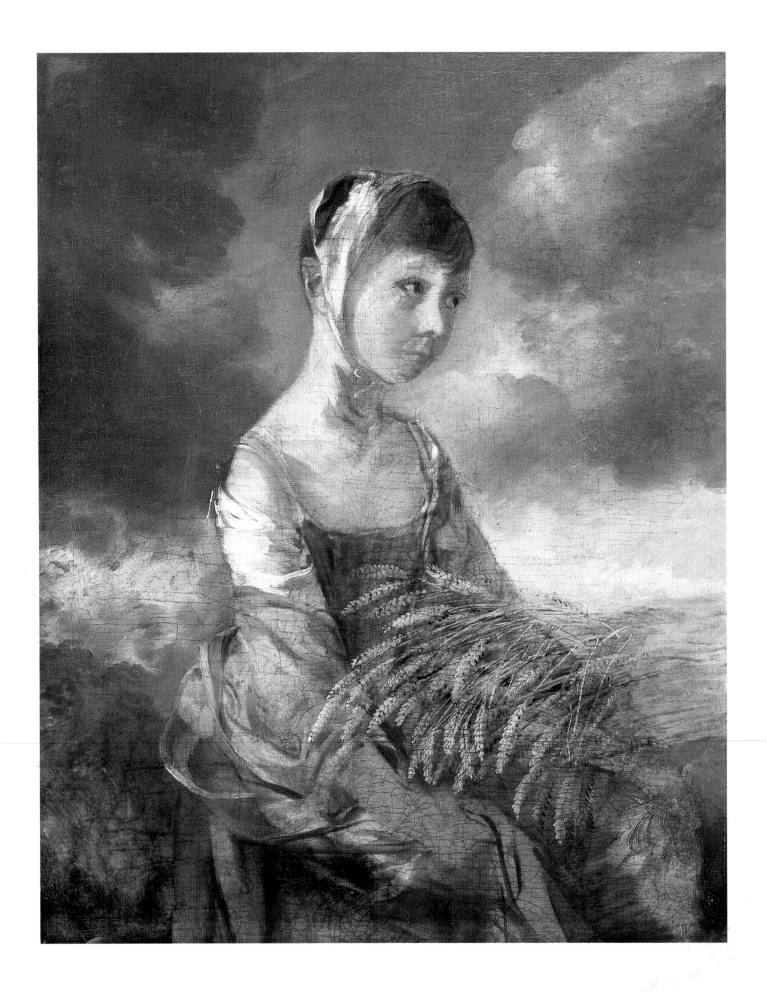

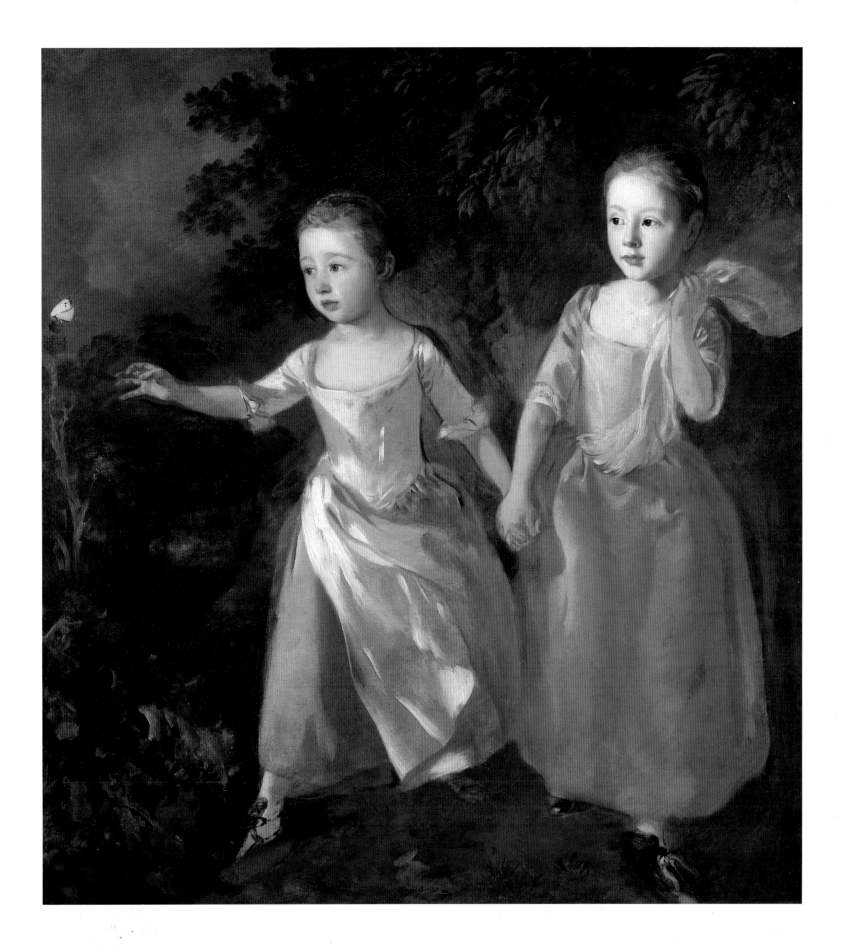

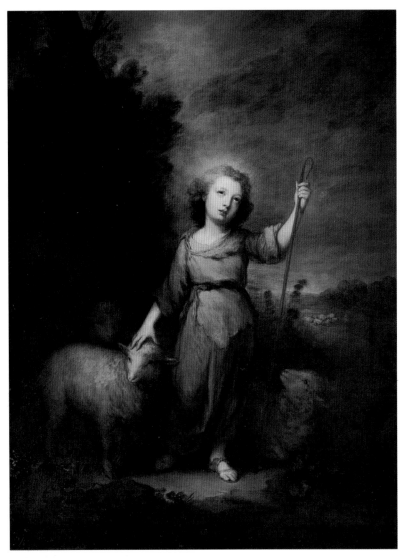

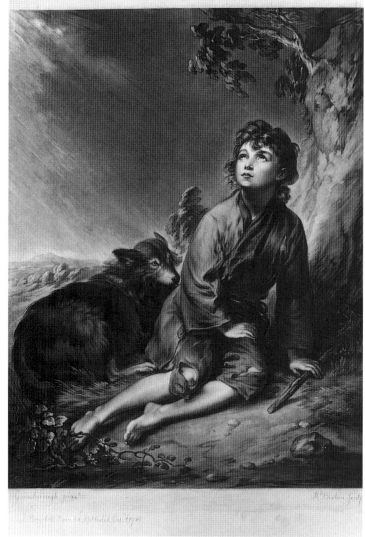

229 (*above left*) After Murillo, *The Good Shepherd*, c.1778, oil on canvas, 1,759 × 1,826 (69 × 72). Private collection.

230 Richard Earlom after Thomas Gainsborough, *A Shepherd*, 1781, mezzotint. Sudbury, Gainsborough's House.

227 (*page 222*) *Margaret Gainsborough as a Gleaner*, c.1758–59, oil on canvas, 762 × 635 (30 × 25). Oxford, Ashmolean Museum.

228 (*previous page*) *The Painter's Daughters chasing a Butterfly*, c.1756, oil on canvas, 1,137 × 1,048 (44³/₄ × 41¹/₄). London, National Gallery.

by her bedside . . . she had four children living; one, a little girl, was at home, and putting together a few embers on the hearth.'⁵ No matter how genuinely sympathetic the artist was to the plight of the poor, such scenes could not become the subject of art, although William Beechey's extraordinary *The Children of Sir Francis Ford giving a Coin to a Beggar Boy* of 1793 (pl. 226), with its amply dressed children gingerly handing over money to a tall, ragged, malnourished, rickety and tubercular youth, comes close. Of this painting, one critic commented, revealingly, that 'Nature is violated, when we shudder amid a scene of foliage. Heaven keep POVERTY from thee, thou man of propriety!'⁶

Gainsborough exhibited his *Girl with Pigs* (pl. 231) at the 1782 Royal Academy and sold it to Sir Joshua Reynolds for the extremely good price of 100 guineas. On hearing of the sale he wrote to Sir Joshua, 'I may truly say I have brought my Piggs to a fine market.'⁷ Reynolds in his turn thought it 'by far the best picture he has ever painted, or perhaps ever will', revealing, in a typically qualified way, the mutual respect that underpinned their rivalry.⁸ This indicates that its value was perceived to lie in qualities additional to its subject; if that reviewer of Beechey is to be believed, a pragmatic assessment of the girl will come close to violating his distaste for rural poverty, for she is silent, shoeless and ragged. She was also an actual person. Both Gainsborough and Reynolds used to paint poor children from life, and Gainsborough is said to have met this one on Richmond Hill. She reappears later in *Cottage*

224

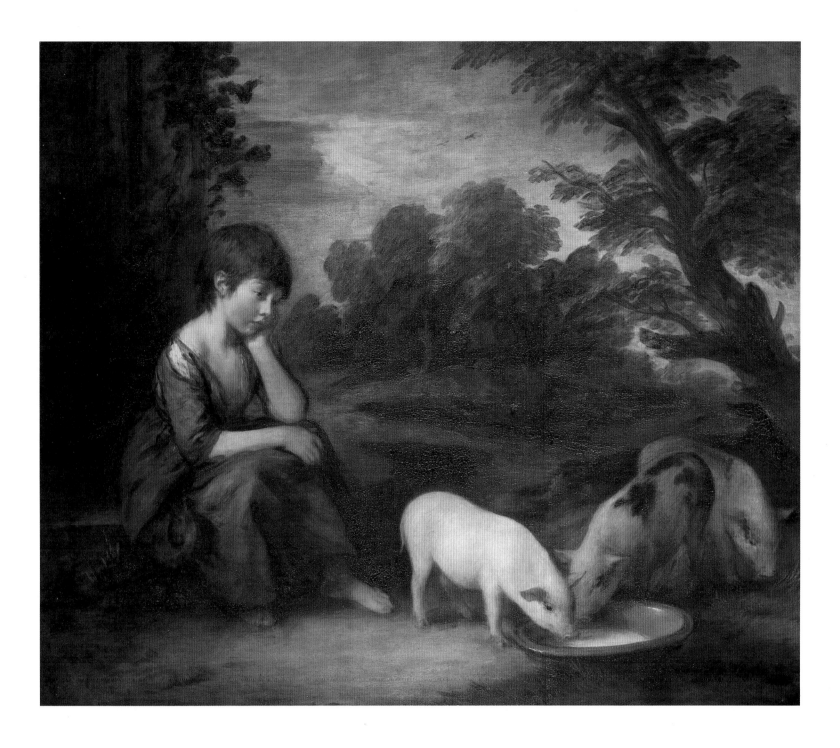

231 *Girl with Pigs*, 1782, oil on canvas, 1,256 × 1,486 (49$\frac{1}{2}$ × 58$\frac{1}{2}$). From the Castle Howard Collection.

Girl with Dog and Pitcher (pl. 232).[9] If Gainsborough perceived the poor sufficiently as individuals as to be concerned to reproduce their likeness accurately (which was sometimes less a concern with some of the portraits he was paid to do) this further distances his painting from others of this type. But he also painted from three piglets which were seen 'gambolling about his painting room, whilst he at his easel was catching an attitude or leer from them'.[10] While their grunts and squeals may have formed an harmonious counterpoint to the sounds being generated by the Celestial Bed at Dr Graham's next door, their presence in his studio does confirm that Gainsborough needed some kind of a model. Reynolds's purchase of the picture indicates that Gainsborough had turned the mundane into what might be recognised as art.

Reynolds for his part was showing a flexibility in taste consistent with what he had said in his seventh *Discourse* in 1776:

perfection in an inferior style may be reasonably preferred to mediocrity in the highest walks of art. A landskip of Claude Lorrain may be preferred to a history by Luca Giordano; but hence appears the necessity of the connoisseur's knowing in what consists the excellency of each class, in order to judge how near it approaches to perfection.[11]

Gainsborough was allowing the connoisseur this opportunity. He had begun studying Murillo in the late 1770s, and in 1780 had made a close copy of his *Good Shepherd* (pl. 229).[12] He coincidentally exhibited, to huge acclaim, *A Shepherd* (pl. 230) in 1781. This was an exercise in the manner of Murillo. A ragged shepherd boy accompanied by a strange-looking sheepdog squats by a tree, face raised to heaven in the manner of a Saint receiving inspiration.[13] For one critic, the merit of this composition lay in its being 'the Representation of a familiar Object . . . placed in a simple and expressive posture; the face is handsome, and the Colouring beautiful and true'.[14] When he followed it up with the *Girl with Pigs*, Gainsborough enhanced this aspect by placing the girl in the pose of melancholy, a sophisticated tactic in its dictating conceptually how the subject may be perceived both as an actual poor child with pigs, and a fictional figure who belongs with a population of comparable inventions in the history of art: for example, Wright's figuring of *Maria, from Sterne* (pl. 244).[15] It remains hard, though, to gauge from reviews what the reactions were. 'Where is the Man', asked 'Candid', in the *Morning Chronicle and London Advertiser* of 9 May 1782, 'who will dare to complain of any part of the canvas, on which his three pigs . . . are painted, cold must those feelings be which will allow us for a moment to turn our eyes from them'. There is nothing to say that this is not a standard sentimental response. We can approach closer to assessing the reception of these pictures when we consider the *Cottage Girl with Dog and Pitcher* of 1785 (pl. 232).

Here, the same girl stands in the middle of an anonymous landscape, barefoot, dressed in rags, dog in one arm, right hand clutching a broken earthenware pitcher. Her expression is downcast. To the rear left is a cottage, and in the right middle distance a few sheep hint at the independence that was the lot of his cottagers and other rural figures. However, this, as Patricia Crown has noted, is a silenced and harrowing image.[16] Whitley quotes a contemporary description which takes account of none of this: 'it is a peasant girl on her way to a brook to fetch water. Under one of her arms a little dog is borne; the position of the animal is extremely natural and pleasing. A cottage is shown in the distance, and a charming landscape, with sheep and pastoral objects, fill the expanse.'[17] Gainsborough went on to sell this painting to a Sir Francis Bassett very soon after completion, which indicates the very great value the invention was perceived to have, and prompts the question of why someone might want a life-size representation of rural child poverty, albeit one realised with considerable art.

For an answer it is enlightening to turn to an essay, 'An Enquiry into those kinds of distress which excite agreeable Sensations', which John and Arthur Aikin published in 1774.[18] At one point they observe that 'Poverty, if truly represented, shocks our inner feelings; therefore whenever it is made use of to awaken our compassion, the rags and dirt, the squalid appearance and mean employments incident to that state must be kept out of sight, and the distress must arise from the idea of depression, and the shock of falling from higher fortunes.'[19] The sentiment was not unusual and was from time to time realised in fiction, as with Frances Brooke's Rosina, who so enchants Captain Belville that he asks her to 'Unveil' her 'whole heart to me . . . The graces of your Form, the native dignity of your mind which breaks through the lovely simplicity of your deportment, a thousand circumstances concur to convince me you were not born a villager.'[20] A preference for fallen gentility, implicitly registered through an elegance and beauty alien to the chronically poor, was not uncommon. Addressing young ladies in a book of 1773, Mrs Chapone taught that Charity should 'animate the industry of the young . . . procure some ease and comfort to old age, and . . . support in sickness those whose Daily labour is their only maintenance in health. They, who

232 *Cottage Girl with Dog and Pitcher,* 1785, oil on canvas, 1,740 × 1,245 (68$\frac{1}{2}$ × 49). Dublin, National Gallery of Ireland.

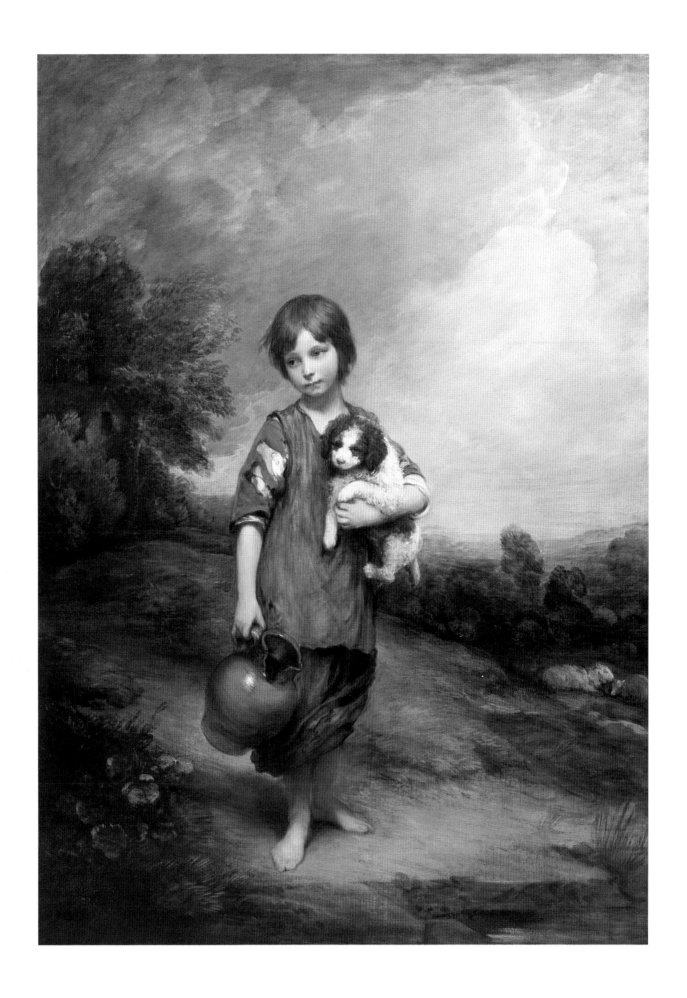

are fallen to indigence, from circumstances of ease and plenty, and in whom education and habit have added a thousand wants, must be considered with the tenderest sympathy.'[21] She would not have excluded such objects as Gainsborough's cottage girl, displaying commendable industry, and perhaps, a sombre awareness of the obligations of her station, from the receipt of such charity. In a sermon, *The Charitable Man the best Oeconomist, Patriot, and Christian*, the Reverend E. Radcliff observed how 'The world is constituted so as to require the mutual intercourses of charity for its subsistence, and the mutual stations and characters of human life are admirably diversified to promote and encourage it.' And while 'the number of the poor are a reflection on our pride, and mock the magnificence of our riches', this 'distribution . . . seems to the wise man just and good', for the 'rich are moved with compassion while they are relieving distress, and the poor are melted into gratitude, while they are supplied with good'.[22]

Another writer for young women defined 'Compassion' as that 'pleasing pain which every generous heart feels upon seeing a fellow creature in distress, and wrote of the 'very considerable degree of pleasure' attendant upon supplying relief. Charity was to be dispensed to both undeserving and deserving poor, for "tis enough for you that they are poor and needy', and was to be given discreetly.[23] This indicates the extent to which Adam Smith's ideas had become common currency. Compassion, he maintained, was motivated by empathy on the spectator's part, 'the consideration of what he himself would feel if reduced to the same unhappy situation'.[24] And, it appears, however selfish

> man may be supposed, there are evidently some principles in his nature, which interest him in the fortune of others, and render their happiness necessary to him, though he derives nothing from it, but the pleasure of seeing it. Of this kind is pity or compassion, the emotion we feel for the misery of others, when we see it, or are made to conceive it in a very lively manner.[25]

This idea was picked up by the Aikins, who mused that it 'is undoubtedly true, though a phenomenon of the human mind difficult to account for, that the representation of distress frequently gives pleasure'.[26]

Smith writes of 'the pleasure of seeing it', the Aikins how 'the representation of distress' frequently gives pleasure. In 1785 Bate was to write of *Cottage Children with an Ass* (pl. 233) (featuring that same female model) that

> The girl appears to have been sent from a distant cottage with her little brother to gather firewood at the entrance to a grove, but meeting with a young ass the girl sits her brother on it. The boy seems pleased, yet terrified at his situation, and the action of the right hand at the side of his head adds force to the expression of his countenance. They are painted in tattered drapery that well accords with rustic penury, and on that account the picture has greater value.[27]

Aesthetic value lies in the representation of penury: the frame of reference is expanded beyond the approval of the moral economy (and, therefore, custom and tradition). We are given a surrogate opportunity for a display of that compassion, which, under conditions of actuality, would translate into practical relief. Here it takes the form of extreme refinement, reflected in the prices these canvasses fetch. The old-master references to Murillo or Rubens define these as objects of cultural value, what the period might have termed objects of *virtu*, such as confirm the civilised qualities of those who gaze upon them. Rather than unite the body of the public by their expression of one general idea, they evoke an exhibition of general sympathy, and, consequently, humanity; or they do so in theory.

Gainsborough was, nevertheless, sailing close to the wind, approaching a little to picturing the 'rags and dirt, the squalid appearance and mean employments' which, according to the Aikins, 'must be kept out of sight'. The cottage girl may be barefoot, but her feet are clean. She may be penurious, but she is bonny and scrubbed and her hair has been combed. It is an acknowledgement of the aesthetic tightrope being walked here that with his Cottage

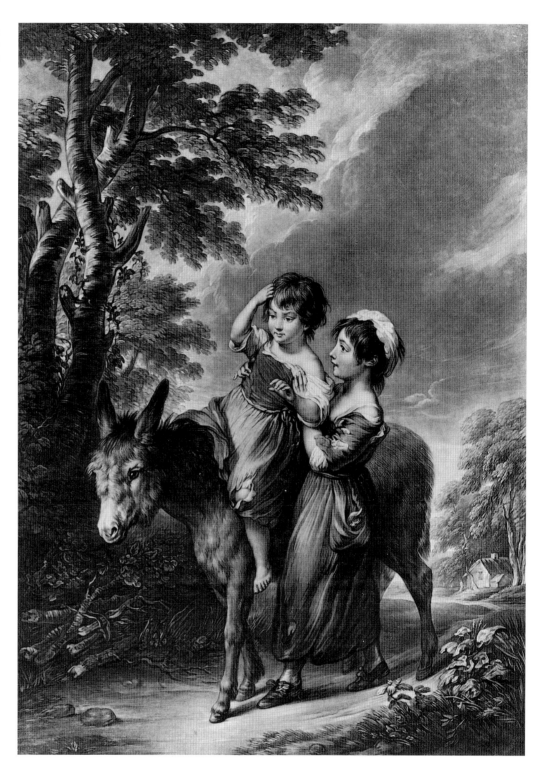

Doors in particular Gainsborough did not risk picturing crowds of obviously poor people. The woman about whom children swarm in a painting shown at the 1780 Royal Academy (Huntington Art Gallery, San Marino) is a beauty on a par with any of his portrait sitters, and she is not alone, as we see with one of the paintings Gainsborough withdrew from the 1784 exhibition, *Charity relieving Distress* (which has since been cut down) (pl. 234).

The architecture here is generically related to that Italianate type apparently associated with Gaspard, presumably to import value by association, and to dissociate the scene from

234 *Charity relieving Distress*, 1784, oil on canvas, cut down to 980 × 762 (38¹/₂ × 30). Private collection.

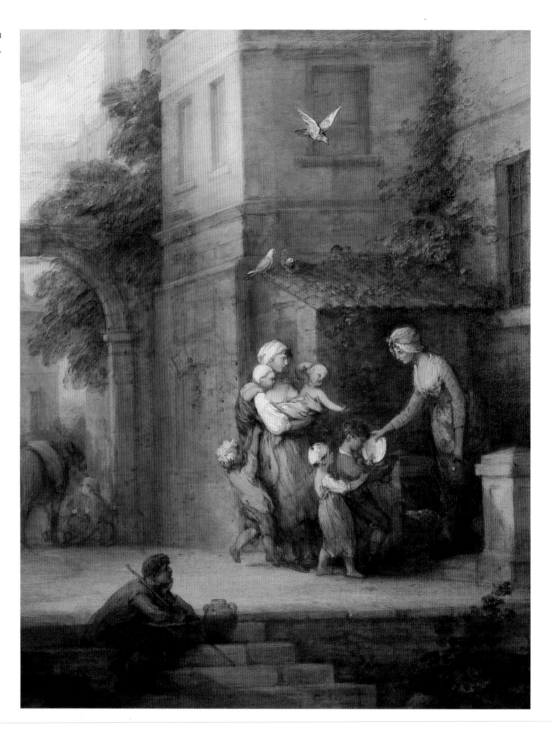

the here and now. There are two drawings connected with this painting. One shows a figure with a basket striding through a pedimented arch, with a classical fountain in the left foreground. The other is rather more complex (pl. 235).[28] Most of the right-hand side is taken up with a Georgian–Italianate building fronted by a broad terrace from which an elegant family descends by means of stairs, against the side of which is an indigent, while in the left middle distance a herdsman drives cattle. In the painting, an act of charity is taking place.[29] What survives of the work is complicated by pentimenti, but we have a view into a courtyard, reached by steps, against which rests an introductory figure. The poor family is as numerous as those pictured in the Cottage Doors (but lacking a male provider), with a woman, baby, and four other children, the eldest of whom braves the dog frightening his

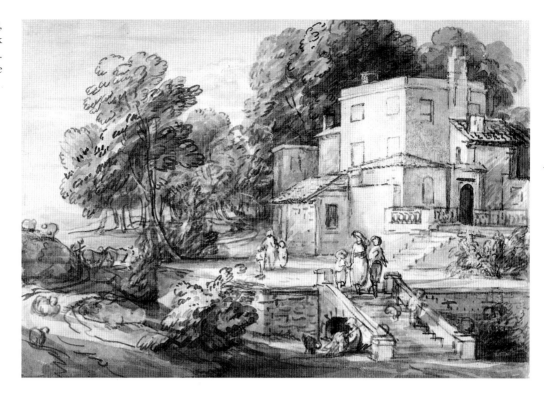

siblings, and receives into his basket the victuals which the servant, who is as beautiful as his mother, tips from a pewter plate. In the rear an arch opens to a view of further houses and a church tower, and here there is a seated figure with a donkey. The handling displays the extreme refinement seen too in *The Mall*, and the elegance may be meant to be associated with the courtliness of Watteau. Yet the painting has odd features. The dispensation of charity, as the church tower confirms, is a Christian act, and the white dove hovering over the principal group cannot but be an allusion to the Dove of the Holy Ghost; much as that baby conceivably connects with Raphael's *Bridgewater Madonna*, and the donkey hints at the iconography of the Flight into Egypt. What unhinges this somewhat is the mother's discreet revelation of her nipples. This has been done apparently to accommodate her within that idiom where pictures of the female poor were meant as objects of the salacious gaze. This may be a strategem to reassert a distance between the painting and its spectators, to impress how in comparison with the refinement it pictures, theirs is superior. Its artistically sophisticated fiction is germane to actual social relationships. The servant girl displays genuine concern not to spill any food; to compare her with the girl in the Kenwood painting (pl. 199) points up her scrupulous compassion. She, too, is acting out of sympathy, rather than, as we have seen to be far more usual with Gainsborough, being its object, to establish a hierarchy topped by the virtue of those we imagine to employ her.

If sensibility is so central to such a painting as this, then it must be enquired into in greater depth. Paul Langford writes how in 'the 1760s and 1770s there was a revolution, called by some a sentimental revolution. In part its function was to express the middle-class need for a code of manners which challenged aristocratic ideals and fashions . . . Its most beneficial consequence was thought to be a heightened sensitivity to the social and moral problems brought by economic change.' He quotes a 1775 newspaper which defined sensibility as 'a lively and delicate feeling, a quick sense of the right and wrong, in all human actions, and other objects considered in every view of morality and taste'.[30] In commercial society as it was perceived to be developing, the courtly structures of morality and manners were clearly obsolete, and new systems had to be erected. These evolved on the basis of society itself

being a multi-layered and complex phenomenon in which, none the less, members were connected through mutual obligations, friendship and conviviality. As commerce joined people in actual networks of relationships, a sympathetic or moral economy was thought to subsist between the citizens of the nation. In this culture of politeness, 'conversation assumed the equality of participants and insisted on a reciprocity in which particpants were sometimes talkers and sometimes listeners'.[31] David Hume wrote how, in these changed circumstances, people 'love to receive and communicate knowledge . . . show their wit and their breeding; their taste in conversation or living'.[32]

This society was founded in the belief of the innate goodness of humanity, as we have seen in Adam Smith. This notion had been advanced by Shaftesbury, who had contended that the 'sense of right and wrong' was 'a first principle' 'in our constitution', 'implanted in our heart'. He wrote how 'No sooner are actions viewed, no sooner the human affections and passions discerned (and they are most of them as soon discerned as felt) than straight an inward eye distinguishes and sees the fair and shapely, the amiable and admirable, apart from the deformed, the foul, the odious, or the despicable.'[33] Shaftesbury's follower Francis Hutcheson took up the torch. 'It is plain', he wrote, 'we have some *secret Sense* which determines our Approbation without regard to *Self-Interest*.'[34] Thus the concept of a society bound together by ties of sympathy could enter the public domain. As Lord Kames observed, 'nature, which has designed us for society, has connected us together by a participation in the joys and miseries of our fellow creatures', for 'Sympathy with our fellow-creatures is a principle implanted in the breast of every man.'[35] David Hume agreed that 'a warm concern for the interests of our species is attended with a delicate feeling of all moral distinctions', and distinguished the British from 'uncultivated nations, who have not, as yet, had full experience of the advantages attending beneficence, justice, and the social virtues.'[36] Thus it is, writes Hume, that the traditional virtues of the Public Man, 'Courage, intrepidity, ambition, love of glory, magnanimity, and all the shining virtues of that kind, have plainly a strong mixture of self-esteem in them', and are, as plainly, inappropriate in a public bound together by ties of sympathy.[37]

Virtue, therefore, is no longer patrician, civic and abstracted, but private and practical, with social morality regulated by the instinctively correct responses of individuals, rather than by the imposition of external constraints. As the novelist Charles Jenner explained, in an *apologia* for having written a novel of contemporary manners, rather than an improving history,

> The account of a generous action, may raise a warmth in the heart, very likely to incite the doing one; the sympathetic tenderness which may arise in the breast from the history of a feigned distress, may open the heart to an attention to real misery . . . In these respects a history of this kind, which turns upon the more minute parts of the economy of human life, may possibly, with reverence be it spoken, have the advantage of all other histories. The great actions of great statesmen, or great heroes, upon which revolutions of states depend, are not very likely either to excite the curiosity, or influence the conduct of private peoples, but the propriety and rectitude of a man's conduct, who is conversant only in the common occurrences of life, and which are most conscious in little actions, every man is willing to contemplate, and able to imitate; and in this respect these histories may certainly have their use.

However,

> It is a certain elevation of mind alone, a sensibility of what is great and good, a comprehensive view of what is desirable or contemptible, which sets a man above the common level, and shows him everything in its true light . . .[38]

So when Thomas Gainsborough complained of Reynolds's instruction tending to promote a history painting for which there was no need, and that rather 'there must be a Variety of

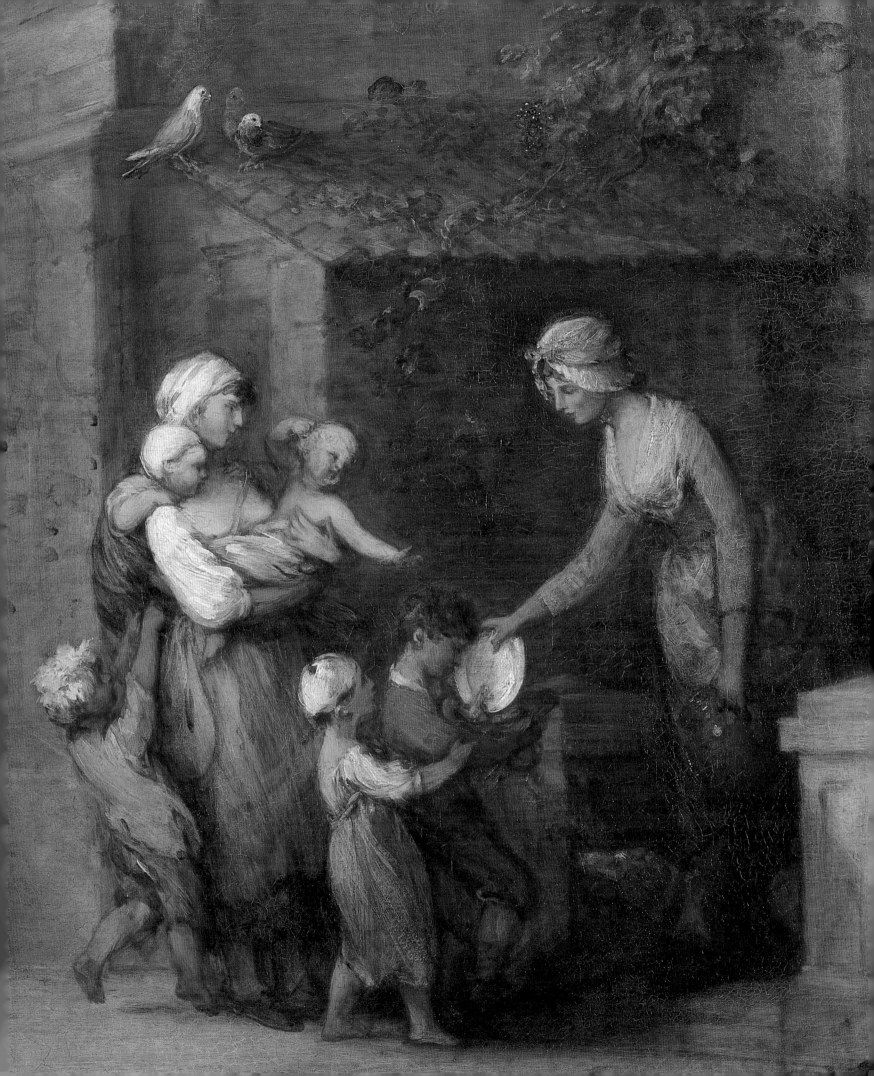

lively touches and surprizing effects to make the Heart dance' (language which could apply to a physical encounter as much as the response to a painting), he was demonstrating his total assimilation into the culture of sensibility in which the key organ was the heart. 'I had rather direct five words point blank to the heart', states Yorick in the key novel of sensibility, *Tristram Shandy*.[39]

As will have become apparent, the eye was second only to the heart in the cult of sensibility. Sight was paramount, and was stimulated as much by the most insignificant as significant phenomena. One follower of Sterne's, having admired a cottage and its inhabitants and thinking, 'I never saw any object upon which the inexpressible delicacy of Horace's Simplex Munidibiis could have been bestowed', wanders off, deep in thought, when he looks down and discovers himself to have trodden on a worm. This, 'by the writhing of it's body, must have been in incredible agony'. He lifts his foot so that it can return to the hole from which

> it had lately crawled forth to enjoy the moisture of the morning, and be a partaker of those benefits which the bountiful hand of Providence sheds impartially alike upon all his creatures – And, in a moment! – Good God! – it is so strong a resemblance of what happens daily in human life, that it will not bear so close a reflection as I was about to bestow on it![40]

The narrator is extravagantly alert to the natural world, which, it has been suggested, and contemporary writing backs up, may have been due to the volumes of tea and coffee people used to drink, notwithstanding which, kindness to animals was a commonplace of sensibility.[41]

Cowper, who himself 'would not enter on my list of friends . . . the man/Who needlessly sets foot upon a worm', wrote that

> The heart is hard in nature, and unfit
> For human fellowship, as being void
> Of sympathy, and therefore dead alike
> To love and friendship both, that is not pleas'd
> With sight of animals enjoying life,
> Nor feels their happiness augment his own.[42]

Gainsborough was equally fond of animals, and where George Stubbs tended to paint dogs from the side, to demonstrate their muscular conformation, the head partly turned to display the features, Gainsborough saw them far less as specimens requiring description.[43] He painted the family dogs, Tristram and Fox, around 1770 (pl. 237). As we saw, calling a dog Tristram was an exquisitely Sternean touch, and this is a work that subtly confirms what is effectively a modern sensibility towards pets. Handling and viewpoint encourage us to see these as sentient beings in their own right: a perception enhanced by catch-lights in Tristram's eyes, along with his part-open mouth. To wish thus to portray an animal indicates some affection towards it.

This is confirmed by other paintings. Earlier, *William Poyntz* (pl. 40) was noticed, with his spaniel resting at his feet. The image is parallelled by Gainsborough's Bath acquaintance Richard Graves, who writes of how his character Mr Wildgoose enjoyed his leisure:

> He frequently walked out indeed with his gray-hound, or with his spaniel and gun; but the one was rather for a companion, and the other for shew, than for any great pleasure which he took either in coursing or shooting.[44]

In 1763 Gainsborough exhibited a portrait of Thomas John Medlycott, sitting on a stile, gazing into space, while his spaniel looks up at him. Four years later he showed the ultimate in animal companionate imagery with his portrait of George, second Lord Vernon (pl. 36), who, lost in contemplation in a landscape, instinctively caresses the springer spaniel that

237 *Tristram and Fox, c.*1770, oil on canvas, 610 × 510 (24 × 20). London, Tate Gallery.

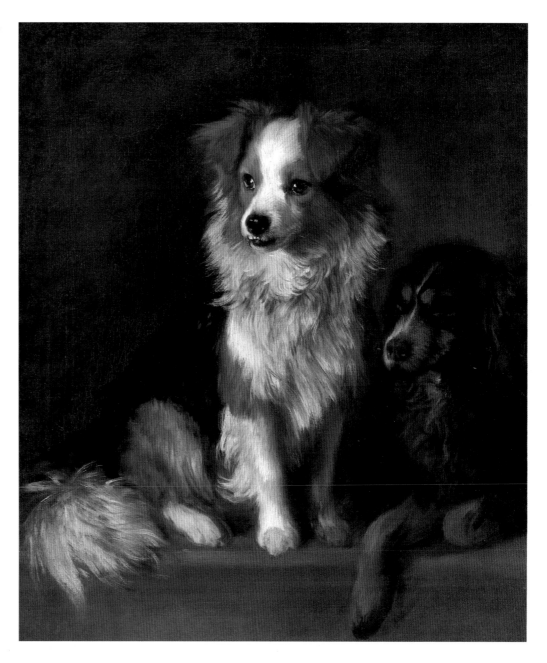

rests its paws on his torso: a behaviour natural, but rarely tolerated.[45] In contrast, in 1788 Reynolds painted the first Baron Cawdor (pl. 239) equally as much a man of sensibility, but actively so: directing attention to some feature of the landscape, the very noticing of which qualifies him for the epithet, and with a dog which is a duly subordinate companion. Something akin to this might be remarked of Joseph Wright's portrait of the Reverend Thomas Gisborne with his wife Mary (pl. 240), in which they enjoy the shade of a parasol on a sketching excursion, and a subtle distinction in roles is articulated. Their going sketching together is the pastime of people of sensiblity; nevertheless it is he who has the pencil and portfolio and prospects the distance; she who holds the parasol for their mutual benefit and gazes at him; while their greyhound stands content to one side, resting its chin on his hand and looking at her. This is an hieratic system of affection and respect.

Enjoying a walk in the country was one of the focal tropes of sensibility. It was on such a walk that our man of feeling discovered himself to have trodden on a worm. The alternative title to Graves's *Spiritual Quixote* is *The Summer Ramble of Mr Gregory Wildgoose*, and

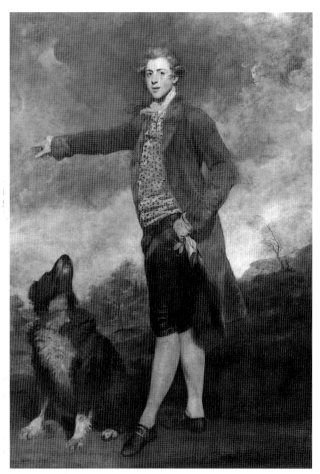

238 (*above left*) *Thomas John Medlycott*, 1763, oil on canvas, 2,210 × 1,448 (87 × 57). Private collection.

239 (*above right*) Sir Joshua Reynolds, *John Campbell, first Baron Cawdor*, 1778, oil on canvas, 2,050 × 1,450 (80¹¹/₁₆ × 57). Cawdor Castle, Scotland.

240 Joseph Wright, *Thomas and Mary Gisborne*, 1786, oil on Canas 1,855 × 1,525 (73 × 60). New Haven, Yale Center for British Art, Paul Mellon Collection.

241 (*facing page*) *The Morning Walk*, 1785, oil on canvas, 2,362 × 1,791 (93 × 70¹/₂). London, National Gallery.

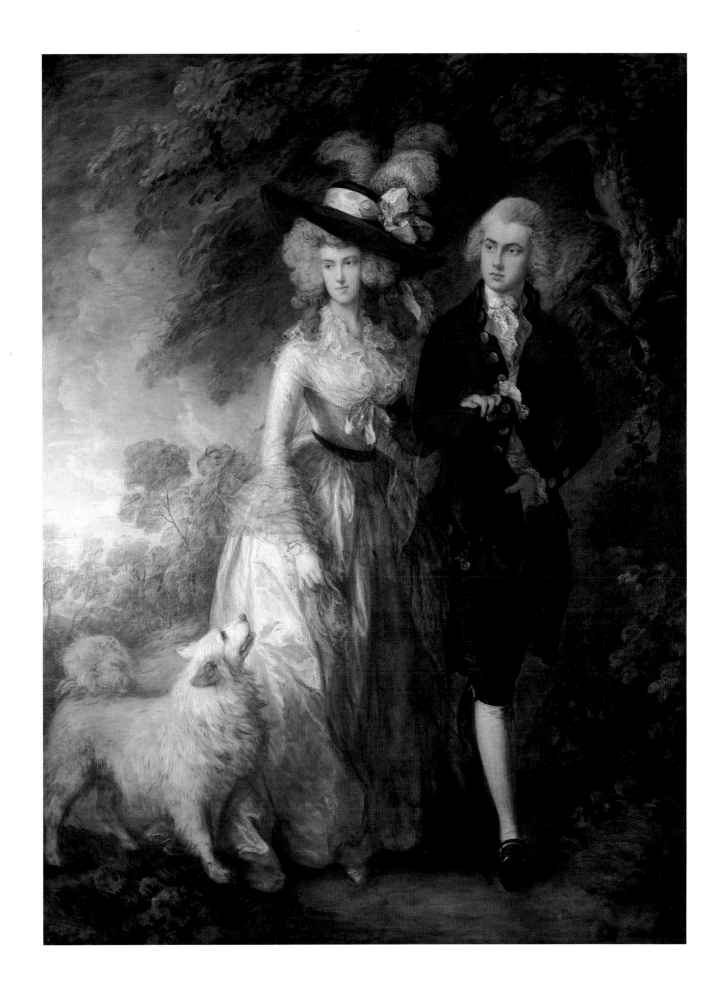

Cowper's lines about loving the brute creation were extracted from the book entitled 'A Winter Walk at Noon' in *The Task*. The country walk was so normal an activity that at one point in *The Seasons* the poet appears spoilt for choice – 'Which way, Amanda, shall we tend our course?' he asks his female companion.[46] The pleasures of such an excursion are detailed in 'Spring':

> Perhaps thy loved Lucinda shares thy walk,
> With soul to thine attuned. Then nature all
> Wears to the lover's eye a look of love;
> And all the tumult of a guilty world,
> Tost by ungenerous passions, sinks away.
> The tender heart is animated peace;
> And, as it pours its copious treasures forth
> In varied converse, softening every theme,
> You, frequent pausing, turn, and from her eyes,
> Where meekened sense and amiable grace
> And lively sweetness dwell, enraptured drink
> That nameless spirit of ethereal joy,
> Inimitable happiness! Which love
> Alone bestows, and on a favoured few.[47]

Desmond Shawe-Taylor has perceptively connected this passage to one of Gainsborough's best-known paintings, the portrait of the Halletts known as *The Morning Walk* (pl. 241).[48]

'Going for a walk' was no artless experience. The circuits designed around the landscaped parks of Rousham, Stowe, Stourhead and at the Leasowes earlier in the century had involved the walker in a particular interaction with scenes and objects (buildings, sculptures) as they gradually appeared during the progress of the walk. A walk in the woods such as the

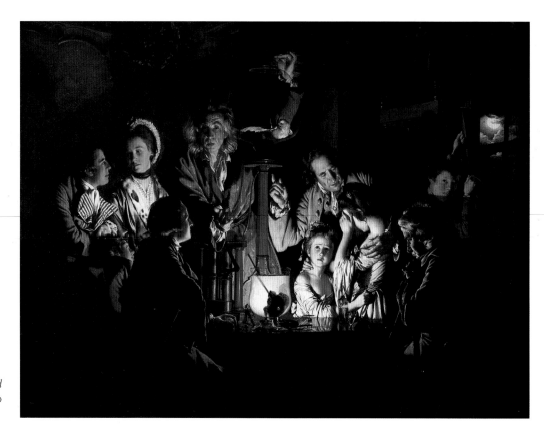

242　Joseph Wright, *An Experiment upon a Bird in the Air Pump*, 1768, oil on canvas, 720 × 960 (28$\frac{1}{4}$ × 37$\frac{3}{4}$). London, National Gallery.

Halletts take cannot be preordained in this way, but a certain amount of role-playing is necessary if we are to recognise the significance of their companionate stroll, and of the dog looking up to attract attention. Although the couple is fashionable, each is painted to deflect any accusation of their therefore being afflicted with the ills of luxury. He is in a sober black suit, that melts on one side into the gloom of nature and, on the other, into the shaded side of her diaphanous dress, which in turn corresponds in brilliance of tone to the bright clouds that dominate the landscape background. Correspondences between the feathers of her hat and some of the clumps of foliage again reinforce the perception that they are part of the nature through which they stroll, and point up their exemplary character, for nature is the touchstone of all. In presenting his figures thus, Gainsborough is unique. Wright had painted *The Reverend d'Ewes Coke, his Wife, Hannah, and Daniel Coke, M.P.* (pl. 157) around 1780–82, also to present us with an imagery of cultivated leisure, to show what it is suitable for men and women to do when looking at a view in the country (making drawings, for instance). Through these means they signal their status as a contented pair and companion enjoying nature. The Halletts have no need to do this as they are at one with nature, and this is a difference which, with regard to Gainsborough as a painter of sensibility, marks him out.

Wright, of course, is incredibly various. In such paintings as, *An Experiment upon a Bird in the Air Pump* (pl. 242) he posits a society bound together by ties of sympathy, by displaying a range of people reacting differently to the prospective fate of the bird, and by leaving a space at the front of the table, inviting our participation in the demonstration.[49] But Gainsborough does stand apart when it comes to the presentation of subjects and of sitters in portraits. For instance he eschewed the most popular class of sentimental subject, the representation of scenes well known from literature. In 1774 Joseph Wright painted *The Captive, from Sterne* (pl. 243) whom Yorick had created in fantasy in *The Sentimental Journey*, and in 1777 *Maria, from Sterne* (pl. 244) (referring both to that book and to the earlier *Tristram Shandy*). The captive is as emaciated as Yorick describes him, spotlit within the Piranesian gloom of a cell, his plight inviting our compassion, much as does Maria, posed, as noted earlier, in the condition of melancholy contemplation, 'sitting with her elbow in her lap, and her head leaning on one side within her hand', and dressed, as Sterne describes, in white with a green ribbon and accompanied by a dog.[50] The spectator is invited to

243 (*below left*) Joseph Wright, *The Captive, from Sterne*, 1774, oil on canvas, 1,020 × 1,275 (40^1/$_8$ × 50^1/$_4$). Vancouver Art Gallery.

244 (*below right*) Joseph Wright, *Maria, from Sterne*, 1777, oil on canvas, 1,003 × 1,257 (39^1/$_2$ × 49^1/$_2$). Private collection.

compare their own imaginary version with Wright's actual picturing of scenes from literature, and, in this the paintings relate to the prints illustrating episodes from the literature of sensibility popular at the time.[51] Here the spectator is forearmed, so an appropriate sympathetic response can be acted out, thus keeping at bay the extremes of sensibility, as Henry Mackenzie represents them in his novel *The Man of Feeling* (1771).

Gainsborough's community of sensibility is subtly different from this both in the ways described above, and because he does not allow for this particular sort of option. Indeed, his paintings uniquely embody sensibility through demanding our active looking. If virtue was made explicit in the frank and open countenance, then such portraits as those of the Duchess of Bedford (pl. 33), her daughter Caroline, and nieces Elizabeth and Mary Wrottesley (pls 61, 62, 65, 66), all painted onto canvases of 30 by 25 inches in the mid-1760s, conform to this.[52] *Caroline Russell* (pl. 62) was earlier compared with Ramsay's *Mrs Bruce of Arnot* (pl. 67) as embodying a comparable approach, particularly as regards that indistinctness in the representation of the features that demands sympathetic spectating. However, there are noteworthy differences. Ramsay distances his sitter. The viewpoint is low, and light directs attention to her costume as much as to her face. Gainsborough views his sitters on a level and invites us to concentrate on the features through the directness of their gazes, although, appropriately, due respect is paid the Duchess by lighting her more evenly, and having her look over our right shoulders. These are portraits of great intimacy and distinction, suggestive of the artist and his sitters inhabiting the same world, and it is intriguing to examine the means by which these illusions were created.

Janet Todd has written how the literature of sensibility was marked by 'broken syntax and typographical exuberance'.[53] That is, the disconnectedness of the prose, as we saw it in that account of treading on a worm, leaves spaces for the imaginative and sympathetic engagement of the reader. Sterne uses lines, not language, to communicate the movement of Trim's stick, or the experience of reading.[54] It is with this in mind that I wish to quote from Gainsborough's obituary in the *Gentleman's Magazine*. In his portraits, it stated,

> imitation assumes the energy of life. He seems almost the only painter of this country who attempts the thin brilliant style of pencilling of Vandyke; and yet, with all this blaze of excellence (and he gives not merely the map of the face, but the character, the soul of the original), his likenesses are attained more by the indecision, more than the precision of the outlines. He gives the feature and the shadow, so that it is sometimes not easy to say which is which; for the scumbling about the features sometimes looks like the feature itself; so that he shews the face in more points of view than one, and by that means it strikes every one who has seen the original as a resemblance; and while the portrait with rigid outline exhibits the countenance only in one disposition of mind, his gives it in many.[55]

As do 'broken syntax and typographical exuberance', Gainsborough's handling invites the active enagement of the spectator, and this focussed looking is in itself a symptom of sensibility. Gainsborough, after all, wrote about 'a variety of touches' making 'the heart dance'.

Artist and sitters ideally coexisted in a social environment moderated by the mores of sensibility, befitting a nation that was becoming commercial and domestic. It is a measure of the exclusivity of sensibility that it is not an attribute of all of Gainsborough's portrait sitters, which in turn undermines its claims effectively to regulate the mores of the whole of society, and introduces us to some of the more problematic issues which surrounded it. Vicesimus Knox appears in general to have approved of sensibility; but he was also aware of its immanent dangers. Gainsbrough would surely have agreed with his writing that

> The imitative arts are capable of conveying moral instruction in the most effectual manner, as their operation is instantaneous. They require not the deductions of reason, which can only be made by cultivated intellects; but by appealing to the senses,

246 Engraving after Titian, *Duke of Mantua* (Madrid, Prado). London, British Museum.

which are sometimes combined in great perfection with the rudest minds, they strike immediately and irresistibly on the susceptible heart.[56]

There is a danger here, then, that sensibility might be socially indiscriminate. This was circumvented by a straightforward means, already implicit in Addison's remark that a 'Man of a polite Imagination is let into a great many Pleasures that the Vulgar are not capable of receiving'. The polite had a greater capacity for discrimination. 'The vulgar eye', wrote Knox, 'gazes with equal satisfaction on the canvas of a Titian, and the daubings of a sign.'[57] As Dr George Cheyne had put it earlier in the century: 'There are as many different Degrees of *Sensibility* or of *Feeling* as there are Degree of *Intelligence* and Perception in *human* Creatures', and therefore one might argue that true sensibility came only with true refinement and could therefore be only the province of the genuinely polite.[58]

Gainsborough's portrait of the Duke of Buccleuch (pl. 245) has been described by Desmond Shawe-Taylor as 'one of the most striking "portraits of feeling"'. By now we will recognise the significance of the landscape setting, the display of affection towards the dog, and the enticing lack of definition about the painting of the features as denoting a man of sensibility. But the artist has also achieved a fascinating balancing act in communicating the idea that such refinement is incumbent on social status. A low viewpoint ensures the spectator's deference. The Order of the Thistle is, as Shawe-Taylor notes, 'half concealed . . . The Duke refrains from turning his full glory on us', but it is still, nevertheless, there.[59] Finally,

as the most suggestive prototype for this conception is Titian's *Duke of Mantua* (pl. 246), we can begin to understand that so refined a sensibility was dependent on that extreme politeness only to be found amongst the most socially exalted – an interpretation supported by the way that, at Arundel, Gainsborough's portraits of the eleventh and twelfth Dukes of Norfolk (pls 145, 146) contrast strikingly with Van Dyck's of their forebears in excluding the obvious insignia of rank, to cast each sitter as contemplative men of sensibility. Decorum is maintained in other ways besides. The darkness of the colouring reinforces it. The Van Dyck costume worn by each intimates a continuum with the past, linking them to their ancestors, with Charles Howard in particular leaning against a grand column about which a curtain swirls, to recall the conventions of aristocratic portraiture. Bernard, his successor, is absolutely modern in displaying his sensibility by being alone in nature, which perhaps tells us that extreme refinement was a given in great aristocratic families: effectively a timeless attribute. The portraits further confirm the dynastic health of a great Catholic family.

Sensibility is hedged round in various ways, to permit it to confirm rank. This is additionally done through posture, for each sitter is posed with insouciant ease. This is important, for 'by the middle of the century [manners] have become, more blatantly than before, a matter of precise calculation and exhuastive cultivation . . . seen as an embodiment of social and gender authority'.[60] And this is closely tied up with sensibility, for it is manifested by the body, either in its reaction to some affecting sight, or through a properly natural posture.[61] Hence, in *The Placid Man* Charles Jenner has his hero, Beville, tell an affecting tale to a Miss Clayton (incidentally at the Assembly Rooms at Bath), to which she drops a tear, and Beville 'did more than see that tear, he felt it'. The exquisitely *sensible* Miss Clayton's facial beauty, we are then told, was 'heightened by an animated sensibility in her aspect, which shewed at one glance the excellence of her heart and understanding. She was graceful and commanding in her air, and with the greatest ease and affability in her manner, possessed at the same time that dignity of character which keeps impertinence at a distance.'[62] Like Gainsborough's representations of Mary, Countess Howe (pl. 287) or the Hon. Frances Duncombe (pl. 288), this is a model of decorum. In this there appears to be a concordance between men and women; the poses of both Countess Howe and the twelfth Duke of Norfolk (and, for that matter, the subject of *The Blue Boy*) mirror that of Captain William Wade (pl. 247), whose portrait Gainsborough exhibited at the 1771 Royal Academy. Splendid in 'a red silk suit and a waistcoat of gold satin embroidered in multi-coloured silk', Wade, who as Master of Ceremonies at Bath had to be consummately polite, is posed to show it. Hogarth wrote how 'people of rank and fortune generally excel their originals, the dancing-masters, in easy behaviour and unaffected grace; as a sense of superiority makes them act without constraint, especially when their persons are well turn'd'.[63] He demonstrated this opinion with the print of *The Country Dance* (pl. 38).

Politeness and sensibility could be expressed comparably because of a necessity to constrain the latter. Vicesimus Knox explained why. While 'extreme delicacy of sentiment . . . is become universally prevalent', and 'adds greatly to the happiness of mankind by diffusing an universal benevolence', and must therefore be approved, there was one potential danger. It might lead to an 'effeminacy of mind, which may disqualify us for vigorous pursuits and manly exertions'.[64] Sensibility *in extremis* might turn society effeminate, which was in any case a danger with the indolence and vice which were companions of the luxury that a flourishing commercial society brought in its wake. It was only possible to be a person of sensibility if you had the time to spare. Thus, the very similar poses of Captain Wade and Countess Howe point to the dangerously narrow dividing line between efortless elegance and effeminacy. That line was virtually crossed with Wright's portrait of Brooke Boothby (pl. 248). Boothby qualifies under Knox's terms as the essential man of sentiment. He rests contemplatively on the side of a brook (or in French, *ruisseau*) having been reading Rousseau, invoking what Thomson terms 'bold fancy' amongst the 'haunts of meditation'.[65]

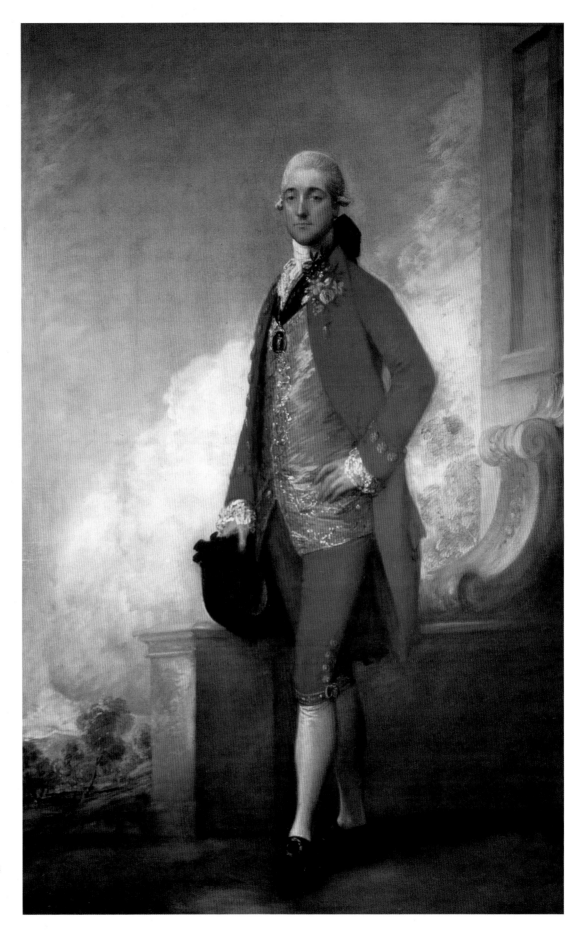

247 *Captain William Wade*, 1771, oil on canvas, 2,310 × 1,490 (91 × 51). Victoria Art Gallery, Bath and North East Somerset Council.

Joseph Wright, *Brooke Boothby*, 1781, oil on canvas, 1,486 × 2,976 (58^1/$_2$ × 81^3/$_4$). London, Tate Gallery.

Boothby is presumably thinking on Rousseau's ideas, and yet, as has been pointed out, in so doing is sliding close to the effeminacy of the man of feeling whom Mackenzie characterised as tending to stretch out besides rivers, as his pose and figure recall those of numerous Venetian Venuses.[66]

Boothby is perhaps rescued by the sober plainness of his garb. But the dangers of excess are none the less apparent, and these were recognised as an unfortunate side-effect in particular of sentiment when it was affected. Mrs Chapone wrote how 'Nothing so effectually defeats its own ends . . . for though warm affections and tender feelings are beyond measure amiable and charming when perfectly natural, and kept under the due control of reason and principle, yet nothing is so truly disgusting as the affectation of them.'[67] Knox concurred: 'The affectation of great sensibility . . . is . . . as odious as the reality is amiable', and, often, hypocritical besides.[68] In light of these reservations, we might compare Gainsborough's portrait of his brother Humphry (pl. 249) with his near contemporary rendering of the actor and playwright George Colman (pl. 149). Helped by a real sobriety of colouring, the painter directs attention to Humphry's head by means of highlighting and presents him in the way of a saint receiving inspiration in a sixteenth- or seventeenth-century painting. Proprieties are preserved. With Colman the paint is so unfixed as to suggest overreaction, features appearing virtually in a state of dissolution; an instructive contrast here would be with the regular and disciplined features of Carl Friedrich Abel (pl. 85), who is surely just as inspired as he composes music. With the Colman portrait one might suspect a slippage towards affectation, perhaps countered by the private character of the portrait (to assess which it is necessary only to imagine it alongside those of the Dukes of Norfolk). In picturing sensibility numerous checks and balances had to be built into the imagery, and it is essential too that we suspend our own disbelief.

Such a suspension of disbelief was notably demanded by two portraits: *The Linley Sisters* (pl. 176), exhibited at the 1772 Royal Academy; and *Mrs Sheridan* (as Elizabeth Linley became) of 1786 (pl. 251). Both show what we might expect never to see, although they

249 *The Reverend Humphry Gainsborough,* *c.*1770–74, oil on canvas, 595 × 495 (23$\frac{1}{2}$ × 19$\frac{1}{2}$). New Haven, Yale Center for British Art, Paul Mellon Collection.

accord with how characters in sentimental fiction might behave. In the first the heads appear too large for their bodies, and Mary Linley fixes the spectator with an intense stare. Exquisite sensibility is intimated through the painting of silence, and consequently, of muted contemplation; the glorious harmony of voices and guitar are dormant, but reside pictorially in the blue and gold costumes. Elizabeth Linley who displays an affectionate modesty of deportment, resting on her sister's shoulder, registers her conformity with approved modes of behaviour, for Fanny Burney found her at this time 'really beautiful', possessed of 'most bewitching eyes' while 'her Carriage is modest and unassuming, and her Countenance indicates diffidence, and a strong desire of pleasing, a desire in which she can never be disappointed'.[69] The later portrait shows Elizabeth almost absorbed into, become part of the natural order, as her hair follows the fall of the foliage, and her body is shaped into the landscape, the white, blue and gold of her costume picked up in the clouds and sunset sky to intimate that she is a creature of the wind and air.

We need to suspend our disbelief if we are to take this apparition for a representation of the element of play-acting that sensibility called for. Commerce, wrote Vicesimus Knox, 'gives the moderns an opportuity of acquiring opulence without much difficulty or danger; and the infinite numbers who inherit this opulence, in order to pass away life with ease, have recourse to the various arts of exciting pleasure.' The real dangers of these 'arts of exciting pleasure' were mitigated by the fact that this opulence also offered the opportunity 'to humanize the heart and refine the sentiments', so that, assuming that everybody grasped this opportunity, civilisation would progressively advance.[70] Yet sensibility, in which innate morality manifested itself as emotional reaction, was for that very reason extremely problematic. It was one way of accounting for the world as it was, but in this it had necessarily to allow for the pluralism one might expect from people reacting to their private responses. Creating art within the idiom of sensibility enabled Gainsborough to maintain a modernity such as underlay his split with Reynolds, but when we come to examine some of the consequences of that, we confront the paradox of its demonstrating an aesthetic unfixedness which undermined the feasibility of any art with such pretensions to contemporary universality.

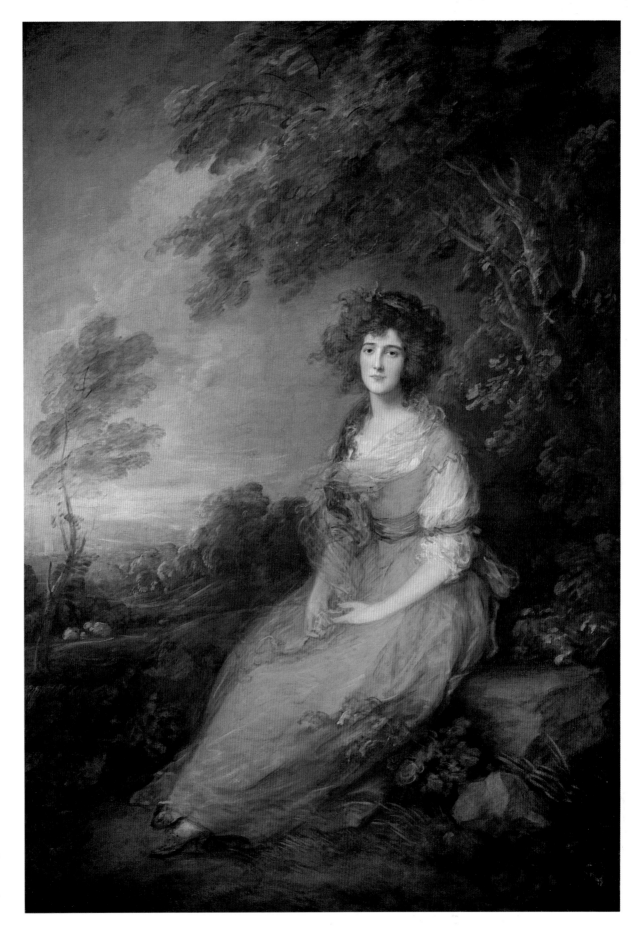

250 (*facing page*) Detail of pl. 176.

251 *Mrs Sheridan*, 1785–86, oil on canvas, 2,197 × 1,537 (86¹/₂ × 60¹/₂). Washington, National Gallery of Art, Andrew W. Mellon Collection.

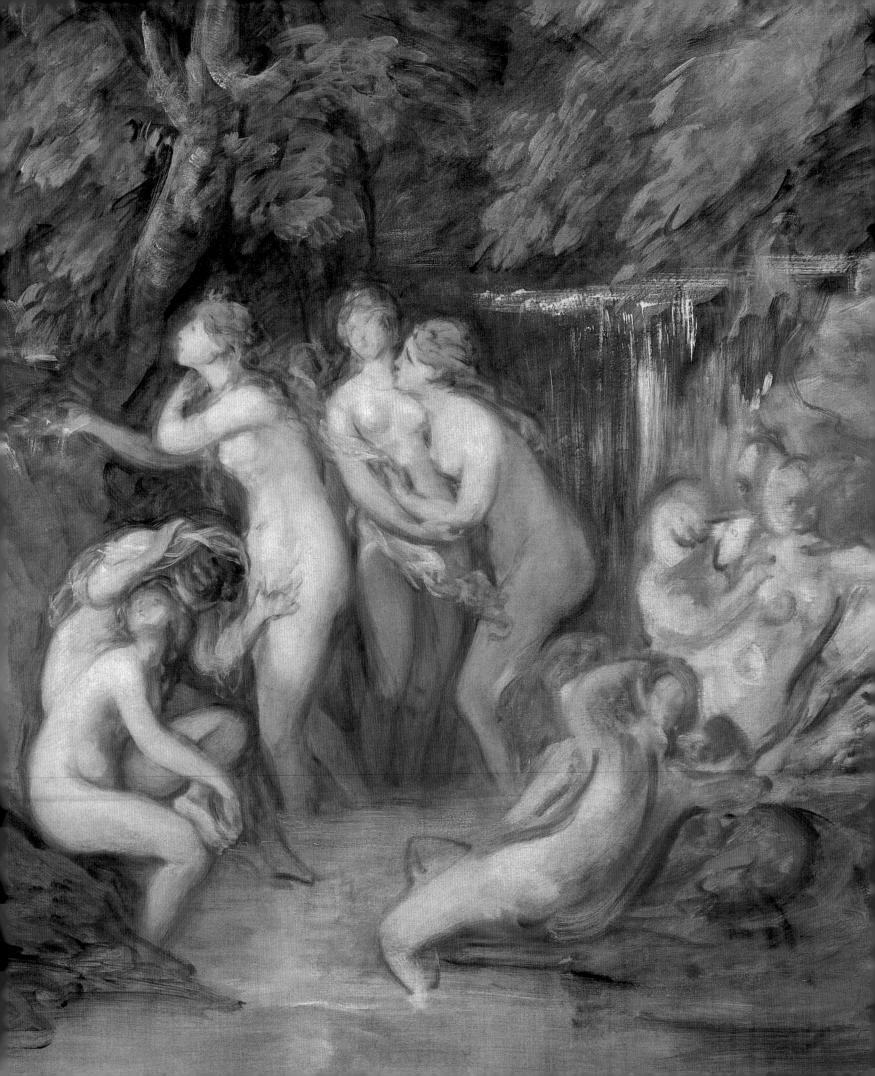

10 *The Meanings of Art*

THE PERSON OF SENSIBILITY COULD BE MOVED by the most insignificant as well as the most dramatic of incidents: the sight of a worm in agony, the prospect of a deserted village. There were no hierarchies in this morality, as it was precisely because a person was sensible of the smaller that they would react appropriately to the larger. As Charles Jenner wrote, the 'great actions of great statesmen, or great heroes, upon which revolutions of states depend, are not very likely to excite the curiosity, or influence the conduct of private peoples'; rather it was 'a certain elevation of mind alone, a sensibility of what is great and good, a comprehensive view of what is desirable or contemptible, which sets a man above the common level, and shows him everything in its true light'. A man may be a hero, but what matters is that quality of intellect that inspires him to become one, and which, under different circumstances, might fit him to be an exemplary civilian. Reynolds casts Colonel St. Leger in the role of military hero, something to be praised, but an incidental to his exemplary character, not a signifier of it. Gainsborough shows him as a gentleman of proper comportment and therefore virtuous. This is an epistemology that does not allow for hierarchies of genres as Reynolds constructs them, but instead puts in place a ranking which is ordered according to refinement and delicacy of feeling, and which consequently allows social distinctions to remain, even if artistic ones are collapsed.

It is indicative of this that Gainsborough was not much concerned with the propriety of media, even going so far as to travesty them with the drawings in imitation of oil paintings which he exhibited in 1772 (pl. 73). We can assess the significance of this through the eighth *Discourse*, which Reynolds delivered in December 1778. He appeared to moderate his loyalty to the rules of art, on the grounds that the audience was now sufficiently mature to be permitted its own judgement. He confessed that his strictures against the ornamental style might have left people with 'an impression too contemptuous', but he had 'said then, what I thought it was right at that time to say', admitting that our 'taste has a kind of sensuality about it', and that there are 'some rules whose absolute authority . . . continues no longer than we are in a state of childhood'.[1] He went on to speak of successful instances of artistic extemporisation in Veronese, or in Rubens, who had painted a convincing moonlight despite having 'diffused more light over the picture than is in nature'.[2] This is not, however, to dispense with rules, but to display their 'reason' to 'the Artist to clear his mind from a perplexed variety of rules and their exceptions, by directing his attention to an intimate acquaintance with the passions and affections of the mind, from which all rules arise, and to which they are all referable.'[3] When it came to 'the passions and affections of the mind', Reynolds had pronounced in the seventh *Discourse* that 'We may suppose a uniformity and conclude that the same effect will be produced by the same cause in the minds of others'.[4]

For Reynolds this 'uniformity' confirms the probability of there being rules of art which create hierarchies of genres, privilege line over colour, and, eventually, allow for immutable truths. Towards the end of the eighth *Discourse* he is extremely interesting on how painting's material display of subjects leaves little scope 'for exciting those powers over the imagination which make so very considerable and refined a part of poetry', for such definitive representation leaves nothing for the imagination to supply. The exception, he writes, is sketches, where the beholder's share in completing the image can supply 'more than the painter himself, probably, could produce'.[5] He concludes, however, with a warning:

253 *Study for Landscape with Cattle passing over a Bridge*, c.1780–81, black chalk and stump and white chalk, with grey and grey-black washes, 276 × 337 (10⁷/₈ × 13¹/₄). London, Courtauld Gallery.

> We cannot on this occasion, nor indeed on any other, recommend an undeterminate manner, or vague ideas of any kind, in a complete and finished picture. This notion, therefore, of leaving any thing to the imagination, opposes a very fixed and indispensable rule in our art – that every thing shall be carefully and distinctly expressed, as if the painter knew, with correctness and precision, the exact form and character of whatever is introduced into the picture.[6]

He reiterates that the artist has a public responsibility to make unambiguously visible the ideas that make up the common culture of a society.

When it came to elaborating upon the pleasures of looking at sketches, Reynolds was saying nothing very new. De Piles had expressed similar sentiments: 'Designs that are but just touch'd, and not finish'd, have more spirit, and please more, than those that are perfected, provided their character be good, and they put the idea of the spectator in a good way. The reason is, that the imagination supplies all the parts that are wanting, or are not finish'd, and each man sees it according to his own Gout.' He allowed such works a higher place than did Reynolds, for he advanced the view that they 'denote best the character of the master, and shew if his genius be lively or heavy, if his thoughts are elevated or common', because they are conformable with the essential nature of an artist's work. The 'designs of excellent masters, who join solidity to a fine genius, lose nothing by being finished'.[7] To write that they 'lose nothing' by being finished is to argue for sketches being a more immediate or essential expression of artistic ideas, and the difficulty to lie in retaining this aspect as they are worked up or translated into other media. According to this view, the ideal spectators of art are the community of the polite, bound together by the imagination which understands the essence of painting to lie in the facility and skill with which the image is realised. Sketches and drawings are not subservient but different to paintings. This exhibits

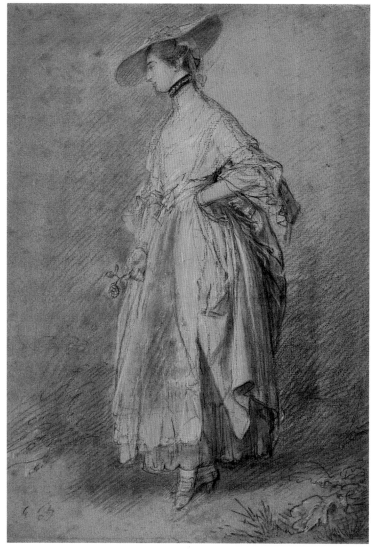

254 (*above left*) *A Woman seated in a Landscape*, early 1760s, pencil and black chalk, 352 × 254 (13⁷/₈ × 10). New York, Frick Collection.

255 (*above right*) *A Woman with a Rose*, *c.*1763–65, black chalk and stump on greenish-buff paper, 466 × 330 (18¹⁵/₁₆ × 13). London, British Museum (BM 1855-7-14-70).

an interesting contradiction. To some this parity will manifest the homogeneity of polite culture; to others its very blurring of proprieties must signal potential breakdown. Certainly something like the latter case may be made out for the way in which Gainsborough worked, for his art, while in one light presuming to conform to a standard of taste, in another does no such thing.

So, in line with de Piles, we discover Thomas Gainsborough representing similar subjects in varieties of media. Sometimes, of course, this will be because a drawing serves as a study for a painting, as with *Miss Ford* (pls 161, 166, 167), or the wash drawing up from which the scene of cattle being driven across a bridge in an oval landscape was extemporised (pl. 253). At other times the connection is more generic. A fine drawing of a woman seated cross-legged resting her cheek on her hand in a landscape relates to *Miss Ford*, but cannot be her for there is no common likeness (pl. 254). A slightly later drawing of an elegant woman thinking, resting an elbow on a plinth (Pierpont Morgan Library, New York), may represent a stage in that graphic contemplation on the concept of the cogitating woman, given its more public representation in oil paintings. Likewise, a study of a woman walking in a meadow (pl. 255) echoes the theme of *Mary, Countess Howe*, even down to the hand on the hip. Her holding a rose makes a connection with other portraits, although the profile view of a head looking away and down argues against this being a preparatory drawing. Rather,

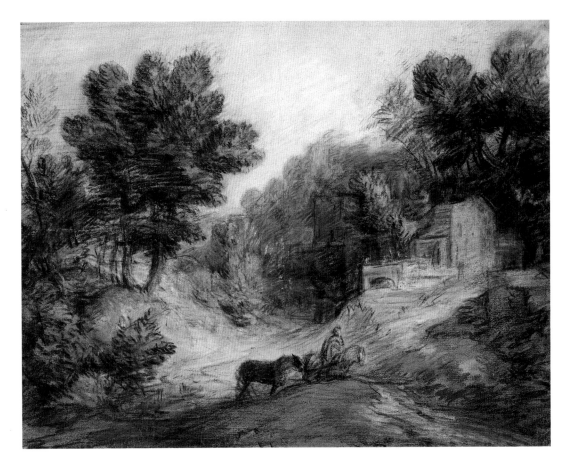

256 *Wooded Landscape with Herdsman
and Buildings*, c.1776–78, black chalk
and stump, white and coloured
chalks on blue paper, 313 × 403
(12¼ × 15⁷⁄₈). Birmingham Museum
and Art Gallery.

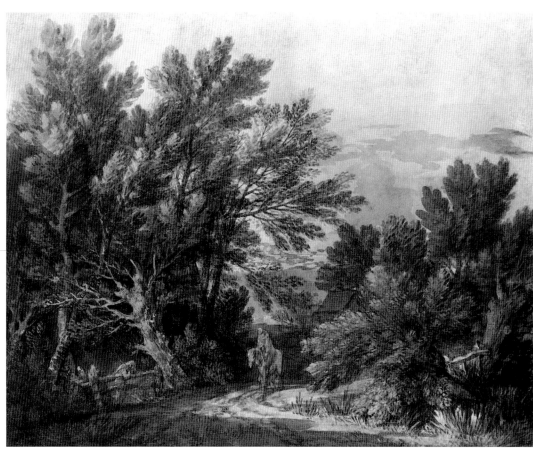

257 *Wooded Landscape with a
Horseman*, mid-1760s, watercolour and
bodycolour over pencil, 240 × 308
(9⁷⁄₁₆ × 12¹⁄₈). Toledo, Ohio, Toledo
Museum of Art, Museum Purchase.

258 *Landscape with a Horseman and Figures*, c.1783, black and brown chalks, grey and brown washes, and oil on white paper, varnished, 221 × 305 (8¹¹/₁₆ × 12). London, Courtauld Gallery.

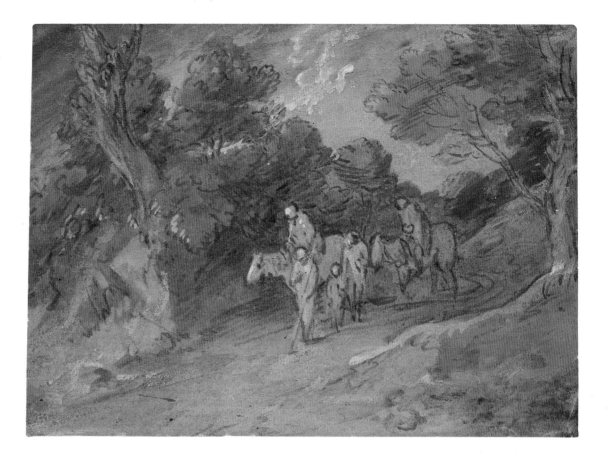

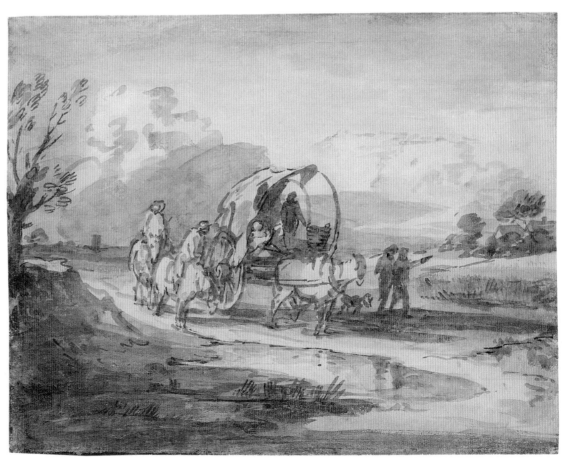

259 *Open Landscape with Herdsmen and Covered Cart*, c.1780–85, grey and black wash, with traces of black and white chalk on laid paper, 271 × 356 (10¹¹/₁₆ × 14). New Haven, Yale Center for British Art, Paul Mellon Collection.

it is displaying refined technique, with the chalk variously hatched and smudged, the diaphanous character of the apron hinted at through meticulous marks in white, the greenish paper adding a further chromatic variation, to allow the study its own life as an independent exercise in a figure type which can be additionally used for portraits.

Gainsborough drew those things to which he felt attracted, so there are far fewer independent studies of men. There are drawings of the poor which might be set against their counterparts in his paintings (pl. 260), and numerous landscapes of the sort we know he would spend evenings engaged in creating (pls 256–59). Some, as we have seen, connect directly with paintings, while others develop themes generically; for one drawing related to the *Cottage Door* in Cincinatti, there are many unspecified cottage scenes.[8] The landscape drawings survive in large numbers, and William Jackson made an interesting assessment of them: 'No man ever possessed methods so various in producing effect, and all excellent – his washy, hatching style, was here in its proper element. The subject which is scarce enough, for a picture, is sufficient for a drawing, and the hasty loose handling, which is painting is poor, is rich in a transparent wash of bistre and Indian ink.'[9] This not only recognised the extraordinary technical sophistication of these drawings, in which we will see various media worked over coloured papers and then varnished to get maximum effect, details of which were communicated by Gainsborough to Jackson in 1773 with the injunction, 'Swear now never to impart my secret to any one living', but also shows Jackson to have been discomfited by Gainsborough's use of media.[10] For if we read 'hasty loose handling' alongside his censure of Gainsborough's second manner in oil paint as 'an extravagant looseness of pencilling, which, though reprehensible, none but a great master can possess', we are reminded that aesthetic was also social probity, and the tensions inherent in Jackson's language derive from this.[11] The gulf between the two men is clearly apparent from Gainsborough's response to the death of Carl Friedrich Abel in June 1787 – 'I shall never cease looking up to heaven . . . in hopes of getting one more glance of the man I loved from the moment I heard him touch the string. Poor Abel!' – compared with Jackson's complaining of Gainsborough in 1778, that had he 'been properly educated and connected, he would have been one of the first that ever lived. He has given Abel as many Pictures and Drawings as are worth some hundreds of Pounds, and he in return has taught him to drink himself into a premature blind Old-Age.'[12]

If we return to the drawings, we discover what Jackson recognised. There is a congruity of subject-matter across all media, and astonishing effects are achieved. These range from landscapes in which watercolour and bodycolour are worked over pencil underdrawing to create scenes quite as complex in the management of their components and the communication of silhouette and volume as anything the artist managed in oil (pl. 257). Against this one might put translucent wash drawings of scenes of those mounted figures which we have seen in oil paintings as articulating an aesthetic opposing the consequences of agrarian capitalism. This inverts the convention, as expressed by Reynolds, according to which the painting represents the fully realised idea, and the drawing the first thought, for here all is expressed by a minimalist formal vocabulary. As de Piles wrote, 'sketches shew us further what touches great masters make use of to characterize things with a few strokes'[13] Gainsborough's drawings show great variety, from sketches of a musical party (pl. 261), deftly realised in red chalk, to a sheet of studies of a cat sleeping, cleaning itself, and stretching (pl. 262). Rather than serve as preparations for oil paintings, they go in tandem with them, so that mixed media pictures of carts going down wooded lanes (pl. 259) are complementary to compositions such as *The Harvest Wagon*; and later drawings of poor children gathering bundles of twigs (pl. 260) match comparable paintings.

Gainsborough was as dextrous with chalk as oil paint. The drawings communicate something of the compulsiveness motivating the working through, the repetition, of particular motifs. Here he could engage in significant experimentation. Henry Angelo gave a virtually parodic account of his methods:

instead of using crayons, brushes, or chalks, he adopted for painting tools his fingers and bits of sponge . . . one evening . . . he seized the sugar tongs, and found them so obviously designed by the genii of art for the express purpose, that sugar-tongs at Bath were soon raised two hundred per cent.

He had all the kitchen saucers in requisition; these were filled with warm and cold tints, and, dipping the sponges in these, he mopped away on cartridge paper, thus preparing the masses, or general contours and effects; and drying them by the fire (for he was as impatient as a spoiled child waiting for a new toy), he touched them into character, with black, red, and white chalks.

Some of these moppings, and grubbings, and hatchings, wherein he had taken unusual pains, are such emanations of genius and picturesque feeling, as no artist perhaps ever conceived, and certainly such as no one ever surpassed.[14]

In fact, as the artist revealed in a letter of 1773 to William Jackson, he was considerably more systematic about setting about drawings, which, as we have seen, were sufficiently technically complex to pass muster as imitations of oil paintings at the 1772 Royal Academy exhibition. The process involved pasting a sheet of blotting paper together with a sheet of drawing paper, stretching this according to an elaborate system, and then sketching in the composition with indian ink and chalk. This was fixed by dipping in skimmed milk, with the process being repeated until the general effect was achieved, when colours were added. After this the drawing was to be floated 'all over with Gum water, 3 ounces of Gum Arabic to a pint of water with a Camels pencil', after which it was to be dried, and given three coats of varnish. As noted earlier, Gainsborough ended this letter: 'Swear now never to impart my secret to any one living.'[15] If drawings were aspiring to the condition of

261 *A Music Party*, c.1770, red chalk and stump, 241 × 324 (9¹⁄₂ × 12³⁄₄). London, British Museum.

262 *Studies of a Cat*, mid-1760s, black chalk and stump, white chalk on buff paper, 332 × 459 (13¹⁄₁₆ × 18¹⁄₁₆). Amsterdam, Rijksmuseum.

paintings, then the reverse could also obtain. Gainsborough's daughter Margaret recalled how 'his colours were very liquid, and if he did not hold the palette right would run over'.[16] This is conformable with the practice of a technical experimenter, who liked to paint portraits onto loosely stretched canvases under very little light, and who is credited with using brushes six feet long.[17]

This is apparent too when we consider some of the paintings on glass that he made for what has been termed his 'peep-show box': a device which Gainsborough invented around 1781, in which glass plates would be fitted into slats within the box, lit from behind by a row of candles, and viewed through an aperture, magnified by a lens (pl. 263). As with the drawings, the subjects tended to be those of paintings: drovers with cattle, coastal scenes (pls 264, 265). Yet there are exceptions. Cottage scenes are hardly unusual, but here Gainsborough was able to represent one under moonlight with its own light shining through the windows, effects that could not have been achieved through conventional oil painting.

263 Gainsborough's show box, London, Victoria and Albert Museum.

264 (*below left*) *Cottage Scene by Night*, c.1781–82, transparency on glass, 279 × 337 (11 × 13¼). London, Victoria and Albert Museum.

265 (*below right*) *Coastal Scene*, c.1783, transparency on glass, 279 × 337 (11 × 13¼). London, Victoria and Albert Museum.

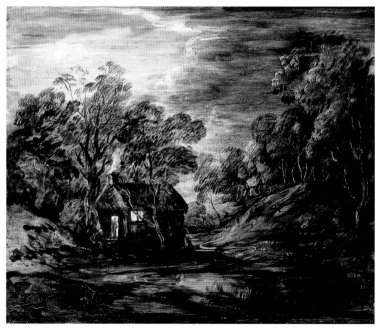

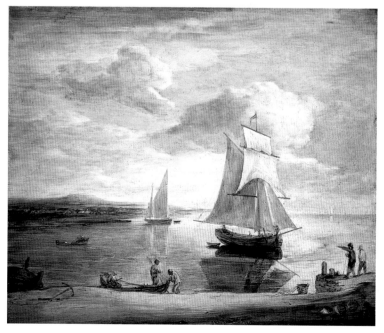

257

266 (*facing page top*) *Wooded Landscape with Three Cattle at a Pool*, mid-1780s, aquatint, 283 × 351 (11⅛ × 13¹³/₁₆). London, Tate Gallery.

While some have thought that the impetus behind this invention was an exhibition of transparencies, these were not new to him (as we saw, he made one himself, in 1775, for Bach and Abel's concert rooms), and it has been suggested that the inspiration may have been de Loutherbourg's Eidophusikon.[18] This was a show where the public was astonished by carefully managed successions of moving images reenacting particular events, under controlled but varying lighting and sound effects, and it may well have alerted Gainsborough to the possibilities for the fine arts in an age of technological invention. After all, Gainsborough's brother Jack was a crazed inventor, and his other brother, Humphry, was so successful as to win premiums from the Society of Arts, and to be cheated out his patent for a condenser for the steam engine by the calculating chicanery of James Watt.[19] None the less, if we recall the intense efforts he was making around this time to secure the effective hanging of his exhibition pictures, he would hardly have been appearing to envisage an expanded role for the fine arts; and the paintings on glass, to follow Hayes, may be considered in a comparable light with the drawings.

It is evident that Gainsborough enjoyed experimentation, which was, as Wright's pictures of scientific demonstrations show (pls 16, 242), a popular amusement of the period. Before painting onto glass, he had shown a keen interest in the new printmaking techniques of aquatinting and soft-ground etching.[20] As Anthony Griffiths points out, the history of these techniques is obscure, and this makes the establishing of a chronology for Gainsborough's prints problematic. Aquatint was invented in France between c.1757 and c.1762 and Gainsborough prefered to use the sugar-lift method, in which the porous ground of the plate 'was covered in stopping-out varnish and the subject . . . brushed in with a solution composed of sugar and Indian ink; the design was revealed on the plate when the solution was lifted off after immersion in water'.[21] This allowed for more immediate and painterly approaches to printmaking (pls 266, 267), which would have appealed to Gainsborough, who, as we saw, was wearied so much of the work required in etching the plate he supplied for *Dr Brooke Taylor's Perspective made Easy* that J. Smith had to finish it for him. It seems most likely that he learned the technique (which had been imported into England by Peter Perez Burdett) some time around 1775, from Paul Sandby. Sandby himself introduced soft-ground etching. Here, the plate is covered in a soft wax and paper laid over this, and the drawing made onto the paper, so that, when lifted, it takes the wax with it, and the plate can then be bitten. As Sandby wrote, 'it saves all the trouble of Etching with a Needle, and will produce an outline like fine Indian chalk'.[22] Gainsborough liked to combine both techniques, to create prints which, in their management of tonal areas and deployment of rough line came close to being surrogates for his actual watercolours and drawings, particularly when printed on to the coloured papers which he preferred.

In one respect there was nothing very novel in this, for there was a respectable tradition of prints in imitation of drawings. Arthur Pond and George Knapton had attempted to produce such facsimiles in the 1730s, but aquatint and soft ground would prove to be far more effective in mimicking washes and line.[23] Gainsborough had become technically deft enough to contemplate publishing soft-ground etchings in 1780, for three prints have a publishing line at their bottom, although the artist seems never to have taken the final step (pls 268–70).[24] John Hayes has remarked on the care Gainsborough took over selecting the paper for what was evidently planned as a series, and remarks on how the 'result is a perfect equivalent of the . . . black chalk drawings' that he was making at the time.[25] It goes farther than this, though. Because Gainsborough printed on to the same coloured papers as those he used for actual drawings, the result is to produce works which are very easily mistaken for such drawings.

267 (*facing page bottom*) *Wooded Landscape with Cows beside a Pool, Figures, and Cottage*, mid- to late 1770s, soft-ground etching with aquatint. Ipswich Borough Council Museums and Galleries.

He used this ambiguous technique to realise three separate classes of landscape. One print (pl. 268) represents a procession of carts and figures going down a track in a mountainous country, past a rock and trees, the composition coming very close to that of both *Harvest Wagons* (pls 214, 216). Another, again set in mountainous country, has a figure leaning on

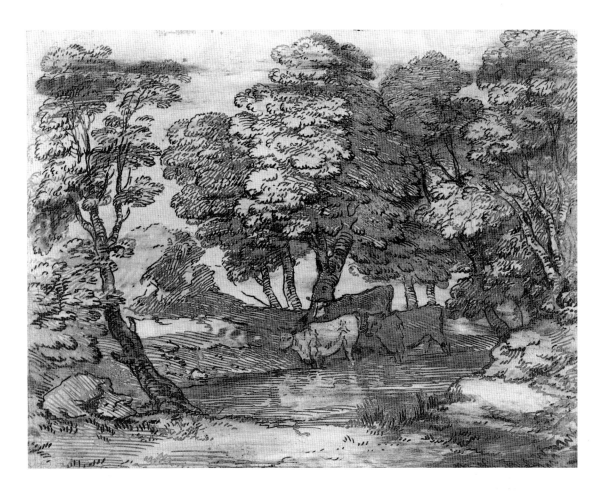

268 *Wooded Landscape with Carts and Figures*, 1779–80, soft-ground etching, on blue laid paper, 302 × 394 (11⁷⁄₈ × 15¹⁄₂). New Haven, Yale Center for British Art, Paul Mellon Collection.

a stick, to contemplate a tombstone in the graveyard of a ruinous church (pl. 269). The third is a version of that oil painting where cattle and a mounted drover pass over a bridge spanning a lively stream in a wooded terrain (pl. 270). Each makes references to other art. The idea upon which Gainsborough elaborated in the first was developed from the Rubens *Watering Place* (pl. 191) which he implored Garrick to go and see, and then assimilated into his own art. The oil painting from which he developed the image of cattle passing over a bridge was, as we saw, reputedly given to Oldfield Bowles in exchange for a violin (pl. 97), and was worked out through at least two drawings, which blurs the boundaries between original and copy and suggests that it is the subject that matters, not the medium in which it has been realised. The landscape, which John Hayes has seen in terms of Fragonard and Hubert Robert, also appears to amalgamate the Claudean with the Italianate scenes of Berchem. The third print has as its ancestor Poussin's *Et in Arcadia Ego*, and improvises upon a theme laid down in an oil painting exhibited in 1780. Now known from Maria Prestal's print (pl. 271), it portrayed a youth and a girl kneeling to inspect a headstone in a country

269 *Churchyard, with Figure contemplating Tomb-stone*, 1779–80, soft-ground etching on blue laid paper, 303 × 394 (11⁷/₈ × 15¹/₂). New Haven, Yale Center for British Art, Paul Mellon Collection.

churchyard, and when published in 1791 had the first sixteen lines of Gray's 'Elegy' for letterpress.[26] That connection is made in the soft-ground (which effectively replicates a chalk drawing) for the contemplative figure has, as we saw, come from one of Bentley's 1753 illustrations to Gray (pl. 185) (and was later adapted to *The Woodman* (pl. 186)), and the implicit intellectual presence of the poet may be one reason for the line of the ridge calling to mind the profile of Langdale Pikes in the Lake District. As he was on the point of setting off on a tour there in 1783, the artist wrote to a Kew friend, William Pearce, that he proposed 'when I come back to show you your Grays and Dr Brownes were tawdry fan-Painters'.[27]

The imagery in all three prints has a radical link to a respectable group of seventeenth-century artists, integrated into the *oeuvre* of a modern British painter, to show how tradition can be maintained and developed. They confirm Gainsborough's concern about his art and its ranking at this time. The publication lines indicate that he planned to make this point to the public. And he was going to do it through prints which without due attention would

easily be mistaken for drawings. This is momentous. While other artists, famously Rembrandt, had demonstrated their creative range in etchings, these were distinct from his work in oil. Gainsborough's soft grounds were equal and reciprocal versions of subjects that might otherwise be worked up in chalks, in washes, or in oil paint. Yet, if an artist wished to advertise his or her merits, they would, as we saw, usually resort to line engraving or mezzotint. The former, in particular, by abstracting the painterly into a linear medium allowed for the conception of a history of art in which images, however disparate, could be ranked and integrated precisely thorough their common pictorial language. This was not an option Gainsborough considered.[28]

His public display of his artistic capacities and his range as a landscape painter was to have been by means of the publication of prints which looked like drawings or sketches. They would ideally have been kept in portfolios and, perhaps, looked over of an evening (as against being pasted onto the walls of rooms, as many prints were destined to be). And, as I have indicated, they contain profound content, the obligation to contemplate death in the midst

262

271 Maria Prestal after Thomas Gainsborough, *The Country Churchyard*, 1790, aquatint, 491 × 648 (19^5/$_{16}$ × 25^1/$_2$). Sudbury, Gainsborough's House.

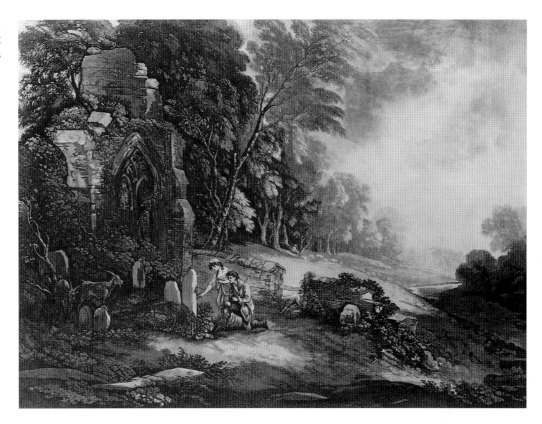

of happiness, ideas of bucolic pastoral, conceptions of the ideal in landscape, of a kind more properly the province of public art, of oil paintings which might be hung on walls. These etchings were works of a type that Reynolds might allow as having the power to fire the imagination, but that could play no public role. To a person of sensibility, no such problems arose, and the proper place for the contemplation of moral landscape imagery would be in the house, where, in the grander apartments, oil paintings might communicate a similar ethos.

An interesting parallel here is with Alexander Cozens's *Various Species of Composition of Landscape in Nature*, upon which he was engaged in the early 1770s. These comprised a series of sixteen tiny etchings, on four sheets of paper, around 96 by 142 mm (pl. 272). Each represented, mainly by very broadly descriptive line with some shading, various kinds of generalised landscape, akin to Gainsborough's soft grounds. Cozens supplied a descriptive list to accompany each image, and, as Kim Sloan has shown, meant them to be used as educational aids, for he was possessed of a 'moral, improving intention'.[29] The spectator was 'supposed to be in a tranquil state of mind' when contemplating these landscapes, and they were meant to provoke trains of thought on various abstracted ideals – 'progression, Liberty', 'riches, commerce', or 'delight', amongst them.[30] Now these should be the province of a grand public art, not tiny etchings of scenery, and it is significant that Cozens found it legitimate to arrogate the dignity of high art to these images. The status of history painting itself was, of course, equivocal. Histories painted by Wright and by Dance, Cipriani, West and Kauffman, were done not as great schemes of decoration in public buildings, but often as easel paintings of a size proper for the embellishment of domestic interiors, to which they would contribute equally with paintings in other *genres*. Kauffman complicated the issue by being a female painter of histories, although this appeared not to discredit her. Reviewing the 1773 Royal Academy, the *Public Advertiser* wrote of West's *Agrippina, surrounded by her Children, weeping over the Ashes of Germanicus*, that it was 'well composed', and had 'great merit', but wanted 'that melancholy Cast, which would have drawn Tears of the Spectator',

The Various Species of Composition of Landscape, in Nature.

272 Alexander Cozens, *The Various Species of Landscape in Nature*, early 1770s, sixteen etchings on four sheets, each approx. 96 × 142 (3³⁄₄ × 5⁵⁄₈). London, British Museum.

while Kauffman's *Telemachus at the Court of Sparta* was 'well composed, well executed, and very expressive'.[31]

It is germane to this that when Barry attempted large-scale histories as a public art at the Society of Arts, the imagery was such as defied credulity – for one would not expect to find a half-submerged Captain Cook closely followed by Charles Burney propelling the vessel on which Father Thames reclines – and obscure enough to require a densely written pamphlet to assist visitors.[32] As history painting should communicate straightforwardly, this anomaly suggests that the subjects appropriate to the modern era were highly elusive. In light of this, the prints of Gainsborough or Cozens may be understood as constituting a rational response to the requirement for a moral art, but in a society in which the proper place for its spectating will be the private apartment rather than public gallery. In this wise, Gainsborough might be appearing to subvert the whole apparatus of traditional academic dogma, which would fit very well with his activities during the 1780s.

Shepherd Boys with Dogs Fighting (pl. 103), in combining the modern morality of Hogarth with the setting and colouring of Titian, evidently aspired to be a serious art existing in continuum with tradition, but speaking to its own generation. I earlier noticed its 'anti-pastoral'. Perhaps in representing so unnatural an event Gainsborough also had in mind the American War which had led to what some saw as a tragic internecine rift, to make this a kind of equivalent to history painting. His conception has the advantage over those grandiose picturings of contemporary heroics (an instance would be Copley's *Death of Major Pierson* (Tate Gallery, London)), in that it was not tied to the illustration of a specific event and therefore allowed the contemplation of the general issues we may still detect. Nor was it tainted through its having to be commercially exploited, by means of fee-paying exhibition and the sales of prints, to be viable at all, as Louise Lippincott has shown to be the case with much history painting of this time.[33]

If we follow this line, it appears that Gainsborough was concerned to deny the authority of the academic. There was an element of parody in rendering a theme of Poussin in a soft-ground etching of a country churchyard, and that is true, too, of the one mythological picture which he ever attempted, *Diana and Actaeon* (pl. 273), which we suppose to have been painted at some time in the mid-1780s.[34] It is hard to know why Gainsborough deviated so dramatically from his usual track, although some impetus might have come from Reynolds's praise for Titian in the eleventh *Discourse* of 1782, where he quoted Vasari's approbation and added his own, remarking his 'excellence with regard to colour, and light and shade', and how he knew 'how to mark the general image and character of whatever object he attempted' by a few strokes, before going on to extol the way that, in sketches, a 'dextrous facility . . . indicates the true power of the Painter, even though roughly executed'.[35] This must have seemed a fairly extraordinary turn-around, and perhaps West's sensational discovery in 1785 and purchase for £20 of what was imagined to be the original of Titian's *Death of Actaeon*, moved Gainsborough to try out Reynolds's version of the Titianesque on a Titianesque subject.[36] After the severance with the Royal Academy, he might have had the leisure to attempt the experiment.

Recalling Gainsborough's dismissal of history pictures as 'tragicomic', there is some irony in his attempting this one. He would have known the fable through Hogarth who had referred to it variously (pls 108, 282), and, according to Ronald Paulson, Gainsborough consulted Addison's translation of Ovid, which tells of Actaeon's happening upon Diana and her nymphs bathing, for which accident he gets turned into a stag and hunted and killed by his own hounds.[37] Hayman had painted the subject around 1760, but it was mainly associated with Italian artists – Titian of course, but at Devonshire House and Burlington House there were versions by Carlo Maratta and Sebastiano Ricci respectively.[38] As Gainsborough exhibited a portrait of the Duchess of Devonshire in 1783, he may have had access to the Maratta. In the event, he followed Reynolds's advice about borrowing from the masters and plundered various figures from particular works. The principal group was adapted from an

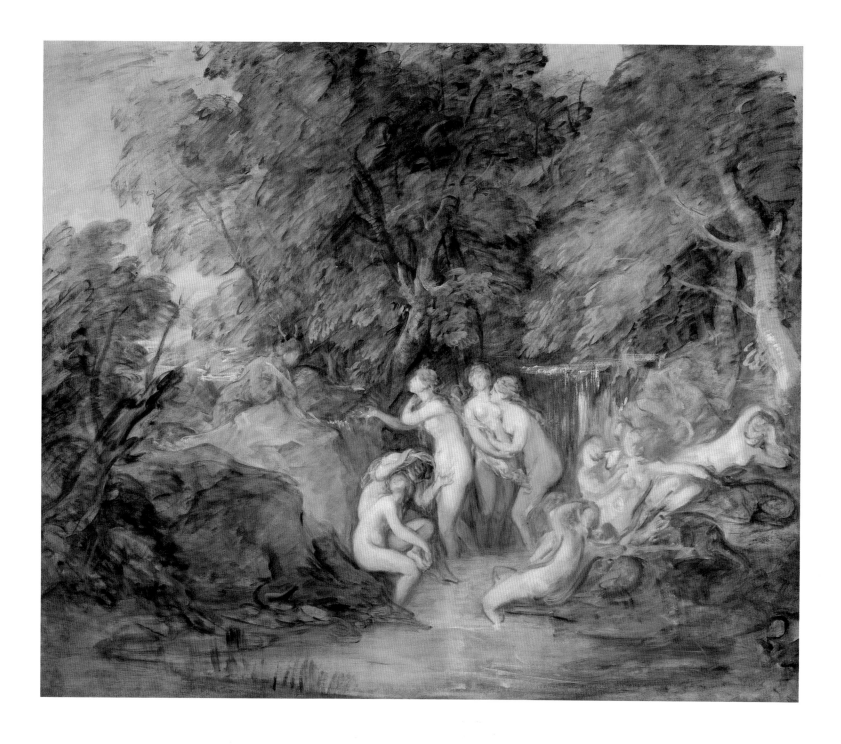

273 *Diana and Actaeon*, c.1785, oil on canvas, 1,581 × 1,880 (62½ × 74). The Royal Collection. © Her Majesty Queen Elizabeth II.

engraving of an antique relief of Diana and Actaeon reproduced by Spence (pl. 274) in *Polymetis* (which book Gainsborough possessed); the woman clutching her foot appeared in Claude's *Judgement of Paris*, and again in Watteau's *Diana Bathing* (pl. 275); while the reclining woman to the right is a version of a Venetian Venus. Gainsborough modelled his invention as a whole on Filippo Lauri's *Diana and Actaeon*, a print of which Woollett had published in 1764 (pl. 276).[39]

This 'poetical impossibility' was assembled from everywhere except life. And, it appears, Gainsborough was intent upon cocking a snook at the third Earl of Shaftesbury, who, in musing upon the problems of temporality in painting, had commended the history of Hercules as an ideal repository of incidents such as intimated the past and anticipated the future; thus the toddler Hercules could reveal the man through displays of freakish strength,

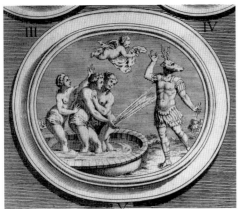

274 C. P. Boitard, *Diana and Actaeon*, from J. Spence, *Polymetis: or an Enquiry concerning the Agreement between the Works of the Ancient Poets and the Remains of Ancient Artists*, second ed., London, 1755, plate XIII.V. Oxford, Bodleian Library.

275 After Watteau, *Diana Bathing*, 1726 engraving.

276 William Woollett after Filippo Lauri, *Diana and Actaeon*, 1764, engraving. London, British Museum.

277 *Study for Diana and Actaeon*, c.1784–86, black chalk with grey and grey-black washes, heightened with white, on buff paper, 256 × 333 (10$^{1}/_{16}$ × 13$^{1}/_{8}$). Sudbury, Gainsborough's House.

as painted by Reynolds for the Empress of Russia in 1785.[40] The antithesis was supplied by the story of Actaeon, and Shaftesbury reserved particular censure for precisely the incident Gainsborough chose to paint, as demonstrating a lamentable disregard of the sanctity of unity of time and place. He explained that the 'Horns of Actaeon, which are the Effects of a Charm, sho'd naturally await the execution of that Act in which the Charm consists . . . But in the usual Design . . . the Horns are already *sprouted*, if not full grown; and the Goddess is seen watering the *sprouts*.'[41] Actaeon, exactly in this condition, cowers, arms crossed over his chest in a gesture which is either femininely protective, or mimicking that of the baptised Christ as seen in some paintings.[42]

Reynolds had spoken against 'an indeterminate manner, or vague ideas of any kind', and was anxious to separate out paintings from sketches. Here, three surviving preparatory drawings (pls 277–79) (which confirm, incidentally, that in the painting the waterfall was indeed an addition, painted wet over dry after Gainsborough had seen Lauri's print) are in a variety of media. They are almost as indeterminate as the painting, in which only the principal group is invested with any opacity – and even here features are barely indicated.[43] The figures

to the right are amazingly sketchy, with a reclining dog outlined only. There is therefore real parity between drawings and painting. At a near distance the latter breaks down into random marks and tonal accents, as the white of the waterfall is picked up in some of the flesh, or the pond. Focus fluctuates; so Actaeon, realised in earth colours, blends into, emerges from landscape. Because of this indistinctness the spectator has to engage actively in making the scene appear whole, fixing it as an illusion. Gainsborough specifies what this process involved by blocking the vanishing point with his principal group, who, in the way of Graces, variously display their charms. To supply what is missing – faces and eyes, nipples and pudenda – is to indulge in enticing play, to engage in imagination with what in an actual encounter would be for many men an intimate and sexually arousing experience. This looking is directed to no moral end, and perhaps the painting therefore contains its own censure.

It is significant, then, that Gainsborough's only other extant study of a naked woman is the composition called *Musidora* (Tate Gallery, London), said to have been painted from

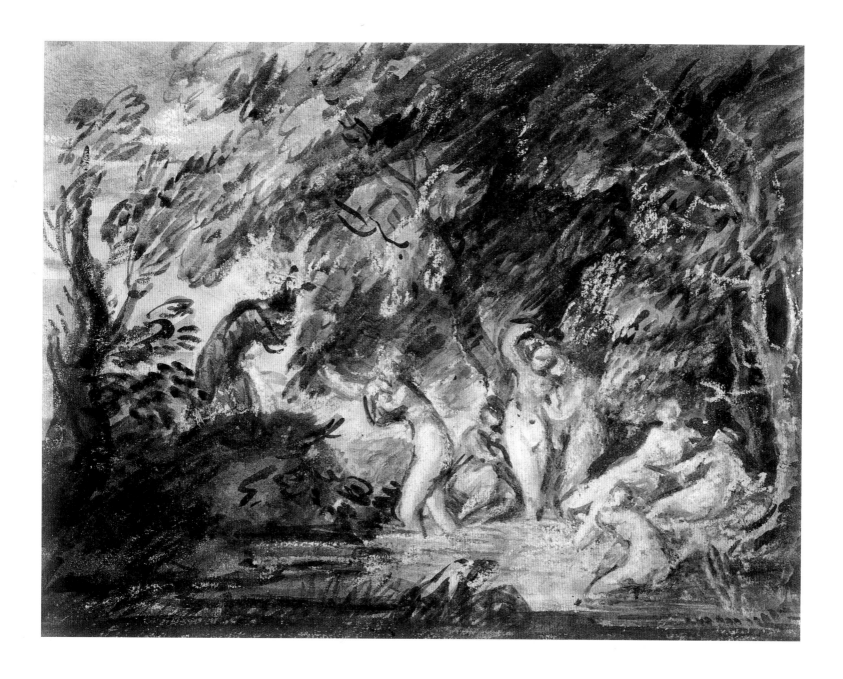

279 *Study for Diana and Actaeon*, *c.*1784–86, grey and grey-black washes, heightened in white chalk, on buff paper, 279 × 367 (11 × 14⁷/₁₆). Courtesy of the Huntington Library, Art Collections, and Botanical Gardens, San Marino, California.

Emma Hamilton.[44] Whether or not it was Gainsborough's, the title does expose the content of the image. In *The Seasons* Musidora was loved by Damon. Her 'bashfull coyness or . . . maiden pride', left him complaining of her cruelty. As Thomson tells the story, Damon was bemoaning his lot above a waterfall when she came to swim in the pool it fed. The poet describes what ensued.

> Meantime, this fairer nymph than ever blest
> Arcadian stream, with timid eye around
> The banks surveying, stripped her beauteous limbs
> To taste the lucid coolness of the flood.
> Ah! then not Paris on the piny top
> Of Ida panted stronger, when aside
> The rival goddesses the veil divine
> Cast unconfined, and gave him all their charms,
> Than, Damon, thou; as from the snowy leg

And slender foot the inverted silk she drew;
As the soft touch dissolved the virgin zone;
And through the parting robe, the alternate breast,
With youth wild-throbbing, on thy lawless gaze
In full luxuriance rose. ('Summer', ll. 1278, 1300–13)

Voyeurism gave a sexual thrill to Paris and Damon alike; and when Musidora discovers that she has been observed –

With wild surprise,
As if to marble struck, devoid of sense,
A stupid moment motionless she stood:
So stands the statue that enchants the world;
So, bending, tries to veil the matchless boast
The mingled beauties of exulting Greece. ('Summer', ll. 1344–49)

Thomson would be referring to the Medici Venus here, and exposing what we shall discover to have been an interesting confusion of stone with flesh.

Gainsborough reveals that any painting of naked women must be about voyeurism – he may have had in mind the *Death of Dido* Reynolds showed at the Royal Academy of 1781 (pl. 95). And this did cause a problem. In 1764 one critic thought a *Jupiter and Leda* 'caused chastity to blush and even Obscenity itself disowned it'.[45] In 1771 Barry's *Adam and Eve* had been censured for an 'insufficiency of drapery', whereas Barry himself argued that abstract beauty had of necessity to be represented by naked figures. They could not be censured as 'indecent and tending to lewdness', as 'a great mind can raise great and virtuous ideas'.[46] In the early 1780s it would have been easy to have been sceptical. One of the high points of 1782 was the trial between Sir Richard Worsley and his wife Seymour (whom Reynolds had exhibited in appropriate scarlet at the 1780 Royal Academy) for her adultery with a George Bisset. Horace Walpole summarised her defence in a letter to Horace Mann.

280 *Sir Richard Worse-than-Sly, Exposing his Wife's Bottom – O fye!*, 1782, engraving. London, British Museum.

she summoned thirty-four young men of the first quality to depose to having received her favours . . . but few of them were examined – and they blushed for her. A better defence for her was the connivance of her husband, who was proved to have carried one of the troop on his back to the house-top to view his fair spouse naked in the bath – the jury was as equitable as to give the plaintiff but one shilling in damages.[47]

281 *Lady Worsley dressing in the Bathing House*, 1782, engraving. London, British Museum.

The affidavit of the woman who kept the bath at Maidstone stated that 'the Plaintiff there had absolutely raised the Defendant upon his shoulders to view his naked Wife while bathing, and at the same time called to her, saying SEYMOUR! SEYMOUR! *Bisset is looking at you*' (pls 280, 281).[48] Amongst the various squibs which the affair inspired, one was dedicated to the Duchess of Grosvenor as an aristocratic whore, while others resorted to doggerel.[49] The verses from one read:

Without a blush I gave him time to gaze,
And set his youthful spirits in a blaze;
Not so chaste Dian by Actaeon seen,
What *I* exposed, *she* most contriv'd to screen.

This trope was repeated.[50] The caricaturists also had a field day, two of them showing Lady Worsley as a less than modest Venus de Medici, while in a third print, the picture on the wall depicts a naked woman in the pose of Gainsborough's *Musidora*.

The classical deities had long had a bawdy reputation, as we see from Hogarth's travesty of Diana and Actaeon in *Strolling Actresses dressing in a Barn* (pl. 282). The *Connoisseur* for May 1755 advertised a 'Scheme for a naked Masquerade', where the characters would be drawn from the '*Pantheon of the Heathen Gods, Ovid's Metamorphoses*, and *Titian's Prints*'. It

282 William Hogarth, *Strolling Actresses dressing in a Barn*, 1738, etching and engraving, 453 × 566 (17³/₄ × 22¹/₄). London, British Museum.

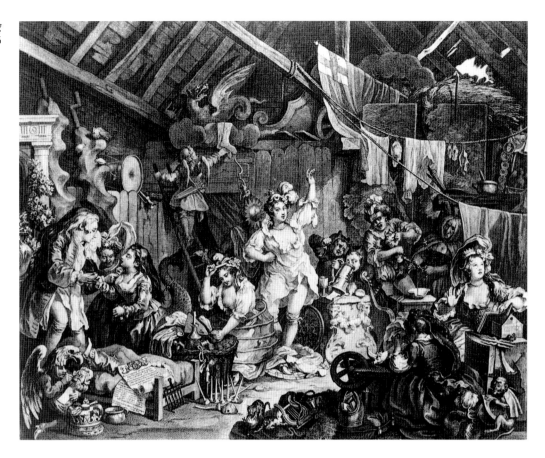

went on to advise readers that 'Three sisters, celebrated for their charms, design to appear together as the *Three Graces*: And a certain Lady of Quality, who most resembles the Goddess of Beauty, is now practising from a model of the noted statue of the *Venus de Medicis*, the most striking attitude for that character.'[51] This was not far from the truth. In 1749 Miss Chudleigh had appeared at a masquerade as Iphigenia 'so naked the High Priest might easily inspect the entrails of the victim'.[52] In 1775 a report of a masquerade at the Pantheon wrote of how the room was 'not entirely cleared of nymphs and bacchanals til nine or ten in the morning'.[53] If to this we add the information that classical statuary was itself regarded as morally dubious, Gainsborough's attempt at a mythology becomes even richer in its resonances.

In keeping with the status of the Royal Academy, copies after classical statues adorned the interior of Somerset House, where its exhibitions were held. In 1780 a copy after the Apollo Belvedere was complained of as being so well endowed as to be offensive to female modesty. In a letter addressed to Sir Joshua Reynolds, 'Peeping Tom' suggested that cabbage might substitute for fig leaves 'in the cause of decency'.[54] And the following year the complaints spread to Schomberg House, where Dr Graham was indicted 'for a nuisance, in exhibiting before his house in Pall-Mall, a number of naked figures', which we later discover to have been statues of female deities, and a subsequent notice linked Graham's affront with the Royal Academicians' laying 'before the public sight Venus Callipudia, whose indecent posture cannot but fully the imagination of every beholder' [*sic*].[55] While Gainsborough, whose visit to a little Venus rising up from the sea was noticed earlier, must have been vastly amused by all this, it does remind us that at that time the illusion of life in a statue does seem to have been unusually strong. Watteau's statues often seem half human, and Joseph Spence wrote of the Venus de Medici, 'One might very well . . . insist particularly on the beauty of the breasts, which in the statue itself are the finest that can be conceived. They

273

are small, distinct, and delicate to the highest degree; with a degree of softness much beyond what any one can conceive.'[56] Spence was fantasising about a statue as a woman; and he was doing this within the conventions of eighteenth-century conceptions of female beauty. 'A Physician' writes: 'Pliny asserts, what is known from experience, that the fish *esquadre*, applied to large hanging breasts, lessens them so much by its astringent quality, that they become like the breasts of a young virgin.'[57] In 1758 an Irish visitor to Italy first kissed the Venus de Medici 'as one would any piece of marble . . . but, upon my conscience I began to conceive it was real flesh and blood . . . I don't know what I should have done had not my sensual Reverie been interrupted.'[58] Later in the 1780s, Emma Hamilton bewitched Goethe with her 'attitudes', as she assumed the poses of classical sculptures, an 'image of beauty as a moving statue'.[59]

As in sculpture confusion between marble and flesh was so rife, Gainsborough painted *Diana and Actaeon* so as to expand that confusion. Although there are patches of blue and red to hint at colouring and Venice, this in some places is effectively painting as drawing, an impression augmenting his etymological anarchy, and, in itself, going some distance towards discrediting the notion of any academic canon. It shows up histories for what they are, and suggests that it is with the modern subjects that Gainsborough usually paints that art should be concerned. Around this time Gainsborough adapted the hounds who hunt in Titian's *Death of Actaeon* into three lurchers coursing a fox, as they more logically might do, to drive home the point.[60] One has to presume that his acute anxiety to have exhibition pictures displayed properly reflected a belief in their unique value. That is, these were to be contemplated as discrete works of art. The problem was, there was no apparent consensus about how to look and what to see. Newspapers carried contradictory reports; Reynolds changed his mind; portraits were successes to some and failures to others. Gainsborough's fastidiousness about the destination of landscapes betrays a recognition that, if they were going to work as he wished, they needed all the help they could get. Paintings were part of the furniture, after all. That was the problem in painting for people of excessive refinement.

In certain respects, the status of art at this time was extremely ambivalent. Reynolds painted *Mrs Hale as Euphrosyne* for the Music Room at Harewood House in 1764–66, producing a charming and learned invention to advertise the culture of his patron (pl. 137). It also confirms his taste in interior décor, for it fits neatly above the chimney piece, and the predominantly bronze, gold and blue colours chime harmoniously with those with which Adam was later to decorate the room (pl. 283). There must have been some consultation going on.[61] While artists such as James Barry and the engraver Valentine Green complained that, rather than flourishing, the arts were 'made subservient to trivial pleasures, and ostentatious parade', serious subjects appeared in unusual places.[62] Kauffman's inventions were adapted to the decoration of furniture. Interiors by Robert Adam (the libraries at Kenwood and Home House are good examples) have extensive programmes of history paintings by the most respectable artists, such as Kauffman and Cipriani – set, however, into ceilings, contributing, along with mouldings, mirrors, carpets, furniture, oil paintings and people themselves, to a general effect, thus broadcasting the civilisation of their proprietors. Adam 'endeavoured' to make Syon House 'a noble and elegant habitation, not unworthy a proprietor, who possessed not only wealth to execute a great design, but skill to judge of its merits'.[63]

The artwork (and it is worth remembering the price differentials between oil paintings and clothing or candles) was part of a *tout-ensemble*, and it was viewed under an extraordinary variety of conditions. The heir to the twelfth Duke of Norfolk would have seen the Gainsborough portraits at Arundel in different ways at different times (pl. 144), and would have been affected by phenomena such as lighting – under candlelight the paintings would have looked very differently to their appearance under sunlight, or an evening light – sobriety, and so forth. The particular viewer has also to be taken into account; a distant

283 The Music Room at Harewood House, with *Mrs Hale as Euphrosyne* by Reynolds above the fireplace.

female cousin would have not have shared the heir's perception. A fashionable interior populated by a polite assembly would have provided a dazzling environment with candelabra, rich clothes, jewels, elaborate furnishings all contending for attention. The sitters of portraits might appear besides them, or each be reflected in mirrors, the frames of which would match those of the paintings. Under more stable conditions, the connoisseur of *virtu* will have admired the ultra-sophisticated technique of a Gainsborough on the same terms as the inlays, veneers and craftsmanship of a piece of Sheraton furniture. Works of art had multifarious appearances. There are paintings – Zoffany's *Sir Lawrence Dundas and his Grandson*, Thomas Bardwell's picture of Sir Rowland and Lady Winn enjoying art in their new library at Nostell Priory – in which viewing works of art is presented as the sober, sensible and moral activity one presumes Gainsborough wished it to be. If we ignore the differences between Wright's *Three Persons viewing the Gladiator by Candlelight* (pl. 285) and Zoffany's *Tribune of the Uffizi* (pl. 284), we can trace the linking thread of the cultural imperative to contemplate classical statuary. But the very real disconnections point up the numbers of options available for looking at art.

Gainsborough had to contend with this unfixedness. *Mary, Countess Howe* (pl. 287) presumably records her appearance, and we have already noted how her pose makes her out as supremely elegant and, therefore, polite. In addition, she is up-to-the-minute as regards fashion and saunters in a fairly wild and mountainous setting which appears, in part at least, as a deer park, so that we have an attempt to reconcile modishness with sensibility, while at the same time the likeness is preserved, for although Gainsborough made revisions to the pose and clothes, once he had fixed the features he let them stay.[64] It is virtually impossible to recover the original portrait: to know, for instance, to what degree Countess Howe was in accordance with this image of herself, an image distancing her from *hoi polloi* as effectively as any invention of Reynolds, but doing this by stressing actualities, not creating fictions. It was a thin line. *The Hon. Frances Duncombe* (pl. 288), painted around 1777, would make a pair with *Mrs Graham* (pl. 84), showing a vivacious beauty in an extraordinary park setting which, here, appears to contain to the right an 'Italianate' building which should

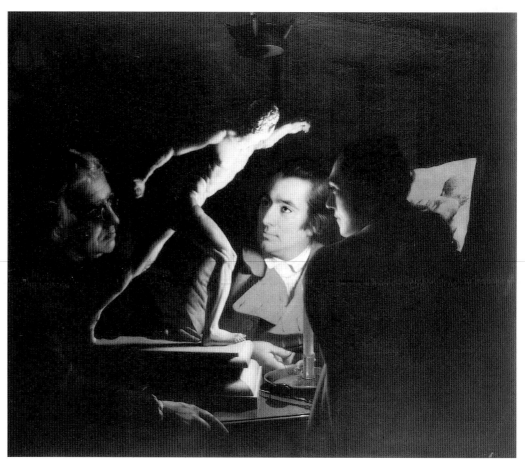

286 *The Extravaganza. Or the Mountain head Dress of* 1776, publ. M. Daly, 1776. London, British Museum.

qualify it as an invented fairyland of qualities refined enough to suit the sitter. This is another of those female portraits where the eye is drawn to the way the face communicates an impression of life and intelligence, or to the luxuriance of the costume. However, what I want to direct attention to is the hair.[65] Duncombe has her hair piled fashionably high. This kind of tonsorial affectation was gleefully satirised in prints (pl. 286) and, as we saw, by the Reverend John Penrose. 'A Physician' did not know 'whether a more extravagant fashion ever existed', but it was unfortunate that this one did, for 'it carries an offensive smell in bed'. In *The Placid Man*, Beville, on enquiring of a lady 'the favour of the name of your head', receives the information that this 'is *un tête de mouton*'.[66] *The Hon. Frances Duncombe* consequently, might have been an easy target for the satirist, in the same way as the face-painting indulged by some of those he painted was grist to the humourist's mill. When Gainsborough exhibited among others *Grace Dalrymple* and *Clara Haywood* at the 1778 Royal Academy, one reviewer commented that

> The likenesses in these three pictures are remarkably strong, and as the real faces of the ladies we have mentioned have not been seen by the world for many a year, they were very fit subjects for Mr. Gainsborough's pencil, since he is rather apt to put that sort of countenance upon his female portraits, which is laughably described in the School of Scandal as *coming in the morning and going away at night*, than to blend what is, properly speaking, *nature, red and white*.[67]

One spoof of 1770 laid it down as a rule that 'No female . . . who uses the art cosmetic, shall find fault with her limner that he has not done her justice in a picture, unless she will own that she makes a better face of herself every day she lives.'[68] The integrity of these images was additionally compromised by their being (less often in Gainsborough's case than with other painters) disseminated as prints, so that the crowds around a print-shop window might admire a politician's portrait as well as his caricature, or the Duchess of Devonshire in a comparable variety of guises.

The status of the painting as embodying particular cultural values was further undermined by the way that the close looking we are meant to bestow upon a *Countess Howe* or *Frances Duncombe* exactly matches what would have been expected by the sitters themselves, and how here the etiquette was particularly brittle. This was an era when, as John Brewer puts it, and here we may bear in mind Gainsborough's painting of *The Mall* (pl. 104),

> culture was characterised by an emphasis upon social display: cultural sites were places of self-presentation in which audiences made publicly visible their wealth, status, social and sexual charms. The ostensible reason for an individual's presence at a cultural site – seeing the play, attending an auction, visiting an artist's studio, listening to a concert – was often subordinate to a more powerful set of social imperatives.[69]

Matthew Bramble's account of the Assembly Rooms at Bath betrayed sharp observation, while Eliza Haywood invented a character, Lady Starebuck, the coquette, who, in the Mall and elsewhere, 'throws her eyes in the face of every well dress'd man she meets, turns and looks back upon him as he is pass'd; if he returns the glance, she presently sets up a loud laugh . . . at the Opera and Play she knows little of what is done upon the stage.'[70]

Yet, while staring was the norm, the mark could be overstepped. In 1773 Henry Bate was involved in what became a violent incident at Vauxhall Gardens, when the actress Mrs Hartley, who had gone there with George Colman (pl. 149), had been put out of countenance by the 'impudent looks' of a group of macaronis. She appealed to Bate, who interposed himself between her and them, to become 'the subject of their loud horse-laughs and wise remarks. Thus unpleasantly circumstanced, I thought it better to face these desperadoes, and therefore turned about and looked at them, in my turn, full in the face; in consequence of which, some distortions of features, I believe, passed on both sides.'[71] If looking was so charged an activity, then uncertainty as to how we are meant to appraise Countess

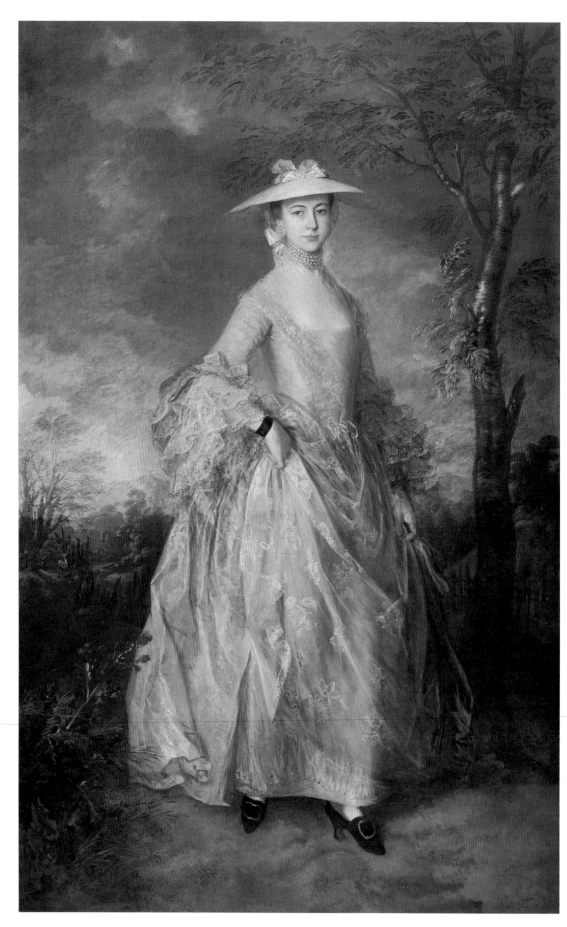

287 *Mary, Countess Howe, c.*1763–64, oil
on canvas, 1,257 × 1,543 (49¹/₂ × 60³/₄).
London, Kenwood, House, Iveagh
Bequest.

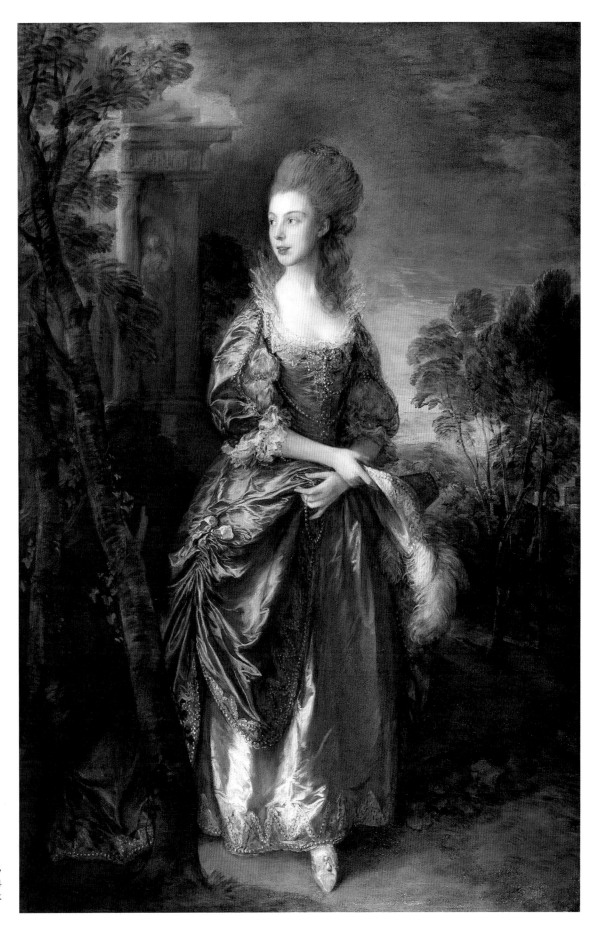

288 *The Hon. Frances Duncombe,*
*c.*1777, oil on canvas, 2,311 × 1,524
(91 × 60). New York, Frick
Collection.

289 Worcester porcelain large cabbage-leaf jug, transfer printed with an etching by Thomas Hancock after *The Rural Lovers* by Thomas Gainsborough, *c.*1765–70. Sudbury, Gainsborough's House.

Howe or Frances Duncombe develops. Ambiguities hovered about such portraits. Smirke and Pordern wrote of Gainsborough's 'lovely creatures of fashion' that they 'have so little about them that looks like common Nature, that surely they are another race of Beings . . . and did we not know that they eat, sleep, and would couch with men in the fair face of heaven, we could never think them mortal'.[72] Gainsborough himself appeared to satirise these creatures in *The Mall*, where there is hardly a man in sight, and fashionably dressed but doll-like women, stare quizzically at one another, frozen in the artifice of their encounter. In full-scale portraits, this ambiguity will be ameliorated because these are works of art of a certain status destined for polite interiors, however unstable and uncertain even those settings will be for their display. And this instability was universal.

For example, Gainsborough's landscape designs sometimes reached the public in the form of transfers on jugs (pl. 289), and the figures within them were mimicked in ceramic form. Yet I have written on Gainsborough's art as though it were stable, and as though it were simply concerned with manifesting high culture, not least because he clearly wished it to be seen in this way himself. Hence by the 1780s he was attempting, as we have seen, and as Reynolds recognised, to shift it onto a higher plane. *The Market Cart* of 1786 (pl. 292),

290 Detail of pl. 104.

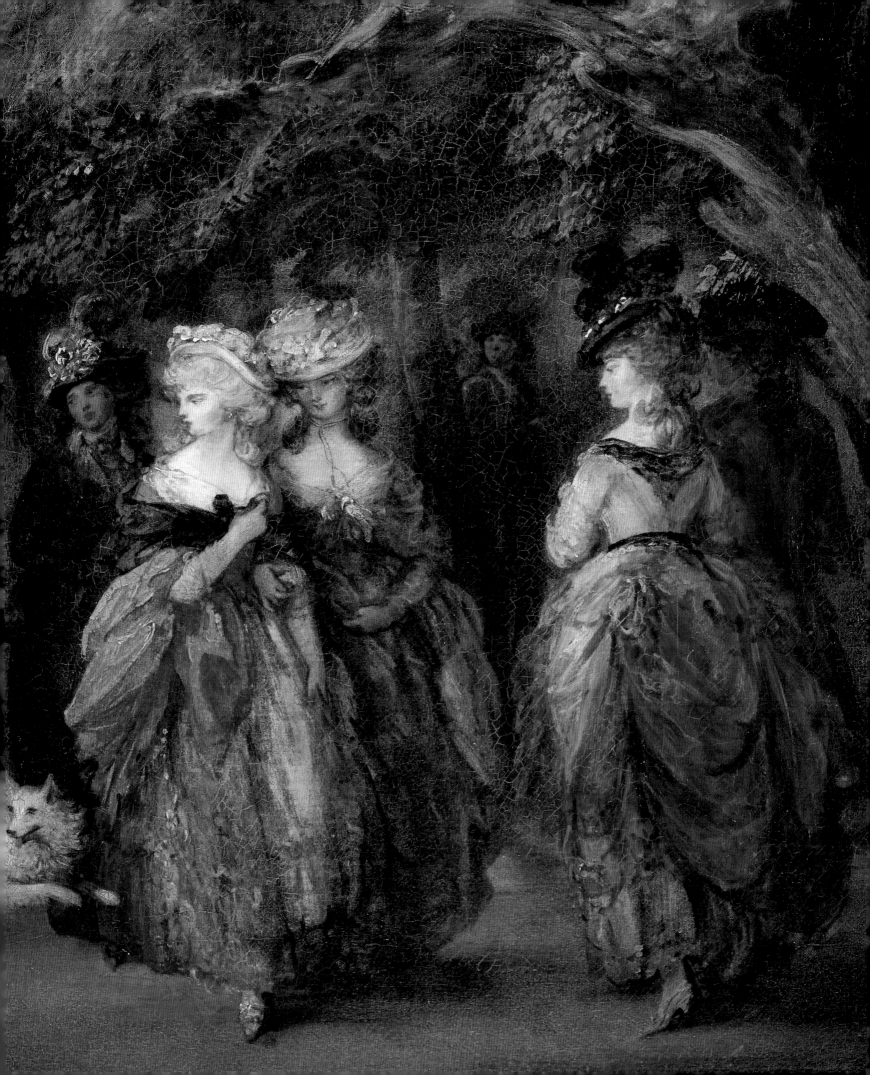

bought by the Prince of Wales, is a grand invention, with the woodcutter appearing as a latter-day Actaeon, but with the option of retiring into the forest; and we are allowed the delight of blue skies, clouds and green trees in a celebration of some imagined Britain. It is evident that Gainsborough saw great value in these rustic subjects. His various fine drawings of an aged woodcutter were eventually translated into a last great painting of one such sheltering from a storm (pl. 186). This reprises a figure type he had used before, recalls the type of the contemplative man, and, in the upturned face, relates to a pictorial tradition in which saints seek inspiration. In a complementary way, the Hagar and Ishmael who trudge through a late dark landscape might be two of his rustics (pl. 291). This is a significant ambiguity, a meaningful interchangeability. One might speculate that Gainsborough's faith imbued him with a degree of fatalism and helped him understand resignation to one's lot as a virtue. While it is extremely hard to unravel these images, beyond suspecting that it is in the poor that, as Christ taught, virtue resides, it is evident that he was bent on supplying an art with subjects both modern and moral.

Gainsborough, as we have seen, was one artist among others attempting to supply an extremely fluid and rapidly developing society with the fine art it required to confirm its moral well-being. That this should have been attempted in such a variety of ways by himself and his contemporaries attests to the pluralistic nature of that society. In the attempt he created works which can appear to contain something of the elegance of the eighteenth century, as well as paintings both enigmatic and beautiful. *The Blue Boy* has attained an iconic status, and in one respect Gainsborough's *oeuvre* represents a transitional stage in a tradition of oil painting that was continued, very differently, by Lawrence, and later on by Sargent. Although, as Hazlitt's censure of a fancy picture in 1814 as displaying 'a regular insipidity, a systematic vacancy, a round, unvaried smoothness to which real nature is a stranger' indi-

cates, Gainsborough's world was soon to be supplanted by one very different to it. He along with Wilson opened up the possiblity for landscape painting to assume for itself the status of the great national art that it became, quintessentially, in the hands of J. M. W. Turner.[73]

Gainsborough had few illusions. When he wrote to William Jackson of 'the fictitious character of a Gentleman', he was demonstrating that, as Smollett and others perceived, dressing politely was also a matter of disguise. The only measure of true gentility was refinement and sensibility, and these he professed, becoming eventually court painter in all but name. His was a serious art, which he wished to have viewed as seriously within the sophisticated domestic environment. Sensibility was the manifestation of an innate morality cultivated by looking, and this could stabilise painted imagery despite those forces to the contrary. But in a rapidly developing, increasingly pluralistic society there could be no guarantee that all would look and respond in the same way. And, as we saw, sensibility was in itself inherently destabilising, blurring boundaries of gender and even class, and, most of all, being activated by emotion, not reason.

In this wise, sight became the channel by which gross appetite might be gratified, rather than the sense through which morality was activated. Reaction to excessive visual stimulation, as to music, had the potential to cause responses which, reason would tell you, were not in the common good. Throughout this book Sir Joshua Reynolds has shadowed Thomas Gainsborough as a kind of foil. Reynolds was making a deeply serious point when he stated that 'Though it be allowed that elaborate harmony of colouring, a brilliancy of tints, a soft and gradual transition from one to the other, present to the eye what an harmonious concert of music does to the ear, it must be remembered that painting is not merely a gratification of the sight.'[74] Gainsborough, the courtier, found social structures at the upper end stable enough to allow him to incorporate into his art some of the developing technology (in the way of aquatint and soft-ground etching) which underpinned the very rapid changes that were taking place within society, while maintaining a tradition of oil painting originated by Van Dyck. In part, the exemplary character of his painting resided in its extreme refinement, its technical virtuosity, chromatic brilliance and pictorial wit.

Yet such painterly art could be lumped in with the particular materiality of commerce as a manifestation of the invidious luxury it continually threatened, and, for Reynolds, this very characteristic, inherent in an art so evidently gratifying a sensual appetite, had to be rejected for a painting which was linear, abstracted, non-sensual, one lifted away from the actual world, in a way that befitted Reynolds's own political radicalism, allowing it to become the province, the intellectual property, of any gentleman with the capacity to apprehend and comprehend it. So, in a process analogous to Johnson's laying claim to the whole of the English language in his *Dictionary*, Reynolds moves the fine arts away from the courts and into the intellectual sphere he sees developing under the impetus of thinkers like Johnson or Adam Smith, one that creates a system where, in a commercial society, one can safeguard against the dangers caused by profligate appetites. Gainsborough, by contrast, can exist only within the *status quo*.

The question eventually focusses upon how culture is to function in what we now perceive as early capitalist society. This dilemma is glaringly manifest in the opposing positions taken by Gainsborough and Reynolds. They did share one cardinal belief, however. Their reconciliation in 1788 pointed to a common conviction that the fine arts were central to any society that aspired to a moral, humane and rational condition, one that aspired towards what we used to think of as civilised values.

Abbreviations

Hayes 1970	J. Hayes *The Drawings of Thomas Gainsborough* 2 vols London 1970
Hayes 1975	J. Hayes *Gainsborough* London 1975
Hayes 1982	J. Hayes *The Landscape Paintings of Thomas Gainsborough* 2 vols London 1982
Paulson 1971	R. Paulson *Hogarth. His Life, Art, and Times* 2 vols New Haven and London 1971
Thicknesse 1788	P. Thicknesse *A Sketch of the Life and Paintings of Thomas Gainsborough Esq.* London 1788
Wark 1975	*Sir Joshua Reynolds Discourses on Art* ed. R. Wark New Haven and London 1975
Waterhouse	E. K. Waterhouse *Gainsborough* London 1966
Whitley 1915	W. T. Whitley *Thomas Gainsborough* London 1915
Whitley 1928	W. T. Whitley *Artists and their Friends in England 1700–1799* 2 vols London 1928
Woodall	M. Woodall *The Letters of Thomas Gainsborough* London 1963

Notes

INTRODUCTION

1 J. Brown *An Estimate of the Manners and Principles of the Times* London 1757; P. Matthias *The Transformation of England* London 1979; J. Barrell (ed.) *Painting and the Politics of Culture. New Essays on British Art 1700–1850* Oxford 1992; S. Copley (ed.) *Literature and the Social Order* London 1984; P. Langford *A Polite and Commercial People. England 1727–1783* Oxford 1989; R. Porter *English Society in the Eighteenth Century* Harmondsworth 1982; N. McKendrick, J. Brewer and J. H. Plumb *The Birth of a Consumer Society: The Commercialization of Leisure in Eighteenth-century England* new ed. London 1983.

2 Langford *op. cit.* p. 725.

3 Woodall p. 111.

4 W. Jackson *The Four Ages* London 1798 p. 183.

5 K. Garlick and A. Macintyre *The Diary of Joseph Farington IV January 1799–July 1801* New Haven and London 1979, p. 1130; Woodall p. 43.

6 Jackson *loc. cit.*; Woodall p. 125; for Shenstone see the *General Advertiser and Morning Intelligencer* 30 April 1778, and Sterne, the *Morning Chronicle and London Advertiser* 10 May 1781. For the connection with Gray, *ibid.* 8 August 1788.

7 J. Ireland *Letters and Poems by the late Mr John Henderson. With Anecdotes of his Life* London 1786 p. 29; Jackson *op. cit.* p. 160; Whitley 1915 p. 10. For Gainsborough and literary culture, see R. Paulson *Emblem and Expression. Meaning in English Art of the Eighteenth Century* London 1975 pp. 204–19; M. Pointon 'Gainsborough and the Landscape of Retirement' *Art History* 2 (December 1979) pp. 441–55; and J. Barrell *The Dark Side of the Landscape. The Rural Poor in English Painting 1730–1840* Cambridge 1980 pp. 35–88.

8 T. Clifford 'Drawings by Gainsborough and Reynolds' in T. Clifford, A. Griffith and M. Royalton-Kisch *Gainsborough and Reynolds in the British Museum. The Drawings of Gainsborough and Reynolds with a Survey of Mezzotints after their Paintings, and a Study of Reynolds's Collection of Old Master Drawings* (EC) London 1978 p. 3.

1 STUDENTSHIP AND SUFFOLK

1 Obituary in the *Morning Chronicle and London Advertiser* 5 August 1788; see also *Morning Herald* 4 August 1788, *Morning Chronicle and London Advertiser* 8 August 1788 and Whitley 1915 pp. 307–08; Hayes 1982 I pp. 29–59; B. Allen *Francis Hayman* (EC) New Haven and London 1987 pp. 39–44; G. W. Fulcher *Life of Thomas Gainsborough* London 1856 pp. 27–35; Paulson 1971 I pp. 369–75; M. Girouard 'Coffee at Slaughter's' *Town and Country* New Haven 1992 pp. 15–34. Gainsborough was marked as a member of the St Martin's Lane Academy in the subscription list to J. Kirby *Dr Brooke Taylor's Perspective made Easy in both Theory and Practice, in Two Books. Being an Attempt to make the Art of Perspective easy and familiar . . .* 2nd ed. Ipswich 1754.

2 Allen *op. cit.* cat. 12. The quote is p. 92. The Dance portrait is cat. 20, p. 99.

3 Hayes 1982 p. 29

4 Girouard *op. cit.* p. 32.

5 For the best account of the extremely problematic nature of the decorations at Vauxhall, see D. H. Solkin *Painting for Money. The Visual Arts and the Public Sphere in Eighteenth-century England* New Haven and London 1992 Chapter 4, 'Vauxhall Gardens: or, The Politics of Pleasure'. See also T. J. Edelstein and B. Allen *Vauxhall Gardens* (EC) New Haven 1983; D. Coke *The Muse's Bower. Vauxhall Gardens 1728–1786* (EC) Sudbury 1978; 'Vauxhall Gardens' in Victoria and Albert Museum *Rococo. Art and Design in Hogarth's England* (EC) London 1984 pp. 74–98; B. Allen 'Francis Hayman and the Supper Box Paintings for Vauxhall Gardens' Victoria and Albert Museum *The Rococo in England* 1989; and *Francis Hayman* pp. 14, 16, 62–70, 73, 107–12.

6 For Roubiliac's *Handel*, see D. Bindman and M. Baker *Roubiliac and the Eighteenth-century Monument* New Haven and London 1995, pp. 49, 65–71.

7 David Coke suggests that William Hogarth, Hubert Francois Gravelot, Louis-Francois Roubiliac, Francis Hayman, Peter Monamy, George Michael Moser, and Isaac Ware were certainly involved, in *The Muse's Bower* (unpaginated).

8 Hayes *op. cit.* pp. 33–34. There is a close formal similarity between this image and the self-portrait of a boy (pl. 3) which Adrienne Corri has suggested is the young Gains-

borough in *The Search for Gainsborough* London 1984 pp. 240–44. See also L. Gowing 'Hogarth, Hayman, and the Vauxhall Decorations' *Burlington Magazine* XCV p. 598 (Jan. 1953) for the first suggestion of Gainsborough's involvement.

9 Allen *Francis Hayman* p. 39. See also R. Jones 'Gainsborough's materials and methods. A "remarkable ability to make paint sparkle"' in S. Foister, R. Jones and O. Meslay *Young Gainsborough* (EC) London 1997 pp. 19–20.

10 For the Foundling Hospital decorations, Solkin *op. cit.* pp. 159–76; E. Einberg *Manners and Morals. Hogarth and British Painting 1700–1760* (EC) London 1987 pp. 182–87; R. Paulson *Hogarth* New Brunswick and London 1991 II pp. 324ff. For Gainsborough's involvement, Einberg *op. cit.* p. 180.

11 *The Town and Country Magazine; or Universal Repository of Knowledge, Instruction and Entertainment* IV (1772) p. 486; Thicknesse 1788 p. 8.

12 Kirby *op. cit.* p. 58; Paulson *op. cit.* III p. 201. For Hogarth's expressing further pessimism about the prospects for landscape painters, see M. Kitson 'Hogarth's "Apology for Painters"' *Walpole Society* XLI (1966–68) pp. 46–111, p. 96.

13 S. Sloman 'Mrs Margaret Gainsborough, "A Prince's Daughter"' *Gainsborough's House Review* 1995/6 pp. 47–58. I am extremely grateful to Susan Sloman for having allowed me to see this article in advance of its publication.

14 Sloman *op. cit.* p. 53.

15 Whitley 1915 p. 10.

16 Woodall p. 103.

17 J. Bensusan-Butt *Thomas Gainsborough in his Twenties. A Memorandum based on Contemporary Sources* 3rd ed. Colchester 1993 p. 11. This is an invaluable account of Gainsborough's East Anglian sojourns and of his connections there.

18 Woodall p. 179. As Gainsborough refers to his 1753 portrait of Admiral Vernon (National Portrait Gallery) elsewhere in this letter, this dates it. J. Lindsay *Thomas Gainsborough. His Life and Art* London 1981 p. 39; Woodall p. 61. For Mayhew see Bensusan-Butt *op. cit.* p. 13ff.

19 J. A. Rouquet *The Present State of the Arts in England* Paris 1755 p. 52ff. For the 1780s, M. Pointon *Hanging the Head. Portraiture and Social*

Formation in Eighteenth-century England New Haven and London 1993 pp. 36ff; 'Portraiture as a Business: London in the 1780s' is essential. From 1782 Reynolds was getting 50 guineas for a head or bust, 100 for a kit-kat or half-length, and 200 for a full-length portrait (N. Penny (ed.) *Reynolds* (EC) London 1986 p. 58). By the 1770s Gainsborough was charging 30, 60, and 100 guineas, raising his fee in 1787 to 40, 80 and 160 guineas (Hayes 1975 p. 42). In 1775 Romney was making £15, £30, and £60, and, in 1781, £20, £40, and £80, which latter prices matched Angelica Kauffman's (A. Rosenthal 'Kauffman and Portraiture' in W. W. Roworth (ed.) *Angelica Kauffman. A Continental Artist in Georgian England* London 1992 pp. 96–112, p. 109, p. 199). In 1789–90 Joseph Wright had 50 guineas for the full-length *Sir Richard Arkwright* (J. Egerton *Wright of Derby* (EC) London 1990 no. 126, p. 197).

20 J. Egerton *George Stubbs 1724–1806* (EC) London 1984 pp. 12–13.

21 For Reynolds's prices see n. 19, above. In 1758/9 he had charged 20 guineas for a head, bust, or three-quarter length, 30 for a kit-kat, 50 for a half length, and 100 for a whole length. By 1764 these had risen to 30, 35, 50, 70 and 150 guineas, and in 1765 the cost of a head rose to 35 guineas. For his subject pictures and historical compositions, see M. Postle *Sir Joshua Reynolds. The Subject Pictures* Cambridge 1995.

22 For a valuable discussion of the complexities of the relations between artists and their customers see I. Pears *The Discovery of Painting. The Growth of Interest in the Arts in England 1680–1768* New Haven and London 1988 pp. 139–56.

23 For visiting artists' houses, see Gainsborough to Jackson, Woodall p. 101; B. Mitchell and H. Penrose (eds) *Letters from Bath 1766–1767 by the Rev. John Penrose* Gloucester 1983 p. 137; Rouquet *op. cit.* pp. 67–69; Sloman 'Artists' Picture Rooms in Eighteenth Century Bath'.

24 Paulson 1971 II pp. 130–52, 206–08; Whitley 1928 I pp. 156–67; Allen *Francis Hayman* pp. 6–7; Pears *op. cit.* pp. 119–32.

25 S. Johnson, *The Works of Samuel Johnson L.L.D. A New Edition in Twelve Volumes. With an Essay on his Life and Genius, by Arthur Murphy, Esq.* London 1823, V p. 178; D. Webb *An Inquiry into the Beauties of Painting; and into the Merits of the most Celebrated Painters, Ancient and Modern* 2nd edition London 1761 p. 35.

26 D. Solkin *Richard Wilson. The Landscape of Reaction* (EC) London 1982 p. 15 and *passim*, but particularly Chapter Two, pp. 37–55.

27 A. Smart *Allan Ramsay. Painter, Essayist, and Man of the Enlightenment* New Haven and London 1992, quoted pp. 59, 74.

28 *Ibid.* pp. 81–3. For the sources of the pose,

Postle *op. cit.*; see also D. Solkin 'Great Pictures or Great Men' *Oxford Art Journal* IX 2 (1986) pp. 42ff.

29 Smart *op. cit.* Chapter Five.

30 Penny *op. cit. Reynolds* (EC) 1986 *passim*; A. Griffiths 'Prints after Reynolds and Gainsborough' in T. Clifford, A. Griffiths and M. Royalton-Kisch *Gainsborough and Reynolds in the British Museum* (EC) 1978 pp. 29–59; T. Clayton *The English Print 1688–1802* New Haven and London 1997, pp. 181–206. Clayton has conclusively demonstrated how centrally important prints after their works were to the business of artists.

31 The best account of Grangerising and other ways of head-collecting is in M. Pointon *op. cit.* Part I, section ii 'Illustrious Heads' pp. 53–78.

32 For a full account of the *Niobe* in its context, Solkin *Richard Wilson* pp. 59–65, no 87, pp. 200–02; also W. G. Constable *Richard Wilson* London 1953 pp. 160–63.

33 T. Clayton 'The Engraving and Publication of Prints of Joseph Wright's Paintings' in Egerton *op. cit.* pp. 25–29, quoted p. 29.

34 See Chapters Four and Five below.

35 The four were (figures from Waterhouse) no. 21 Rev. Thomas Ashton, 1765; no. 302, John Garrett D.D., 1758; no. 684 Sir Edward Turner, Bart, 1763; no. 692 Admiral Edward Vernon 1753. For Reynolds see Penny *op. cit.* pp. 200–01, cat. no. 38.

36 For Gainsborough and printmaking see J. Hayes *Gainsborough as Printmaker* London 1971, and H. Belsey *Gainsborough the Printmaker* (EC) Aldeburgh 1988.

37 Thicknesse 1788 p. 11.

38 Pears *op. cit.* Chapter 6, particularly pp. 168–69, Waterhouse p. 13.

39 Hayes 1975 p. 201. Mrs Hill is Waterhouse no. 369.

40 Gainsborough and the cult of sensibility are discussed in Chapters Eight and Nine.

41 According to Hayes 1982, catalogue nos 2, 4, 6, 9 and 43 have a provenance originating with Joshua Kirby. He also states (1982 p. 2) that Kirby owned over one hundred of Gainsborough's landscape drawings.

42 *The Female Spectator* (1744) 4 vols 7th ed. London 1771 III p. 160. The hat was identified by Ann Bermingham in *Landscape and Ideology: The English Rustic Tradition 1740–1860* Berkeley, Los Angeles, London 1986 p. 29; pp. 28–33 supply a useful discussion of this painting, to which my own account is indebted.

43 Bermingham *op. cit.* pp. 28–33.

44 A. Pope 'Epistle to the Earl of Burlington' (1731) in Pope, A. *Pope. Poetical Works* (ed. H. Davis) London 1966 (pp. 314–21) pp. 320–21.

45 Bensusan-Butt *op. cit.* p. 69.

46 Hayes 1982 II no. 94, pp. 437–38. The letter to Lord Hardwicke is Woodall pp. 87–91.

47 Hayes 1982 I. p. 61, where we learn that the house Gainsborough was to occupy would be vacant from June 1752.

48 Whitley 1915 pp. 18–19; Bensusan-Butt *op. cit.* pp. 45–48 and *passim*.

49 Whitley 1915 p. 115.

50 H. Angelo *Reminiscences* 2 vols 1904 I pp. 200–02.

51 R. B. Beckett (ed.) *John Constable's Correspondence II. Early Friends and Maria Bicknell (Mrs Constable)* Ipswich 1964 pp. 11–12; *The Suffolk Traveller. First published by Mr John Kirby of Wickham Market, who took an Actual Survey of the Whole County, in the Years 1732, 1733, and 1734. The Second Edition with Many Alterations and large Additions, By several Hands* London 1764 p. 14.

52 Fulcher *op. cit.* pp. 48–49 supposes this to refer to 'Mr Hingeston, a clergyman residing near Southwold'. The record has been put straight by Bensusan-Butt *op. cit.* p. 11.

53 Bensusan-Butt *op. cit.* pp. 30–70.

54 Woodall pp. 163, 39, 35–37.

55 Bensusan-Butt *loc. cit.*; H. Belsey 'Gainsborough and caricature: two new pieces of evidence', unpublished article. I am grateful to Hugh Belsey for letting me have a copy of this article.

56 These figure are computed from Waterhouse in combination with Bensusan-Butt *op. cit.* p. 66. From Hayes 1982 II it appears that, at the most, eleven (still known) landscapes were commissioned or sold during the Ipswich years.

57 Woodall pp. 61–63.

58 Smart *op. cit.* pp. 110–13. For Cotes, see E. M. Johnson *Francis Cotes* Oxford 1976 pp. 11–12.

59 Hayes 1982 p. 35 suggests that Gainsborough was frequently in London.

2 BATH

1 Waterhouse p. 107, catalogue nos 829, 833. For Gainsborough's move to Bath, see A. Sumner 'Gainsborough and his circle of friends and patrons in Bath' in Holbourne Museum *Gainsborough in Bath* (EC) 1988 pp. 9–17; S. Sloman 'Gainsborough in Bath in 1758–59' *Burlington Magazine* CXXXVII (August 1995) pp. 509–12; M. Rosenthal 'Testing the Water. Gainsborough in Bath in 1758' *Apollo* CXLII. 403 (September 1995) pp. 49–54.

2 Thicknesse 1788 p. 17.

3 For evidence of their being on good terms, see the letter from Gainsborough to Hoare, in Woodall pp. 95–97, and also H. Belsey 'A Visit to the Studios of Gainsborough and Hoare' *Burlington Magazine* CXXIX. 1007 (February 1987) pp. 107–09; S. Sloman 'Artists' Picture Rooms in Eighteenth-century Bath' *Bath History* VI (1996) pp. 132–54, and 'The Holloway Gainsborough

and its Subject Re-examined' *Gainsborough's House Review* (1997–8) pp. 47–54.

4 Thicknesse 1788 p. 15.

5 R. S. Neale *Bath 1680–1850. A Social History or A Valley of Pleasure, yet a Sink of Infamy* London, Boston and Henley 1981 pp. 41–46.

6 Woodall p. 135.

7 For a fascinating analysis of the architecture of Bath, see Neale, *op. cit.* p. 174.

8 T. Smollett *Humphry Clinker* (1771) Harmondsworth 1967 pp. 65–66, 68. *Town and Country Magazine* III (1771) pp. 319–20 prints the excerpt quoted as a documentary account, and, p. 3, claims to be selling 12,000 copies a month, which would have given the description universal dissemination.

9 M. Girouard *The English Town* New Haven and London 1990 p. 79.

10 P. Borsay *The English Urban Renaissance. Culture and Society in the Provincial Town 1660–1770* Oxford 1989 p. 150. For the social significance of display in eighteenth-century England see J. Brewer ' "The most polite age and the most vicious". Attitudes towards culture as a commodity' in A. Bermingham and J. Brewer (eds) *The Consumption of Culture 1600–1800. Image, Object, Text* London and New York 1995 pp. 341–61.

11 B. Mitchell and H. Penrose (eds) *Letters from Bath 1766–1767 by the Rev. John Penrose* Gloucester 1983 pp. 30 (15 April 1766), 75 (1 May 1766), 181 (15 May 1767).

12 Smollett *op. cit.* pp. 95–96, 97. For the stink of public assemblies see Soam Jenyns 'The World' CLIII in *The Works of Soame Jenyns, Esq. In Four Volumes. Including Several Pieces never before Published. To which are prefixed, short Sketches of the History of the Author's Family, and also of his Life; by Charles Nelson Cole, Esq.* London 1790 II pp. 103–14, especially p. 107.

13 Smollett *op. cit.* p. 89.

14 C. Lloyd *The Queen's Pictures. Old Masters from the Royal Collection* London 1994 no. 23, pp. 78–79, in which the connection of the later canvas with Hogarth's *Simon, Lord Lovat* is noted. Bate, obituary of Gainsborough in the *Morning Chronicle and London Advertiser* 5 August 1788.

15 For Lovat see Paulson, 1971 II pp. 58–59; for Quin and Lovat, J. Burke *English Art 1714–1800* Oxford 1976 p. 216; for the bequest, *The Life of James Quin. With the History of the Stage, from his commencing Actor to his Retreat to Bath. Illustrated with many curious and interesting Anecdotes of several Persons of Distinction, Literature, and Gallantry. To which is added, a genuine and authentic Copy of his last Will and Testament* London 1766 p. 114 (also A. Summer *Gainsborough in Bath* (EC) Bath 1988 p. 15) A letter from Gainsborough to Lord Royston (Woodall p. 131) of 21 July 1763 contains news of Quin.

16 Neale *op. cit.* p. 32. For Gainsborough and Thicknesse see R. Wark 'Thicknesse and Gainsborough: some new Documents' *Art Bulletin* XL 40 (1958) pp. 331–334.

17 Borsay *op. cit.* p. 142; S. Sloman 'Artists' Picture Rooms in Eighteenth-century Bath' *Bath History* VI (1996) pp. 132–54.

18 Neale *op. cit.* p. 38.

19 For the Bedford portraits, J. Hayes 'Gainsborough and the Bedfords' *Connoisseur* 167 (April 1968) pp. 217–24. The Argyll is Waterhouse 19, the Vernon, Waterhouse 693.

20 Woodall p. 61.

21 This was discovered by Ann Sumner. See 'Gainsborough and his Cicle of Friends and Patrons in Bath' in Sumner *op. cit.* p. 10. For this first visit see S. Sloman 'Gainsborough in Bath in 1758–59'; M. Rosenthal 'Testing the water: Gainsborough in Bath in 1758'.

22 Sloman 'Gainsborough in Bath'; see also Whitley 1915 pp. 28–29.

23 H. K. Miller (ed.) *Miscellanies by Henry Fielding, Esq.* (1743) Oxford 1972 p. 123.

24 F. Hutcheson *An Inquiry into the Original of our Ideas of Beauty and Virtue. In Two Treatises. I. Concerning Beauty, Order, Harmony, Design. II. Concerning Moral Good and Evil* (1728) fifth ed. London 1753 p. 13. For body language in general, W. Hogarth *The Analysis of Beauty. Written with a View of fixing the fluctuating Ideas of Taste* London 1753 p. 139 and *passim*. For the history of politeness and its social consequences, F. A. Childs 'Prescriptions for Manners in English Courtesy Literature 1690–1760 and their Social Implications' D.Phil. Oxford 1984; A. Fletcher *Gender, Sex and Subordination in England 1500–1800* New Haven and London 1995 pp. 322–46; D. H. Solkin *Painting for Money. The Visual Arts and the Public Sphere in Eighteenth-century England* New Haven and London 1992; S. Copley 'The Fine Arts in Eighteenth-century Polite Culture' in J. Barrell (ed.) *Painting and the Politics of Culture. New Essays on British Art 1700–1850* Oxford 1992 pp. 13–38; J. Locke *Some Thoughts concerning Education* 1693 pp. 207–08.

25 [E. Fitzgerald] *The Artist's Repository or Encyclopaedia of the Fine Arts. Vol. I. The Human Figure* (1788) London 1808 p. 82.

26 For comparable sentiments, see R. de Piles *The Principles of Painting . . . now first Translated into English. By a Painter* London 1743 p. 158. It will be argued in Chapter Six below that de Piles was extremely influential in forming Gainsborough's aesthetic ideas.

27 S. Sloman 'Sitting to Gainsborough in Bath in 1760' *Burlington Magazine* CXXXIX (May 1997) pp. 325–28.

28 *Town and Country Magazine; or Universal Repository of Knowledge, Instruction, and Entertainment* IV (1772) printed for A. Hamilton jun. pp. 484–86. Rosenthal *op. cit.* gives a lengthy transcription of the article. The *Discourses* and likeness are discussed below, pp. 59 ff.

29 Ozias Humphry *Memoir* Royal Academy, Humphry Papers HU 1/20–40/36 (I am grateful to the Royal Academy for permission to quote from this manuscript); P. Thicknesse *Sketches and Characters of the Most Eminent and most Singular Persons now living* London 1772 p. 96.

30 *St James's Chronicle* 22–25 May 1762; *Gentleman's Magazine* 58 (August 1788) p. 754; Wark 1975 pp. 254, 259. For Liotard, see J. Brewer *The Pleasures of the Imagination. English Culture in the Eighteenth Century* London 1997 p. 310.

31 P. Gosse *Dr Viper. The querulous Life of Philip Thicknesse* London 1952 (pp. 149–52) p. 150; Woodall p. 101.

32 Woodall pp. 165, 115; H. Angelo *Reminiscences* 2 vols London 1904 p. 171.

33 Woodall p. 97.

34 Whitley 1915 pp. 21–22, 28.

35 For example, *William Poyntz* SA 1762 (Althorp), *Thomas John Medlicott* SA 1763 (Waterhouse 477), *George, Second Lord Vernon* SA 1767 (Waterhouse 693).

36 This analysis emerged from one of many conversations with Paul Hills. For Bellini's portraiture, see L. Campbell *Renaissance Portraits. European Portrait Painting in the Fourteenth, Fifteenth and Sixteenth Centuries* New Haven and London 1990 p. 30. The technique was noticed by the obituarist in the *Gentleman's Magazine*, 58 (July–December 1788) pp. 753–56.

37 Desmond Shawe-Taylor makes this point about *Wollaston* in *Art Treasures of England* (EC) London 1998 no. 41. Musical and pictorial analogies are to be discussed below, *passim*.

38 Thicknesse 1788 p. 17. For prices, Hayes 1975 p. 42. Figures computed from Waterhouse.

39 Thicknesse 1788 pp. 15–16.

40 S. Sloman 'Gainsborough and the "lodging-house way" ' *Gainsborough's House Review* 1991/2 pp. 23–43.

41 Woodall p. 157.

42 Whitley 1915 p. 49.

43 Mitchell and Penrose *op. cit.* p. 137, where the response to a portrait of Lady Waldegrave is that she is 'no such flaming Beauty in my Eyes'. For Dorothy Richardson see H. Belsey 'A Visit to the Studios of Gainsborough and Hoare' *Burlington Magazine* CXXIX (February 1987) pp. 107–09.

44 Woodall p. 73.

45 J. A. Rouquet *The Present State of the Arts in England* London 1755 pp. 42–43. For the situation in Bath, see Sloman 'Artists' Picture Rooms'; for Ozias Humphry, Brewer *The Pleasures of the Imagination* pp. 294–320.

46 Woodall p. 55.

47 Lindsay *op. cit.* pp. 115–16.

48 Woodall pp. 95–97. For suspecting that Hoare sent the fifth, and not as has been thought the fourth *Discourse*, see p. 290 n. 61 below.

49 S. Sloman 'The Holloway Gainsborough and its Subject re-examined' *Gainsborough's House Review* 1997/8.

50 Whitley 1915 p. 79.

51 Hayes 1982 II no. 76; Sumner *Gainsborough in Bath* p. 11; *Morning Herald* 4 August 1788.

52 Sumner *Gainsborough in Bath* p. 9.

53 For Gainsborough and the Linleys see G. Waterfield *et al.*, *A Nest of Nightingales. Thomas Gainsborough. The Linley Sisters* (EC) London 1988, particularly pp. 49–52; L. Stainton *Gainsborough and his Musical Friends* (EC) London 1977, particularly the entry to no. 4. For Gainsborough and Abel, Whitley 1915 *passim* and p. 366.

54 B. Nicolson *Joseph Wright of Derby. Painter of Light* 2 vols London 1968 I pp. 14–15.

55 Sumner *Gainsborough in Bath* p. 31; Woodall p. 67.

56 For the Musical Club at Ipswich, see Whitley 1915 p. 22.

57 Hayes 1982 I p. 93.

58 Woodall p. 155. The portrait, thought to date from 1764, is in the Ringling Museum, Sarasota, Florida, Waterhouse 375. For Gainsborough and Van Dyck see Philippa Bishop's excellent essay in Sumner *Gainsborough in Bath* pp. 18–26; A. French (ed.) *The Earl and Countess Howe by Gainsborough. A Bicentenary Exhibition* (EC) London 1988; and, in particular, D. Cherry and J. Harris 'Eighteenth-century Portraiture and the Seventeenth-century Past: Gainsborough and Van Dyck' *Art History* 5 (September 1982) pp. 287–309.

59 Whitley 1915 p. 57. For Gainsborough and Claude, see D. A. Brenneman 'Thomas Gainsborough's *Wooded Landscape with Cattle by a Pool*' *Gainsborough's House Review* 1995/96 pp. 37–46. The Gainsborough is Hayes 1982 II no. 79.

60 Woodall p. 67

61 Cherry and Harris *loc. cit.*

62 A. Ribeiro *The Art of Dress. Fashion in England and France 1750 to 1850* New Haven and London 1995 pp. 62–65, and French *op. cit.* pp. 31–35.

63 Cherry and Harris *op. cit.* p. 289.

64 Woodall p. 151; Sumner *Gainsborough in Bath* p. 27, cat. no. 3.

65 Sumner *Gainsborough in Bath* p. 27, cat. no. 4.

66 Whitley 1915 p. 36.

67 This is to be discussed in Chapter Seven below.

68 Woodall pp. 93, 103.

69 Penny *op. cit.* pp. 217–18, no. 50; Waterhouse p. 20.

70 For instance, *Sir John Nettlethorpe out shooting* 1776, or *Valentine Knightley with his shooting-pony Monarch, and his pointer, Bell, in Barton Field, Lincolnshire* 1776; illustrated in J. Egerton *George Stubbs 1724–1806* (EC) London 1984, cat. nos 113, 114, pp. 154, 155.

71 Whitley 1915 p. 39; Humphry *op. cit.* f. 36.

72 Humphry *op. cit.* f. 35.

73 For Reynolds's painting see Penny *op. cit.* pp. 205–07, no. 42. *St James's Chronicle* 25–27 May 1762. William Jackson makes the Choice of Hercules connection in *The Four Ages; together with Essays on Various Subjects* London 1798 pp. 169–70.

74 Anthony Ashley Cooper, third Earl of Shaftesbury, Treatise III, *viz. A Notion of the Historical Draught or Tablature of the Judgement of Hercules* London 1713.

75 I should like to thank Simone Poulton for bringing the Zoffany to my notice. For this painting see also S. West *The Image of the Actor. Verbal and Visual Representation in the Age of Garrick and Kemble* London 1991 pp. 29–30, 32.

76 Humphry *loc. cit.*

77 T. Friedman *The Man at Hyde Park Corner. Sculpture by John Cheere 1709–1787* (EC) Leeds 1974 No. 45.

78 Hayes 1982 II. no. 80 was probably exhibited in 1763. no. 87, the *Landscape with Milkmaid and Drover* is discussed pp. 426–27, whence the sale particulars and quote are taken.

79 *Ibid.* no. 88 pp. 427–30.

80 Whitley 1915 pp. 396–97.

81 Woodall pp. 145, 51.

82 T. B. *A Call to the Connoisseurs . . .* pp. 25, 38, 42, 43.

83 This was pointed out in Paulson 1971 II pp. 332–34.

84 *Public Advertiser* 28 April 1766; *Gazetteer* 19, 23, 26 May 1766.

85 *Middlesex Journal; or Chronicle of Liberty* 14–19 October 1769, 8–10 February 1770. An exemplary account and interpretation of this episode is to be found in Solkin *op. cit.* Chapter seven, in particular pp. 261–76.

86 F. Owen 'Joshua Kirby (1716–74): a biographical sketch' *Gainsborough's House Review* 1995/6 pp. 61–75; Whitley 1915 p. 65.

87 Woodall p. 125.

3 THE ROYAL ACADEMY

1 Wark 1975 p. 13.

2 Woodall p. 141.

3 *Middlesex Journal: Or, Chronicle of Liberty* 14–17 October 1769.

4 D. Stroud *George Dance, Architect, 1741–1825* London 1971 pp. 90–91.

5 Unpublished letter of 29 March 1784 in Waterhouse Papers, Paul Mellon Centre for Studies in British Art. The painting is in a private collection, but a photo exists in the archive of the Mellon Centre.

6 For prototypes, J. de Wet *John, first Marquis of Atholl* c.1680, Blair Castle, Perthshire; A. Van Dyck *Lady Digby as Prudence* 1633 National Portrait Gallery; *A Lady as Erminia, attended by Cupids* c.1638, Duke of Marlborough; Benedetto Genaro *Elizabeth Panton as St Catherine* 1689, Tate Gallery.

7 D. Shawe-Taylor *The Georgians. Eighteenth-Century Portraiture and Society* London 1990 p. 147; Wark 1975 p. 88.

8 Arthur Devis and Joseph Wright were also immune, but others – Romney, Cotes, Zoffany and later John Hoppner – all adapted their portrait manners to fit with that of Reynolds.

9 Shawe-Taylor *op. cit.* pp. 147–64 offers an exemplary discussion of the phenomenon. For Ligonier, A. Ribeiro *The Art of Dress. Fashion in England and France 1750 to 1820* New Haven and London 1995 p. 26.

10 Wark 1975 p. 19.

11 P. Linebaugh *The London Hanged. Crime and Civil Society in the Eighteenth Century* Harmondsworth 1991 p. 256.

12 Wark 1975 pp. 14, 16.

13 [A Member of said Society] *A concise Account of the Rise, Progress, and Present State of the Society for the Encouragement of Arts, Manufactures and Commerce* London 1763 pp. 41–42.

14 N. Foster *An Enquiry into the Present High Price of Provisions* (1767) p. 41; quoted in N. McKendrick, J. Brewer and J. H. Plumb *The Birth of a Consumer Society: The Commercialization of Leisure in Eighteenth-Century England* London 1982 p. 11.

15 For a comprehensive analysis of Reynolds's writings see J. Barrell *The Political Theory of Painting from Reynolds to Hazlitt. 'The Body of the Public'* New Haven and London 1986 pp. 1–162 (but also A. Hemingway 'The Political Theory of Painting without the Politics' *Art History* 10 (September 1987).

16 Wark 1975 p. 33.

17 *Ibid.* p. 42.

18 *Ibid.* pp. 45–47.

19 *Ibid.* pp. 47–48.

20 *Ibid.* p. 50.

21 This point was first made by Paulson, 1971 II pp. 296–98. See also J. Uglow *Hogarth. A Life and a World* London 1997 pp. 616–17. For a fine analysis of Reynolds's management of his career, see R. Wendorf *Sir Joshua Reynolds. The Painter in Society* Boston and London 1996, especially pp. 61–65.

22 A. Bermingham 'Introduction. The Consumption of Culture: Image, Object, Text' in A. Bermingham and J. Brewer (eds) *The Consumption of Culture 1600–1800. Image, Object, Text* London and New York 1995 (pp. 1–20) p. 5; R. de Piles *The Principles of Painting . . . now first Translated into English. By a Painter* London 1743 p. 2.

23 Wark 1975 pp. 51–52.

24 *Ibid.* p. 57.

25 For discussions of this see Barrell *op. cit.*, and *English Literature in History 1730–80. An Equal, Wide Survey* London 1983; J. G. A. Pocock *Virtue, Commerce and History. Essays on Political Thought and History, Chiefly in the Eighteenth Century* Cambridge 1985; D. Solkin *Painting for Money. The Visual Arts and the Public Sphere in Eighteenth-century England* New Haven and London 1992; and M.

Craske *Art in Europe 1700–1830* Oxford 1997 pp. 134–36.

26 Paulson 1971 II pp. 130–52, 354–99; D. Bindman *Hogarth and his Times* (EC) London 1997 pp. 168–201.

27 For Gainsborough and Hogarth, see Chapter Six below.

28 Wark 1975 p. 59.

29 *Ibid.* pp. 277–78.

30 *Ibid.* pp. 61, 62.

31 *Ibid.* p. 72.

32 M. Postle *Sir Joshua Reynolds. The Subject Pictures* Cambridge 1995 p. 10 for the de Piles connection; T. Pennant *The Journey from Chester to London* London 1782 pp. 175–76. For an extremely useful discussion of likeness and associated problems, see M. Pointon *Hanging the Head. Portraiture and Social Formation in Eighteenth-century England* New Haven and London 1993 pp. 80 ff. This conclusion would be borne out both by the habit of collecting illustrious heads, noted above (pp. 5, 12), and by William Melmoth the Younger's extremely popular *The Letters of Sir Thomas Fitzosborne, on several Subjects* (1742, 10th ed. 1795) 3rd ed. London 1750 p. 9: 'For myself, at least, I have often found much satisfaction in contemplating a well-chosen collection of the portrait kind, and comparing the mind of a favourite character, as it was either expressed or conceald in its external lineaments.'

33 R. B. Sheridan *The School for Scandal* (1970) London 1970 p. 101 (Act 3, Scene 3).

34 Wendorf *op. cit.* p. 166.

35 Marquis of Kildare to the Marchioness of Kildare, London, 18 May 1762, in E. B. Fitzgerald (ed.) *Correspondence of Emily, Duchess of Leinster 1731–1814. Vol. I. Letters of Emily, Duchess of Leinster; James, First Duke of Leinster; Caroline Fox, Lady Holland* Dublin 1949 p. 133. I am extremely grateful to Kate Retford for this reference.

36 Ozias Humphry 'Memoir' Royal Academy Humphry Papers HU1/20–40 f. 36.

37 The letters are Woodall p. 49 (8 April 1771), 51 (13 April), 51–53 (18 April).

38 Wark 1975 p. 140.

39 J. A. Rouquet *The Present State of the Arts in England* 1755 pp. 69–70.

40 For this episode see also Hayes 1975 pp. 13–14, 215; plates 89, 90; and G. Perry 'Women in Disguise. Sir Joshua Reynolds' in G. Perry and M. Rossington (eds) *Feminity and Masculinity in Eighteenth-century Art and Culture* Manchester 1984 pp. 18–40, esp. pp. 28–30 for the Dartmouth episode.

41 For the phenomenon in general see J. Brewer '"The most polite age and the most vicious". Attitudes towards culture as a commodity, 1600–1800, in Bermingham and J Brewer (eds) *op. cit.* pp. 341–61. The aesthetics and social conventions of looking and being looked at will be discussed below, pp. 277–88.

For an example of the novelistic failure of recognition, see [Herbert Lawrence] *The contemplative Man, or the History of Christopher Crab, Esq., of North Wales* 2 vols London 1771, I pp. 44, 285.

42 B. Cozens-Hardy (ed.) *The Diary of Sylas Neville 1767–1788* Oxford 1950 p. 114.

43 E. Fletcher (ed.) *Conversations of James Northcote R.A. with James Ward on Art and Artists. Edited and arranged from the manuscripts and notebooks of James Ward* London 1901 pp. 159, 161.

44 J. Northcote *The Life of Sir Joshua Reynolds, LLD. F.R.S. F.S.A. &c. Late President of the Royal Academy. Comprising Original Anecdotes of many distinguished Persons his contemporaries; and with a brief Analysis of his Discourses* 2 vols second ed. London 1818 II p. 238.

45 *Middlesex Journal* 23–26 April 1772.

46 Whitley 1915 pp. 87–88.

47 *Ibid.* pp. 88–89.

48 Woodall pp. 75–77.

49 *Ibid.* pp. 61–63.

50 *Ibid.* p. 63.

51 For these see J. P. Derow 'Gainsborough's Varnished Watercolour Technique' *Master Drawings* 26 (Autumn 1988) pp. 259–71.

52 Woodall p. 143.

53 For this, see R. Wark *Meet the Ladies. Personalities in Hurtington Portraits* San Marino 1972 pp. 1–22. A contemporary account of the Ligonier affair was published in *The Generous Husband; or the History of Lord Lelius and the fair Emilia* London 1771. I am most grateful to Kate Retford for this reference.

54 Letter to Constantine Phipps, later Lord Mulgrave, 13 February 1772. I am most grateful to John Hayes for sending me a transcription of this letter. Woodall p. 141.

55 Whitley 1915 pp. 87, 96–97.

56 P. Thicknesse *Sketches and Characters of the Most Eminent and Most Singular Persons now living* London 1770 pp. 95–6.

57 *The Town and Country Magazine; or Universal Repository of Knowledge, Instruction and Entertainment* IV (1772) p. 485.

58 Reynolds was fairly concerned with the concept of 'excellence' at this time. In the fourth *Discourse* of December 1771, he mentioned 'excellence' twice (Wark 1975 pp. 62, 68) and 'petty excellencies' once (Wark 1975 p. 71), and used the adjective 'excellent' twice (Wark 1975 pp. 69, 71). For his continuing concern with excellence and excellencies see the quotations from the fifth *Discourse* below.

59 In a letter to the Hon. Edward Stratford of 21 March 1771 he wrote of 'well knowing that if ever I am Knighted or have anything to do at St James's it must be through your Interest and singular Friendship for me'. Woodall p. 143.

60 Wark 1975 pp. 77, 82, 80.

61 Woodall pp. 95–97. Mary Woodall suspects that Hoare had sent Gainsborough the fourth

Discourse, but, as Martin Postle has noted, it is in the fifth that he concerns himself with the ornamental style, and uses the phrase 'down to Watteau' as in (Wark 1975 p. 89) 'from Michael Angelo down to Watteau'. I am grateful to Brian Allen for mentioning this to me in conversation.

62 Whitley 1915 p. 95. For Zoffany, see Queen's Gallery *Gainsborough and Reynolds. Contrasts in Royal Patronage* (EC) London 1994 pp. 84–85, entry to no. 57, J. Zoffany *The Academicians of the Royal Academy*.

63 Details and quotation from A. Graves. *The Society of Artists of Great Britain 1760–1791. The Free Society of Artists 1761–1783. A Complete Dictionary of Contributors and their Work from the Foundation of the Societies to 1791* London 1907 p. 287.

64 Whitley 1915 pp. 96–98.

65 Woodall p. 175.

4 LONDON

1 Thicknesse 1788 p. 31. For this episode see Whitley 1915 pp. 106–08.

2 B. Nicolson *Joseph Wright of Derby. Painter of Light* 2 vols London 1968 I p. 13; Whitley 1915 p. 102.

3 For Wright and the press, see, for example, *Public Advertiser* 7 May 1778, *Morning Chronicle and London Advertiser* 8 May 1773, Nicolson *loc. cit.*

4 Figures computed from Waterhouse 1958.

5 S. Sloman 'Gainsborough and "the lodging-house way"', and Appendix 'The Gainsborough Family Involvement in Lodging-Houses in Bath, 1760–1800' *Gainsborough's House Review* 1991/92 pp. 132–54; 'Artists' Picture-Rooms in Eighteenth-century Bath' *Bath History* VI (1996) pp. 132–54.

6 Sloman 'Gainsborough and "the lodging-house way"', p. 34. For Schomberg House see Whitley 1915 pp. 108–12; G. Walkley *Artists' Houses in London 1764–1914* Aldershot 1994 pp. 16–17.

7 Walkley *loc.cit.*

8 He did exhibit *The Portrait of a Nobleman* (no. 347) at the Free Society of Artists in 1774, having, presumably, sent the picture up from Bath.

9 S. McVeigh *Concert Life in London from Mozart to Haydn* Cambridge 1993 p. 14; C. Avison *An Essay on Musical Expression . . . 1753* pp. 119–20, quoted in L. Stainton *Gainsborough and his Musical Friends* (EC) London 1977 entry to no. 3.

10 Royal Academy, Humphry Papers HU 1/20–40 f. 33. Woodall p. 45.

11 Woodall p. 31; McVeigh *op. cit.* p. 15.

12 McVeigh *loc. cit.*

13 Stainton *op. cit.* entry to no. 10.

14 Letter of 13 May 1997.

15 Unpublished letter, to be published by John Hayes.

16 A. Asfour, P. Williamson, and G. Jackson '"A second Sentimental Journey": Gainsborough abroad' *Apollo* CXLVI (August 1997) (pp. 27–30) p. 29.

17 *Morning Chronicle and London Advertiser* 8 August 1788; Whitley 1915 p. 308.

18 For Gainsborough and music, Stainton *op. cit.*; Whitley 1915 pp. 359–67; Hayes 1982 I pp. 145–46.

19 McVeigh *op. cit.* pp. 14–15; Whitley 1915 p. 114, quoting a Mrs Harris.

20 McVeigh *op. cit.* p. 15. For solidarity amongst Italian *artists* in London, see S. West 'Xenophobia and xenomania: Italian Artists and the English Royal Academy' in S. West (ed.) *Italian Culture in Northern Europe in the eighteenth Century* Cambridge 1999 pp. 116–39.

21 H. Angelo *Reminiscences* 2 vols London 1904 I p. 391.

22 K. Garlick and A. Macintyre (eds) *The Diary of Joseph Farington* IV New Haven and London 1979 pp. 1129–130.

23 R. Wendorf *Sir Joshua Reynolds. The Painter in Society* Cambridge, Mass., and London 1996 pp. 164–65.

24 *Ibid.* pp. 104–07. Examples of the dinner service are reproduced as plate VII.

25 Angelo *op. cit.* pp. 377–79, 392; J. Barry *An Account of a Series of Pictures in the Great Room of the Society of Arts, Manufactures, and Commerce, at the Adelphi* London 1783 pp. 10–11.

26 H. Belsey 'A Visit to the Studios of Gainsborough and Hoare' *Burlington Magazine* CXXIX (February 1987) pp. 107–09.

27 Woodall p. 39.

28 Whitley p. 336. Hayes 1982 I pp. 187–236 Appendix I 'The Problem of Gainsborough Dupont' goes a long way to unravelling Dupont's work from that of his uncle.

29 E. Fletcher (ed.) *Conversations of James Northcote R.A. with James Ward on Art and Artists* London 1901 p. 161.

30 Woodall pp. 143, 133.

31 Angelo *op. cit.* p. 275.

32 Garlick and Macintyre *loc.cit.*; Angelo *op. cit.* p. 279.

33 Hayes 1982 II cat. nos 88, 113, 89, 95, 107, 105, 106, 110.

34 For Bateman, Waterhouse 48; Rutland, Waterhouse 590; Abel, Waterhouse 3; Giardini, Waterhouse 311.

35 M. Pointon 'Portrait-Painting as a Business Enterprise in London in the 1780s' *Art History* 7 (June 1984) (pp. 187–205) pp. 195, 191, also *idem Hanging the Head. Portraiture and Social Formation in Eighteenth-century England* New Haven and London 1993 pp. 36–52. For Romney see E. Allen 'George Romney' in J. Turner (ed.) *The Dictionary of Art* London 1996 27 pp. 117–20.

36 D. H. Solkin *Painting for Money. The Visual Arts and the Public Sphere in Eighteenth-century England* New Haven and London 1992 p. 220.

37 *Morning Chronicle and London Advertiser* 18 May 1773.

38 *Middlesex Journal* 27–29 April 1773; *Public Advertiser* 28 April 1773; *Morning Chronicle and London Advertiser* 30 April 1773; N. Penny *Reynolds* (EC) London 1986 entry to no. 82.

39 *Morning Chronicle* 22 April 1776.

40 *London Evening-Post* 23–25 April 1778; *Morning Post and Daily Advertiser* 29 April 1778.

41 A. Graves *The Royal Academy of Arts Exhibitions 1769–1904* 4 vols London 1905 vol. 3 p. 272.

42 L. E. Troide (ed.) *The Early Journals and Letters of Fanny Burney* Oxford 1988 II pp. 190, 203–04.

43 Figures from my own computation.

44 Wark 1975 pp. 138–39.

45 Waterhouse 1015–22 are copies after Van Dyck, including whole-length copies of the latter's *Lords John and Bernard Stuart* and *James, Duke of Richmond and Lennox*. From D. Cherry and J. Harris 'Eighteenth-century Portraiture and the Seventeenth-century Past: Gainsborough and Van Dyck' *Art History* 5 (September 1982) pp. 287–309 we discover the latter to have been the model for the pose of both *The Blue Boy* and *Captain Wade* of 1771.

46 Cherry and Harris *op. cit.* p. 291, Wark 1975 pp. 138–39.

47 For Hayman, Whitley 1915 p. 373.

48 A. Ribeiro *The Art of Dress. Fashion in England and France 1750 to 1820* New Haven and London 1995 p. 195.

49 Whitley 1915 p. 132.

50 *Morning Post and Daily Advertiser* 25 April 1777.

51 *Public Advertiser* 26 April 1777; *Morning Chronicle* 25 April 1777.

52 R. Strange *An Enquiry into the Rise and Establishment of the Royal Academy of Arts* London 1775 p. 121 wrote 'I know of no painter, the remembrance of whose works will depend more on the art of engraving than that of Sir Joshua Reynolds', to drive home the fugitive quality of his paint surfaces.

53 For Bate and Gainsborough see Whitley 1915 *passim*. William Pordern and Robert Smirke, writing as 'R. Shanagan' in *The Exhibition, or a Second Anticipation. Being Remarks on the Principal Works to be exhibited next Month at the Royal Academy* London 1779, p. 5, claimed of their plan for a preemptive review that visitors' 'attention to the pictures will no more be distracted by the necessity of forming opinions: They will not more be obliged to news papers and magazines . . . In my Criticisms they shall find opinions ready made for all future Exhibitions.'

54 Hayes 1982 II no. 117, quote on p. 467.

55 *Lord Gage* is Waterhouse 272, plate 172. Walpole is quoted from Graves, *op. cit.* p. 191.

56 Cherry and Harris *op. cit.* pp. 302, 304. For military portraiture, D. Shawe-Taylor *The Georgians: Eighteenth-century Portraiture and Society* London 1990 pp. 33–60.

57 R. de Piles *The Art of Painting . . . Containing a Complete Treatise of Painting, Designing, and the Use of Prints . . . Translated from the French . . .* [1706] 2nd ed. London 1744 p. 7.

58 Wark 1975 p. 68.

59 M. Cormack *The Paintings of Thomas Gainsborough* Cambridge p. 120.

60 Hayes 1982 II p. 467.

61 Wark 1975 p. 107.

62 For Gainsborough's experiments with print-making techniques, see J. Hayes *Gainsborough as Printmaker* London 1971; H. Belsey *Gainsborough the Printmaker* (EC) Aldeburgh 1988. For aquatint, A. Griffiths 'Notes on early Aquatint in England and France' *Print Quarterly* IV 1987 (Autumn 1987) pp. 255–70.

63 For this see M. Rosenthal 'The rough and the smooth: rural subjects in later eighteenth century British art' *Eighteenth-century Life* 18 (May 1994) pp. 36–58, reprinted with minor revisions in M. Rosenthal, C. Payne and S. Wilcox (eds) *Prospects for the nation: Recent Essays in British Landscape, 1750–1880 Studies in British Art* 4 New Haven and London 1997 pp. 37–59, and below, Chapter Eight.

64 *St James's Chronicle* 3–6 May 1777.

65 *Ibid.* 26–29 April 1777.

5 DIVERSIFICATION AND DEFECTION

1 *Whitehall Evening Post* 29 April–1 May 1783; *Morning Chronicle and London Advertiser* 30 April 1782.

2 J. H. Pott *An Essay on Landscape Painting. With Remarks General and Critical, on the different Schools and Masters* London 1782 pp. 71–74.

3 Hayes 1982 I p. 181.

4 Whitley 1915 p. 7. *Morning Chronicle and London Advertiser* 8 August 1788; *Gentleman's Magazine* 58 (July–December 1788) p. 755; W. Jackson *The Four Ages* London 1798 p. 155.

5 Woodall p. 91.

6 Whitley 1928 II p. 221.

7 D. A. Brenneman 'Thomas Gainsborough's "Wooded Landscape with Cattle by a Pool", Art Criticism and the Royal Academy' *Gainsborough's House Review* (1995/6) pp. 37–46. Brenneman's valuable article backs up some of the conclusions which are being drawn here.

8 *Morning Post and Daily Advertiser* 4 May 1780.

9 For Bate's journalistic activities, see Whitley 1915 Chapter Seven, pp. 127–140.

10 *St James's Chronicle, or British Evening Post* 21–23 April 1778.

11 *London Evening Post* 23–25 April 1778.

12 *Morning Chronicle and London Advertiser* 25 April 1778.

13 *Morning Post and Daily Advertiser* 27 April, 29 April 1778.

14 R. B. Sheridan *The Critic or a Tragedy Rehearsed* London 1771 p. 40.

15 *Morning Herald and Daily Advertiser* 1 May 1781, reprinted in *Whitehall Evening-Post* 1–3 May 1781. For other reviews see *Morning Chronicle and London Advertiser* 1 May 1781; *Public Advertiser* 1 May 1781.

16 *London Courant and Westminster Chronicle* 3 May 1781.

17 *Gazetteer and New Daily Advertiser* 24 April 1784.

18 Woodall p. 29.

19 *Public Advertiser* 24 April 1784; *Whitehall Evening Post* 22–24 April 1784; *Morning Post and Daily Advertiser* 28 April 1784.

20 *Morning Post and Daily Advertiser* 26 April 1784. Whitley 1928 II p. 39.

21 *The Ear-Wig; or an Old Woman's Remarks on the Present Exhibition of Pictures of the Royal Academy: Preceded by a Petit Mot pour Rire, instead of a Preface. Including Anecdotes of Characters well known among the Painters; Observations on the Causes of the Decline of the Arts; a Description of the Buildings of Somerset House, and the Appartments occupied by the Royal Academy* London 1781 pp. 8, 12, 9, 16, 13, 5.

22 M. Postle *Sir Joshua Reynolds. The Subject Pictures* Cambridge 1995 passim. For *The Ear-Wig* and *Thais* pp. 44–48; *The Death of Dido* pp. 187–92.

23 *The Ear-Wig* pp. 13–14, 17.

24 Whitley 1915 pp. 173–76.

25 The Queen's Gallery *Gainsborough and Reynolds. Contrasts in Royal Patronage* (EC) London 1994 p. 17.

26 B. Nicolson *Joseph Wright of Derby. Painter of Light* 2 vols London 1968 I. p. 14.

27 For Press notices of Stubbs, *London Courant and Westminster Chronicle* 1 May 1781; *Public Advertiser* 2 May 1781; *Morning Chronicle and London Advertiser* 5 May 1781; *St James's Chronicle; or British Evening Post* 8–10 May 1781.

28 B. Taylor *Stubbs* London 1971 p. 19, quoting Ozias Humphry.

29 For Wright and the Royal Academy, see, in particular, D. Solkin *Painting for Money. The Visual Arts and the Public Sphere in Eighteenth-century England* New Haven and London 1992 pp. 214–76.

30 *Morning Chronicle and London Advertiser* 5 May 1781; *London Courant and Westminster Chronicle* 7 May 1781.

31 *Parker's General Advertiser and Morning Intelligencer* 29 April 1783. For the commission, see Queen's Gallery *op. cit.* pp. 60–64.

32 [John Wolcot] *Lyric-Odes* (1785) p. 10.

33 *Morning Herald and Daily Advertiser* 29, 30 April 1783.

34 *Public Advertiser* 2 May 1783.

35 Woodall p. 29.

36 *Ibid.*

37 *General Evening Post* 29 April–1 May 1783; *Morning Chronicle and London Advertiser* 10 May 1783.

38 Whitley 1915 pp. 186–87.

39 For this see M. Rosenthal 'Gainsborough's *Diana and Actaeon*' in J. Barrell (ed.) *Painting and the Politics of Culture. New Essays on British Art 1700–1850* Oxford 1992 pp. 167–94, especially pp. 185–88.

40 Woodall p. 43.

41 The above is extracted from A. Asfour, P. Williamson and G. Jackson '"A second Sentimental Journey": Gainsborough abroad' *Apollo* CXLVI (August 1997) pp. 27–30.

42 J. Barry *An Account of a Series of Pictures in the Great Room of the Society of Arts, Manufactures, and Commerce, at the Adelphi* London 1783 pp. 7–8.

43 *Ibid.* p. 12.

44 *Ibid.* p. 17.

45 *Ibid.* p. 11.

46 *Ibid.* For Hone, see J. Newman 'Reynolds and Hone: "The Conjuror" unmasked' in N. Penny (ed.) *Reynolds* (EC) London 1986 pp. 344–54.

47 Anthony Pasquin [John Williams] *The Royal Academicians. A Farce. As it was performed to the Astonishment of Mankind, by his Majesty's Servants, at the Stone House, in Utopia, in the Summer of 1786* London 1786 p. 42. Whitley 1915 pp. 247–48 points out that the particular *animus* Williams directed against Gainsborough was very probably consequent upon his falling out with Henry Bate.

48 Woodall p. 29.

49 Whitley 1915 p. 220.

50 *Public Advertiser* 24 April 1784, repeated in *Whitehall Evening Post* 22–24 April 1784.

51 Whitley 1927 II p. 39.

52 *Gazetteer and New Daily Advertiser* 27 April 1784; *Morning Post, and Daily Advertiser* 28 April 1784.

53 Whitley 1915 p. 225.

54 *Morning Herald and Daily Advertiser* 26 July 1784, first quoted by Whitley 1915 pp. 226–29.

55 Nicolson *op. cit.* p. 16.

56 *Public Advertiser* 17, 23, 26 May 1785.

57 Woodall p. 133.

58 [Sophie v. de la Roche] *Sophie in London in 1786 being the Diary of Sophie v de la Roche. Translated from the German with an Introductory Essay by Clare Williams* London 1933 p. 152.

59 E. Wind *Hume and the Heroic Portrait. Studies in Eighteenth-century Imagery* ed. J. Anderson Oxford 1986 p. 31.

60 F. W. Hilles *Letters of Sir Joshua Reynolds* Cambridge 1929 p. 112 (to the Duke of Rutland 24 September 1784, repeated in a letter to the Reverend Jonathan Shipley the following day, *ibid.* p. 113).

61 R. Wendorf *Sir Joshua Reynolds. The Painter in Society* Boston and London 1996 p. 184.

62 M. Kirby Talley Jr '"All Good Pictures Crack". Sir Joshua Reynolds's practice and studio' Penny *op. cit.* (pp. 55–70) p. 57.

63 *Public Advertiser* 26 May 1785.

6 ST MARTIN'S LANE

1 Woodall p. 127.

2 Wark 1975 p. 252.

3 *Ibid.* pp. 248, 130 (*Discourse* VII 1777), 249.

4 D. A. Brenneman 'The Critical Responses to Thomas Gainsborough's Painting: A Study of the Contemporary Perception and Materiality of Gainsborough's Art' Ph. D. Brown University 1995, pp. 180–208 Chapter 5 'Sir Joshua Reynolds's Fourteenth Discourse', especially pp. 190–99. I am indebted to Dr Brenneman for permission to cite his dissertation. Wark 1975 p. 247.

5 Wark 1975 pp. 257–58. For handling and social proprieties, see S. Smiles '"Splashers", "scrawlers", and "Plasterers": British Landscape Painting and the Language of Criticism 1800–1840' *Turner Studies* 10. 1 (Summer 1990) pp. 5–11, especially p. 6.

6 Wark 1975 pp. 257–58; A. Asfour and P. Williamson 'On Reynolds's use of de Piles, Locke and Hume in his Essays on Rubens and Gainsborough' *Journal of the Warburg and Courtauld Institutes* 60 (1998) pp. 215–29.

7 W. Aglionby *Painting illustrated in Three Dialogues, containing some Choice Observations upon the Art, together with the Lives of the most Eminent Painters, from Cimabue, to the Time of Raphael and Michaelangelo. With an Explanation of the Difficult Terms* London 1685 pp. 359–60 (reissued as *Choice Observations upon the Art of Painting. Together with Vasari's Lives of the Most Eminent Painters, from Cimabue to the Time of Raphael and Michaelangelo. With an Explanation of the Difficult Terms* London 1719, same pagination).

8 Wark 1975 pp. 195, 67.

9 *Ibid.* pp. 282, 248.

10 Asfour and Williamson *op. cit.*

11 For Bartolozzi, Woodall pp. 179–81; *The Shrimp Girl*, M. Postle *Angels and Urchins. The Fancy Picture in Eighteenth-century British Art* (EC) Nottingham 1998 pp. 78–79; for *The Harvest Wagon*, Hayes 1982 II pp. 530–32 (catalogue no. 157). The Rake was spotted in the earlier *Harvest Wagon* by Nick Leigh.

12 For the rage for collecting Hogarth's prints, see T. Clayton *The English Print 1688–1802* New Haven and London 1997 pp. 232–33.

13 Hayes 1982 I p. 29.

14 Paulson 1971 I pp. 215, 248, plate 173.

15 *Ibid.* II pp. 151, 158–60, 206.

16 J. Kirby *Dr Brooke Taylor's Perspective made Easy, both in Theory and Practice, in Two Books. Being an Attempt to make the Art of Perspective easy and familiar; to Adapt it intirely to the Arts*

of Design; and To make it an entertaining Study to any Gentleman who shall chuse so polite an Amusement Ipswich 1754, Dedication. R. Paulson *Hogarth* 3 vols New Brunswick and London 1991–92, III p. 140.

17 Kirby *op. cit.* p. 58.

18 See J. Bensusan-Butt *Thomas Gainsborough in his Twenties. A Memorandum based on contemporary Sources* 3rd ed., Colchester 1993, *passim*.

19 *Ibid.* p. 16. See p. 99 below.

20 Paulson 1971, II, pp. 384–99.

21 Woodall pp. 87–91.

22 Woodall p. 119; Paulson 1971 II pp. 406, 165. See also M. Kitson 'Hogarth's "Apology for Painters"' *Walpole Society* XLI (1966–68), pp. 83, 100–01.

23 Paulson 1971, II, p. 292.

24 D. Bindman *Hogarth* London 1981 p. 42. See Joseph Nollekens *Two Children of the Nollekens Family* 1743, Yale Center for British Art, Paul Mellon Collection. For Gainsborough and Hogarth see also A. Asfour and P. Williamson 'Gainsborough's Wit' *Journal of the History of Ideas* 58 (July 1997) pp. 479–501.

25 Hayes 1982 I pp. 33–34.

26 In a lecture at the National Gallery, London, 19 March 1995.

27 J. Hayes *Thomas Gainsborough* (EC) Ferrara 1998 p. 68.

28 S. Congreve *The Old Batchelor* (1693) London 1781 p. 4. See also J. Thurston *The Toilette. In Three Books* London 1730 p. 41. One might add here that Gravelot later supplied numerous erotic illustrations for books published in France, for which see O. E. Holloway *French Rococo Book Illustration* London n.d.

29 Woodall p. 93.

30 The connections detailed below have been outlined by Asfour and Williamson 'Gainsborough's Wit', although my conclusions are slightly at variance with theirs.

31 See O. Meslay 'The youthful Gainsborough and French Art' in S. Foister, R. Jones and O. Meslay *Young Gainsborough* (EC) London 1997 pp. 12–18, esp. pp. 14–16.

32 Hayes 1982 I p. 35. Rather than Watteau, the direct origin of the pose, with its connotations of dissoluteness, may be the figure to the right in B. Baron's print after Picart's *A Monument Dedicated to Posterity in Commemoration of ye incredible Folly transacted in the Year 1720*, published by T. Bowles in 1720. I owe this reference to Clare Walcot.

33 Plampin contributed an 'Account of a Plantation' to A. Young, *Annals of Agriculture and other Useful Arts* IV (1785) pp. 18ff. On pp. 47 ff is R. Andrews 'On the Advantages of mixing Lime with Dung'.

34 J. Clubbe *Physiognomy: being a Sketch only of a larger Work upon the same Plan: wherein the different Tempers, Passions, and Manners of Men will be particulary considered* 1763 p. 7. For Bensusan-Butt, see n. 18, above.

35 For Hayman see *Grosvenor Bedford and Francis Hayman c.1748–50*, London, National Portrait Gallery; *The Rev. Dr John Hoadly and Dr Maurice Green* 1747, London, Tate Gallery; *The Artist and his Friends c.1745–48*, Yale Center for British Art, Paul Mellon Collection.

36 M. Girouard 'Coffee at Slaughters: English Art and the Rococo' *Town and Country* New Haven 1992 (pp. 15–34) p. 16.

37 R. Paulson *Hogarth*, II '*High Art and Low 1732–1750*' New Brunswick and London 1991–92 pp. 68–69, 73.

38 Paulson 1971 I p. 433.

39 G. Turnbull *A Treatise on Ancient Painting* London 1740 p. ix. For Hogarth's aesthetic, particularly as formed and articulated in *The Analysis of Beauty*, see Paulson 1971 II pp. 153–87, and 'Introduction' in William Hogarth *The Analysis of Beauty* ed. R. Paulson New Haven and London 1997 pp. xvii–lxii.

40 Turnbull *op. cit.* p. 157. For Hogarth and de Piles, Paulson 1997 pp. xxxix, 2, 3–4, 86, 87, 131.

41 G. de Lairesse *The Art of Painting, in all its Branches, Methodically demonstrated by Discourses and Plates, and exemplified by Remarks on the Paintings of the best Masters; and their Perfections and Oversights laid open* London 1738 p. 349.

42 J. A. Rouquet *The Present State of the Arts in England* London ?1755 p. 68 (for Hogarth and Rouquet see Paulson 1971 II pp. 211–14); R. de Piles *The Principles of Painting . . .* London 1743 pp. 158, 163.

43 Thicknesse 1788 pp. 9–11; de Piles *op. cit.* p. 6. See also T. Puttfarken *Roger de Piles's Theory of Art* New Haven and London 1985 p. 47.

44 De Piles *op. cit.* p. 2.

45 [R. de Piles] *The Art of Painting . . . Containing a Complete Treatise of Painting, Designing, and the Use of Prints . . . Translated from the French . . .* 2nd ed. London 1744 p. 20.

46 *Ibid.* p. 268.

47 *Ibid.* p. 8. Woodall p. 97, see also p. 107.

48 De Piles *The Art of Painting* pp. 7, 34. He also makes the musical analogy in *The Principles of Painting . . .* p. 6.

49 Woodall p. 75.

50 L. Sterne *The Life and Opinions of Tristram Shandy* Harmondsworth 1967 p. 175.

51 Quoted in P. Sohm *Pittoresco. Marcho Boschini, his Critics, and their Critiques of Painterly Brushwork in Seventeenth- and Eighteenth-century Italy* Cambridge 1991 p. 139. Here it is salient that, as we learn from E. H. Gombrich *The Story of Art* 11th ed. London 1966 p. 248, in his *Marriage at Cana* (Louvre) Veronese featured as musicians himself on the violoncello, Titian the bass viol, and Jacopo Bassano on flute.

52 This was pointed out by Paulson 1971 II p. 165.

53 J. Addison 'Spectator' no. 411 in the *Spectator* VI London 1753 (for which Hayman supplied the frontispiece) pp. 62–65.

54 *Ibid.* no. 414 pp. 73–76.

55 I am assuming that if Gainsborough read de Piles at all, rather than learning of his ideas through the conversation of Hayman, Hogarth, Ramsay and others, then he would have taken them at face value. For excellent discussions of the complexity of de Piles's thought see Puttfarken *op. cit.* and J. Lichtenstein *The Eloquence of Color. Rhetoric and Painting in the French Classical Age* Berkeley, Los Angeles, Oxford 1993. I thank Marcia Pointon for alerting me to this book.

56 De Piles *Art of Painting . . .* pp. 20, 165; *Principles of Painting . . .* p. 155.

57 De Piles *Principles of Painting . . .* pp. 70–71.

58 Sohm *op. cit.* p. 14. For a connection with Gainsborough see Brenneman *op. cit.* pp. 139–40.

59 De Piles *A Dialogue upon Colouring: Translated from the Original French of Monsieur du Pile, Painter at Paris. Necessary for all Limners and Painters by Mr Ozell* London 1711 p. 18; Lichtenstein *op. cit.* pp. 158, 179.

60 Sohm *op. cit.* p. 146.

61 S. Shesgreen *Hogarth and the Times-of-the-Day Tradition* Ithaca and London 1983 pp. 90–114, 136.

62 S. Johnson 'The Idler' 45 (24 February 1759).

63 For this, see Paulson 1971 and Hogarth *The Analysis of Beauty* 1997, Introduction.

64 Hogarth *The Analysis of Beauty* 1997, Introduction p. xxxii.

65 W. Hogarth *The Analysis of Beauty. Written with a View of fixing the fluctuating Ideas of Taste* London 1753 p. 3.

66 For the historiography of gender studies in eighteenth-century England, see H. Barker and E. Chalus 'Introduction' in H. Barker and E. Chalus (eds) *Gender in Eighteenth-century England. Roles, Representations and Responsibilities* London and New York 1997 pp. 1–28.

67 Hogarth *The Analysis of Beauty* 1753 p. 66.

68 Hogarth *The Analysis of Beauty* 1997 p. 6.

69 Count Francesco Algarotti *An Essay on Painting* Glasgow 1764 p. 142. For Algarotti in England see A. Smart *Allan Ramsay. Painter, Essayist and Man of the Enlightenment* New Haven and London 1992 p. 226.

70 James Buchanan *A Plan of an English Grammar School Education* London 1770, quoted in T. Mortimer *The Elements of Commerce, Politics, and Finance* (1772) London 1780 p. 210.

71 Smart *op. cit.* p. 306 for dates of first editions of Ramsay's writings. A. Ramsay *The Investigator. Containing the following Tracts: I On Ridicule II On Elizabeth Canning III on Naturalization IV On Taste* London 1762 p. 72 (pp. 72–73 contain an encomium on Hogarth).

72 Ramsay *op. cit.* p. 56.

73 *Ibid.* pp. 56–58.

74 Woodall p. 55.

75 Ramsay *loc. cit.*

76 D. Bindman and M. Baker *Roubiliac and the Eighteenth-century Monument* New Haven and London 1995 p. 70.

77 Paulson 1971 I *passim*; Victoria and Albert Museum *Rococo. Art and Design in Hogarth's England* (EC) London 1984.

78 For warning against Rome, Hogarth *The Analysis of Beauty* 1997 p. 19; Kitson *op. cit.* pp. 85–86. For the ready availability of prints, Clayton *op. cit. passim.*

79 R. Jones 'Gainsborough's materials and methods. A "remarkable ability to make paint sparkle"' in Foister, Jones and Meslay *op. cit.* pp. 19–26.

80 For collecting in general, see I. Pears *The Discovery of Painting. The Growth of Interest in the Arts in England 1680–1768* New Haven and London 1988; for paintings in private collections, T. Martyn *The English Connoisseur: containing an Account of whatever is curious in Painting, Sculpture, & in the Palaces and Seats of the Nobility and Principal Gentry of England, both in Town and Country* 2 vols London 1766.

81 J. Barrell *The Political Theory of Painting from Reynolds to Hazlitt. 'The Body of the Public'* New Haven and London 1986 p. 1.

82 For Shaftesbury and contemporary aesthetic debate see D. Solkin *Painting for Money* New Haven and London 1992 pp. 1–26, and for Kneller's kit-kat portraits, pp. 27–47.

83 Barrell *op. cit.* p. 18, and p. 344, fn. 39; also Paulson 1971 I pp. 273–74.

84 J. Richardson *The Theory of Painting* (1715) in *The Works of Jonathan Richardson . . . All corrected and prepared for the press by his son, Mr J. Richardson* London 1773 pp. 14, 93.

85 J. Richardson *A Discourse on the Science of a Connoisseur* in *ibid.* p. 338.

86 Turnbull *op. cit.* p. 77; Wark 1975 pp. 57, 68.

87 Turnbull's was, as we have seen, in part as materialist a view of painting as Hogarth's. On p. 132 he showed himself as an early exponent of sensibility, and on p. 139 he links beauty, truth and utility. For Turnbull see also D. Solkin 'ReWrighting Shaftesbury' in J. Barrell (ed.) *Painting and the Politics of Culture. New Essays on British Art 1700–1850* Oxford 1992 (pp. 73–99) pp. 77–81.

88 E. Malone (ed.) *The Works of Sir Joshua Reynolds Knt. Late President of the Royal Academy* 2 vols London 1797, I pp. 349–62.

89 N. Penny *Reynolds* (EC) London 1986 pp. 29–30; Allen p. 4; Paulson 1991, III pp. 189–90; Bindman and Baker *op. cit.* p. 95.

90 Malone *op. cit.* pp. 350–52.

91 *Ibid.* pp. 253–54.

92 Rouquet *op. cit.* p. 17. For Reynolds's snobbery see R. Wendorf *Sir Joshua Reynolds. The Painter in Society* London 1996.

93 Wendorf *op. cit.* pp. 37–38.

94 Malone *op. cit.* pp. 354–55.

95 *Ibid.* pp. 356–62.

96 E. Wind 'Hume and the Heroic Portrait' in *Hume and the Heroic Portrait: Studies in Eighteenth-Century Imagery* (ed. J. Anderson) Oxford 1986 pp. 1–52.

97 *Ibid.* p. 17.

7 FACES AND LIVES

1 For the complexities of the messages contained within *Mrs Hale as Euphrosyne*, see, in particular, Marcia Pointon, Chapter Five, 'Portraiture, Excess, and Mythology: Mary Hale, Emma Hamilton and others . . . "in Bacchante"' in *Strategies for Showing. Women, Possession and Representation in English Visual Culture 1665–1800* Oxford 1997 pp. 173–228, especially pp. 179–97. For *Susanna Gale* see J. Clark *The Great Eighteenth-century Exhibition in the National Gallery of Victoria* Melbourne 1983 pp. 146–47.

2 For an excellent analysis of such portraits, see D. Shawe-Taylor *The Georgians. Eighteenth-century Portraiture and Society* London 1990 pp. 33–60. *Captain Orme* is discussed on p. 38.

3 Woodall pp. 67–69.

4 M. Postle 'Gainsborough's "lost" picture of Shakespeare . . .' *Apollo* (December 1991) pp. 374–79.

5 For Buccleuch see Shawe-Taylor, *op. cit.* pp. 70–71, and below, pp. 241–42.

6 For portraits of Siddons see S. West 'The Public and the Private Roles of Sarah Siddons' in R. Asleson (ed.) *Mrs Siddons as the Tragic Muse* Los Angeles and San Marino 1999.

7 N. Penny (ed.) *Reynolds* (EC) London 1986 pp. 324–26, entry to no. 151.

8 A. Ribeiro *The Art of Dress. Fashion in England and France 1750–1820* New Haven and London 1995, p. 73.

9 Quoted by Whitley 1915 p. 236.

10 G. Cavendish, Duchess of Devonshire *The Sylph* second ed. 2 vols London 1779, I. p. 50.

11 For prints see D. Donald *The Age of Caricature. Satirical Prints in the Reign of George III* New Haven and London 1996 pp. 75–108; P. Linebaugh *The London Hanged. Crime and Civil Society in the Eighteenth Century* Harmondsworth (1991) 1993 p. 256.

12 Whitley 1915 p. 237.

13 M. Pointon *Hanging the Head. Portraiture and Social Formation in Eighteenth-century England* New Haven and London 1993, pp. 46, 51. For the business of portraiture see particularly pp. 13–52, and Shawe-Taylor *op. cit.* pp. 7–20.

14 Quoted by Shawe-Taylor *op. cit.* p. 9.

15 *Town and Country Magazine* (November 1771) p. 601.

16 S. Tillyard *Aristocrats. Caroline, Emily, Louisa and Sarah Lennox 1740–1832* London 1994 pp. 151, 149.

17 H. Belsey 'A Visit to the Studios of Gainsborough and Hoare' *Burlington Magazine* CXXIX (February 1987) pp. 107–09; B. Mitchell and H. Penrose (eds) *Letters from Bath 1766–1767 by the Rev. John Penrose* Gloucester 1983 p. 137.

18 Pointon *Hanging the Head* pp. 13–36.

19 *Ibid.* p. 23.

20 R. King 'Ignatius Sancho and Portraits of the Black Elite', in R. King, S. Sandhu, J. Walvin and J. Girdham *Ignatius Sancho. An African Man of Letters* London 1997 (pp. 15–43) p. 16.

21 D. Dabydeen *Hogarth's Blacks. Images of Blacks in Eighteenth-Century English Art* Kingston, Surrey 1985 supplies the best account of this subject.

22 Penny *op. cit.* pp. 245–46, entry to no. 77.

23 King *op. cit.* p. 28. Gainsborough's portrait of P. J. de Loutherbourg is at Dulwich College Picture Gallery.

24 *Ibid.* pp. 28–29. For the gentility of the hand-in-waistcoat pose, see A. Smart *Allan Ramsay. Painter, Essayist and Man of the Enlightenment* New Haven and London 1992 pp. 50–52.

25 Viola Pemberton-Pigott in 'The Development of the Portrait of Countess Howe' in A. French (ed.) *The Earl and Countess Howe by Gainsborough* (EC) London 1988 (pp. 37–43) states, p. 41, that 'From the time of his return to London in 1773 [*sic*] until the end of his life, Gainsborough's grounds are invariably pale grey or beige, sometimes with a warm, pinkish wash.'

26 Woodall p. 111; Thicknesse quoted in R. R. Wark 'Thicknesse and Gainsborough: some new Documents' *Art Bulletin* XL (1958) (pp. 331–34) p. 333, a letter to John Cooke, of Gaytre, Monmouthshire, dated 15 August 1777.

27 *Morning Chronicle and London Advertiser* 25 April 1778.

28 Ribeiro *op. cit.* p. 45.

29 The Queen's Gallery *Gainsborough and Reynolds. Contrasts in Royal Patronage* (EC) London 1994, nos 1 and 22. The Duke and Duchess are no. 4.

30 Wright's painting is in Derby Art Gallery. For an account, see J. Egerton *Wright of Derby* (EC) London 1990 pp. 217–18, entry to no. 142.

31 Queen's Gallery *op. cit.* p. 26.

32 *The Trial of His R. H. the D. of C. July fifth, 1770, For Criminal Conversation with Lady Harriet G—— sixth ed.* London 1770 pp. 48, 11. For the letters see pp. 14, 21.

33 *Town and Country Magazine; or Universal Repository of Knowledge, Instruction and Entertainment* 1770, pp. 401–03, 165, 365–68. See also L. Stone *Road to Divorce. England 1530–1987* Oxford 1992 p. 214, plate 26. For the 'Tête-à-Têtes', see C. McCreery 'Keeping up with the *Bon Ton*: the *Tête-à-Tête* series in the *Town and Country Magazine*' in E. Barker and H. Chalus (eds) *Gender in Eighteenth-century England. Roles, Representations and*

Responsibilities London and New York 1997 pp. 207–29.

34 [Herbert Lawrence] *The Contemplative Man, or the History of Christopher Crab, Esq., of North Wales* 2 vols London 1771, I p. 231.

35 See *Morning Post* 28 May 1777, and *Trials for Adultery* London 1780. I am most grateful to Kate Retford for these references. [Sir Herbert Croft] *The Abbey of Kilkhampton; or, Monumental Records for the Year 1960. Faithfully transcribed from the original Inscriptions, which are still perfect, and appear to be drawn up in a Stile devoid of fulsome Panegyric, or unmerited Detraction; and compiled with a View to ascertain with Precision, the Manners which prevailed in Great Britain during the last Fifty Years of the Eighteenth Century. By the Hon. C. F——x* Dublin 1780 p. 12.

36 P. Langford *Public Life and the Propertied Englishman 1689–1798* Oxford 1991 p. 547; Lord Herbert (ed.) *Pembroke Papers (1780–94). Letters and Diaries of Henry, Tenth Earl of Pembroke and his Circle* London 1950 p. 128; B. Weinreb and C. Hibbert (eds) *The London Encyclopaedia* London 1995 p. 797; *Town and Country Magazine* (1771) p. 151.

37 *Celestial Beds* London 1781 pp. 21, 22.

38 See L. Stone *Uncertain Unions and Broken Lives. Intimate and Revealing Accounts of Marriage and Divorce in England* Oxford 1995 p. 436; and Gainsborough's proximity, Whitley 1915 pp. 108–09.

39 Lady Llanover (ed.) *Autobiography and Correspondence of Mary Granville, Mrs Delany* 6 vols London 1861–62 III p. 605.

40 J. Burke *English Art 1714–1800* Oxford 1976 pp. 213–14; W. Wilkes *A Letter of Genteel and Moral Advice to a Young Lady* third ed. Dublin 1751 p. 139. I owe the quote to Kate Retford. See also Ribeiro, *op. cit.* p. 54.

41 See J. Lindsay *Thomas Gainsborough. His Life and Art* London 1981 pp. 53–54; R. Leppert *Music and Image: Domesticity, Ideology and Socio-Cultural Formation in Eighteenth-century England* Cambridge 1988 p. 40; L. Stainton *Gainsborough and his Musical Friends* (EC) London 1977 no. 16; P. Gosse *Dr Viper. The querulous Life of Philip Thicknesse* London 1952 pp. 130–32. Ford's concerts were announced in the *Public Advertiser* 7903, 5 March 1760; 7908, 11 March 1760; 7923, 8 April 1760; and 8407, 14 October 1761.

42 S. Sloman 'Gainsborough in Bath in 1758–59' *Burlington Magazine* CXXVII (August 1995) pp. 509–12.

43 William Whitehead, MS Letters 1. Published by kind permission of the Hon. Mrs C. Gascoigne, Stanton Harcourt Manor. I am extremely grateful to Susan Sloman for sending me a transcription of the letter.

44 S. McVeigh *Concert Life in London from Mozart to Haydn* Cambridge 1993 p. 87. For the viola da gamba and male performers, Leppert *op. cit.* pp. 42, 107.

45 R. Paulson *Emblem and Expression. Meaning in English Art of the Eighteenth Century* London 1975 p. 206.

46 Leppert *op. cit.* p. 42. For the fashion for the English guitar and the musical glasses as 'ladies' instruments' around 1760, McVeigh *op. cit.* p. 115.

47 B. Cozens-Hardy (ed.) *The Diary of Sylas Neville 1767–1788* Oxford 1950 pp. 254–55.

48 G. Beechey 'The Linleys and their Music', in G. Waterfield *A Nest of Nightingales. Thomas Gainsborough. The Linley Sisters* (EC) London 1988 (pp. 9–13) p. 10. For the problems faced by actresses in establishing their respectability, see S. West *The Image of the Actor: Verbal and Visual Representation in the Age of Garrick and Kemble* London 1991 p. 15; J. Brewer *The Pleasures of the Imagination: English Culture in the Eighteenth Century* London 1997 pp. 324–28; K. Crouch 'The Public Life of Actresses: Prostitutes or Ladies?' in Barker and Chalus *op. cit.* pp. 58–78. For instance, J. Brewer '"The most polite age and the most vicious": Attitudes towards culture as a commodity' in A. Bermingham and J. Brewer (eds) *The Consumption of Culture 1600–1800. Image, Object, Text* London and New York 1995 (pp. 341–61) p. 354: 'The woman who was a cultural producer, who appealed to or appeared before the public, compromised her virtue because such conduct was construed by many critics as inherently immodest. It laid women open to the charge of being tantamount to the only other independent woman in the cultural sphere, the punk or prostitute.'

49 J. Boswell *Life of Johnson* ed. R. W. Chapman; new ed. Corrected by J. D. Fleeman, Oxford 1970 p. 638.

50 McVeigh *op. cit.* p. 168.

51 *Ibid.* p. 14.

52 *A Letter to Miss F——d* London 1761 p. 13. The singing of misremembered lyrics from 'The Slighted Lover' was noticed by Lory Frankel.

53 Gosse *op. cit.* p. 132.

54 *Gentleman's Magazine* XXXI 1761 pp. 33–34, 79–80.

55 *A Dialogue occasioned by Miss F——d's Letter to a Person of Distinction* London 1761 p. 34.

56 *A Letter from Miss F——d*, pp. 16–17.

57 R. Porter 'A Touch of Danger: The Man-Midwife as Sexual Predator' in G. S. Rousseau and R. Porter (eds) *Sexual Underworlds of the Enlightenment* Manchester 1987 pp. 206–32. See also A. Vickery *The Gentleman's Daughter. Women's Lives in Georgian England* New Haven and London 1998 pp. 94–96.

58 P. Thicknesse *Man-Midwifery Analysed: and the Tendency of the Practice detected and exposed* London 1764 pp. 2, 18.

59 The Palma Vecchio is in the collection of the Duke of Northumberland, illustrated in

60 Penny *op. cit.* pp. 199–200, no. 37.

61 W. Hogarth 'Autobiographical Notes' quoted in Paulson 1971 II p. 266.

62 D. A. Brenneman 'The Critical Responses to Thomas Gainsborough's Painting: A Study of the Contemporary Perception and Materiality of Gainsborough's Art' Ph.D. Brown University 1995 p. 130 (the painting is discussed on pp. 128–31).

63 I thank Susan Sloman for bringing this drawing to my notice. It is also cited in Hayes 1970 I p. 114, catalogue 16, along with another by William Hoare, BM 1894-4-17-2.

64 Letter of 4 November 1758, Lewis Walpole Library, Farmington, Conn. I am most grateful to Todd Longstaffe-Gowan for supplying me with a photocopy of this letter.

65 For example Hayes 1975 p. 210. The Van Dyck is no. 9 in O. Millar *Van Dyck in England* (EC) London 1982 pp. 48–50.

66 D. Cherry and J. Harris 'Eighteenth-century Portraiture and the Seventeenth-century Past: Gainsborough and Van Dyck' *Art History* 5 (September 1982) (pp. 287–309) p. 293.

67 Woodall p. 167. For the Ligoniers, see R. Wark *Meet the Ladies. Personalities in Huntington Portraits* San Marino 1972 pp. 1–22.

68 R. Baker *Observations on the Pictures now in Exhibition at the Royal Academy, Spring Gardens, and Mr Christies* London 1771 p. 17. I am indebted to Kate Retford for this reference.

69 Wark *op. cit.* p. 21.

70 H. Belsey 'Two Works by Gainsborough. The Master in Two Guises. A Drawing and a Portrait' *National Art Collections Fund Annual Review 1992*.

71 Woodall p. 151.

72 *Ibid.* p. 83.

73 A. C. Seymour *The Life and Times of Selina, Countess of Huntingdon* 2 vols, London 1839, II. p. 203.

74 *Ibid.* p. 204; Gosse *op. cit.* p. 130.

75 *Public Advertiser loc. cit.*

76 F. Kielmansegge *Diary of a Journey to England in the Years 1761–1762 by Count Frederick Kielmansegge. Translated by Countess Kielmansegge with Illustrations* London 1902 p. 148.

77 Barker and Chalus *op. cit.* p. 2; A. Fletcher *Gender, Sex and Subordination in England 1500–1800* New Haven and London 1995 p. xxii.

78 D. Hume *Essays Literary, Moral and Political* London n.d. (?1894) p. 77; 'Philo-Pegasus' *Eclipse Races (addressed to the Ladies) being an impartial Account of the Celestial Coursers and their Riders, starting together, April 1, 1764, for the Eclipse-Plate Prize* London 1764 p. 4.

79 V. Knox *Liberal Education: or a practical Treatise on the Methods of acquiring useful and polite Knowledge* London 1781 pp. 233, 235–36. For the issue in general see V. Jones (ed.) *Women*

in the Eighteenth Century. Constructions of Femininity London 1990.

80 Paulson *op. cit.*

81 McVeigh *op. cit.* Appendix A 'Subscription and Oratorio Series'.

82 Langford *op. cit.* p. 554

83 A. Rouquet *The Present State of the Arts in England* London 1755 pp. 46–47.

84 Hogarth *op. cit.* p. 19.

85 G. Bickham *The Musical Entertainer* London 1737 pp. 11, 9.

8 FIGURING LANDSCAPE

1 A. Cunningham *The Lives of the most Eminent British Painters* London 1829 I pp. 339–40, quoted by Hayes 1982 I p. 140.

2 Thicknesse 1788 pp. 5–7.

3 Woodall p. 91.

4 Woodall p. 115.

5 Information on Chafy is from the wall caption at the Tate Gallery, 30 January 1996.

6 W. Jackson *Thirty Letters on Various Subjects in Two Volumes* second ed. London 1784 II p. 31.

7 Woodall p. 99.

8 Hayes 1982.

9 John Britton in 1801 quoted in Hayes 1982 II p. 431, entry to no. 89.

10 This has been discovered by Susan Sloman. See 'The Holloway Gainsborough: Its Subject Re-examined' *Gainsborough's House Review* 1997/8 pp. 47–48. I must thank Susan Sloman for sending me a draft of this article prior to its publication.

11 T. Pennant *The Journey from London to Chester* London 1782 pp. 347, 351–52.

12 S. Johnson 'The Rambler' 36 (21 July 1750) in *The Works of Samuel Johnson, L.L.D. A New Edition in Twelve Volumes. With an Essay on his Life and Genius, by Arthur Murphy, Esq.* London 1823 II pp. 232–33.

13 J. Scott *Theron; or The Praise of Rural Life* from *Moral Eclogues* (1778) in J. Barrell and J. Bull (eds) *The Penguin Book of English Pastoral Verse* London 1974 p. 60. For the problematic nature of the pastoral see below, and J. Barrell *The Dark Side of the Landscape. The Rural Poor in English painting 1730–1840* Cambridge 1980 pp. 1–88.

14 George Smith, Landscape Painter, at Chichester, in Sussex *Six Pastorals* London 1770 p. 23 (Pastoral IV).

15 This sketchbook, labelled 'George Morland', but clearly dating from the mid-eighteenth century, is PXC 275/1–2 in the Mitchell Library, State Library of New South Wales.

16 Hayes 1982 I p. 80; Whitley 1915 p. 296.

17 J. M. Neeson *Commoners: common right, enclosure and social change in England, 1700–1820* Cambridge 1993 pp. 158–59.

18 Hayes 1982 I *passim*.

19 Walpole is quoted in T. Martyn *The English Connoisseur . . .* 2 vols London 1766 I p. iii;

Reynolds, *The Idler* 79 (20 October 1759) in J. Reynolds *The Works of Sir Joshua Reynolds* 2 vols London 1797 I pp. 353–56.

20 J. Kirby *The Suffolk Traveller* second ed. London 1764 pp. 1–2; N. Scarfe *The Suffolk Landscape* London 1972 p. 29.

21 For oak trees and patriotism, see M. Rosenthal 'The Landscape Moralised in Later Eighteenth-century Britain' *Australian Journal of Art* IV (1985) pp. 37–50, and S. Daniels 'The Political Iconography of Woodland in later Georgian England' in D. Cosgrove and S. Daniels (eds) *The Iconography of Landscape. Essays on the symbolic representation, design and use of past environments* Cambridge 1988 pp. 43–82.

22 A. Bermingham *Landscape and Ideology. The English Rustic Tradition, 1784–1860* Berkeley 1986 pp. 41, 42.

23 Hayes 1982 I pp. 125–27.

24 Waterhouse nos 829, 833.

25 The suggestion was first made by Julian Gardner at a seminar at the University of Warwick, some time around 1980.

26 K. D. M. Snell *Annals of the Labouring Poor. Social Change and Agrarian England 1660–1900* Cambridge 1983 p. 172, n. 51.

27 Hayes 1982 I pp. 78–79.

28 J. Thomson 'Summer' ll. 361–70.

29 R. Porter *English Society in the Eighteenth Century* Harmondsworth 1982 p. 226.

30 J. D. Chambers and G. E. Mingay *The Agricultural Revolution 1750–1880* London 1966 pp. 96–97. For a survey of the debate, see Neeson *op. cit.* Introduction, particularly pp. 6–8; P. Langford *A Polite and Commercial People: England 1727–1783* Oxford 1989 pp. 432–42; J. Rule *Albion's People. English Society 1714–1815* London 1992 p. 133 and *passim*; Porter *op. cit.* pp. 227–29.

31 Neeson *op. cit.* p. 12.

32 *The Advantages and Disadvantages of Inclosing Waste Lands and Open Fields, Impartially stated and considered. By a Country Gentleman* London 1772 pp. 7–8, 36.

33 Chambers and Mingay *op. cit.* p. 78.

34 M. Peters *Agricultura: or the good Husbandman . . .* London 1776 p. 31. See Neeson *op. cit.* p. 96.

35 Quoted in E. Wind 'Hume and the Heroic Portrait' in J. Anderson (ed.) *Hume and the Heroic Portrait: Studies in Eighteenth-century Imagery* Oxford 1986 p. 20.

36 Neeson *op. cit.* pp. 22–23.

37 Lincolniensis 'On Enclosures' in *A New and Impartial Collection of Interesting Letters from the Public Papers &c.* 2 vols London 1767 II p. 308, quoted by D. H. Solkin *Richard Wilson. The Landscape of Reaction* (EC) London 1982 p. 127. In 1782, William Ogilvie in *An Essay on the Right of Property in Land* London 1782 p. 6 argued that as the earth had 'been given to mankind in common occupancy, each individual seems to have by

nature a right to possess and cultivate an equal share'.

38 Langford *op. cit.* p. 440. N. Kent *Hints to Gentlemen of Landed Property* London 1775 pp. 205, 206.

39 *The History of Lady Julia Mandeville. In Two Volumes. By the Translator of Lady Catesby's Letters* second ed. London 1763 pp. 222–23, 59. For another benevolent landlord doing much the same see *Yorick's Skull; or College Oscitations, with some Remarks on the Writings of Sterne, and a Specimen of the Shandean Stile* London 1777 pp. 50ff.

40 O. Goldsmith *The Deserted Village* London 1770 pp. 1, 2, 7, 3, 22, 8.

41 'The Revolution in Low Life' in *Collected Works of Oliver Goldsmith* ed. Arthur Friedman, 5 vols Oxford 1966 III pp. 195–98; for advertisements, *Public Advertiser* 20 September 1780, *Ipswich Journal* 16 June 1770. J. Scott 'On Goldsmith's *Deserted Village*' in *Critical Essays on some of the Poems of several of the English Poets* London 1785 pp. 247–94.

42 Hayes 1982 I pp. 8–9.

43 Hogarth's *Morning* is at Upton House. For the Laroon drawing, see R. Raines *Marcellus Laroon* London 1966 pl. 21. This may be a comment on huntsmen, as plate 57 reproduces a drawing of a mounted gentleman dispensing charity. L. Sterne *The Life and Opinions of Tristram Shandy* Harmondsworth 1967 pp. 342–43. Hugh Belsey convincingly associates a drawing of a man leading a donkey loaded with a woman and children (Gainsborough's House) with the iconography of the Flight into Egypt, the imagery mediated through a Rembrandt etching ('Two Works by Gainsborough. The Master in Two Guises: a Drawing and a Portrait', *National Art Collections Fund Annual Review* 1992 pp. 7–12).

44 Thicknesse p. 42.

45 Whitley 1915 p. 41.

46 Woodall pp. 55, 127. For Reynolds's lack of religion, Whitley 1928 II p. 290.

47 L. Sterne *The Works and Life* (ed. J. F. Taylor) 12 vols London and New York 1904 V p. 38. A. Smith *The Theory of Moral Sentiments* Oxford 1976 p. 9.

48 B. Allen *Francis Hayman* (EC) New Haven and London 1987 p. 57, catalogue no. 47, p. 122. Sterne *op. cit.* pp. 46, 48.

49 For the Zoffany, see M. Webster *Johan Zoffany 1733–1780* (EC) London 1976 p. 49; for the Gainsborough, J. Hayes *The Holloway Gainsborough* London 1995, and S. Sloman *loc. cit.* The link with Raphael was spotted by Paul Hills.

50 Solkin *op. cit.* pp. 130–31.

51 G. E. Mingay *English Landed Society in the Eighteenth Century* London 1966 pp. 165–66.

52 Hayes 1982 II pp. 449–50, entry to no. 105.

53 Porter *op. cit.* pp. 58–59. See also E. P. Thompson *Whigs and Hunters. The Origin of the Black Act* London 1975.

54 W. Gilpin *Remarks on Forest Scenery* 2 vols London 1791 II p. 39.
55 *Ibid.* p. 46.
56 *Ibid.*
57 J. Sekora *Luxury. The Concept in Western Thought, from Eden to Smollett* London and Baltimore 1977 p. 65.
58 Peters *op. cit.* pp. 17–18.
59 J. Howlett *Enquiry into the Influence which Enclosures have had upon the Population of this Kingdom* second ed. London 1786 p. 14.
60 J. Tucker *The manifold Causes of the Increase of the Poor distinctly set forth* [1760] p. 6.
61 Neeson *op. cit.* pp. 25–27.
62 Porter *op. cit.* p. 106, Country Gentleman *op. cit.* p. 59.
63 This was pointed out to me by Clifford Brigden.
64 For oak trees, see n. 21 above.
65 The link with Hogarth was made by Nicholas Leigh. See also Hayes 1982 II no. 88, pp. 429–30; R. Paulson *Breaking and Remaking. Aesthetic Practice in England 1700–1820* New Brunswick and London 1989 p. 274.
66 Barrell *op. cit.* p. 59. Hayes disagrees.
67 M. Webster *Francis Wheatley* London 1970 p. 14; L. Parris *Landscape in Britain c.1750–1850* (EC) London 1974 p. 53, no. 89.
68 Barrell *op. cit.* pp. 68–70.
69 P. Thicknesse *An Account of the Four Persons found starved to Death at Duckworth in Hertfordshire* (1769) second ed. London 1769 p. 1.
70 For this see Bermingham *op. cit.*; Paulson, *op. cit.* pp. 277, 313.
71 For Gainsborough and Claude, D. A. Brenneman 'Thomas Gainsborough's "Wooded Landscape with Cattle by a Pool". Art Criticism and the Royal Academy' *Gainsborough's House Annual Review* 1995/96 pp. 37–46.
72 Hayes 1982 I p. 138; II p. 489, entry to no. 128.
73 J. Todd *Sensibility. An Introduction* London and New York 1986 p. 7.

9 PAINTING SENSIBLY

1 N. Penny *Reynolds* (EC) London 1986 pp. 264–65.
2 For the Robinson, see M. Postle *Angels and Urchins. The Fancy Picture in Eighteenth-century British Art*. Nottingham 1998 p. 72 no. 35.
3 *The Man of Manners; or, Plebeian polish'd . . . Written chiefly for the Use and Benefit of Persons of Mean Births and Education, who have unaccountably plung'd themselves into Wealth and Power* second ed. London (1737) pp. 58–59.
4 H. Belsey *Gainsborough's Family* (EC) Sudbury 1988 no. 19.
5 Quoted by B. Hill, *Eighteenth-century Women. An Anthology* London 1987 p. 162.
6 Postle *op. cit.* p. 93.
7 Woodall pp. 127–29.

8 Whitley 1915 pp. 186–87.
9 Whitley 1915 p. 243. Hayes 1980 p. 147 identifies the sitter as one and the same, as does M. Cormack *The Paintings of Thomas Gainsborough* Cambridge n.d. p. 158
10 Whitley 1915 p. 187.
11 Wark 1975 p. 130.
12 Postle *op. cit.* p. 20.
13 *Ibid.* p. 51.
14 *St James's Chronicle; or British Evening-Post* 10–20 May 1781.
15 The 1777 *Maria* is in a private collection. The 1781 version is in Derby Art Gallery. See J. Egerton *Wright of Derby* (EC) 1990 nos 52, 58.
16 P. Crown 'Portraits and Fancy Pictures by Gainsborough and Reynolds: Contrasting Images of Childhood' *British Journal for Eighteenth-century Studies* (Autumn 1984) pp. 159–67.
17 Whitley 1915 p. 241.
18 J. and A. L. Aikin *Miscellaneous Pieces in Prose* Belfast 1774 pp. 93–105.
19 *Ibid.* p. 99.
20 [Frances Brooke] *Rosina. A Comic Opera in Two Acts* Dublin 1783 p. 29. She based the incident on the tale of Palemon and Lavinia in Thomson's 'Autumn', while stating that it eventually went back to the Biblical story of Ruth.
21 Mrs H. Chapone *Letters on the Improvement of the Mind, addressed to a young Lady* 2 vols second ed. London 1773 II pp. 88–89.
22 E. Radcliff *The Charitable Man the best Oeconomist, Patriot and Christian. A Sermon preached at St Thomas's, Southwark, on January 1st 1761, for the Benefit of the Free-School in Gravel-Lane* London 1761 pp. 6–8. For a reiteration of this argument see R. Reynolds *St Paul's Doctrine of Charity. A Sermon Preached in the Parish Church of St Chad, Salop. September the sixth, 1759, before the Trustees of the Salop Infirmary. And published at their Request* Salop (1759).
23 *The Polite Lady; or a Course of Female Education. In a Series of Letters from a Mother to her Daughter* (?1760) 3rd ed. London 1775 pp. 250, 256–57, 260.
24 A. Smith *The Theory of Moral Sentiments* ed. D. D. Raphael and A. L. Macfie Oxford 1976 p. 12.
25 *Ibid.* p. 1. For an account of theories of sympathy and the Scottish enlightenment, see J. Dwyer *Virtuous Discourse: Sensibility and Community in late Eighteenth-century Scotland* Edinburgh 1987.
26 J. and A. L. Aikin *op. cit.* p. 93.
27 Whitley 1915 p. 250.
28 Hayes 1970 I p. 229 nos 518, 519; II Plates 166, 167.
29 Charity in action is pictured in another drawing, *ibid.* I p. 272 no. 713, II plate 209.
30 P. Langford *A Polite and Commercial People: England 1727–1783* Oxford 1989 pp. 461, 463.
31 L. E. Klein *Shaftesbury and the Culture of Politeness. Moral Discourse and Cultural Politics in early Eighteenth-century England* Cambridge 1994 p. 1.
32 D. Hume 'Of refinement in the Arts' quoted D. H. Solkin *Painting for Money. The Visual Arts and the Public Sphere in Eighteenth-century England* New Haven and London 1992 p. 157.
33 Quoted in G. J. Barker-Benfield *The Culture of Sensibility. Sex and Society in Eighteenth-century Britain* Chicago and London 1992 p. 105.
34 F. Hutcheson *An Inquiry into the Original of our Ideas of Beauty and Virtue. In Two Treatises. I. Concerning Beauty, Order, Harmony, Design. II. Concerning Moral Good and Evil* (1728) fifth ed. London 1753 p. 116.
35 H. H. Kames *Essays on the Principles of Morality and Natural Religion. In Two Parts* Edinburgh 1751 pp. 16, 68.
36 D. Hume 'An Essay concerning the Principles of Morals' in *Essays Literary, Moral and Political* London n.d. (?1894) (pp. 407–501) pp. 442, 459.
37 Quoted in J. Barrell *The Political Theory of Painting from Reynolds to Hazlitt. 'The Body of the Public'* New Haven and London 1986 p. 58. See also pp. 1–68, 'Introduction. A Republic of Taste' and Solkin *op. cit.* pp. 157–213. For sensibility in general, Barker-Benfield *op. cit.*; R. F. Brissenden *Virtue in Distress. Studies in the Novel of Sentiment from Richardson to Sade* London 1974; J. Mullan *Sentiment and Sociability. The Language of Feeling in the Eighteenth Century* Oxford 1988; J. Todd *Sensibility. An Introduction* London and New York 1986.
38 C. Jenner *The Placid Man: or, Memoirs of Sir Charles Beville* 2 vols London 1770 I pp. 3–4, 115.
39 L. Sterne *The Life and Opinions of Tristram Shandy* (1759–67) Harmondsworth 1967 p. 314.
40 *Yorick's Skull, or College Oscitations, with some Remarks on the Writings of Sterne, and a Specimen of the Shandean Stile* London 1777 pp. 71–72.
41 Barker-Benfield *op. cit.* p. 26; *Letters to the Ladies, on the Preservation of Health and Beauty . . . By a Physician* London 1770 pp. 127–28.
42 W. Cowper *The Task* in H. L'Anson Fausset (ed.) *Cowper's Poems* London 1931', VI ll. 560–63, 321–26, and in general, ll. 321–630. For attitudes towards dogs and animals in general, see K. Thomas *Man and the Natural World. Changing attitudes in England 1500–1800* Harmondsworth 1984 pp. 92–191.
43 For some dogs by Stubbs, see J. Egerton *George Stubbs 1724–1806* (EC) London 1984 nos 99–105.
44 [R. Graves] *The Spiritual Quixote: or, the Summer's Ramble of Mr Gregory Wildgoose. A Comic Romance* 3 vols London 1774 I p. 5.
45 For these pictures see D. Shawe-Taylor *The Georgians. Eighteenth-century Portraiture and Society* London 1990 pp. 61–80.

46 J. Thomson *The Seasons* (ed. J. Sambrook) Oxford 1981, 'Summer' l. 1401.

47 *Ibid.* 'Spring' LL. 936–49.

48 Shawe-Taylor *op. cit.* pp. 131–33, from which I have derived much instruction.

49 Solkin *op. cit.* pp. 225–39.

50 J. Egerton *Wright of Derby* (EC) London 1990 pp. 106–110, entries to nos 52, 53.

51 For these, see D. Alexander *Affecting Moments. Prints of English Literature made in the Age of Romantic Sensibility 1775–1800* (EC) York 1993.

52 For these, see J. Hayes 'Gainsborough and the Bedfords' *Connoisseur* 167 (April 1968) pp. 217–224.

53 Todd *op. cit.* pp. 125–26.

54 Sterne *op. cit.* pp. 576, 453–54.

55 *Gentleman's Magazine* 58 (July–December 1788) p. 754.

56 V. Knox *Essays, Moral and Literary* London 1778 p. 261.

57 *Ibid.* pp. 262–63.

58 Barker-Benfield *op. cit.* p. 9.

59 Shawe-Taylor *op. cit.* p. 71.

60 A. Fletcher *Gender, Sex and Subordination in England 1500–1800* New Haven and London 1995 p. 336.

61 Mullan *op. cit.* p. 16.

62 Jenner *op. cit.* I. pp. 103, 107–08.

63 A. Ribeiro *The Art of Dress. Fashion in England and France 1750–1820* New Haven and London 1995 pp. 45–46. W. Hogarth *The Analysis of Beauty. Written with a View of fixing the fluctuating Ideas of Taste* London 1753 p. 139. For gestures, deportment and breeding, see also P. Kirby (ed.) *Thomas Reid's Lectures on the Fine Arts* The Hague 1973 pp. 33–34; *The Polite Academy; or School of Behaviour for young Gentlemen and Ladies* fifth ed. London 1771.

64 Knox *op. cit.* pp. 2, 5, 6.

65 Thomson *op. cit.* 'Summer' ll. 631, 522.

66 Shawe-Taylor *op. cit.* pp. 76–80.

67 Mrs H. Chapone *op. cit.* I p. 121.

68 Knox *op. cit.* p. 7.

69 L. E. Troide *The Early Journals and Letters of Fanny Burney, I: 1768–1773* Oxford 1988 pp. 250–51.

70 Knox *op. cit.* p. 4. For an historical analysis of what Knox describes see J. G. A. Pocock 'The mobility of property and the use of eighteenth-century sociology' in *Virtue, Commerce and History* Cambridge 1985 pp. 103–23.

10 THE MEANINGS OF ART

1 Wark 1975 pp. 153–54.

2 *Ibid.* pp. 154–61.

3 *Ibid.* p. 162.

4 *Ibid.* p. 132.

5 *Ibid.* pp. 163–64.

6 *Ibid.* p. 164.

7 R. de Piles *The Art of Painting* . . . 2nd ed. London 1744 pp. 44–46.

8 Hayes 1970 no. 478.

9 W. Jackson *The Four Ages* . . . London 1798 p. 157.

10 Woodall pp. 177–79.

11 Jackson *op. cit.* p. 155.

12 Woodall p. 31. Jackson is quoted from A. Asfour, P. Williamson & G. Jackson '"A Second Sentimental Journey": Gainsborough abroad' *Apollo* CXLVI (August 1997) (pp. 27–30) p. 29.

13 De Piles *op. cit.* p. 47.

14 H. Angelo *Reminiscences* London 1904 I pp. 168–69.

15 Woodall pp. 177–79.

16 Hayes 1975 p. 24.

17 Whitley pp. 391, 247.

18 Hayes 1982 I pp. 140–42. The Cottage Scene is Hayes 1982 I no. 134.

19 G. H. Peters *Humphrey Gainsborough. Engineer, Inventor, Congregational Minister at Henley-on-Thames, 1748–1776* Henley 1948 pp. 20–21.

20 J. Hayes *Gainsborough as Printmaker* London 1971; H. Belsey *Gainsborough the Printmaker* (EC) Aldeburgh 1988; A. Griffiths 'Notes on early Aquatint in England and France' *Print Quarterly* IV (Autumn 1987) pp. 255–70.

21 Hayes *Gainsborough as Printmaker* p. 9.

22 *Ibid.* p. 15.

23 Griffiths *op. cit.* p. 255; T. Clayton *The English Print 1688–1802* New Haven and London 1997 pp. 175–76.

24 Hayes *Gainsborough as Printmaker* cat. nos 9–11; Belsey *op. cit.* cat. nos 17–24.

25 Hayes *Gainsborough as Printmaker* pp. 17–18; Belsey *op. cit.* 'Introduction'.

26 Hayes 1982 II pp. 482–85, entry to no. 125.

27 Woodall p. 125.

28 For this see W. Ivins *Prints and Visual Communication* (1953) Cambridge (Mass.) and London 1969.

29 K. Sloan *Alexander and John Robert Cozens. The Poetry of Landscape* New Haven and London 1986 p. 57. The etchings are discussed on pp. 49–62.

30 *Ibid.* p. 56.

31 *Public Advertiser* 28 April 1773. See also W. W. Roworth (ed.) *Angelica Kauffman. A Continental Artist in Georgian England* London 1992.

32 W. L. Pressly *The Life and Art of James Barry* New Haven and London 1981 pp. 56–22; J. Barry *An Account of a Series of Pictures in the Great Room of the Society of Arts Manufactures and Commerce at the Adelphi* London 1783.

33 L. Lippincott 'Expanding on Portraiture. The market, the public and the hierarchy of genres in eighteenth-century Britain' in A. Bermingham and J. Brewer (eds) *The Consumption of Culture 1600–1800. Image, Object, Text* London and New York 1995 pp. 75–88.

34 I have written of this work at length in 'Gainsborough's *Diana and Actaeon*', in J. Barrell (ed.) *Painting and the Politics of Culture. New Essays on British Art 1700–1850* Oxford 1992 pp. 167–94.

35 Wark 1975 pp. 195, 198 (196–97 for Titian specifically).

36 Whitley 1928 II p. 36. Titian's *Diana and Actaeon* was then in the collection of the Duke of Orleans.

37 R. Paulson *Emblem and Expression. Meaning in English Art of the Eighteenth Century* London 1974 p. 224.

38 Rosenthal *op. cit.* p. 171.

39 Gainsborough, according to Whitley 1915 p. 352, owned a copy of Spence's *Polymetis*.

40 N. Penny *Reynolds* (EC) London 1986 no. 140, pp. 312–13.

41 A. A. Cooper, 3rd Earl of Shaftesbury Treatise III viz. *A Notion of the Historical Draught or Tablature of the Judgement of Hercules* London 1713 p. 3.

42 Rosenthal *op. cit.* p. 181 for other examples. The connection with the Baptism of Christ was made by Andrew Hemingway.

43 Anthea Callen pointed out to me that the waterfall was painted wet over dry.

44 Whitley 1915 pp. 108–09.

45 Whitley 1928 I p. 198.

46 British Museum Whitley Papers I 47. J. Barry *An Inquiry into the Obstructions to the Acquisition of the Arts in England* London 1775 pp. 152–56.

47 W. S. Lewis (ed.) *Horace Walpole's Correspondence* 25 Oxford 1971 pp. 245–46.

48 *The Trial, with the Whole of the Evidence, between the Right Hon. Sir Richard Worsley, Bart . . . and George Maurice Bisset, Esq. Defendant, for Criminal Conversation with the Plaintiff's Wife. A new edition* London 1782 p. 11.

49 *Memoirs of Sir Finical Whimsy and his Lady, Interspersed with a Variety of authentic Anecdotes and Characters* London 1782.

50 *An Epistle from L——y W——y to S——r R——d W——y Bart.* 3rd ed. London 1782, also *The Whim!!! or, The Maid-Stone Bath. A Kentish Poetic. Dedicated to Lady Worsley* London 1782 p. 7.

51 *The Connoisseur. By Mr. Town, Critic and Censor-General* (1755) 4 vols 6th ed. Oxford 1774 II p. 240.

52 D. Jarrett *England in the Age of Hogarth* London 1976 p. 122.

53 *Town and Country Magazine* VII (1775) p. 230.

54 *Morning Post and Daily Advertiser* 6 May, 15 May 1780.

55 *Lloyd's Evening Post and British Chronicle* 30 April–2 May 1781; *Gazetter and New Daily Advertiser* 8 May 1781.

56 J. Spence *Polymetis: or an Enquiry concerning the Agreement between the Works of the Roman Poets and the Remains of Ancient Artists. Being an Attempt to illustrate them mutually from one another. In ten Books* (1747) 2nd ed. London 1755 p. 66. For statues in Watteau, see C. Seerveld 'Telltale Statues in Watteau's Paint-

ing' *Eighteenth-century Studies* 14 (1980–81) pp. 151–80.

57 *Letters to the Ladies, on the Preservation of Health and Beauty. "By a Physician* London 1770 p. 107.

58 T. P. Kirkpatrick *Henry Quin M.D. President and Fellow of the King and Queen's College of Physicians in Ireland, and King's Professor of the Practice of Physick* Dublin 1919 p. 46. I should like to thank Hugh Belsey for this reference. For erotic statues, see J. Barrell *The Birth of Pandora and the Division of Knowledge* London 1992 pp. 70, 79–80.

59 J. W. Goethe *Italian Journey [1786–1788]* Trans. W. H. Auden and E. Mayer Harmondsworth 1970 pp. 208, 316; also M. Pointon *Strategies for Showing. Women, Possession and Representation in English Visual Culture 1665–1800* Oxford 1997 pp. 200–01.

60 Rosenthal *op. cit.* pp. 187–88. The Titian is in the National Gallery, London, *Lurchers coursing a Fox*, the Iveagh Bequest, Kenwood, London.

61 Pointon *op. cit.* pp. 179–97.

62 V. Green *A Review of the Polite Arts in France, at the Time of their Establishment under Louis XIVth, compared with their present State in England: in which their national Importance, and several Pursuits are briefly stated. In a Letter to Sir Joshua Reynolds, President of the Royal Academy, and F.R.S.* London 1782 p. 22.

63 R. Oresko (ed.) *The Works in Architecture of Robert and James Adam* London and New York 1975 p. 48.

64 A. Ribeiro *The Art of Dress. Fashion in England and France 1750–1820.* New Haven and London 1995 p. 64. V. Pemberton-Piggott 'The Development of the Portrait of Countess Howe' in A. French (ed.) *The Earl and Countess Howe by Gainsborough* (EC) London 1988 (pp. 37–43) p. 39.

65 Ribeiro *op. cit.* p. 194.

66 A Physician *op. cit.* pp. 62–63; C. Jenner *The Placid Man: or, Memoirs of Sir Charles Beville* 2 vols London 1770 II p. 78.

67 *Morning Chronicle, and London Advertiser* 25 April 1778.

68 *Town and Country Magazine* II (1770) p. 145.

69 J. Brewer ' "The most polite Age and the most vicious". Attitudes towards culture as a commodity, 1600–1800' in Bermingham and Brewer *op. cit.* (pp. 341–61) p. 348.

70 [E. Haywood] *The Wife* London 1756 p. 129.

71 *The Vauxhall Affray; or, the Macaronis Defeated. Being a Compilation of all the Letters, Squibs, &c. on both Sides of the Dispute. With an Introductory Dedication to the Hon. Thos Lyttleton, Esq.* London 1773 pp. 5, 11.

72 R. Shanagan *The Exhibition, or a second Anticipation. Being Remarks on the Principal Works to be exhibited next Month at the Royal Academy* London 1779 pp. 52–53.

73 For Hazlitt, Whitley 1915 p. 242. For Gainsborough and landscape, M. Rosenthal 'Landscape as High Art' in K. Baetjer (ed.) *Glorious Nature. British Landscape Painting 1750 1850* (EC) New York 1993 pp. 13–30.

74 Wark 1975 p. 68.

Select Bibliography

All books are published in London, unless otherwise stated. The abbreviation (EC) denotes Exhibition Catalogue.

The Actor. A Poetical Epistle to Bennell Thornton, Esq. 1760

The Advantages and Disadvantages of Inclosing Waste Lands and Open Fields, Impartially stated and considered. By a Country Gentleman 1772

Aglionby, W. *Painting illustrated in Three Dialogues, containing some Choice Observations upon the Art, together with the Lives of the most Eminent Painters, from Cimabue, to the Time of Raphael and Michaelangelo. With an Explanation of the Difficult Terms* 1685

Aikin, J. *An Essay on the Application of Natural History to Poetry* 1777

Aikin, J., and A.L. Aikin *Miscellaneous Pieces in Prose* Belfast 1774

Alexander, D. *Affecting Moments. Prints of English Literature made in the Age of Romantic Sensibility, 1775–1800* (EC) York 1993

Alexander, W. *The History of Women, from the earliest Antiquity to the present Time; giving some Account of almost every interesting Particular concerning that Sex, among all Nations, ancient and modern* 2 vols 1779

Algarotti, F. *An Essay on Painting* Glasgow 1764

Allen, B. 'Watteau and his Imitators in eighteenth-century England', in F. Moreau and M. Graselli (eds) *Antoine Watteau (1684–1721) le peintre, son temps, et sa legende* Paris and Geneva 1987

——*Francis Hayman* (EC) New Haven and London 1987

Angelo, H. *Reminiscences* 2 vols 1904

Anstey, C. *The New Bath Guide: or, Memoirs of the B——R——D Family* 3rd ed. 1766

——*Speculation; or, a Defence of Mankind: a Poem* 1780

D'Archenholtz, M. *A Picture of England: containing a Description of the Laws, Customs, and Manners of England* 2 vols 1789

Asfour, A., and P. Williamson 'Gainsborough's Wit' *Journal of the History of Ideas* 58 (July 1997) pp. 479–501

——'Gainsborough and William Jackson of Exeter. Studies in two Hands' *Apollo* CXLVI (1997) pp. 31–36

——'Splendid Imposition: Gainsborough, Berkeley, Hume' *Eighteenth-century Studies* 31 (1998) pp. 403–32

——'On Reynolds's use of de Piles, Locke and Hume in his Essays on Rubens and Gainsborough' *Journal of the Warburg and Courtauld Institutes* 60 (1998) pp. 215–29

Asfour, A., P. Williamson and G. Jackson '"A second Sentimental Journey": Gainsborough abroad' *Apollo* CXLVI (August 1997) pp. 27–30

Avison, C. *An Essay on Musical Expression . . . To which is added, A Letter to the Author concerning the Music of the Ancients, and some Passages in Classic Writers relating to that Subject. Likewise, Mr. Avison's Reply to the Author of Remarks on the Essay on Musical Expression. In a Letter from Mr. Avison, to his Friend in London* 2nd ed. 1753

T. B. *A Call to the Connoisseurs, or Decisions of Sense, with Respect to the Present State of Painting and Sculpture . . . Intended to vindicate the Genius and Abilities of the Artists of our own Country, from the Malevolence of pretended Connoisseurs, or Interested Dealers* 1761

Baetjer, K. (ed.) *Glorious Nature. British Landscape Painting 1750–1850* (EC) New York 1993

Barker, H., and E. Chalus (eds) *Gender in Eighteenth-century England. Roles, Representations and Responsibilities* London and New York 1997

Barker-Benfield, G.J. *The Culture of Sensibility. Sex and Society in Eighteenth-century Britain* Chicago and London 1992

Barrell, J. *The Idea of Landscape and the Sense of Place 1730–1840. An Approach to the Poetry of John Clare* Cambridge 1972

——*The Dark Side of the Landscape. The rural poor in English painting 1730–1840* Cambridge 1980

——*English Literature in History 1730–80. An Equal, Wide Survey* 1983

——*The Political Theory of Painting from Reynolds to Hazlitt. 'The Body of the Public'* New Haven and London 1986

——*The Birth of Pandora and the Division of Knowledge* 1992

——(ed.) *Painting and the Politics of Culture. New Essays on British Art 1700–1850* Oxford 1992

Barrell, J., and J. Bull (eds) *The Penguin Book of English Pastoral Verse* 1974

Barry, J. *An Inquiry into the Obstructions to the Acquisition of the Arts in England* 1775

——*An Account of a Series of Pictures in the Great Room of the Society of Arts, Manufactures, and Commerce.* 1783

Bate Dudley, H. *The Woodman, a Comic Opera* 1791

Belsey, H. 'A Visit to the Studios of Gainsborough and Hoare' *Burlington Magazine* CXXIX (February 1987) pp. 107–9

——*Gainsborough's Family* (EC) Sudbury 1988

——*Gainsborough the Printmaker* Aldeburgh 1988

Bensusan-Butt, J. *Thomas Gainsborough in his Twenties. A Memorandum based on contemporary Sources* 3rd ed. Colchester 1993

Bermingham, A. *Landscape and Ideology: The English Rustic Tradition, 1740–1860* Berkeley, Los Angeles, London 1986

Bermingham, A., and J. Brewer (eds) *The Consumption of Culture 1600–1800. Image, Object, Text* London and New York 1995

Bignamini, I., and M. Postle *The Artist's Model. Its Role in British Art from Lely to Etty* (EC) Nottingham 1991

Bindman, D. *Hogarth* 1981

Bindman, D., and M. Baker *Roubiliac and the Eighteenth-century Monument* New Haven and London 1995

Bleackley, H. *Ladies Fair and Frail. Sketches of the Demi-Monde during the Eighteenth Century* London and New York 1909

Borsay, P. *The English Urban Renaissance. Culture and Society in the Provincial Town 1660–1770* Oxford 1989

——'Image and counter-image in Georgian Bath' *British Journal for Eighteenth-century Studies* 17 (1994) pp. 165–80

Brenneman, D. A. 'The Critical Response to Thomas Gainsborough's Painting: A Study of the Contemporary Perception and Materiality of Gainsborough's Art' Ph.D. Brown University 1995

Brewer, J. *Party Ideology and Popular Politics at the Accession of George III* Cambridge 1976

—— *The Pleasures of the Imagination. English Culture in the Eighteenth Century* 1997

Brissenden, R. F. *Virtue in Distress. Studies in the Novel of Sentiment from Richardson to Sade* London 1974

Brooke, F. *The History of Lady Julia Mandeville. In Two Volumes. By the Translator of Lady Catesby's Letters* (1763) 2nd ed. 1763

—— *Rosina. A Comic Opera in Two Acts* Dublin 1783

Brown, J. *An Estimate of the Manners and Principles of the Times* 1757

Browne, A. *The Eighteenth-century Feminist Mind* Brighton 1987

Burke, E. *A Vindication of Natural Society. Or, a View of the Miseries and Evils arising to Mankind from every Species of Artifical Society in a Letter to Lord★★★ by a Late Noble Writer* 2nd ed. 1757

Burke, J. *English Art 1714–1800* Oxford 1976

Burney, C. *An Account of the Musical Performances in Westminster Abbey and the Pantheon, May 26th, 27th, 29th; and June the 3rd, and 8th 1784. In Commemoration of Handel* 1785

Cadogan, W. *An Essay upon Nursing, and the Management of Children, from their Birth to three Years of Age* (1748) 4th ed. 1750

Campbell, L. *Renaissance Portraits. European Portrait Painting in the Fourteenth, Fifteenth and Sixteenth Centuries* New Haven and London 1990

Cannon, J. *Aristocratic Century. The Peerage of Eighteenth-century England* Cambridge 1984

Carre, J. 'La Litterature de Civilité et la Condition des Femmes au XVIIIE Siècle' *Etudes Anglaises* XLVIIe Année 1 (Janvier–Mars 1994) pp. 11–21

The Case of Authors by Profession or Trade, stated with Regard to Booksellers, the Stage, and the Public. No matter by Whom 1758

Cavendish, G. (Duchess of Devonshire) *The Sylph* 2nd ed. 2 vols 1779

The Celebrated Lecture on Heads; which has been exhibited upwards of one hundred successive Nights, to Crowded Audiences and Met with the most Universal Applause 1765

Celestial Beds 1781

Chambers, J.D., and G.E. Mingay *The Agricultural revolution 1750–1880* 1966

Chapone, H. *Letters on the Improvement of the Mind, addressed to a young Lady* (1773) 2 vols 2nd ed. 1773

Cherry, D., and J. Harris 'Eighteenth-century Portraiture and the Seventeenth-Century Past: Gainsborough and Van Dyck' *Art History* 5 (September 1982) pp. 287–309

Childs, F.A. 'Prescriptions for Manners in English Courtesy Literature 1690–1760, and their Social Implications' D.Phil. Oxford 1974

Clayton, T. *The English Print 1688–1802* New Haven and London 1997

Clifford, T., A. Griffiths, and M. Royalton-Kisch *Gainsborough and Reynolds in the British Museum. The Drawings of Gainsborough and Reynolds with a Survey of Mezzotints after their Paintings, and a Study of Reynolds's Collection of Old Master Drawings* (EC) 1978

Clubbe, J. *Physiognomy: being a Sketch only of a larger Work upon the same Plan: wherein the different Tempers, Passions, and Manners of Men will be particularly considered* 1763

Coke, D. *The Painter's Eye* (EC) Sudbury 1977

—— *The Muse's Bower. Vauxhall Gardens 1728–1786* (EC) Sudbury 1978

The Conduct of the Royal Academicians, while Members of the Incorporated Society of Artists of Great Britain, viz. From the Year 1760, to their Expulsion in the Year 1769. With some Part of their Transactions since. 1771

The Connoisseur. By Mr. Town, Critic and Censor General (1755) 6th ed. 4 vols Oxford 1774

Constable, W.G. *Richard Wilson* 1953

Cooper, J.G. *Letters concerning Taste* (1754) 2nd ed. 1755

Copley, S. (ed.) *Literature and the Social Order in Eighteenth-century England* 1984

—— 'Commerce, Conversation and Politeness in the Early Eighteenth-century Periodical' *British Journal of Eighteenth-century Studies* 18 (1995) pp. 63–77

Cormack, M. *The Paintings of Thomas Gainsborough* Cambridge n.d.

Corri, A. *The Search for Gainsborough* 1984

Cosmetti *The Polite Arts, dedicated to the Ladies* 1768

Cowper, W. *Poetical Works* (ed. H.S. Mitford) 4th ed. 1967

Cozens-Hardy, B. (ed.) *The Diary of Sylas Neville 1767–1788* Oxford 1950

Croft, H. *The Abbey of Kilkhampton; or, Monumental Records for the Year 1960. Faithfully transcribed from the original Inscriptions, which are still perfect, and appear to be drawn up in a Stile devoid of fulsome Panegyric, or unmerited Detraction; and compiled with a View to ascertain with Precision, the Manners which prevailed in Great Britain during the last Fifty Years of the Eighteenth Century. By the Hon. C. F—x* Dublin 1780

Crown, P. 'Portraits and Fancy Pictures by Gainsborough and Reynolds: Contrasting Images of Childhood' *British Journal for Eighteenth-century Studies* 7 (1984) pp. 159–67

Derow, J.P. 'Gainsborough's Varnished Water-colour Technique' *Master Drawings* 26 (1988) pp. 259–71

Deuchar, S. *Sporting Art in Eighteenth-century England. A Social and Political History* New Haven and London 1988

A Dialogue occasioned by Miss F—d's letter to a Person of Distinction 1761

Dodsley, R. *The Predceptor: containing a General Course of Education. Wherein the first Principles of Polite Learning are laid down in a Way most suitable for trying the Genius, and advancing the Instruction of Youth* (1748) 2 vols 3rd ed. 1758

Donald, D. *The Age of Caricature. Satirical Prints in the Reign of George III* New Haven and London 1996

Downey, J. *The Eighteenth-century Pulpit. A Study of the Sermons of Butler, Berkeley, Secker, Sterne, Whitefield and Wesley* Oxford 1969

Duncombe, J. *The Feminiad* 1754

Dwyer, J. *Virtuous Discourse: Sensibility and Community in Eighteenth-century Scotland* Edinburgh 1987

Dyer, J. *Poems* 1770

Eagleton, T. *The Rape of Clarissa. Writing, Sexuality and Class Struggle in Samuel Richardson* Oxford 1982

—— *The Ideology of the Aesthetic* 1990

The Ear-Wig; or an Old Woman's Remarks on the Present Exhibition of Pictures of the Royal Academy: Preceded by a Petit Mot pour Rire, instead of a Preface. Including Anecdotes of Characters well known among the Painters; Observations on the Causes of the Decline of the Arts; a Description of the Buildings of Somerset House, and the Appartments occupied by the Royal Academy 1781

Edelstein, T., and B. Allen *Vauxhall Gardens* (EC) New Haven 1983

Eden, F.M. *The State of the Poor: or an History of the Labouring Classes in England* 3 vols 1797

Egerton, J. *George Stubbs 1724–1806* (EC) 1984

—— *Wright of Derby* (EC) 1990

Eidelberg, M. 'Watteau Paintings in England in the Early Eighteenth Century' *Burlington Magazine* CXVII (1975) pp. 576–82

Einberg, E. *Manners and Morals. Hogarth and British Painting 1700–1760* (EC) 1987

An Epistle from L——y W——y to S—r R——d W——y, Bart. (1782) 3rd ed. 1782

Everett, N. *The Tory View of Landscape* New Haven and London 1994

The Female Spectator (1744) 4 vols 5th ed. 1755

Ferguson, A. *Institutes of Moral Philosophy* Edinburgh 1773

Fletcher, A. *Gender, Sex and Subordination in England 1500–1800* New Haven and London 1995

Fletcher, E. (ed.) *Conversations of James Northcote R.A. with James Ward on Art and Artists* 1901

Flint C. '"The Family Piece": Oliver Goldsmith and the Politics of the Everyday in Eighteenth-century Domestic Portraiture' *Eighteenth-century Studies* 29 (1995–96) pp. 127–52

Foister, S., R. Jones, and O. Meslay *Young Gainsborough* (EC) 1997

Foote, S. *A Treatise on the Passions, so far as they regard the Stage; With a Critical Enquiry into the theatrical Merit of Mr. G——k, Mr. Q——n, and Mr. B——y. The first considered in the Part of* Lear, *the last two opposed in* Othello n.d.

—— *Taste. A Comedy, of Two Acts* Dublin 1752

—— *The Maid of Bath; a Comedy* 1778

J. Fordyce *The Folly, Infamy, and Misery of unlawful Pleasure. A Sermon preached before the General Assembly of the Church of Scotland, May 25 1760* Edinburgh 1760

—— *The Character and Conduct of the Female Sex, and the Advantages to be derived by young Men from the Society of Virtuous Women (1776)* 2nd ed. 1776

French, A. (ed.) *The Earl and Countess Howe by Gainsborough. A Bicentenary Exhibition* (EC) 1988

Friedman, A. (ed.) *Collected Works of Oliver Goldsmith* Oxford 1966

Fulcher, G. W. *Life of Thomas Gainsborough R.A.* 1856

Garlick, K., and A. Macintyre (eds) *The Diary of Joseph Farington* 17 vols New Haven and London 1979–98

Girouard, M. *Life in the English Country House* New Haven and London 1978

—— *The English Town* New Haven and London 1990

—— *Town and Country* New Haven 1992

Goldsmith, O. *The Traveller, or a Prospect of Society* 1765

The Deserted Village 1770

Gosse, P. *Dr. Viper. The querulous Life of Philip Thicknesse* 1952

Gowing, L. 'Hogarth, Hayman and the Vauxhall Decorations' *Burlington Magazine* XCV (January 1953)

Graham, J. *The Guardian Goddess of Health: or, the whole Art of preventing and curing Diseases; and of enjoying Peace and Happiness of Body and Mind to the longest possible Period of Human Existence: with Precepts for the Preservation of Personal Beauty and Loveliness. To which is added an Account of the Composition, Preparation, and Properties of the great Medicines prepared and dispensed at the Temple of Health, Adelphi, and at the Temple of Hymen, Pall-Mall, London* n.d.

Graves, A. *The Royal Academy of Arts Exhibitions 1769–1904* 4 vols 1905

[Graves, R.] *The Spiritual Quixote: or, the Summer's Ramble of Mr. Gregory Wildgoose. A Comic Romance* 3 vols 1774

Gregory, J. *A Father's Legacy to his Daughters* 1774

Griffiths, A. 'Notes on early Aquatint in England and France' *Print Quarterly* IV (Autumn 1987) pp. 255–70

Grosley, M. *A Tour to London; or, New Observations on England, and its Inhabitants. By M. Grosley, F.R.S. Member of the Royal Academies of Inscriptions and Belles Lettres. Translated from the French by Thomas Nugent, LLD. Fellow of the Society of Antiquaries* 2 vols 1772

Hare, A. *Theatre Royal Bath. A Catalogue of Performances at the Orchard Street Theatre 1750–1805* Bath 1977

Hayes, J. 'Gainsborough and the Bedfords' *Connoisseur* 167 (1968) pp. 217–24

—— *The Drawings of Thomas Gainsborough* 2 vols 1970

—— *Gainsborough as Printmaker* 1971

—— *Gainsborough* 1975

—— *Thomas Gainsborough* (EC) 1980

—— *The Landscape Paintings of Thomas Gainsborough* 2 vols 1982

—— *The Holloway Gainsborough* 1995

Hayes, J., and L. Stainton *Gainsborough Drawings* (EC) Washington 1983

Hayes, W. *The Art of Composing Music by a method entirely New, suited to the Meanest Capacity* 1751

Hayley, W. *An Essay on Painting, in a Poetical Epistle to an Eminent Painter* Dublin 1782

—— *Ode to Mr. Wright of Derby* Chichester 1783

Haywood, E. *Life's Progress through the Passions: or, the Adventures of Natura* 1748

—— *The Wife* 1756

Highmore, J. *Essays, Moral, Religious, and Miscellaneous* 2 vols 1766

Hill, B. *Eighteenth-century Women. An Anthology* 1987

—— *Women, Work and Sexual Politics in Eighteenth-century England* Oxford 1989

Hogarth, W. *The Analysis of Beauty. Written with a View of fixing the fluctuating Ideas of Taste* 1753

—— *The Analysis of Beauty* ed. R. Paulson, New Haven and London 1997

Home, H. (Lord Kames) *Essays on the Principles of Morality and Natural Religion. In Two Parts* Edinburgh 1751

Horne, H.P. *An illustrated Catalogue of engraved Portraits and Fancy Subjects painted by Thomas Gainsborough, R.A., published between 1760 and 1820. And George Romney, published between 1770 and 1820, with the Variations of the State of the Plates* 1891

Howlett, J. *Enquiry into the Influence which Enclosures have had upon the Population of this Kingdom (1786)* 2nd ed. 1786

—— *The Insufficiency of the Causes to which the Increase of our Poor, and of the Poor's Rates have been commonly ascribed; the True One stated; with an Inquiry into the Mortality of Country Houses of Industry, and a slight General View of Mr. Acland's Plan for rendering the Poor independent* 1788

Hume, D. *Essays Literary, Moral and Political* n.d. [?1894]

Hunter, T. *Reflections critical and moral on the Letters of the Late Lord Chesterfield* 1776

Hutcheson, F. *An Inquiry into the Original of our Ideas of Beauty and Virtue. In Two Treatises. I: Concerning Beauty, Order, Harmony, Design. II: Concerning Moral Good and Evil (1728)* 5th ed. 1753

Ireland, J. *Letters and Poems by the late Mr. John Henderson. With Anecdotes of his Life* 1786

Ivins, W. M. *Prints and Visual Communication* Cambridge, Mass. and London 1953

Jackson, W. *Thirty Letters on Various Subjects in Two Volumes* 2nd ed. 2 vols 1784

—— *The Four Ages; together with Essays on Various Subjects* 1798

Jago, R. *Edge-Hill, or the Rural Prospect delineated and moralized* 1767

Jenner, C. *The Placid Man: or, Memoirs of Sir Charles Beville* 2 vols 1770

Jenyns, S. *The Works of Soame Jenyns, Esq. In Four Volumes. Including several Pieces never before Published. To which are prefaced short Sketches of the Author's Family, and also of his Life; by Charles Nelson Cole, Esq.* 1790

Johnson, E. M. *Francis Cotes* Oxford 1976

Johnson, S. *The Lives of the Most Eminent English Poets* 1783

—— *The Works of Samuel Johnson, L.L.D. A New Edition in Twelve Volumes. With an Essay on his Life and Genius, by Arthur Murphy, Esq.* 1823

Jones, R. W. '"Such Strange Unwonted Softness to Excuse": Judgement and Indulgence in Sir Joshua Reynolds's Portrait of *Elizabeth Gunning, Duchess of Hamilton and Argyll*' *Oxford Art Journal* 18 (1995) pp. 29–43

Jones, V. (ed.) *Women in the Eighteenth Century. Constructions of Feminity* 1990

Jones, W. *Sermons on Moral and Religious Subjects; the greater Part of them never printed before* 2 vols 1790

Kenrick, W. *The Whole Duty of Woman. By a Lady. Written at the Desire of a Noble Lord* 1753

Kent, N. *Hints to Gentlemen of Landed Property* 1775

Kielmansegge, F. *Diary of a Journey to England in the Years 1761–1762 by Count Frederick Kielmansegge. Translated by Countess Kielmansegge with Illustrations* 1902

King, P. (ed.) *Thomas Reid's Lectures on the Fine Arts* The Hague 1973

Kirby, J. *The Suffolk Traveller* (1735) 2nd ed. 1764

Kirby, J. *Dr. Brook Taylor's Method of Perspective made Easy, both in Theory and Practice, in Two Books. Being an Attempt to make the Art of Perspective easy and familiar; To Adapt it intirely to the Arts of Design; and To make it an entertaining Study to any Gentleman who shall chuse so polite an Amusement.* Ipswich 1754

Kitson, M. 'Hogarth's "Apology for Painters"' *Walpole Society* XLI (1966–68) pp. 46–111

Klein, L. 'The Third Earl of Shaftesbury and the Progress of Politeness' *Eighteenth-century Studies* 18 (1984–85) pp. 186–214

—— 'Liberty, Manners, and Politeness in Eighteenth-century England' *The Historical Journal* 32 (1989) pp. 583–605

—— *Shaftesbury and the Culture of Politeness. Moral Discourse and Cultural Politics in Early Eighteenth-century England* Cambridge 1994

Knox, V. *Essays, Moral and Literary* 1778

—— *Liberal Education: or a practical Treatise on the Methods of acquiring useful and polite Knowledge* 1781

Lairesse, G. de *The Art of Painting, in all its Branches, Methodically demonstrated by Discourses and Plates, and exemplified by Remarks on the Paintings of the best Masters; and their Perfections and Oversights laid open* 1738

Langford, P. *A Polite and Commercial People. England 1727–1783* Oxford 1989

—— *Public Life and the Propertied Englishman 1689–1798* Oxford 1991

Langhorne, J. *Precepts of Conjugal Happiness. Addressed to a Lady on her Marriage* (1767) 2nd ed. 1769

[Lawrence, H.] *The Contemplative Man, or the History of Christopher Crab, Esq; of North Wales* 2 vols 1771

Leppert, R. *Music and Image. Domesticity, Ideology and Socio-Cultural Formation in Eighteenth-century England* Cambridge 1988

A Letter from Miss F––d to a Person of Distinction. With a new Ballad to an old Tune sent to the Author by an unknown Hand 1761, and 2nd ed. 1761

A Letter to Miss F––d 1761

Letters from a Young Painter abroad to his Friends in England 1748

Letters to the Ladies, on the Preservation of Health and Beauty . . . By a Physician 1770

Lichtenstein, J. *The Eloquence of Color. Rhetoric and Painting in the French Classical Age* trans. E. McVeigh Berkeley, Los Angeles, Oxford 1993

Lindsay, J. *Thomas Gainsborough. His Life and Art* 1981

Linebaugh *The London Hanged. Crime and Civil Society in the Eighteenth Century* Harmondsworth 1991

Lippincott, L. *Selling Art in Georgian England. The Rise of Arthur Pond* New Haven and London 1983

Lloyd, C. *Gainsborough and Reynolds. Contrasts in Royal Patronage* (EC) 1994

—— *The Queen's Pictures. Old Masters from the Royal Collection* (EC) 1994

Lonsdale, R. (ed.) *Eighteenth-century Women Poets* Oxford 1989

Mackenzie, H. *The Man of Feeling* (1773) 1928

McKendrick, N., J. Brewer and J.H. Plumb *The Birth of a Consumer Society. The Commercialization of Leisure in Eighteenth-century England* new ed. 1983

McVeigh, S. *Concert Life in London from Mozart to Haydn* Cambridge 1993

The Man of Manners; or, Plebeian polish'd . . . Written chiefly for the Use and Benefit of Persons of Mean Births and Education, who have unaccountably plung'd themselves into Wealth and Power ?1737

Marriott, T. *Female Conduct: Being an essay on the Art of Pleasing. To be practised by the Fair Sex, before, and after Marriage. A Poem in Two Books. Humbly dedicated to Her Royal Highness, The Princess of Wales* 1759

Marshall, D. *The English Poor in the Eighteenth Century* (1926) New York 1969

Martyn, T. *The English Connoisseur: containing an Account of whatever is curious in Painting, Sculpture, &c. in the Palaces and Seats of the Nobility and Principal Gentry of England, both in Town and Country* 2 vols 1766

Mason, W. *The English Garden . . . a new Edition . . . To which are added a Commentary and Notes, by W. Burgh, Esq. LLD.* York 1783

Mathias, P. *The Transformation of England* 1979

Melmoth, W. *The Letters of Sir Thomas Fitzosborne, on Several Subjects* (1742) 3rd ed. 1750

[A Member of said Society] *A concise Account of the Rise, Progress, and Present State of the Society for the Encouragement of Arts, Manufactures, and Commerce* 1763

Memoirs of Sir Finical Whimsy and his Lady, Interspersed with a Variety of authentic Anecdotes and Characters 1782

Meyer, A. 'Re-dressing Classical Statuary: The Eighteenth-century "Hand-in-Waistcoat" Portrait' *Art Bulletin* LXXVII (1995) pp. 45–64

Millar, J. *Observations concerning the Distinction of Ranks in Society* 1771

Miller, H.K. (ed.) *Miscellanies by Henry Fielding, Esq.* Oxford 1972

Mingay, G.E. *English Landed Society in the Eighteenth Century* London and Toronto 1963

Mitchell, B., and H. Penrose (eds) *Letters from Bath 1766–1767 by the Rev. John Penrose* Gloucester 1983

The Modern Fine Gentleman 2 vols 1774

Modern Manners: in a Series of Familiar Epistles 1781

Mortimer, T. *The Elements of Commerce, Politics and Finance* (1772) 1780

Mullan, J. *Sentiment and Sociability. The Language of Feeling in the Eighteenth Century* Oxford 1988

Mundy, F.C. *Needwood Forest* Lichfield 1776

Murray, C. *The Experiment. A Farce of Two Acts* Norwich 1779

Namier, L. *The Structure of Politics at the Accession of George III* (1929) 2nd ed. 1957

Neale, R.S. *Bath 1680–1850. A Social History or A Valley of Pleasure, yet a Sink of Iniquity* London, Boston and Henley 1981

Neeson, J. *Commoners: Common Right, Enclosure and Social Change in England, 1700–1820* Cambridge 1993

Nicoll, A. *The Garrick Stage. Theatre and Audience in the Eighteenth Century* Manchester 1980

Nicolson, B. *Joseph Wright of Derby. Painter of Light* 2 vols London and New York 1968

Northcote, J. *The Life of Sir Joshua Reynolds . . .* (1814) 2nd ed. 2 vols 1818

—— *The Life of Titian* 2 vols 1830

Nussbaum, F., and L. Brown (eds) *The New Eighteenth Century. Theory. Politics. English Literature* London and New York 1987

D'Oench E.G. *The Conversation Piece: Arthur Devis and his Contemporaries* (EC) New Haven 1980

Parissien, S. *Adam Style* Oxford 1992

Paulson, R. *Hogarth, his Life, Art, and Times* 2 vols New Haven and London 1971

—— *Emblem and Expression. Meaning in English Art of the Eighteenth Century* 1975

—— *Breaking and Remaking. Aesthetic Practice in England 1700–1820* New Brunswick and London 1989

—— *Hogarth* 3 vols New Brunswick and London 1991–92

Payne, C. *Toil and Plenty. Images of the Agricultural Landscape in England 1780–1890* (EC) New Haven and London 1993

Pears, I. *The Discovery of Painting. The Growth of Interest in the Arts in England 1680–1768* New Haven and London 1988

Pennant, T. *The Journey from Chester to London* 1782

Penny, N. (ed.) *Reynolds* (EC) London 1986

Perry, G., and M. Rossington *Femininity and Masculinity in Eighteenth-century Art and Culture* Manchester 1994

Peters, G.H. *Humphrey Gainsborough. Engineer. Inventor, Congregational Minister at Henley on Thames, 1748–1776* Henley 1948

Peters, M. *Agricultura: or the Good Husbandman. Being a Tract of Antient and modern Experimental Observations on the Green Vegetable System. Interspersed with exemplary remarks on the Police of other Nations: to promote Industry, Self-love, and Public Good, by reducing Forests, Chaces, and Heaths into Farms. Together with some Observations on the large Exports that must unavoidably arise from thence, as well as the increase of Population* 1776

'Philo-Pegasus' *Eclipse Races (addressed to the Ladies) being an impartial Account of the Celestial Coursers and their Riders, starting together, April 1, 1764, for the Eclipse-Plate Prize* 1764

Piles, R. de [Mr Ozell] *A Dialogue upon Colouring. Translated from the Original French of Monsieur du Pile, Printed at Paris. Necessary for all Limners and Painters* 1711

—— *The Principles of Painting . . . now first Translated into English. By a Painter* 1743

—— *The Art of Painting, with the Lives and Characters of above 300 of the most Eminent Painters: Containing a Complete Treatise of Painting, Designing, and The Use of Prints. With Reflexions on the Works of the most Celebrated Masters, and of the Several Schools of Europe, as well ancient as modern. Being the most perfect Work of the Kind extant. Translated from the French of Monsieur de Piles. To which is added, An essay towards an English School* [1706] 2nd ed. 1744

Pilkington, M. *The Gentleman and Connoisseur's Dictionary of Painters* 1770

Pocock, J.G.A. *Virtue, Commerce and History. Essays on Political Thought and History, Chiefly in the Eighteenth Century* Cambridge 1985

Pointon, M. 'Gainsborough and the Landscape of Retirement' *Art History* 2 (1979) pp. 441–55

—— *Hanging the Head. Portraiture and Social Formation in Eighteenth-century England* New Haven and London 1993

—— *Strategies for showing. Women, Possession and Representation in English Visual Culture 1665–1800* Oxford 1997

The Polite Academy; or School of Behaviour for Young Gentlemen and Ladies 5th ed. 1771

The Polite Lady; or a Course of Female Education. In a Series of Letters from a Mother to her Daughter [?1760] 3rd ed. 1775

Pope, A. *Poetical Works* (ed. H. Davis) 1966

Porter, R. *English Society in the Eighteenth Century* Harmondsworth 1982

Postle, M. 'Gainsborough's "lost" picture of Shakespeare: "A little out of the Portrait way"' *Apollo* CXL (1991) pp. 374–79

—— *Sir Joshua Reynolds. The Subject Pictures* Cambridge 1995

—— *Angels and Urchins. The Fancy Picture in Eighteenth-century British Art* (EC) Nottingham 1998

Pressly, W.L. *The Life and Art of James Barry* New Haven and London 1981

Puttfarken, T. *Roger de Piles's Theory of Art* New Haven and London 1985

Rack, E. *Essays, Letters, and Poems* Bath 1781

Radcliff, E. *The Charitable Man the best Oeconomist, Patriot, and Christian. A Sermon preached at St. Thomas's, Southwark on January 1st 1761, for the Benefit of the Free-School in Gravel-Lane* 1761

Raines, R. 'Watteaus and "Watteaus" in England before 1760' *Gazette des Beaux-Arts* 89 (1977) pp. 51–64

Ramsay, A. *The Investigator. Containing the following Tracts: I. On Ridicule; II. On Elizabeth Canning; III. On Naturalization; IV. On Taste* 1762

Raven, J. *Judging New Wealth. Popular Publishing and Responses to Commerce in England 1750–1800* Oxford 1992

The Real Character of the Age. In a Letter to the Rev. Dr. Brown. Occasioned by His Estimate of the Manners and Principles of the Times 1757

Reynolds, F. *An Enquiry Concerning the Principles of Taste and the Origin of Our Ideas of Beauty, etc.* 1785

Reynolds, J. *The Works of Sir Joshua Reynolds* (ed. E. Malone) 2 vols 1797

Reynolds, R. *St. Paul's Doctrine of Charity. A Sermon preached in the Parish-Church of St. Chad, Salop September the 6th, 1759, before the Trustees of the Salop Infirmary. And published at their Request* Salop [1759]

Ribeiro, A. *The Art of Dress. Fashion in England and France 1750 to 1820* New Haven and London 1995

Richardson, G. *Iconology: or, A Collection of emblematical Figures, moral and instructive . . . selected from the most approved emblematical Representations of the Ancient Egyptians, Greeks and Romans from the Compositions of Cavaliere, Cesare Ripa, Perugino* 1778

Richardson, J. *An Essay on the Theory of Painting* 2nd ed. 1725

Ripa, C. *Iconologia: or, Moral Emblems* 1709

Roche, S. v. de la *Sophie in London in 1786 being the Diary of Sophie v. de la Roche. Translated from the German with an Introductory Essay by Clare Williams* 1933

Rouquet, J.A. *The Present State of the Arts in England* 1755

Rousseau, G.S., and Porter, R. (eds) *Sexual Underworlds of the Enlightenment* Manchester 1987

Rowarth W.W. (ed.) *Angelica Kauffman. A Continental Artist in Georgian England* 1992

Rule, J. *Albion's People. English Society 1714–1815* 1992

Saumarez Smith, C. *Eighteenth-century Decoration. Design and the Domestic Interior in England* 1993

Scarfe, N. *The Suffolk Landscape* 1972

Scott, J. *Amwell: A Descriptive Poem* 1776

—— *Critical Essays on some of the Poems of several of the English Poets . . . with an Account of the Life and Writings of the Author by Mr. Hoole* 1785

Scott, S. *The History of Cornelia* 1750

—— *A Description of Millenium Hall, and the Country adjacent: together with the Characters of the Inhabitants, and such historical Anecdotes and Reflections as may excite in the Reader proper Sentiments of Humanity, and lead the Mind to a Love of Virtue. By a Gentleman on his Travels* 1762

Sekora, J. *Luxury. The Concept in Western Thought, from Eden to Smollett* Baltimore and London 1977

Seymour, A.C. *The Life and Times of Selina, Countess of Huntingdon* 2 vols 1839

Shanagan, R. [W. Pordern and R. Smirke] *The Exhibition, or a second Anticipation. Being Remarks on the Principal Works to be exhibited next Month at the Royal Academy* 1779

Shawe-Taylor, D. *The Georgians. Eighteenth-century Portraiture and Society* 1990

Shenstone, W. *The Works in Verse and Prose* 3 vols 1764

Sheridan, R.B. *The Critic or a Tragedy rehearsed* 1771

—— *The School for Scandal* (1777) 1970

Shesgreen, S. *Hogarth and the Times-of-the-Day Tradition* Ithaca and London 1983

Sloman, S. 'Gainsborough and "the lodging-house way"' *Gainsborough's House Review* 1991/2 pp. 23–43

—— '"The immaculate Captain Wade". "Arbiter Elegantiae"' *Gainsborough's House Review* 1993/4 pp. 46–61

——'Gainsborough in Bath in 1758–59' *Burlington Magazine* CXXXVII (1995) pp. 509–12

——'Mrs Margaret Gainsborough, "A Prince's Daughter"' *Gainsborough's House Review* 1995/6 pp. 47–58

——'Artists' Picture Rooms in Eighteenth-century Bath' *Bath History* VI (1996) pp. 132–54

——'Sitting to Gainsborough in Bath in 1760' *Burlington Magazine* CXXXIX (1997) pp. 325–8

——'The Holloway Gainsborough and its Subject Re-examined' *Gainsborough's House Review* 1997/8 pp. 47–54

Smart, A. *Allan Ramsay. Painter, Essayist, and Man of the Enlightenment* New Haven and London 1992

Smith, A. *The Theory of Moral Sentiments* ed. D.D. Raphael and A.L. Macfie Oxford 1976

Smith, R. *Harmonics, or the Philosophy of Musical Sounds* Cambridge 1749

Smollett, T. *Humphry Clinker* (1771) Harmondsworth 1967

Snell, K.D.M. *Annals of the Labouring Poor. Social Change and Agrarian England 1660–1900* Cambridge 1983

Sohm, P. *Pittoresco. Marco Boschini, his Critics, and their Critiques of Painterly Brushwork in Seventeenth- and Eighteenth-century Italy* Cambridge 1991

Solkin, D.H. 'Great Pictures or Great Men?' *Oxford Art Journal* IX 2 (1986)

—— *Painting for Money. The Visual Arts and the Public Sphere in Eighteenth-century England* New Haven and London 1992

The Spectator 8 vols 1753

Spence, J. *Polymetis: or, an Enquiry concerning the Agreement between the Works of the Roman Poets and the Remains of Antient Artists. Being an Attempt to illustrate them mutually from one another. In ten Books* (1747) 2nd ed. 1755

Spencer-Longhurst, P., and J.M. Brooke *The Harvest Wagon* (EC) Birmingham 1995

Stainton, L. *Gainsborough and his Musical Friends* (EC) 1977

Sterne, L. *The Life and Opinions of Tristram Shandy* (1759–67) 12 vols Harmondsworth 1967

—— *The Complete Life and Works, V: The Sermons of Mr. Yorick* New York and London 1904

Steward, J.C. *The New Child. British Art and the Origins of Modern Childhood 1730–1830* (EC) Berkeley 1995

Stone, L. *Road to Divorce. England 1530–1987* Oxford 1992

—— *Uncertain Unions and Broken Lives. Intimate and Revealing Accounts of Marriage and Divorce in England* Oxford 1995

Strange, R. *An Inquiry into the Rise and Establishment of the Royal Academy of Arts* 1775

Stroud, D. *George Dance. Architect 1741–1825* 1971

Sumner, A. *Gainsborough in Bath* (EC) 1988

Swedenborg, H.T. *The Theory of the Epic in England 1650–1800* Berkeley and Los Angles 1944

Taylor, B. *Stubbs* 2nd ed 1975

The Temple of Pleasure: A Poem 1783

Thicknesse, P. *Man-Midwifery Analysed: and the Tendency of that Practice detected and exposed* 1764

—— *An Account of the Four Persons found starved to Death at Duckworth in Hertfordshire* 2nd ed 1769

—— *Sketches and Characters of the Most Eminent and Most Singular Persons now living* (1769) 1770

—— *The valetudinarian's bath Guide: or, the Means of obtaining a long Life and Health. Dedicated to Edward, Lord Thurlow, Lord High Chancellor of Great Britain* 2nd ed 1780

—— *A Sketch of the Life and Paintings of Thomas Gainsborough, Esq.* 1788

Thompson, E.P. *Whigs and Hunters. The Origin of the Black Act* 1975

Thomson, J. *The Seasons* (ed. J. Sambrook) Oxford 1981

—— *The Castle of Indolence* 1748

Tillyard, S. *Aristocrats. Caroline, Emily, Louisa and Sarah Lennox 1740–1832* 1994

Tindall, N. *A Guide to Classical Learning; or, Polymetis Abridged* 1764

Todd, J. *Sensibility. An Introduction* London and New York 1986

The Town and Country Magazine; or Universal Repository of Knowledge, Instruction and Entertainment From 1769

The Trial of His R.H. the D. of C. July 5th 1770. For Criminal Conversation with Lady Harriet G— (1770) 6th ed. 1770

The Trial, with the whole of the Evidence, between the Right Hon. Sir Richard Worsley, bart . . . and George Maurice Bisset, esq. Defendant, for Criminal Conversation with the Plaintiff's Wife 1782

Troide, L.E. *The Early Journals and Letters of Fanny Burney* Oxford 1988

Tucker, J. *The Manifold Causes of the Increase of the Poor distinctly set forth* 1760

Turnbull, G. *A Treatise on Ancient Painting* 1740

Turner, A.J. (ed.) *Science and Music in Eighteenth-century Bath* (EC) Bath 1977

The Uncommon Adventures of Miss Kitty F★★★★★* 1759

Underwood, A.C. *A History of the English Baptists* 1947

Unfortunate Sensibility; or the Life of Mrs. L★★★★★★*. Written by herself. In a Series of Sentimental Letters. Dedicated to Mr. Yorick, in the Elysian Fields* 2 vols 1784

Valpy, N. 'Plagiarism in Prints. *The Musical Entertainer* Affray' *Print Quarterly* VI (1989) pp. 54–59

The Vauxhall Affray; or, the Macaronis Defeated. Being a Compilation of all the Letters, Squibs, &c. on both Sides of the Dispute. With an Introductory Dedication to the Hon. Thos. Lyttleton, Esq. 1773

Vickery, A. *The Gentleman's Daughter. Women's Lives in Georgian England* New Haven and London 1998

Victoria and Albert Museum *Rococo. Art and Design in Hogarth's England* (EC) 1984

Wagner, P. *Eros Revived. Erotica of the Enlightenment in England and America* 1988

Walkley, G. *Artists' Houses in London 1764–1914* Aldershot 1994

Walpole, H. *Aedes Walpolianae: or, A Description of Pictures at Houghton Hall in Norfolk* (1741) 2nd ed. 1752

Wark, R.R. 'Thicknesse and Gainsborough: Some New Documents' *Art Bulletin* XL (1958) pp. 331–34

—— *Meet the Ladies. Personalities in Huntington Portraits* San Marino 1972

—— (ed.) *Sir Joshua Reynolds Discourses on Art* New Haven and London 1975

Waterfield, G. *et al. A Nest of Nightingales. Thomas Gainsborough The Linley Sisters* (EC) 1988

Waterhouse, E.K. *Gainsborough* 1958

Watt, I. *The Rise of the Novel* 1987

Weatherly E.H. (ed.) *The Correspondence of John Wilkes and Charles Churchill* New York 1954

Webb, D. *An Inquiry into the Beauties of Painting; and into the Merits of the most celebrated Painters, Ancient and Modern* 2nd ed. 1761

Weber, W. *The Rise of Musical Classics in Eighteenth-century England. A Study in Canon, Ritual and Ideology* Oxford 1992

Webster, M. *Francis Wheatley* 1970

—— *Johan Zoffany 1733–1780* (EC) 1976

Wendorf, R. *The Elements of Life. Biography and Portrait-Painting in Stuart and Georgian England* Oxford 1991

—— *Sir Joshua Reynolds. The Painter in Society* Boston and London 1996

West, S. (ed.) *The Image of the Actor. Verbal and Visual Representation in the Age of Garrick and Kemble* 1991

—— *Italian Culture in Northern Europe in the Eighteenth Century* Cambridge 1999

The Whim!!! Or, The Maid-Stone Bath. A Kentish Poetic. Dedicated to Lady Worsley 1782

Whitehead, W. *The School for Lovers. A Comedy* 1762

Whitley, W.T. *Gainsborough* 1915

——*Artists and their Friends in England 1700–1799* 2 vols 1928

Wildman, S. (ed.) *Gainsborough and Rowlandson. Drawings in the Birmingham Museum and Art Gallery* (EC) Birmingham 1990

Wind, E. *Hume and the Heroic Portrait. Studies in Eighteenth-century Imagery* (ed. J. Anderson) Oxford 1986

Wolcot, J. *Lyric-Odes, for the Year 1785: by Peter Pindar, Esq.* 1785

——*More Lyric Odes to the Royal Academcians by Peter Pindar* 1785

——*Lyric Odes* n.d.

Woodall, M. *The Letters of Thomas Gainsborough* 1963

Woodfin, A. *The Auction. A Modern Novel* 2 vols 1770

Yorick's Skull, or College Oscitations, with some Remarks on the Writings of Sterne, and a Specimen of the Shandean Stile 1777

Index

Numbers in *italic* refer to pages with illustrations

Photograph Credits

Figures refer to plate numbers unless otherwise indicated.